TRUMP

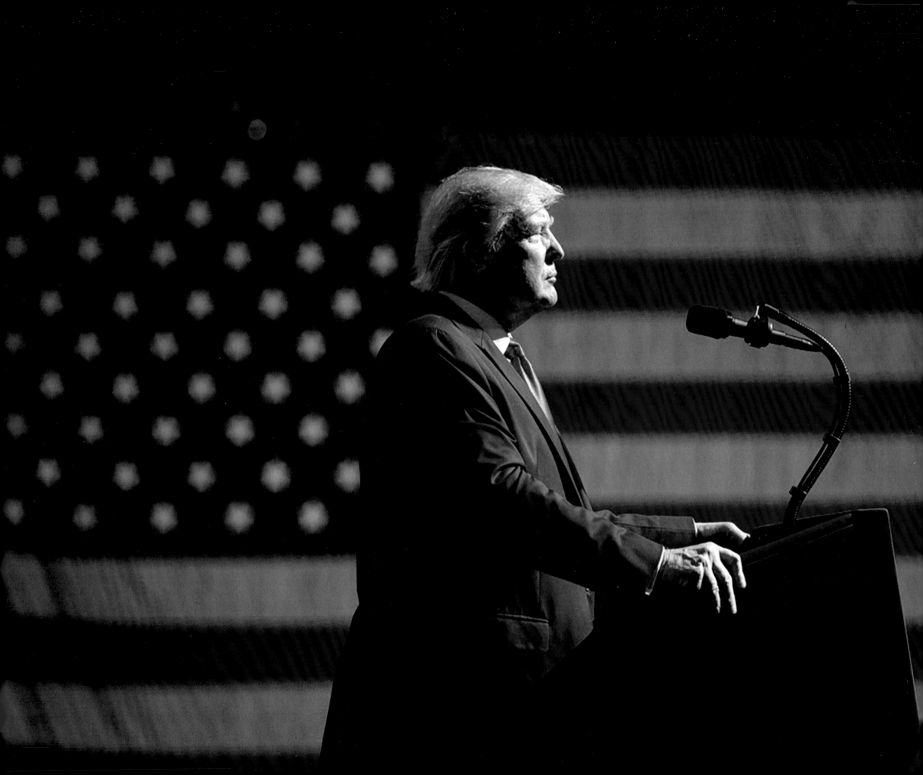

TRUMP

THE PRESIDENTIAL PHOTOGRAPHS

SELECTIONS FROM

THE OFFICIAL WHITE HOUSE PHOTOGRAPHY

CHOSEN BY THE EDITORS OF WILLIAM MORROW

WM

WILLIAM MORROW
An Imprint of Harpercollins Publishers

We, the citizens of America, are now joined

in a great national effort to rebuild our country

and to restore its promise for all of our people.

Together, we will determine the course of America

and the world for years to come.

We will face challenges. We will confront hardships.

But we will get the job done.

—From the Inaugural Address, January 20, 2017

January 20, 2017: President-elect Donald Trump walks to take his seat
for the inaugural swearing-in ceremony. (Shealah Craighead)

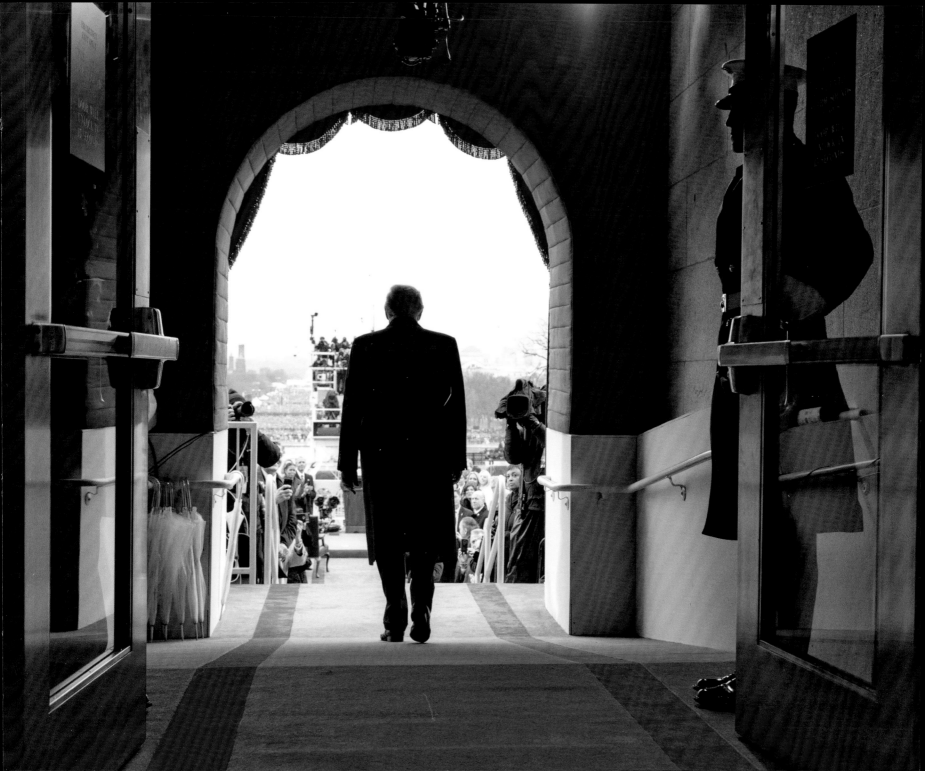

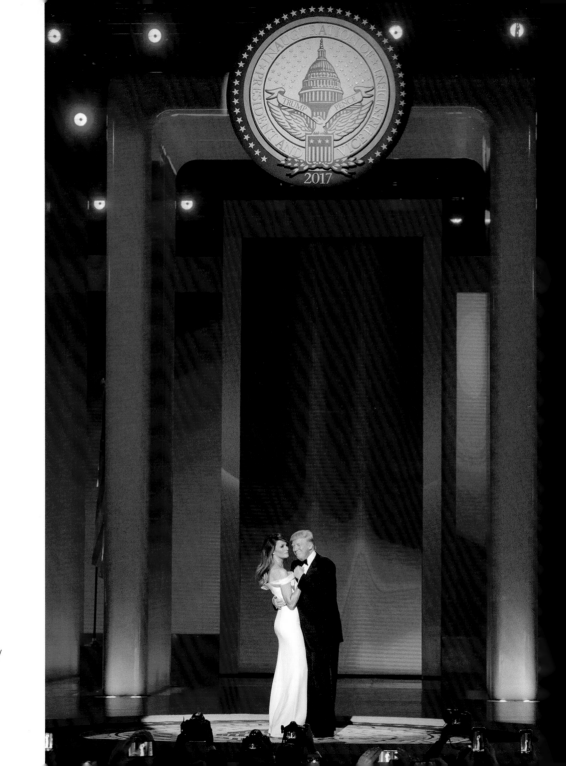

January 20, 2017: Sharing the first dance with First Lady Melania Trump at the Liberty Inaugural Ball. (Grant Miller)

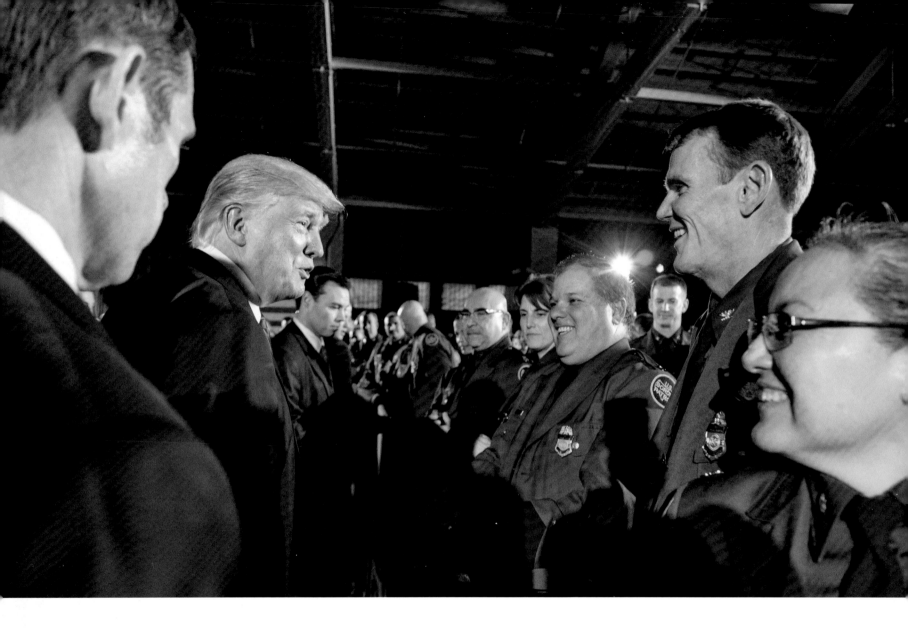

January 25, 2017: Greeting audience members after a speech at the Department of Homeland Security. (Shealah Craighead)

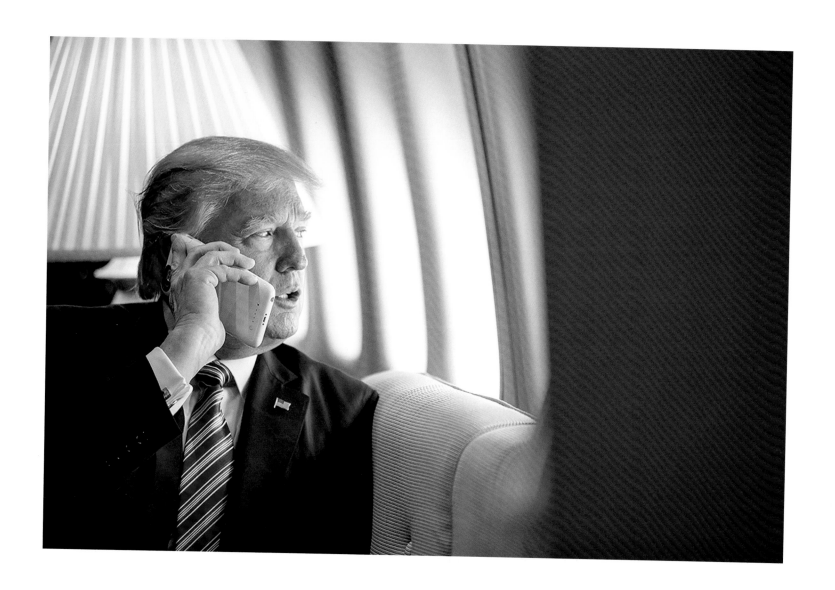

January 26, 2017: The President's first trip
aboard Air Force One. (Shealah Craighead)

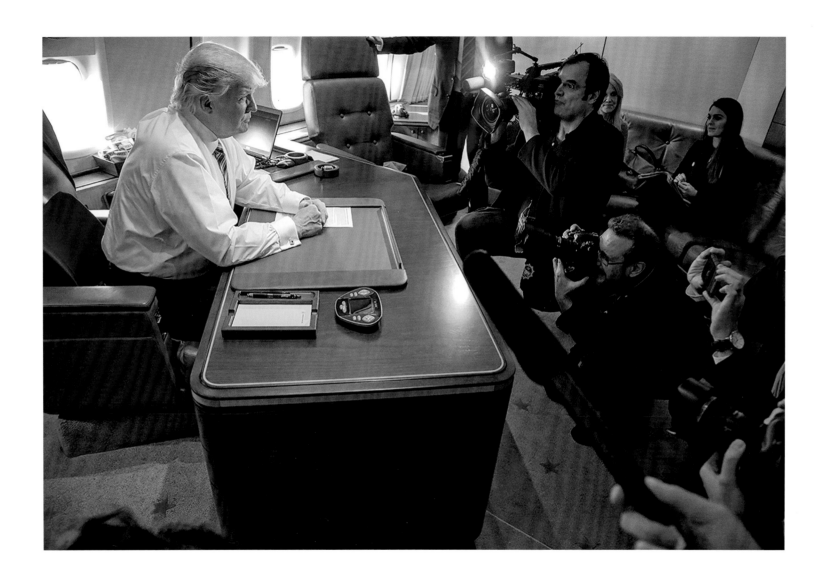

January 26, 2017: Talking to members of the press in the President's office aboard Air Force One. (Shealah Craighead)

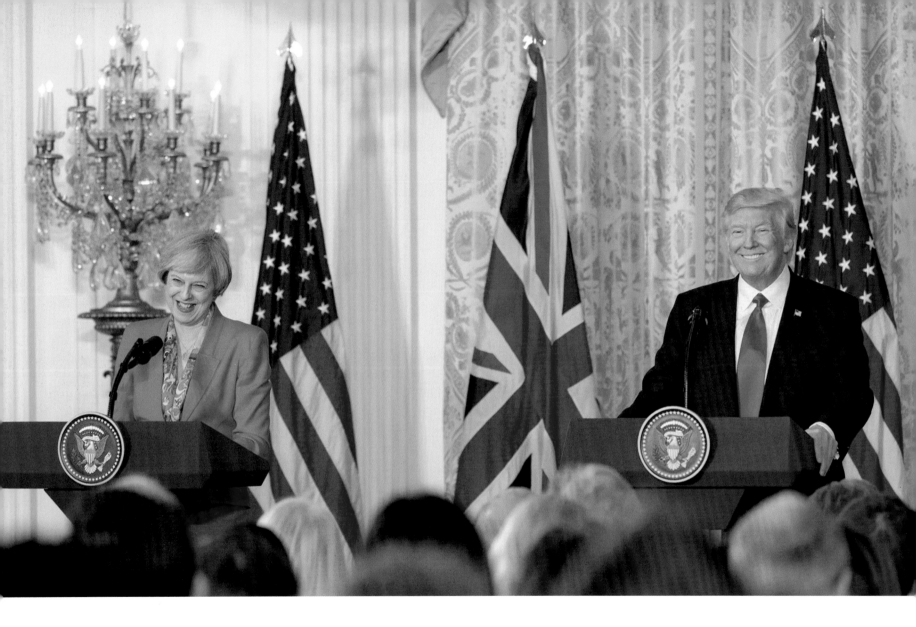

January 27, 2017: A joint press conference with British
prime minister Theresa May. (Shealah Craighead)

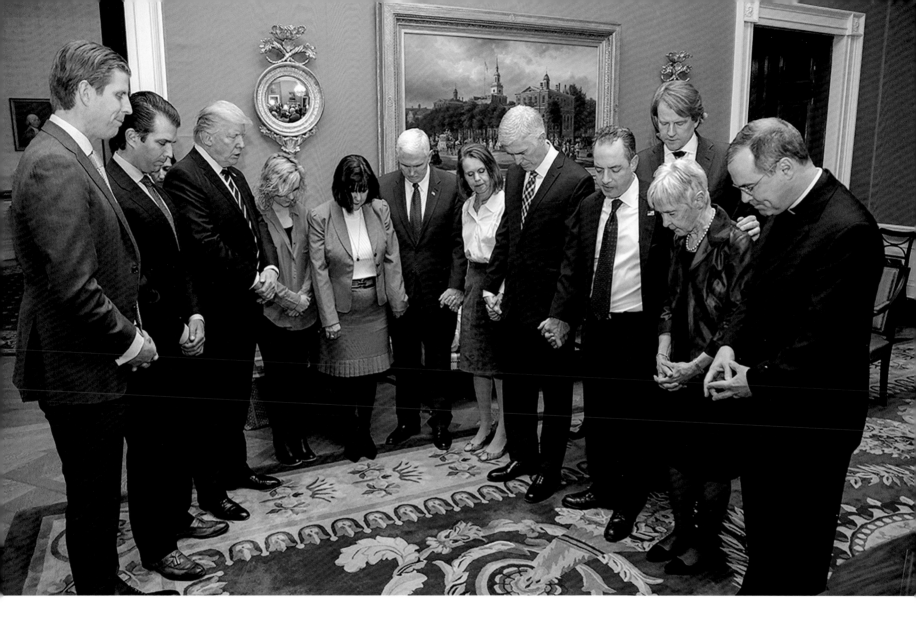

January 31, 2017: Pausing in prayer, after announcing the nomination of Judge Neil M. Gorsuch to the Supreme Court. (Shealah Craighead)

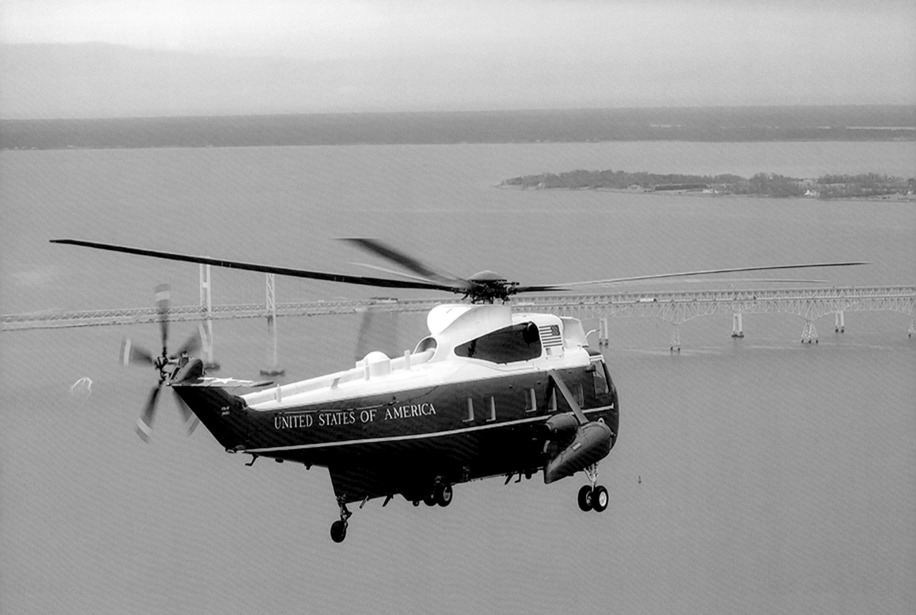

February 1, 2017: Marine One, en route
to Dover Air Force Base. (Shealah Craighead)

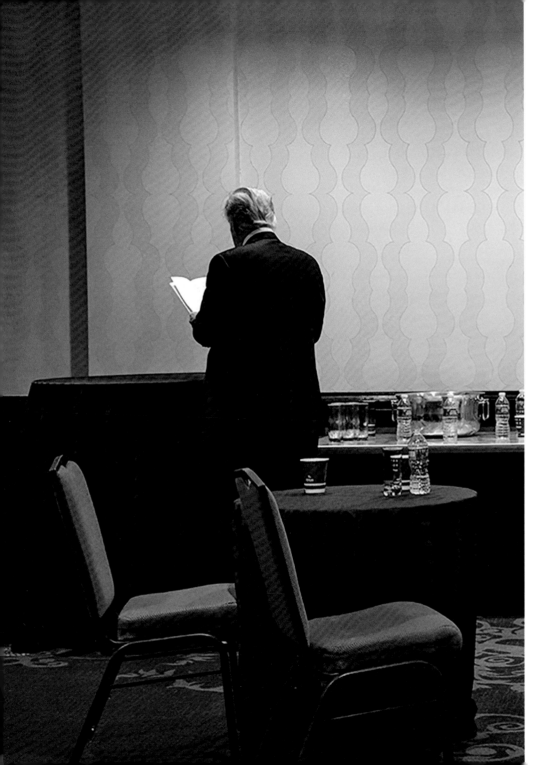

February 2, 2017: The President, reviewing his remarks backstage before the National Prayer Breakfast. (Shealah Craighead)

The time for small thinking is over.

The time for trivial fights is behind us.

We just need the courage to share the dreams that fill our hearts.

The bravery to express the hopes that stir our souls.

And the confidence to turn those hopes and dreams to action.

From now on, America will be empowered by our aspirations— not burdened by our fears.

—From the State of the Union Address, February 28, 2017

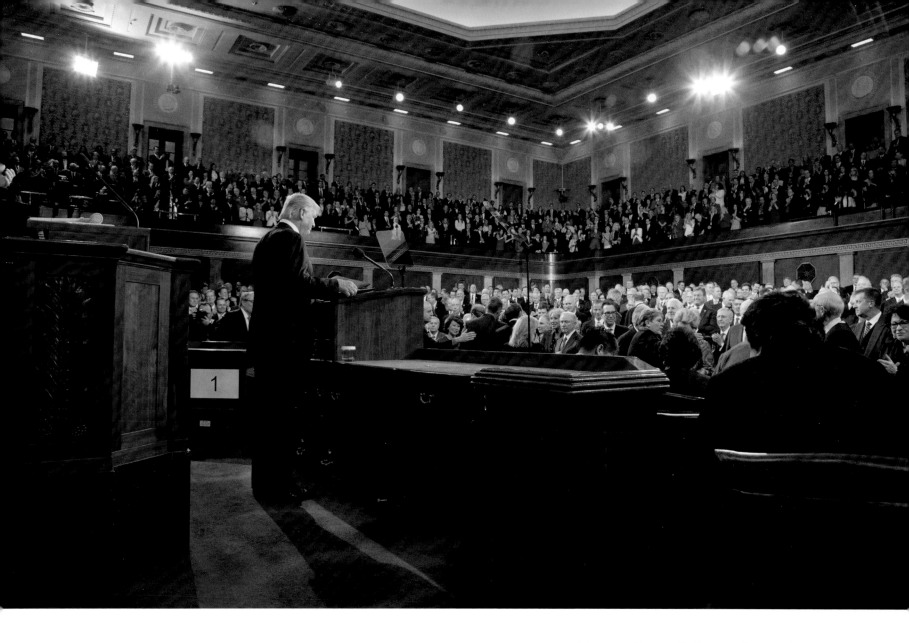

February 28, 2017: Delivering the 2017 State of the Union Address. (Shealah Craighead)

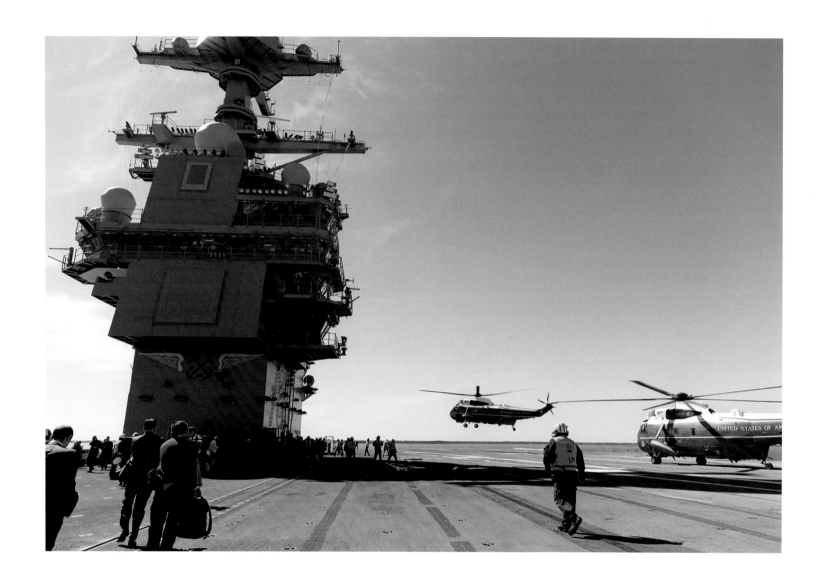

March 2, 2017: Marine One lands aboard the flight deck of the
PCU *Gerald R. Ford* in Newport News, Virginia. (Shealah Craighead)

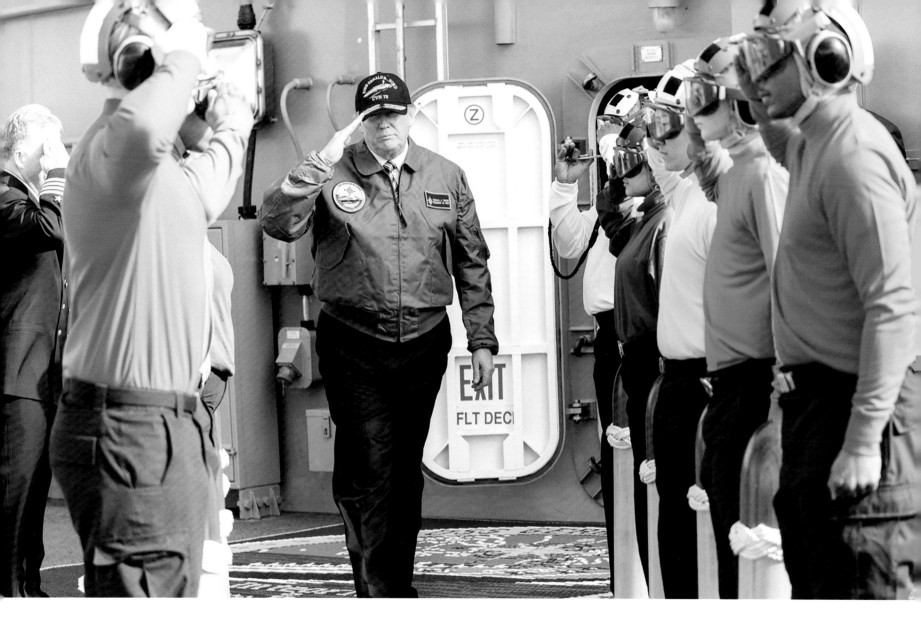

March 2, 2017: Saluting sailors before boarding
Marine One. (Shealah Craighead)

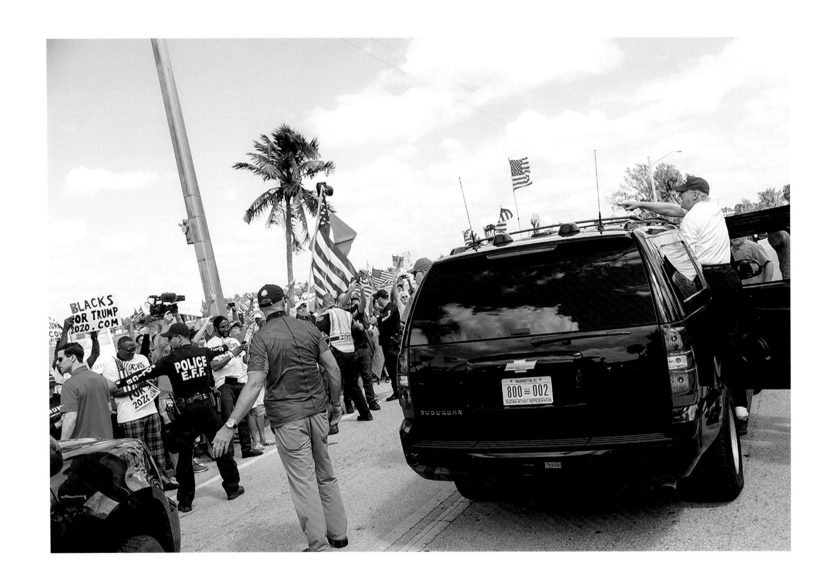

March 4, 2017: Pointing to supporters in
West Palm Beach. (Shealah Craighead)

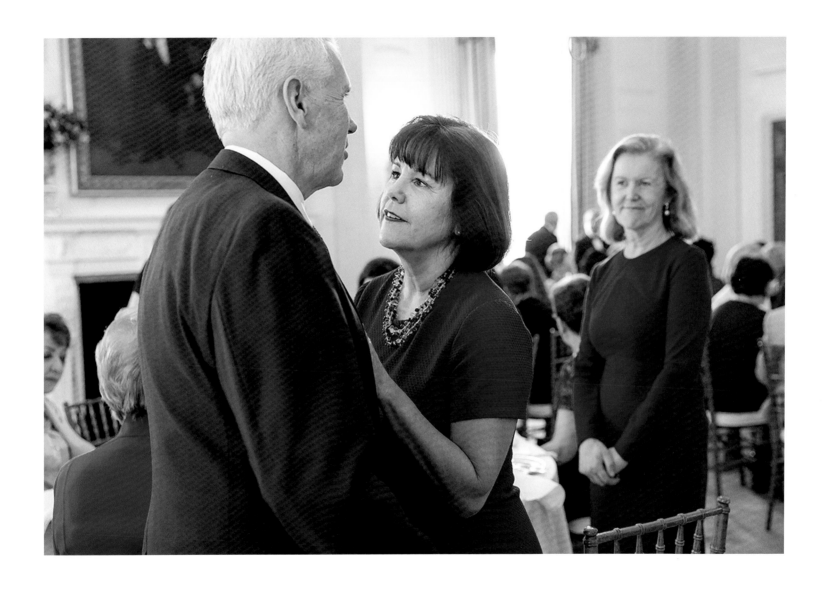

March 8, 2017: Vice President Mike Pence is greeted by his wife, Mrs. Karen Pence, at a luncheon in the State Dining Room of the White House. (Bao N. Huynh)

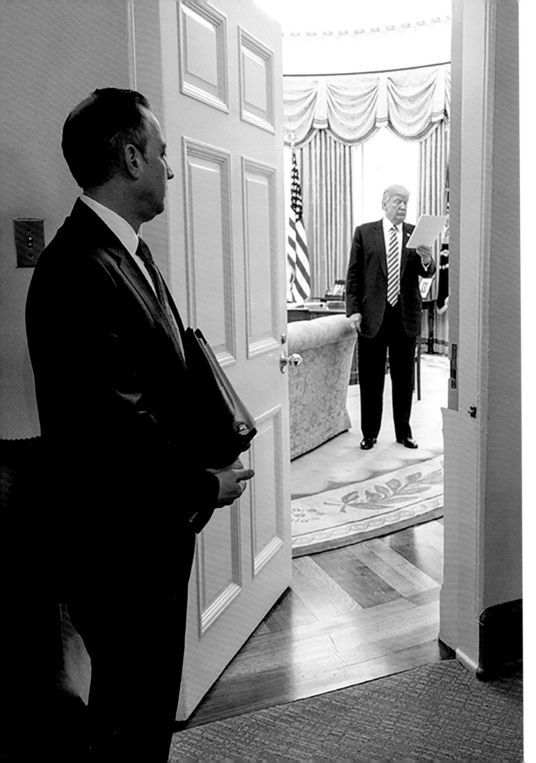

March 10, 2017: Chief of Staff Reince Priebus peers into the Oval Office as President Trump reads over notes. (Shealah Craighead)

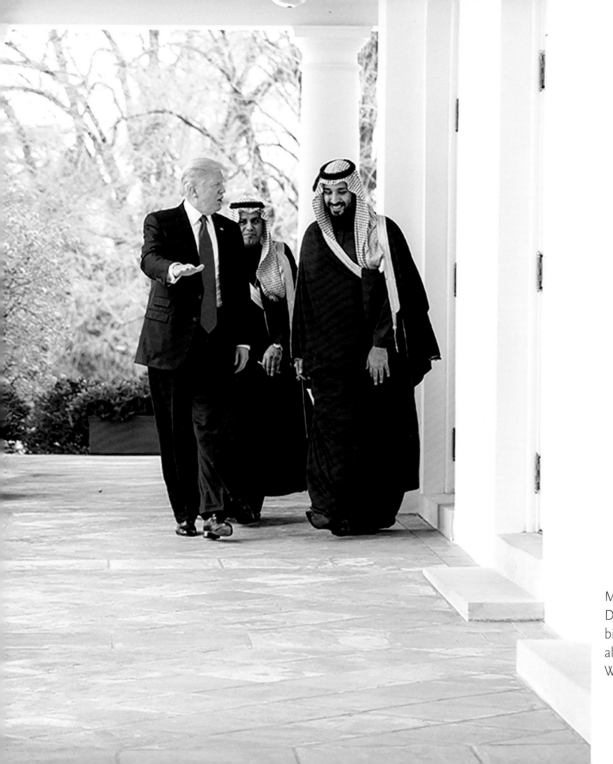

March 14, 2017: Walking with Saudi Deputy Crown Prince Mohammed bin Salman bin Abdulaziz Al Saud along the West Colonnade of the White House. (Shealah Craighead)

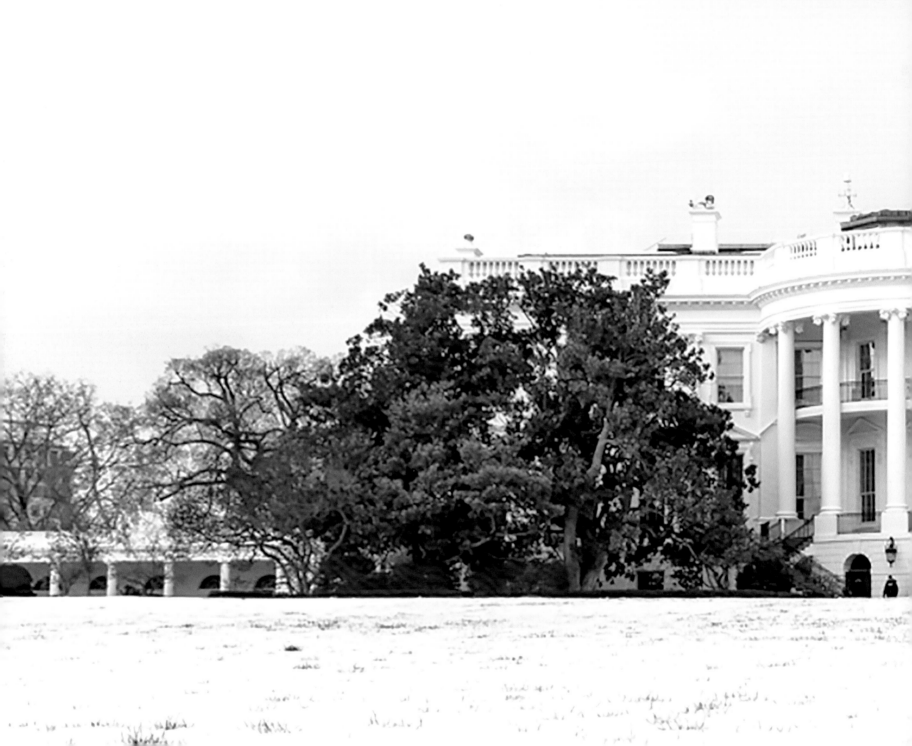

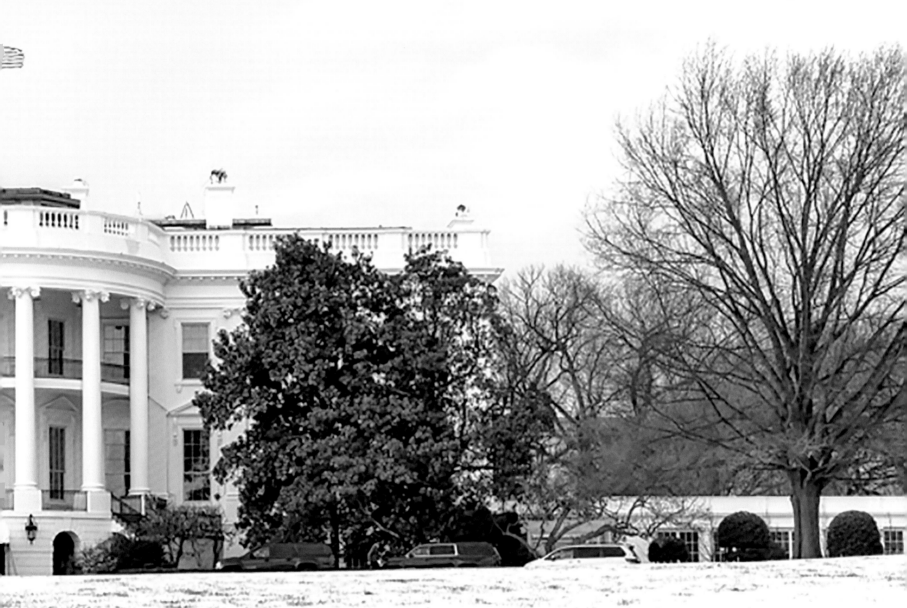

March 14, 2017: The White House's eighteen acres of grounds covered in snow. (Shealah Craighead)

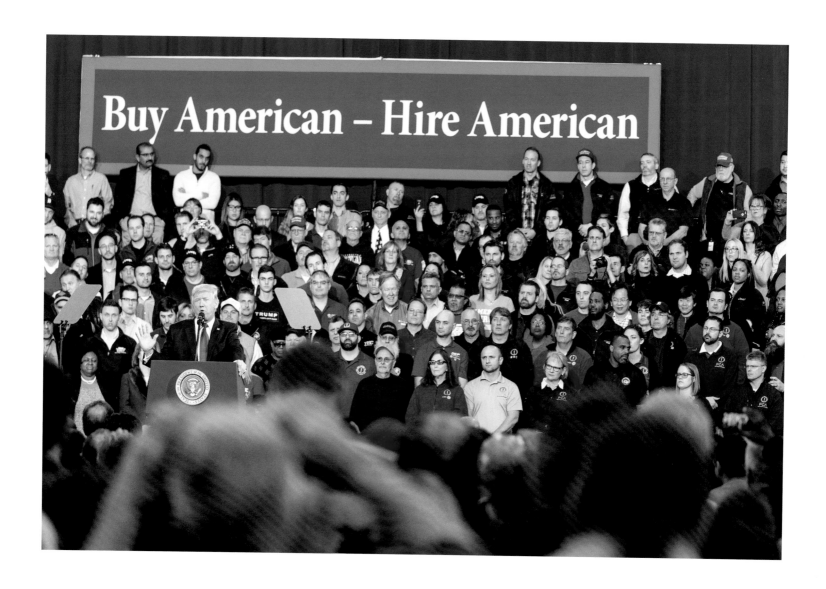

March 15, 2017: Delivering remarks at the American Center
for Mobility in Ypsilanti, Michigan. (Shealah Craighead)

Let us put American workers, American families, and American dreams first once again.

May God bless the American worker.

—*From the President's remarks at the American Center for Mobility in Michigan, March 15, 2017*

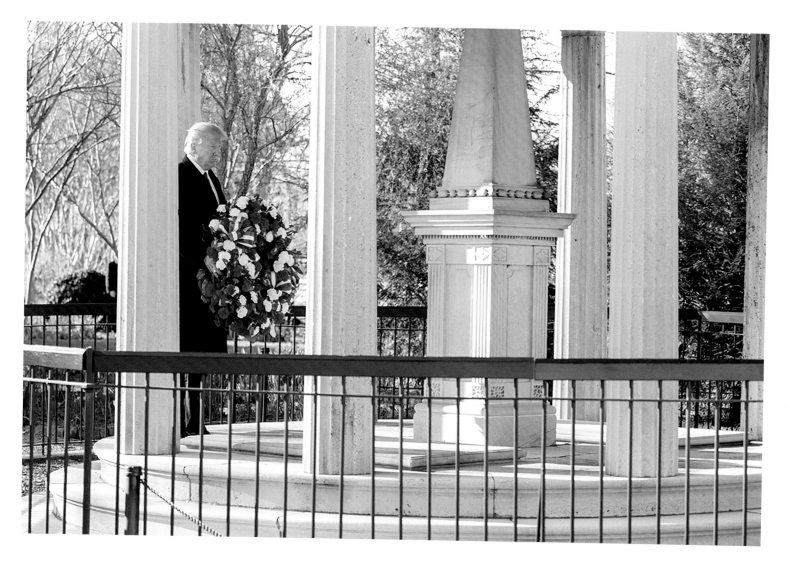

March 15, 2017: Laying a wreath during a ceremony at
Andrew Jackson's Hermitage in Tennessee. (Shealah Craighead)

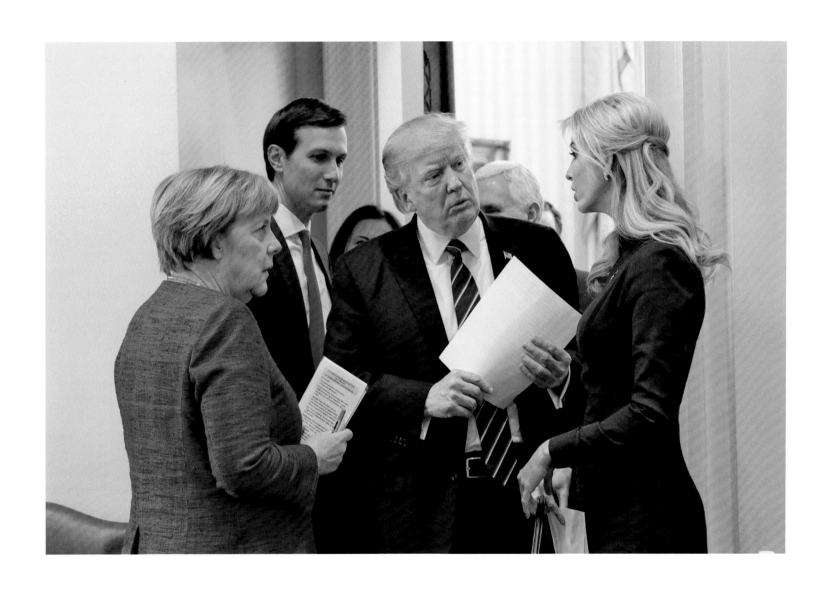

March 17, 2017: Joined by Jared Kushner, the President and Ivanka Trump speak with German chancellor Angela Merkel. (Shealah Craighead)

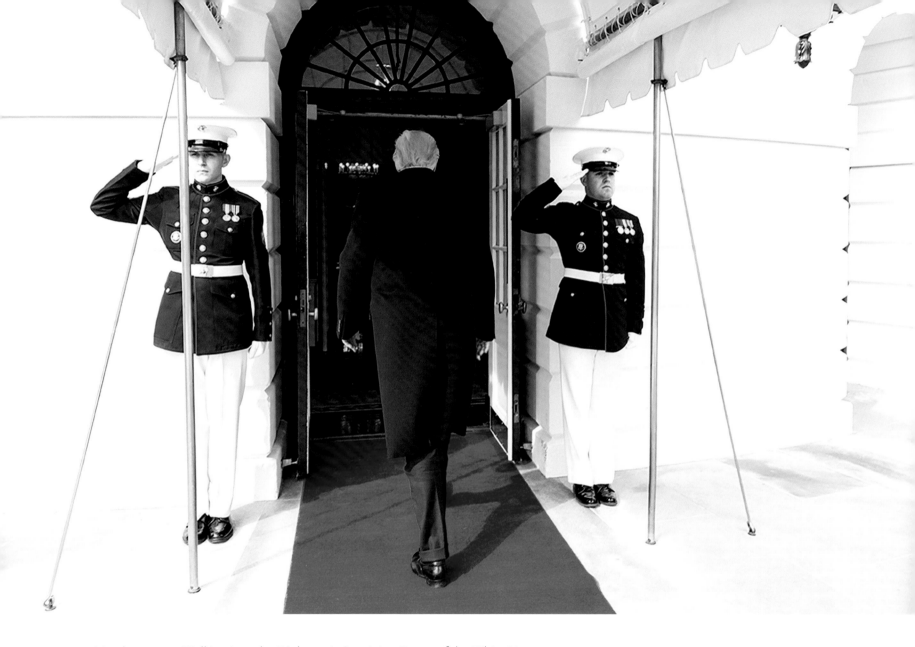

March 17, 2017: Walking into the Diplomatic Receiving Room of the White House after bidding farewell to German chancellor Angela Merkel. (Shealah Craighead)

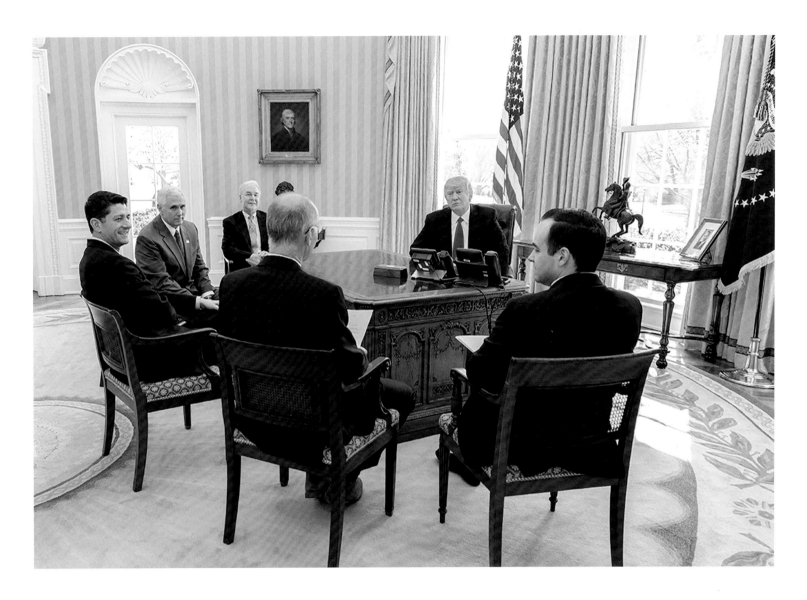

March 20, 2017: Meeting with Tom Price, Mike Pence, Paul Ryan, Dr. Zeke Emanuel, and Andrew Bremberg in the Oval Office. (Benjamin Applebaum)

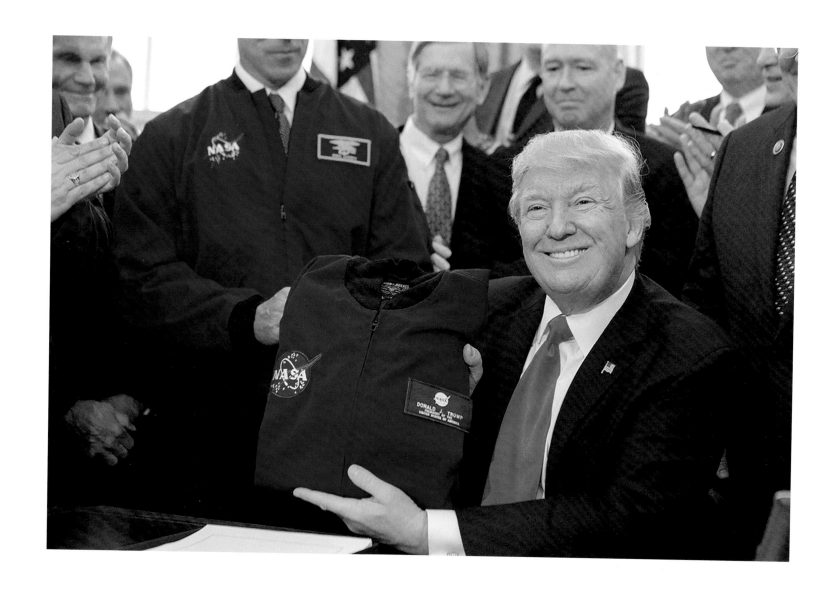

March 21, 2017: Holding up a NASA jacket after signing S.422, the National Aeronautics and Space Administration Transition Authorization Act. (Paul D. Williams)

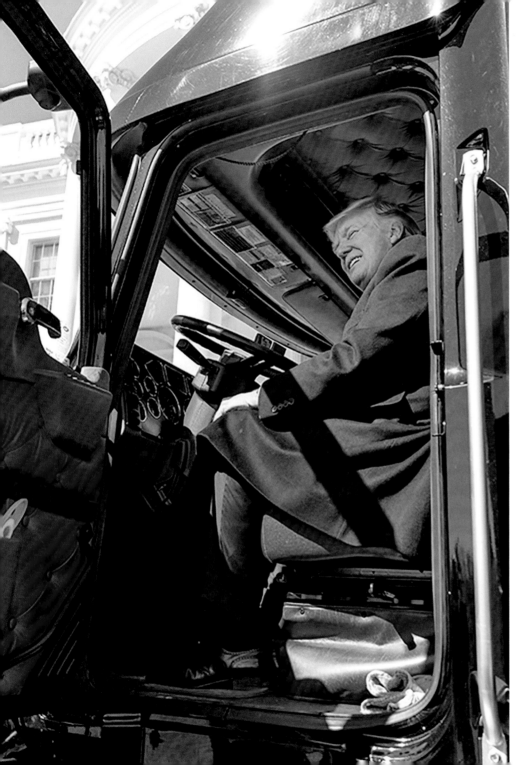

March 23, 2017: The President sits in the driver's seat of a semi as he welcomes truckers and CEOs to the White House. (Benjamin Applebaum)

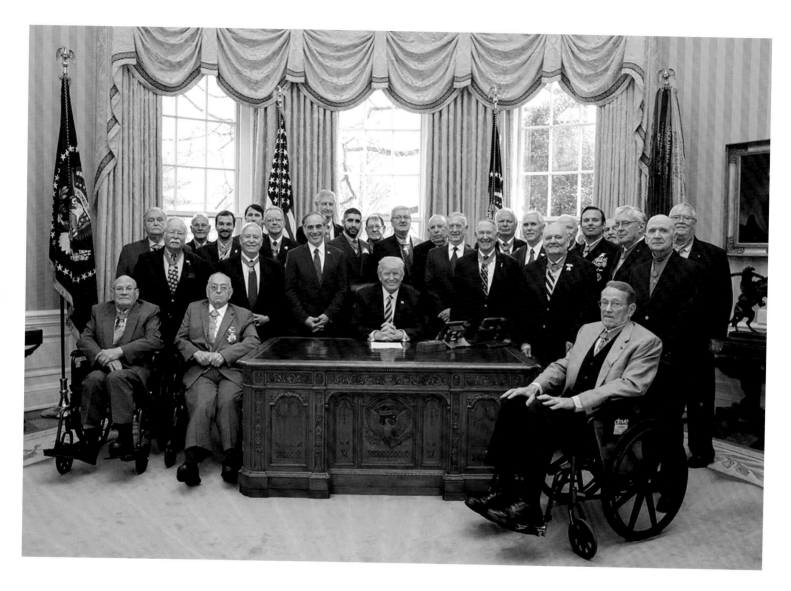

March 24, 2017: Meeting with Medal of Honor recipients in the Oval Office. (Benjamin Applebaum)

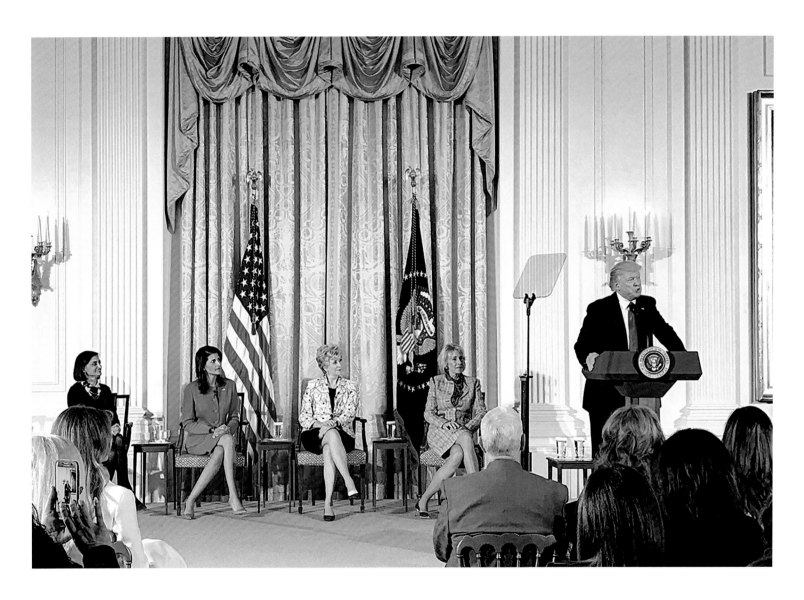

March 29, 2017: Delivering remarks at the Women's Empowerment
Panel in the East Room. (Jonathan Gallegos)

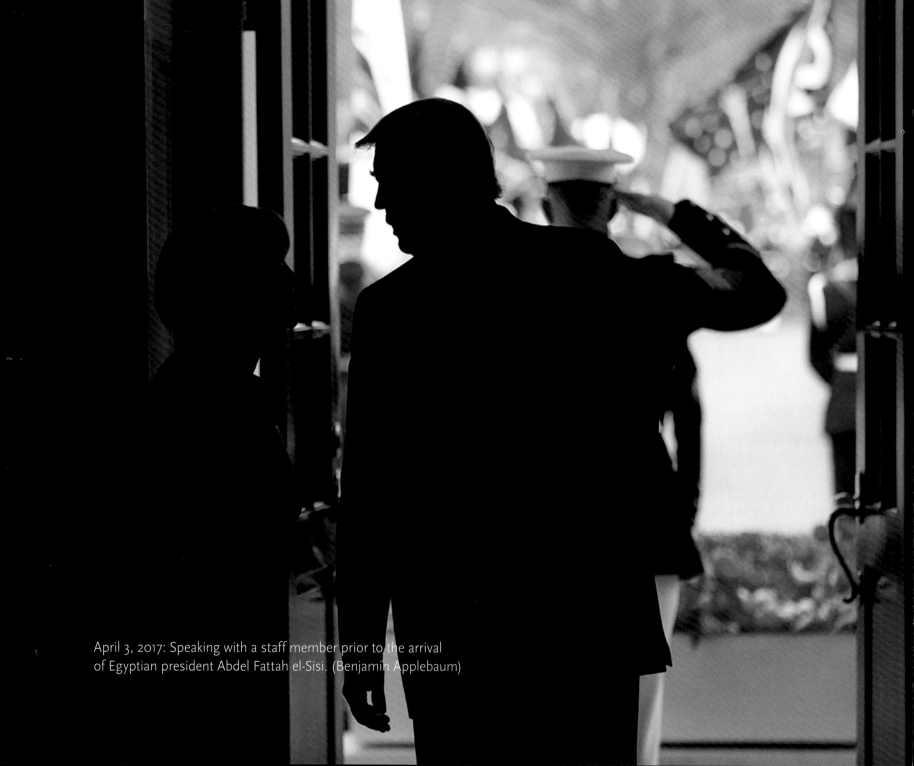

April 3, 2017: Speaking with a staff member prior to the arrival
of Egyptian president Abdel Fattah el-Sisi. (Benjamin Applebaum)

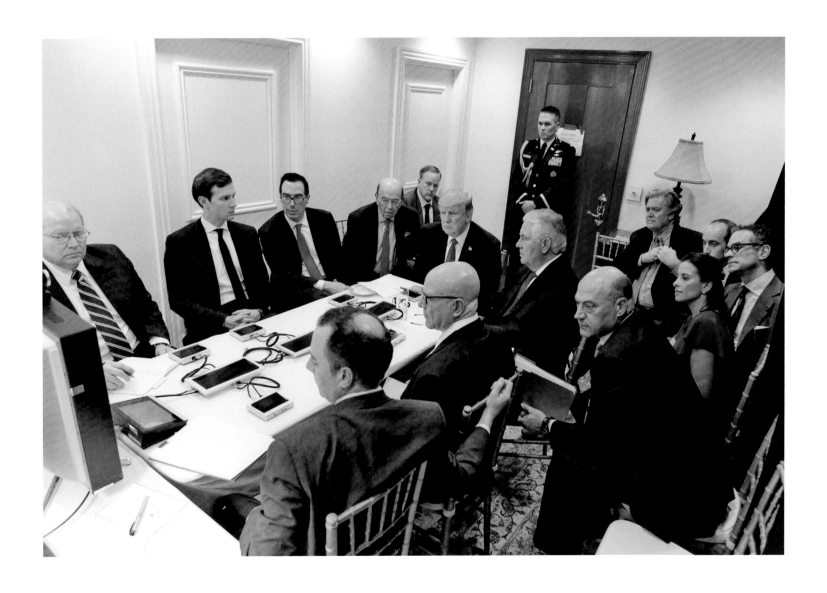

April 6, 2017: Being briefed on a military strike in Syria, by Secretary of Defense Gen. James Mattis (via video) and others. (Shealah Craighead)

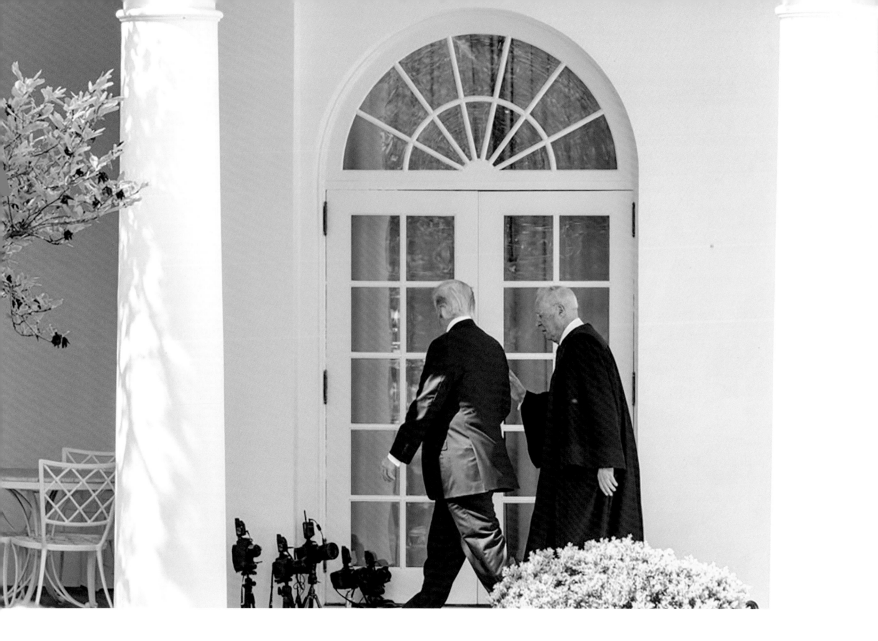

April 10, 2017: Walking along the West Colonnade with
Justice Anthony M. Kennedy. (Shealah Craighead)

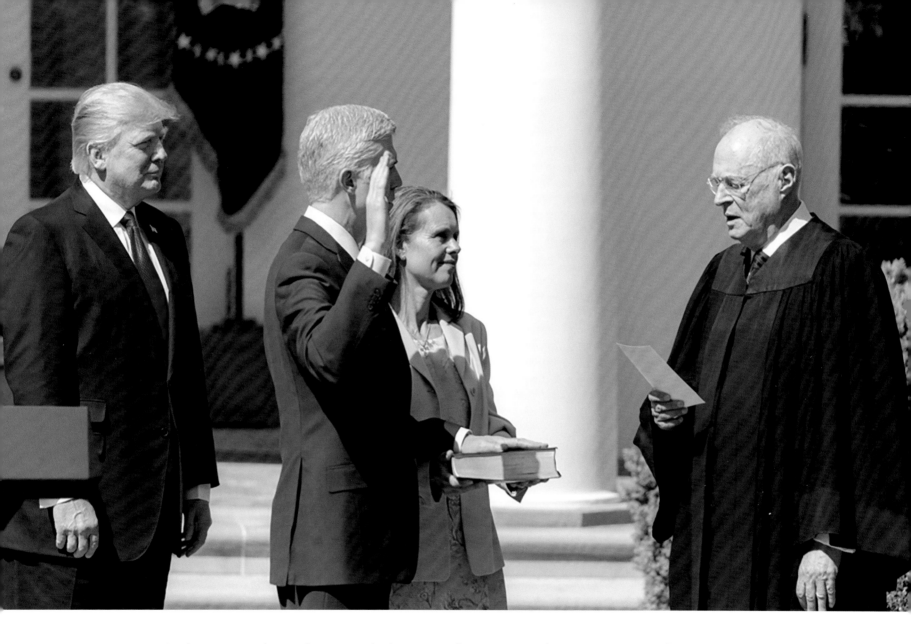

April 10, 2017: With President Trump looking on, Anthony M. Kennedy, Associate Justice of the Supreme Court of the United States, swears in Judge Neil M. Gorsuch to be the Supreme Court's 113th Justice. (Shealah Craighead)

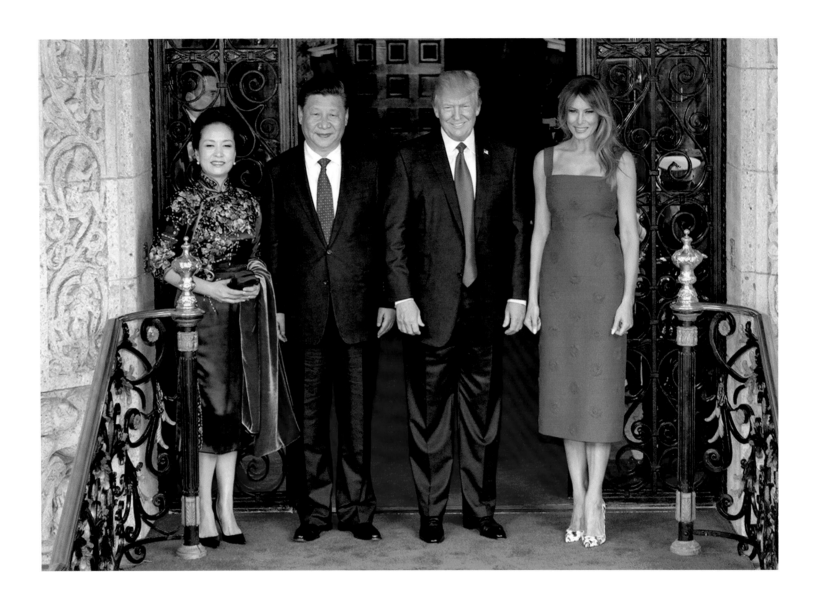

April 6, 2017: With Chinese president Xi Jinping and his wife,
Mrs. Peng Liyuan, at Mar-a-Lago. (D. Myles Cullen)

April 11, 2017: Attending a strategic CEO discussion in the State Department Library. (Paul D. Williams)

April 12, 2017: Spring flowers outside the South Portico
of the White House. (Shealah Craighead)

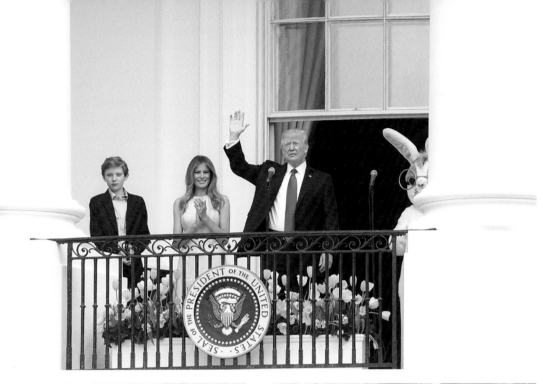

April 17, 2017: The 139th White House Easter Egg Roll. (Joyce N. Boghosian)

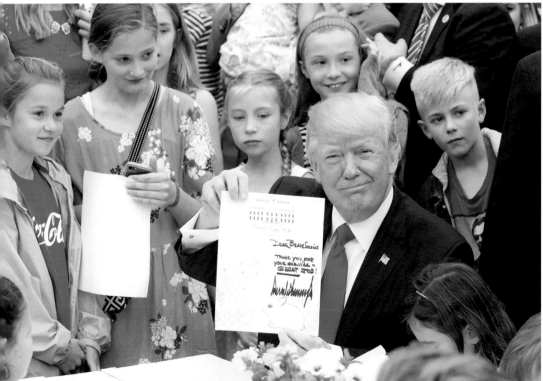

April 17, 2017: At the Easter Egg Roll, writing letters to the men and women serving in the United States Armed Forces. (Shealah Craighead)

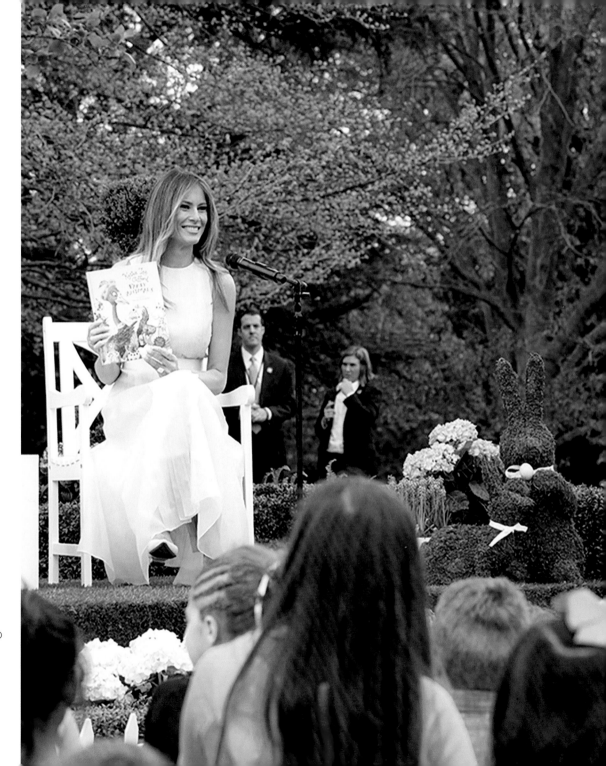

April 17, 2017: The First Lady reads *Party Animals* by Kathy Lee Gifford to a group of children at the Easter Egg Roll. (Keegan Barber)

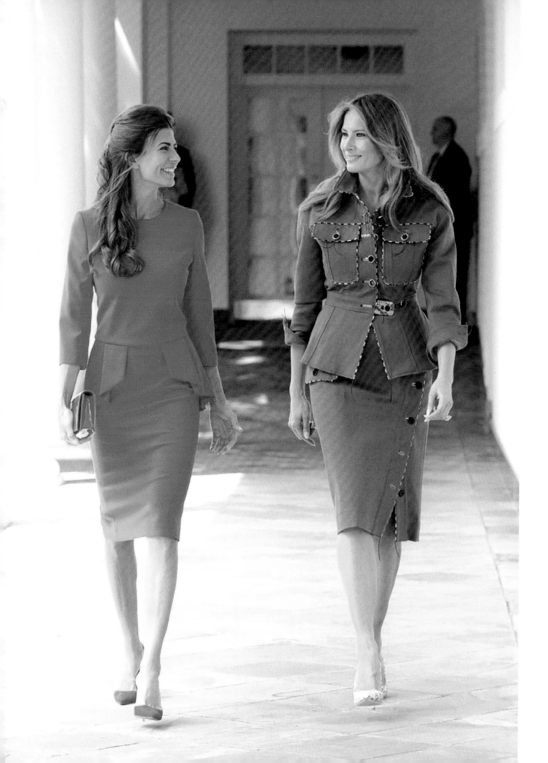

May 1, 2017: First Lady Melania Trump and Mrs. Juliana Awada, wife of Argentine president Mauricio Macri, walk along the Colonnade of the White House. (Shealah Craighead)

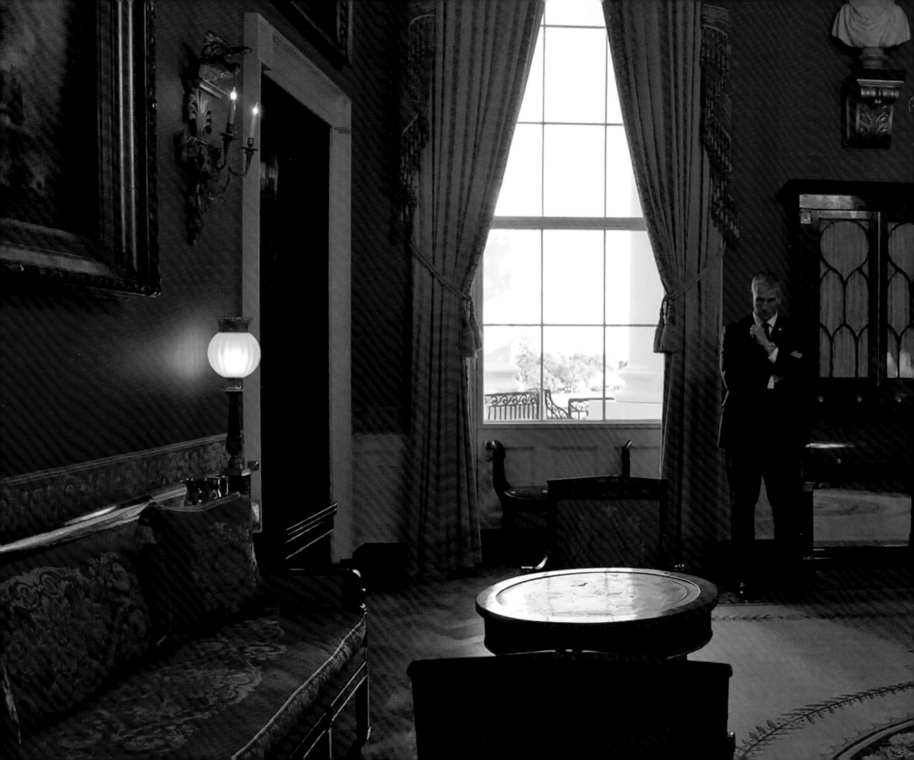

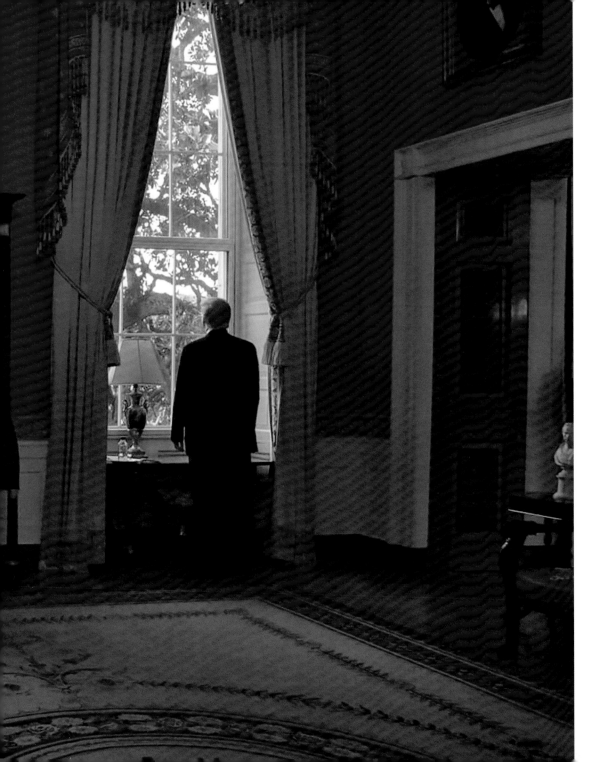

May 10, 2017: The President at the window of the Red Room on the State Floor of the White House. (Shealah Craighead)

May 15, 2017: "America stands strong with our men and women in blue." —From the President's remarks at the 36th Annual National Peace Officers' Memorial Service. (D. Myles Cullen)

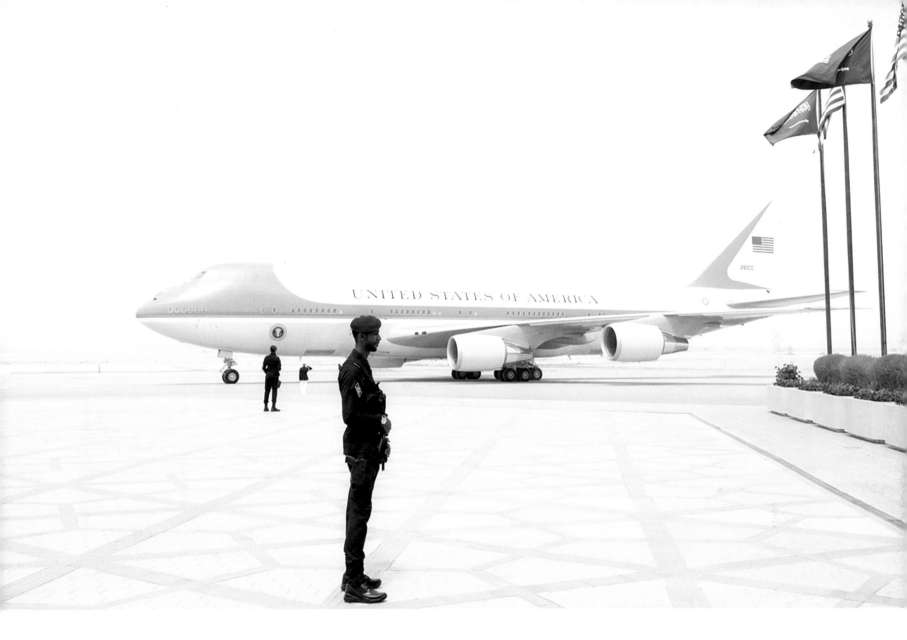

May 20, 2017: Air Force One arrives in
Riyadh, Saudi Arabia. (Andrea Hanks)

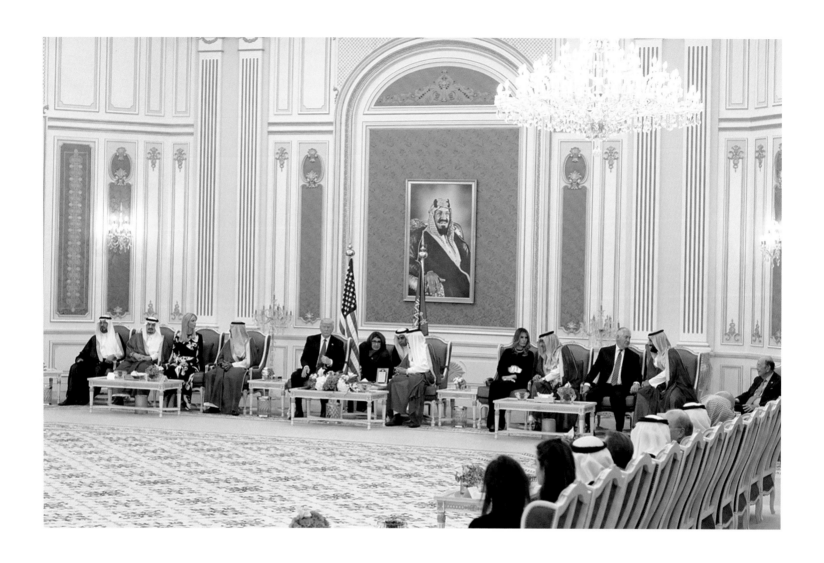

May 20, 2017: Welcoming ceremonies at the
Royal Court Palace in Riyadh. (Andrea Hanks)

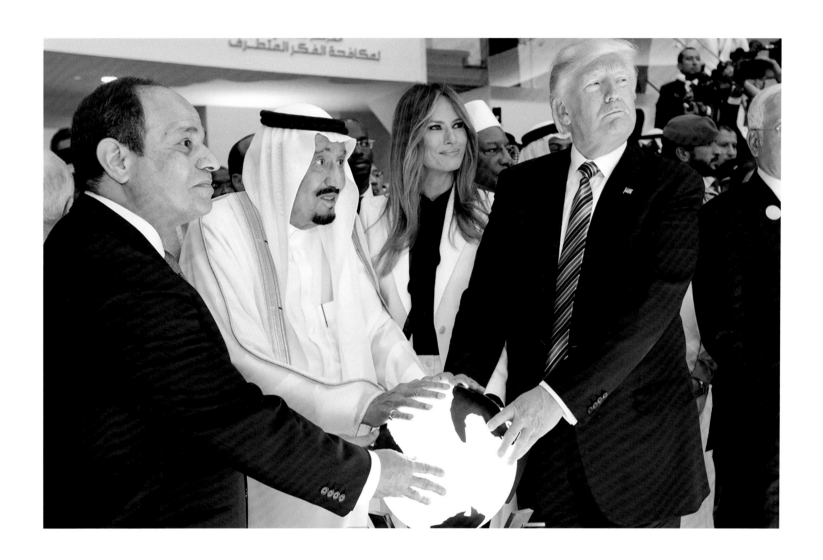

May 21, 2017: With the First Lady, as well as King Salman bin Abdulaziz Al Saud of Saudi Arabia and President of Egypt Abdel Fattah el-Sisi, at the opening of the Global Center for Combating Extremist Ideology. (Shealah Craighead)

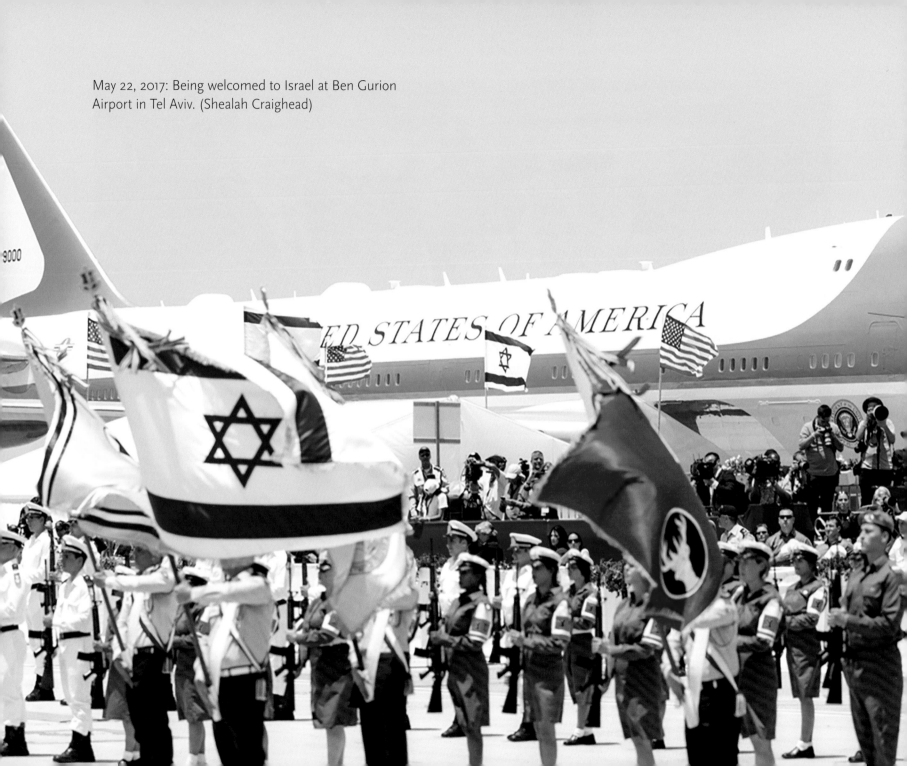

May 22, 2017: Being welcomed to Israel at Ben Gurion Airport in Tel Aviv. (Shealah Craighead)

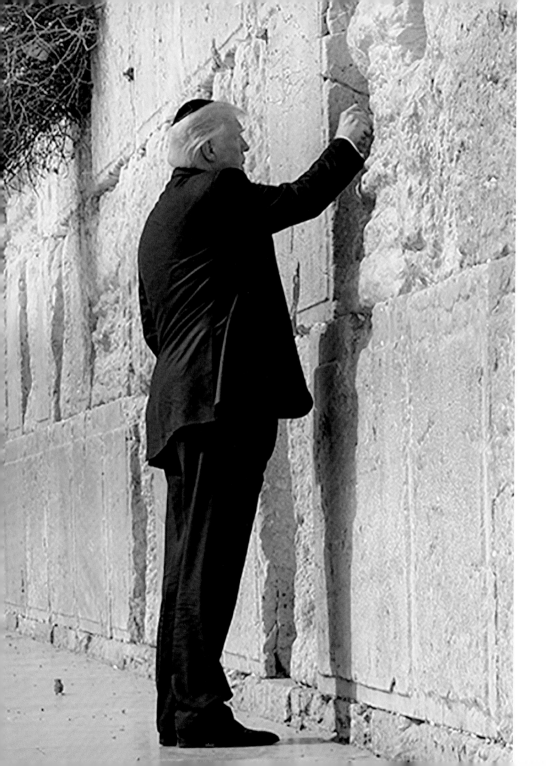

May 22, 2017: The President places a prayer in between the stone blocks of the Western Wall in Jerusalem. (Dan Hansen)

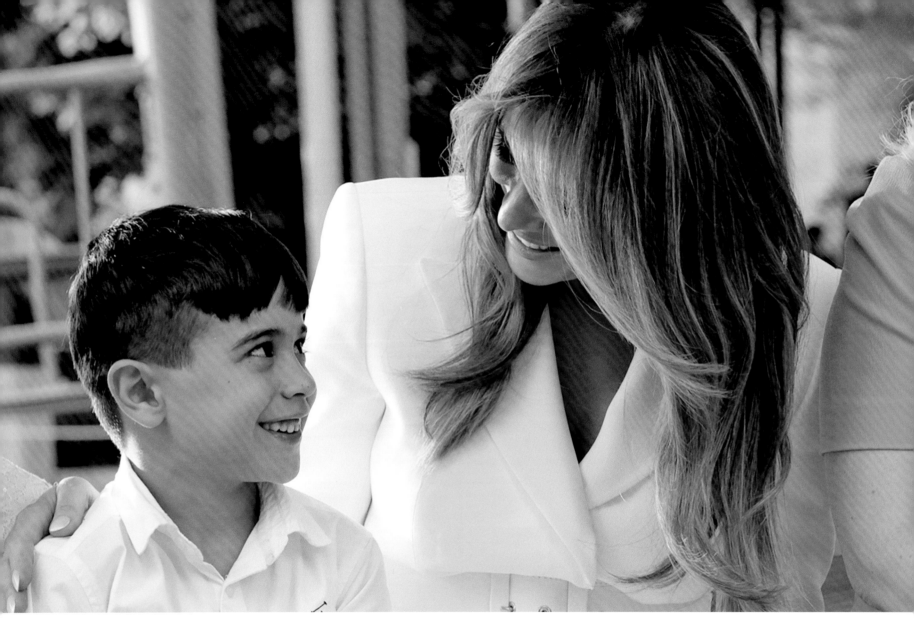

May 22, 2017: The First Lady embraces a
young child in Jerusalem. (Andrea Hanks)

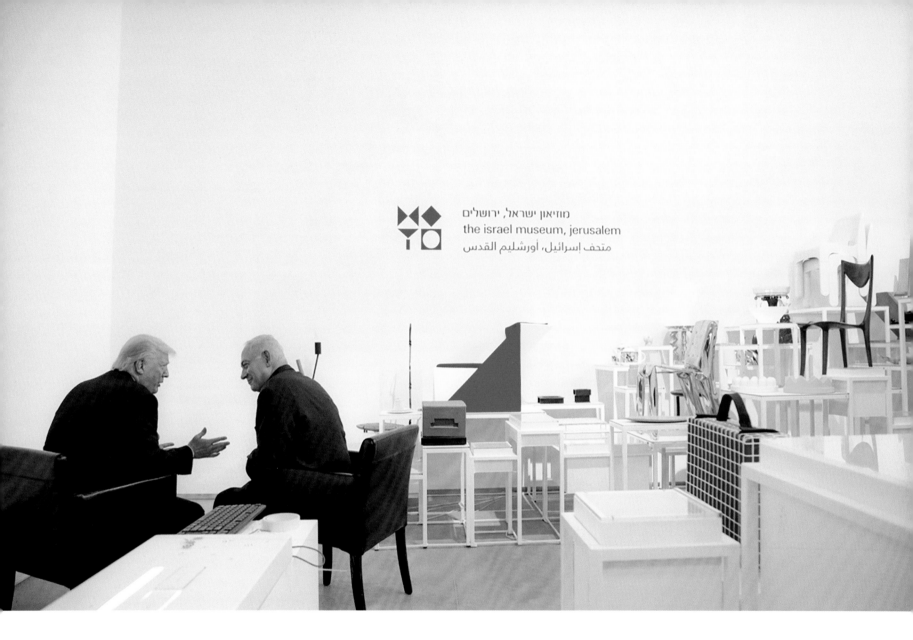

May 23, 2017: Meeting with Israeli prime minister Benjamin Netanyahu
at the Israel Museum in Jerusalem. (Shealah Craighead)

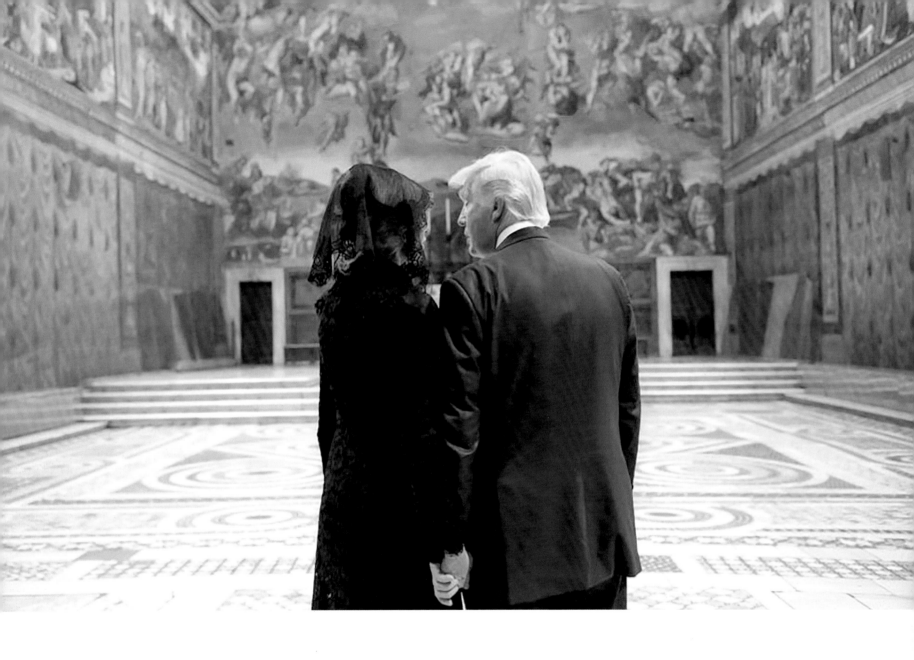

May 24, 2017: With the First Lady at the Sistine Chapel. (Andrea Hanks)

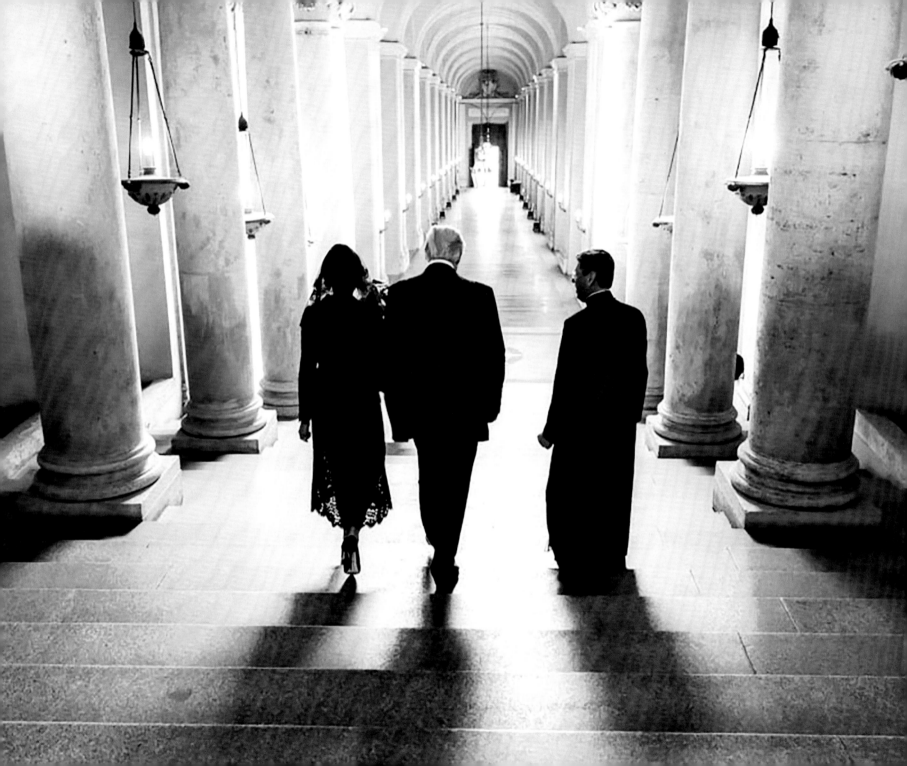

To every Gold Star family who honors us with your presence, you lost sons and daughters, husbands and wives, mothers and fathers. They each had their own names, their own stories, their own beautiful dreams. But they were all angels sent to us by God, and they all share one title in common—and that is the title of hero. Real heroes. Though they were here only a brief time before God called them home, their legacy will endure forever. . . .

Every time you see the sun rise over this blessed land please know your brave sons and daughters pushed away the night and delivered for us all that great and glorious dawn.

—From the President's remarks at Arlington National Cemetery, May 29, 2017

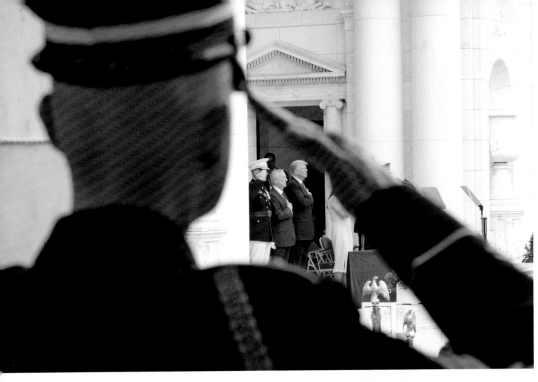

May 29, 2017: President Trump, joined by U.S. Defense Secretary James Mattis, participates in a Memorial Day Ceremony at Arlington National Cemetery. (D. Myles Cullen)

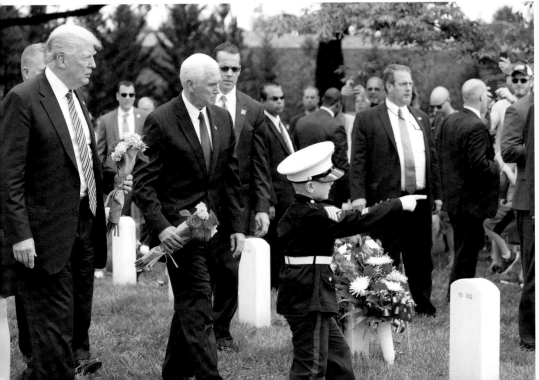

May 29, 2017: President Trump and Vice President Pence are guided by the six-year-old son of fallen U.S. Marine Sgt. Christopher Jacobs to his father's grave. (Shealah Craighead)

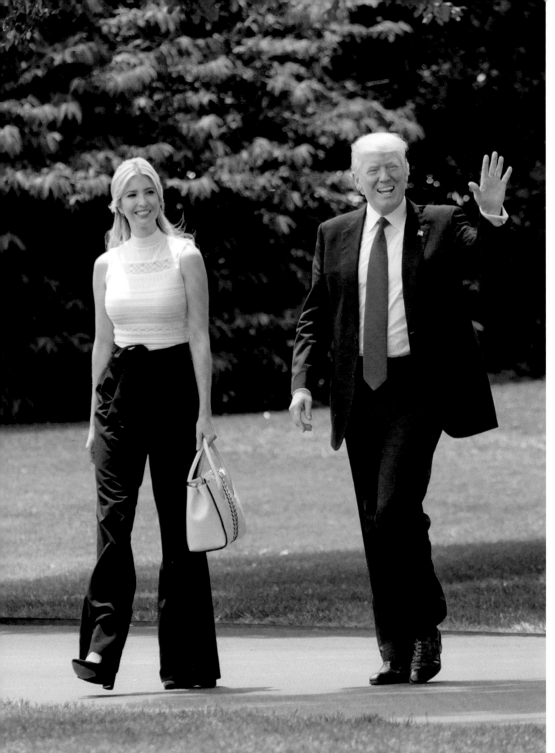

June 13, 2017: Walking along the South Lawn of the White House with Ivanka Trump. (Joyce N. Boghosian)

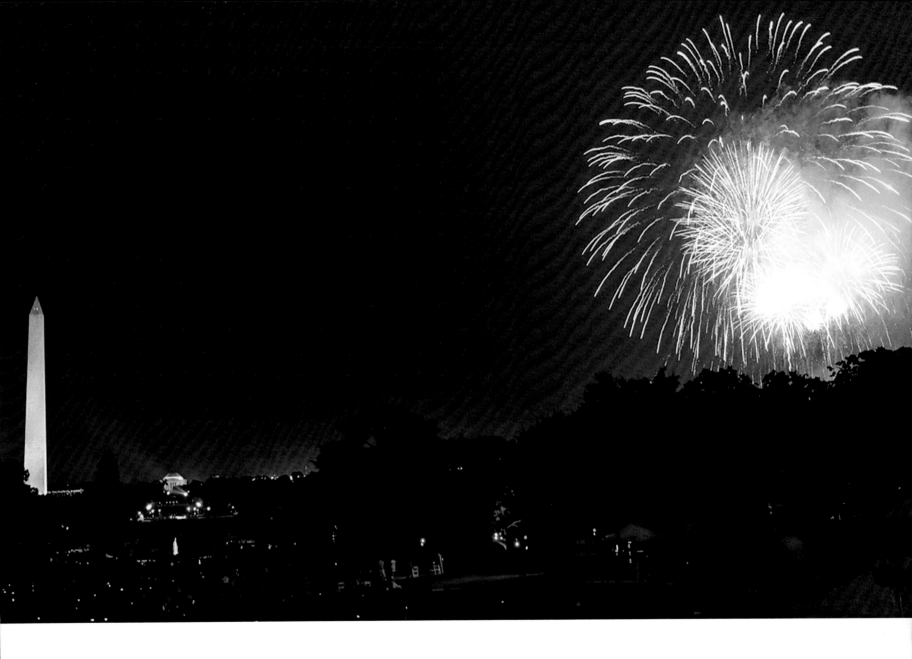

July 4, 2017: Independence Day on the South Lawn. (Andrea Hanks)

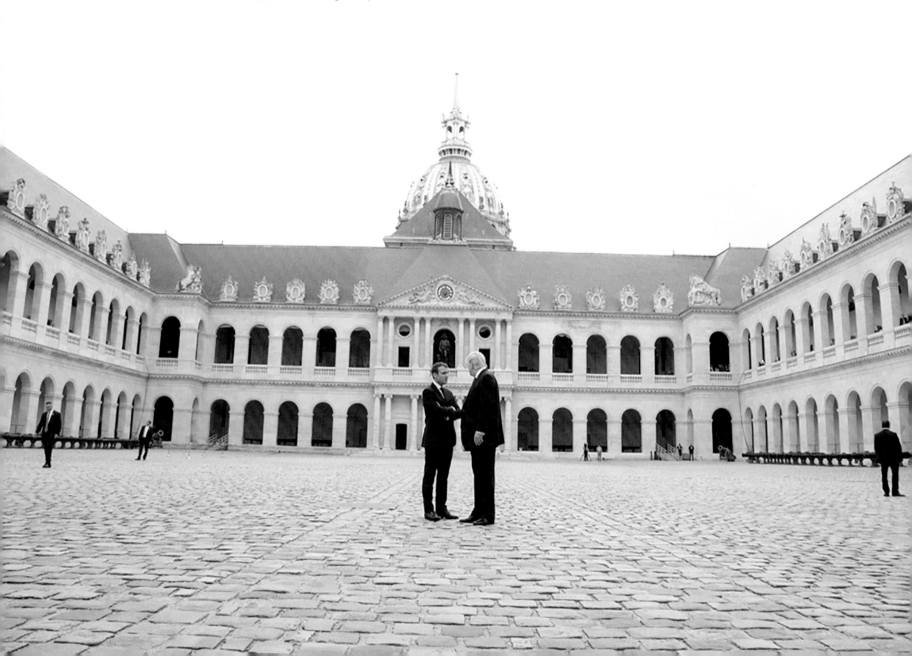

July 14, 2017: Meeting with French president
Emmanuel Macron in Paris. (Shealah Craighead)

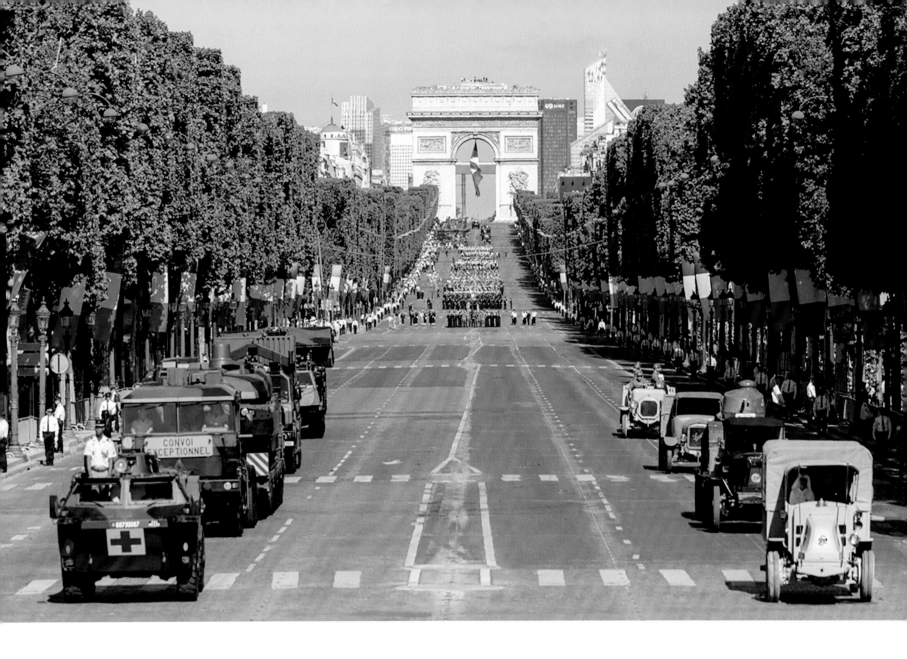

July 14, 2017: Bastille Day ceremonies, Paris. (Shealah Craighead)

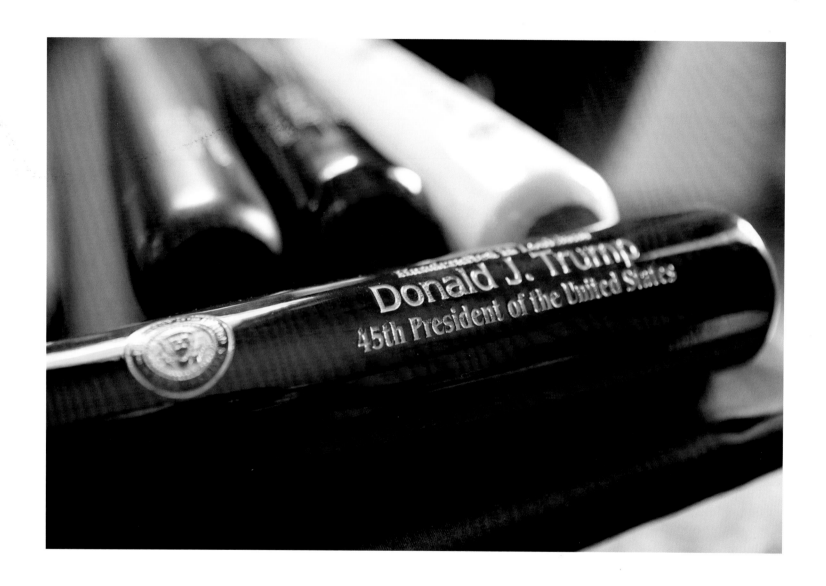

July 17, 2017: A baseball bat bearing the President's name
at the Made in America Product Showcase. (Evan Walker)

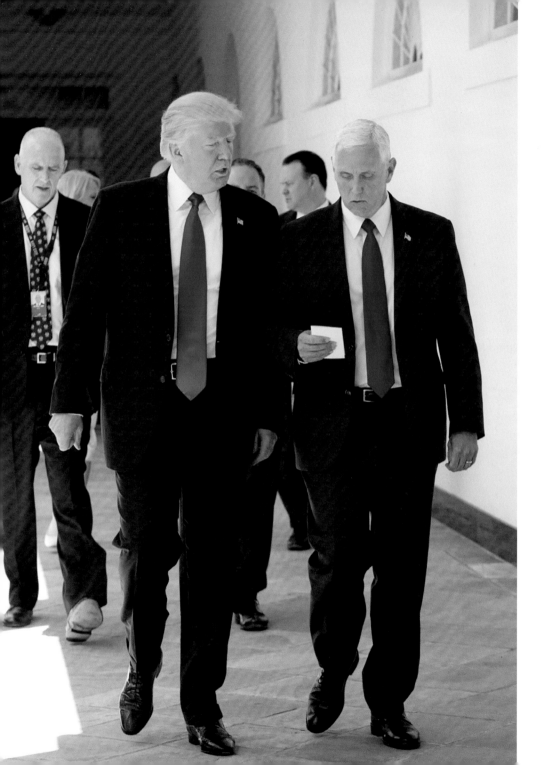

July 20, 2017: Walking with Vice President
Pence. (Joyce N. Boghosian)

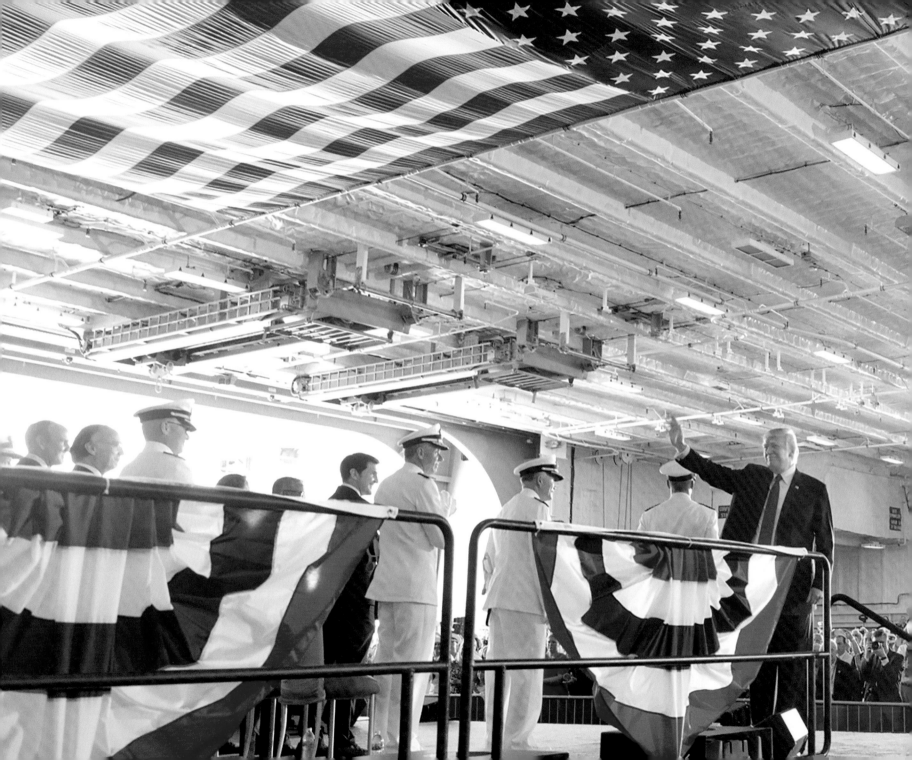

July 22, 2017: At the formal commissioning ceremony of the USS *Gerald R. Ford*. (D. Myles Cullen)

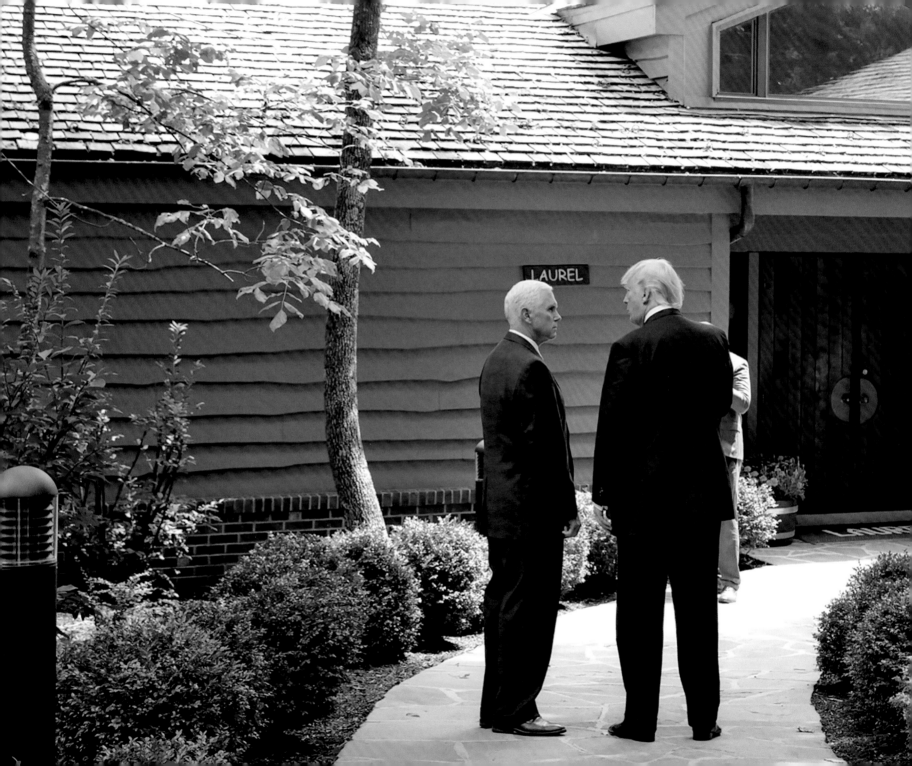

August 18, 2017: With Vice
President Pence at Camp David.
(Joyce N. Boghosian)

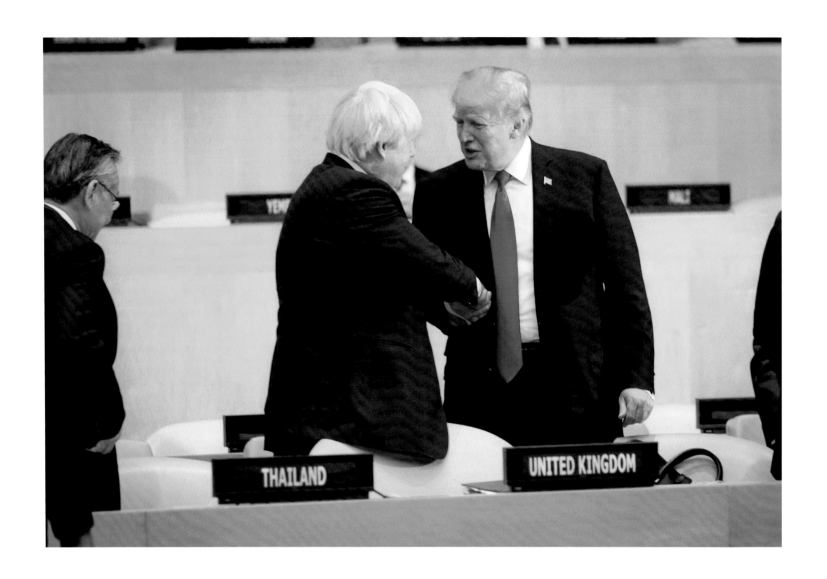

October 2, 2017: With Boris Johnson at the United
Nations General Assembly. (D. Myles Cullen)

November 3, 2017: Departing for the Pacific. (Shealah Craighead)

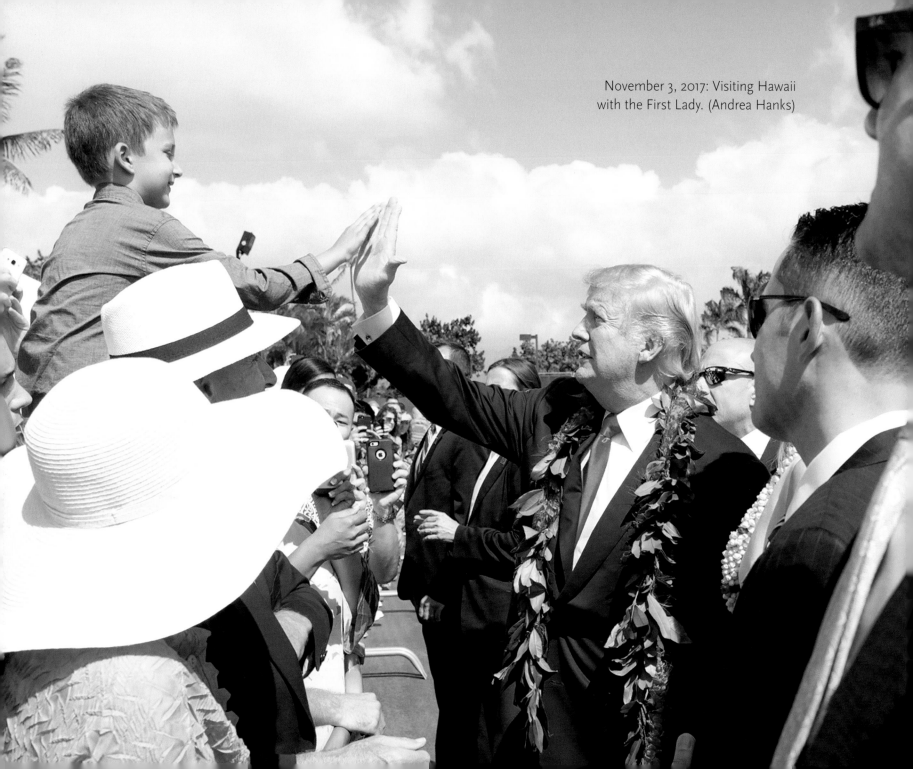

November 3, 2017: Visiting Hawaii with the First Lady. (Andrea Hanks)

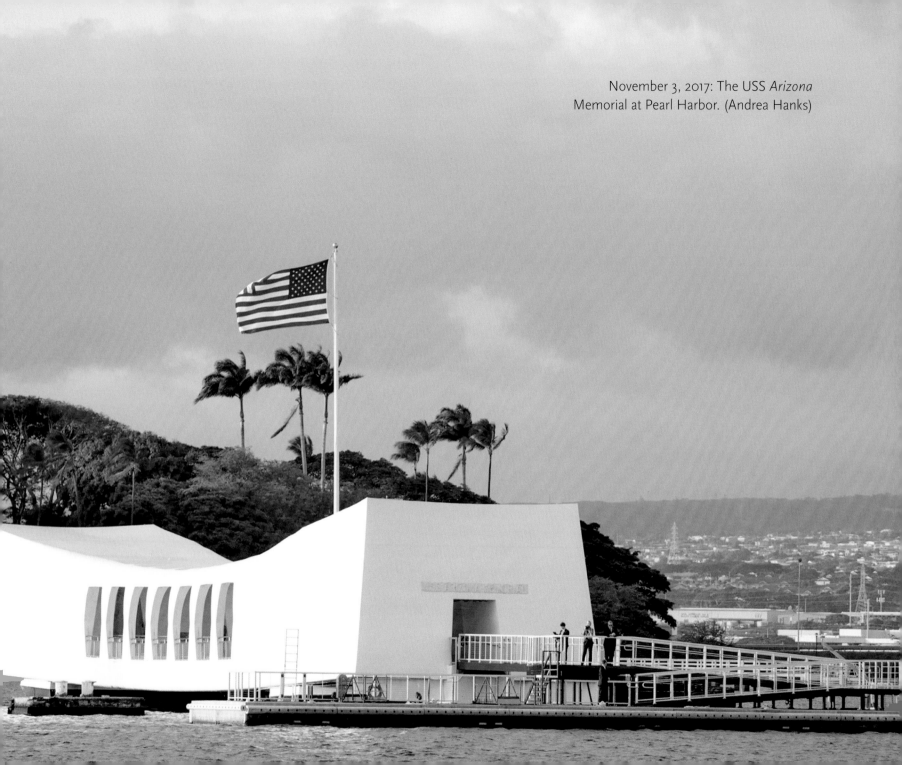

November 3, 2017: The USS *Arizona*
Memorial at Pearl Harbor. (Andrea Hanks)

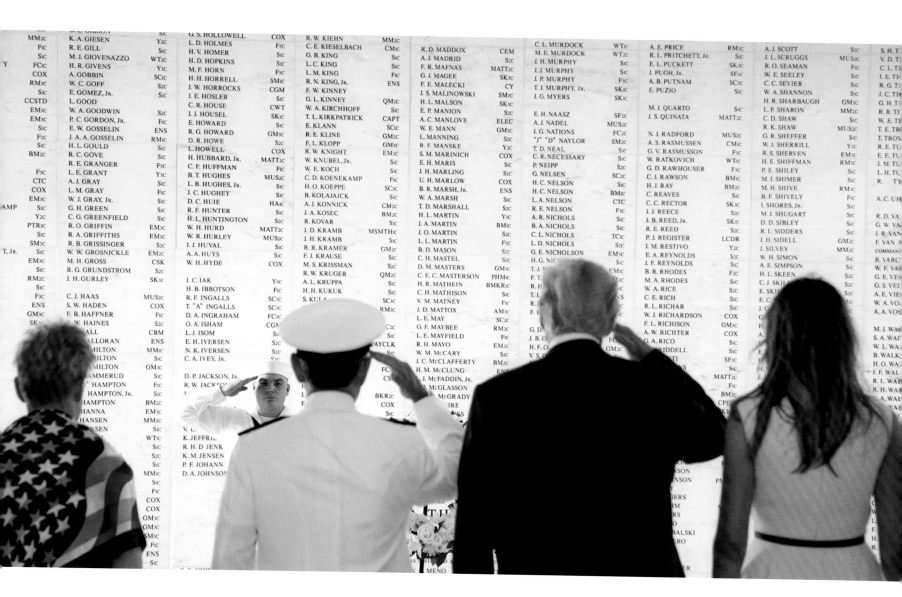

November 3, 2017: The shrine at the
USS *Arizona* Memorial. (Shealah Craighead)

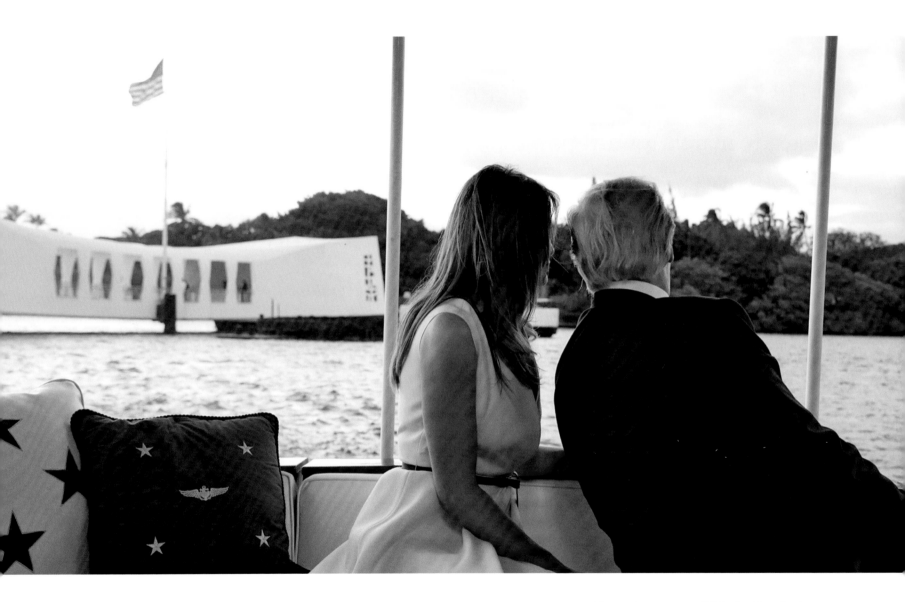

November 3, 2017: With the First Lady
at Pearl Harbor. (Shealah Craighead)

History has proven over and over that the road of the tyrant is a steady march toward poverty, suffering, and servitude. But the path of strong nations and free people, certain of their values and confident in their futures, is a proven path toward prosperity and peace.

—*From the President's remarks to servicemembers at Yokota Air Base, November 5, 2017*

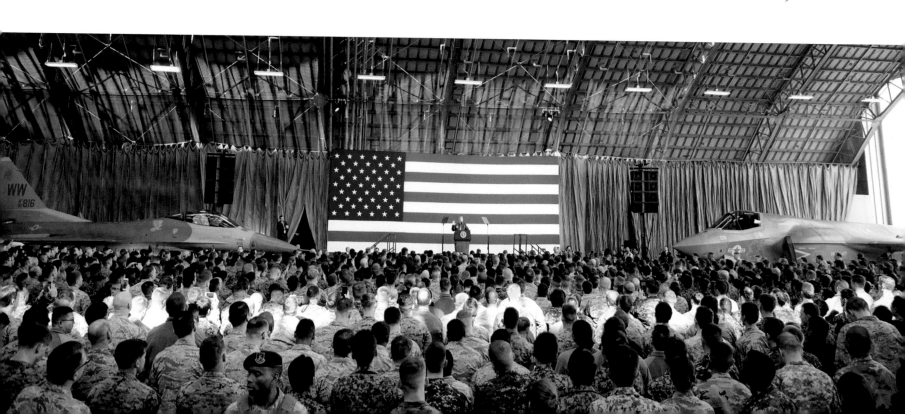

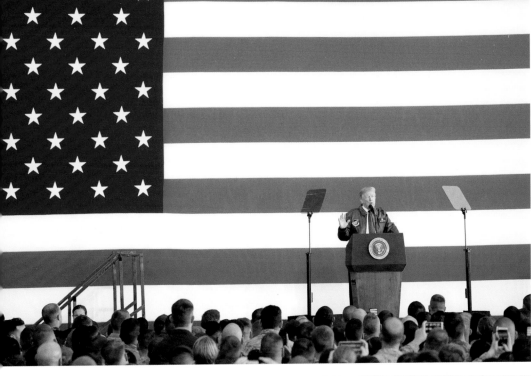

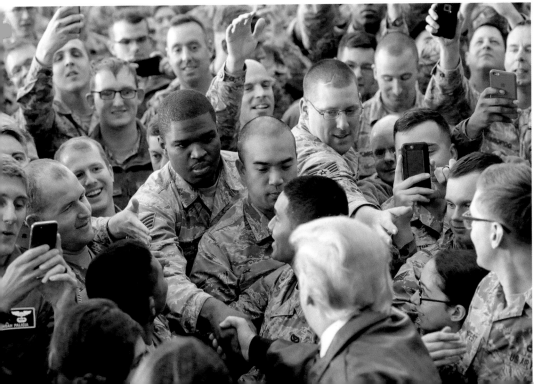

November 5, 2017: Delivering remarks at Yokota Air Base. (Opposite and above photos by Shealah Craighead, left photo by Andrea Hanks)

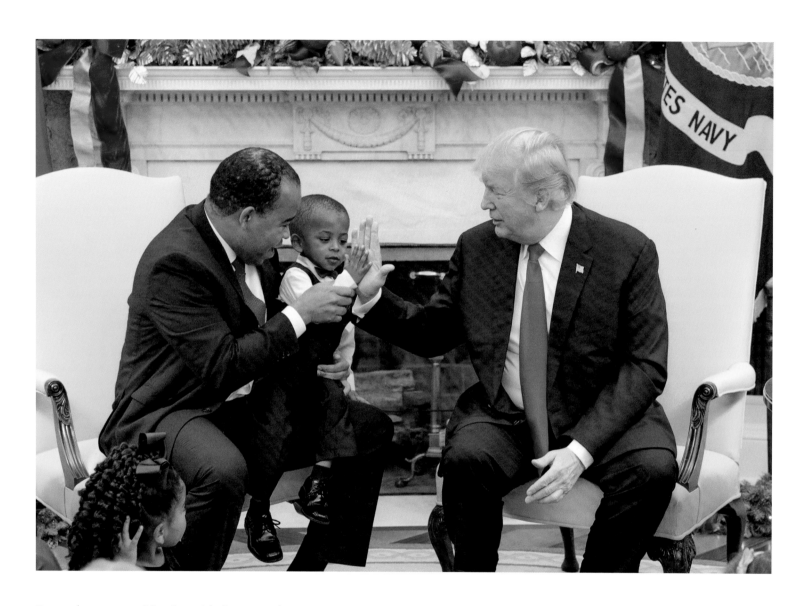

December 5, 2017: Meeting with American business
owners and their families. (Shealah Craighead)

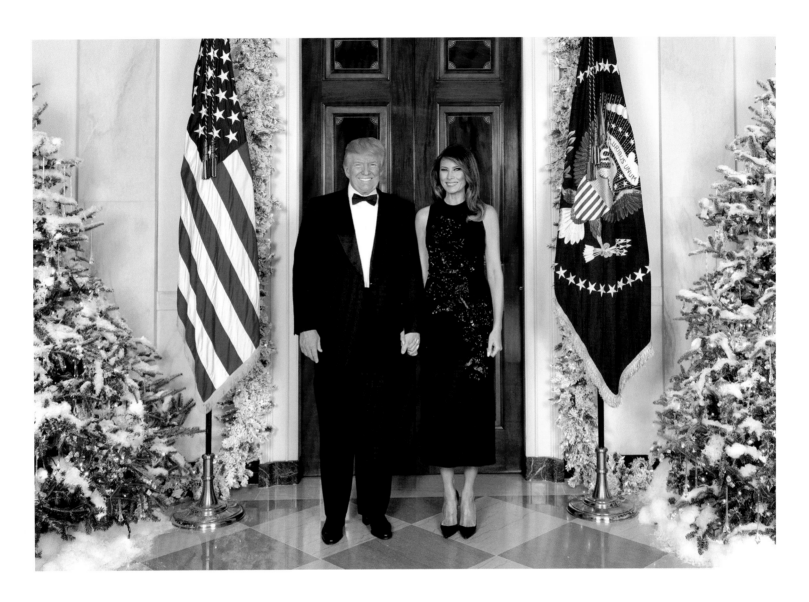

December 5, 2017: The official 2017
Christmas portrait. (Andrea Hanks)

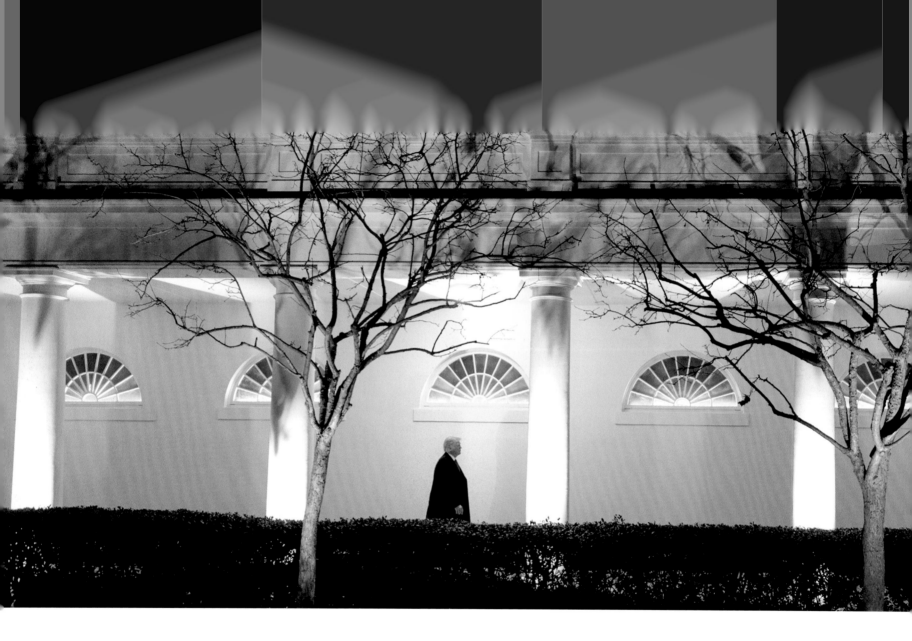

January 3, 2018: Walking down the West Colonnade
of the White House. (D. Myles Cullen)

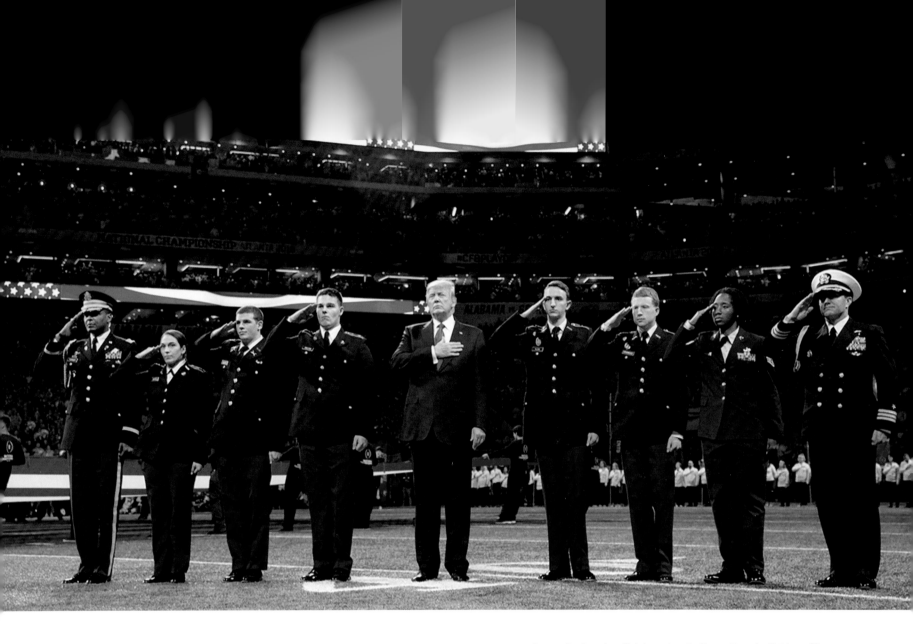

January 8, 2018: On the field at the College Football Playoff
National Championship Game. (Shealah Craighead)

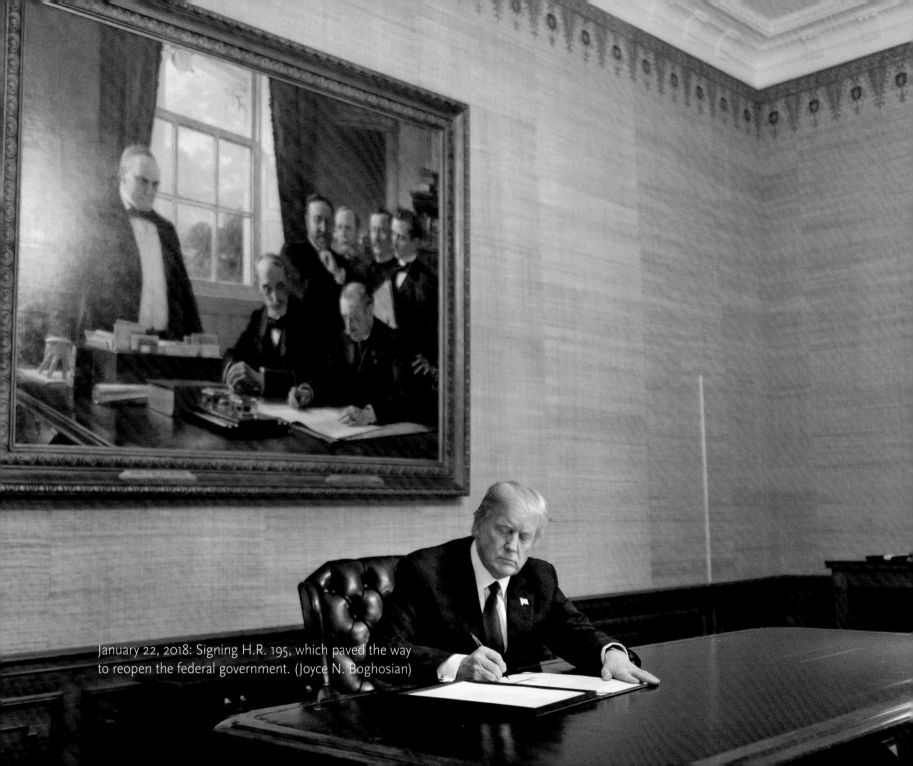

January 22, 2018: Signing H.R. 195, which paved the way to reopen the federal government. (Joyce N. Boghosian)

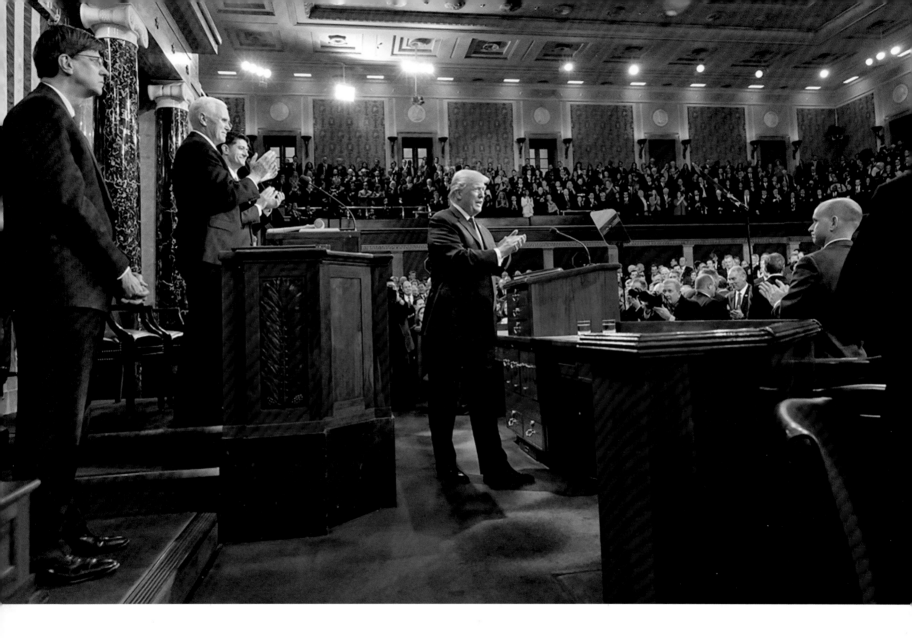

January 30, 2018: The President's 2018 State of the Union Address. (Shealah Craighead)

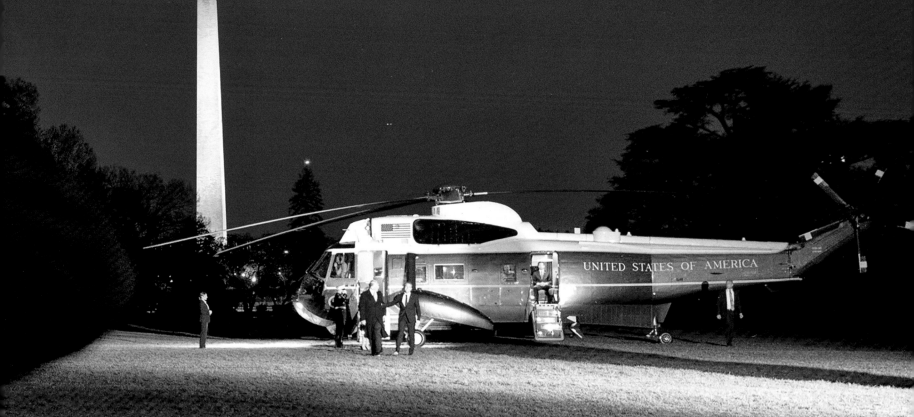

April 23, 2018: President Trump and President Macron of France arrive at the White House. (Joyce N. Boghosian)

The veins that link our nations are forged in battle, strengthened through trial, and defined by the timeless principles that make us who and what we are: respect for life; love for our neighbors; pride in our traditions; defense of our heritage; and reverence for the rights bestowed on us through grace and the glory of God.

—*From the President's remarks at the State Dinner for President Macron of France, April 25, 2018*

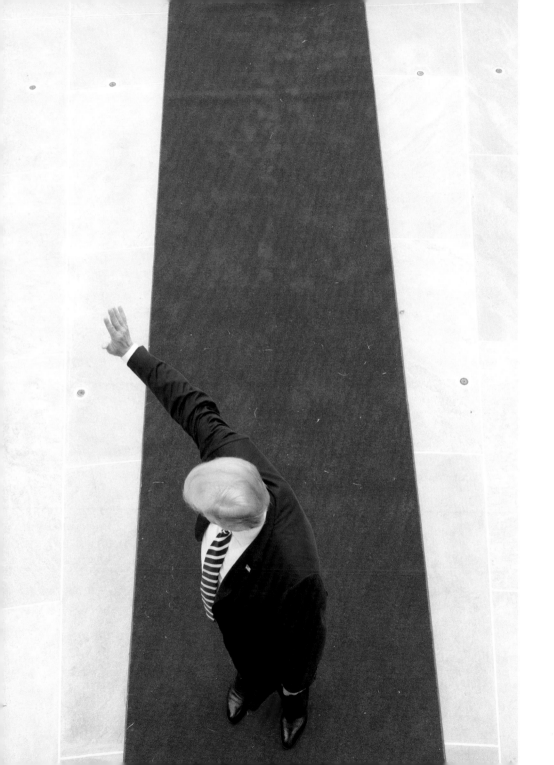

April 24, 2018: The arrival ceremony for the Macrons. (Shealah Craighead)

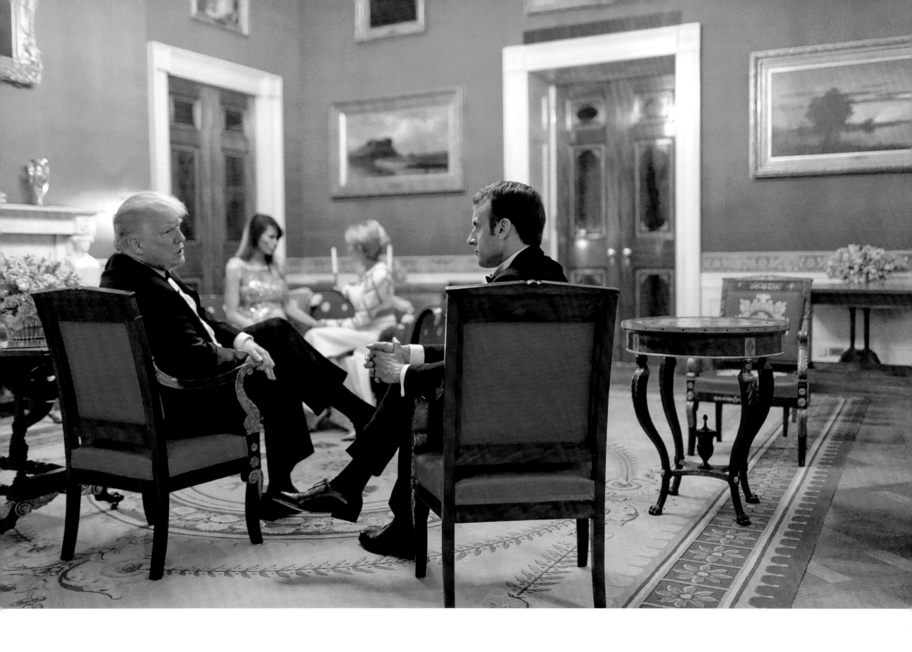

April 24, 2018: A state dinner with President and Mrs. Macron. (D. Myles Cullen)

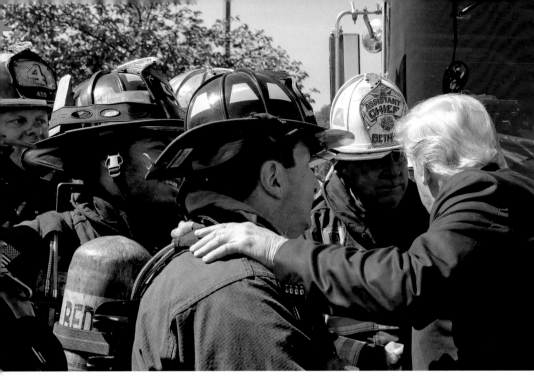

May 23, 2018: Meeting with members of the Bethpage, New York, Fire Department. (Andrea Hanks)

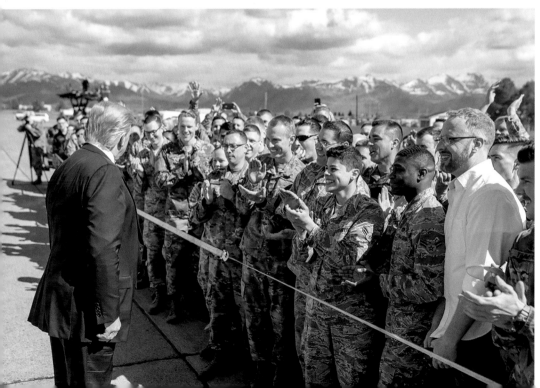

May 24, 2018: Greeting the troops at Joint Base Elmendorf-Richardson. (Shealah Craighead)

We are gathered here on the sacred soil of Arlington National Cemetery to honor the lives and deeds of America's greatest heroes: the men and women who laid down their lives for our freedom. Today, we pay tribute to their service, we mourn alongside their families, and we strive to be worthy of their sacrifice.

The heroes who rest in these hallowed fields—in the cemeteries, battlefields, and burial grounds near and far—are drawn from the full tapestry of American life. They came from every generation, from towering cities and windswept prairies, from privilege and from poverty. They were generals and privates, captains and corporals, of every race, color, and of every creed. But they were all brothers and sisters in arms. And they were all united then, as they are united now forever, by their undying love of our great country.

—From the President's Memorial Day remarks, May 28, 2018

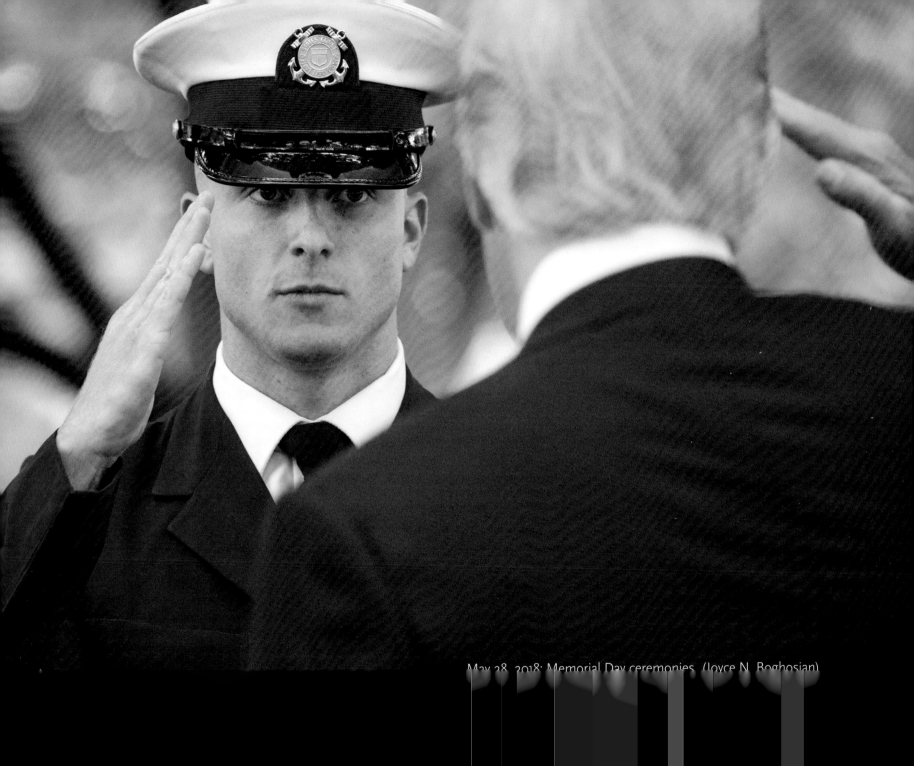

May 28, 2018: Memorial Day ceremonies. (Joyce N. Boghosian)

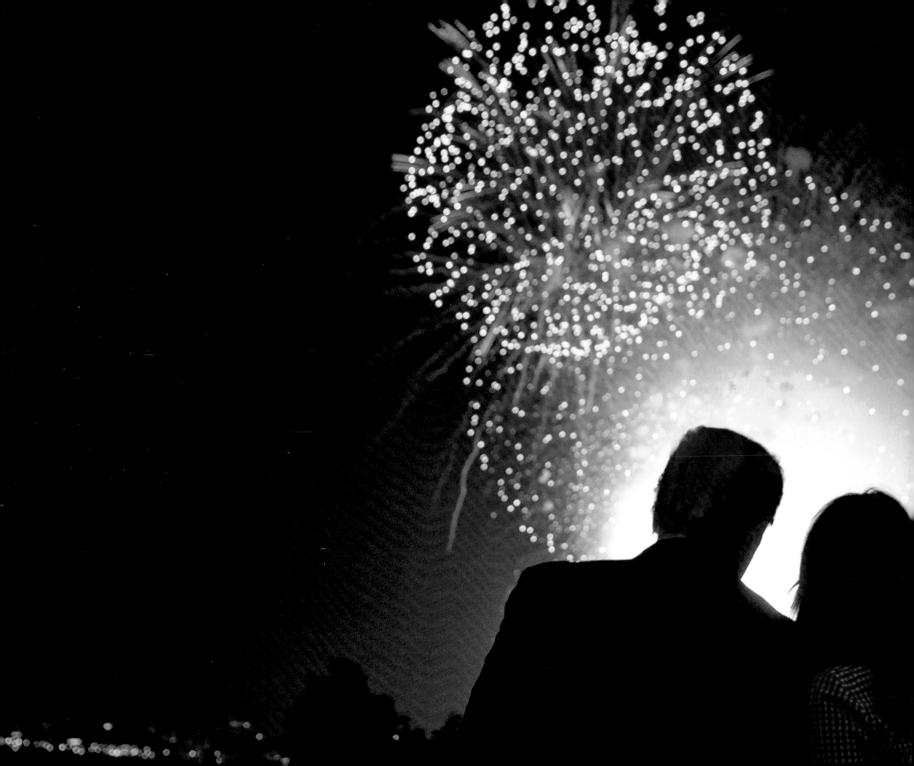

July 4, 2018: Watching the Fourth of July
fireworks at the White House.
(Shealah Craighead)

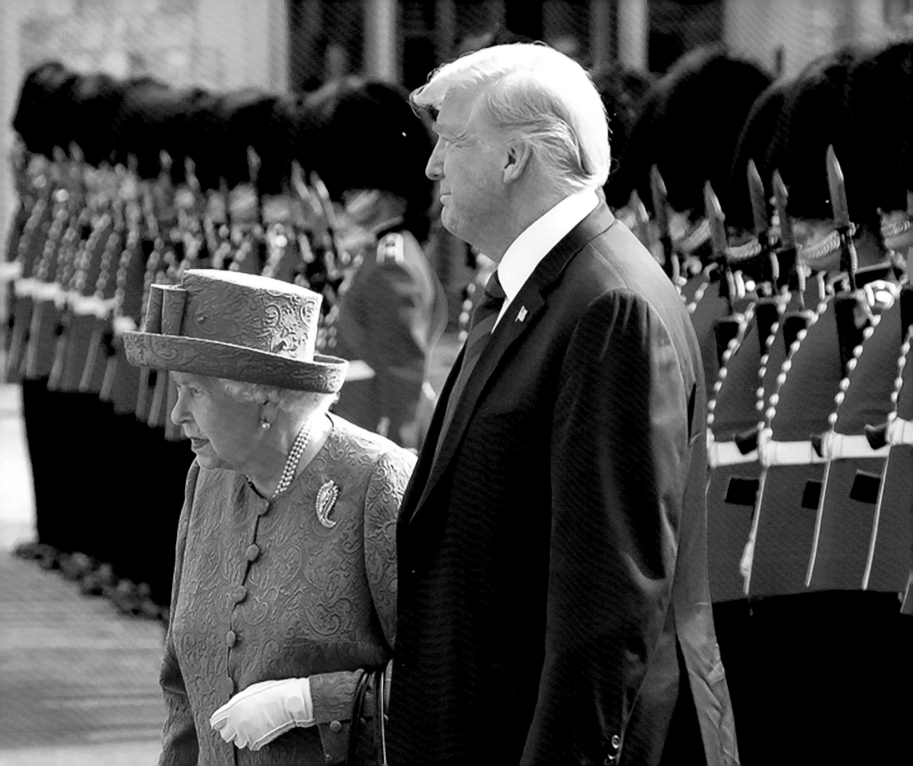

July 13, 2018: The President with Her Majesty Queen Elizabeth II at Windsor Castle. (Andrea Hanks)

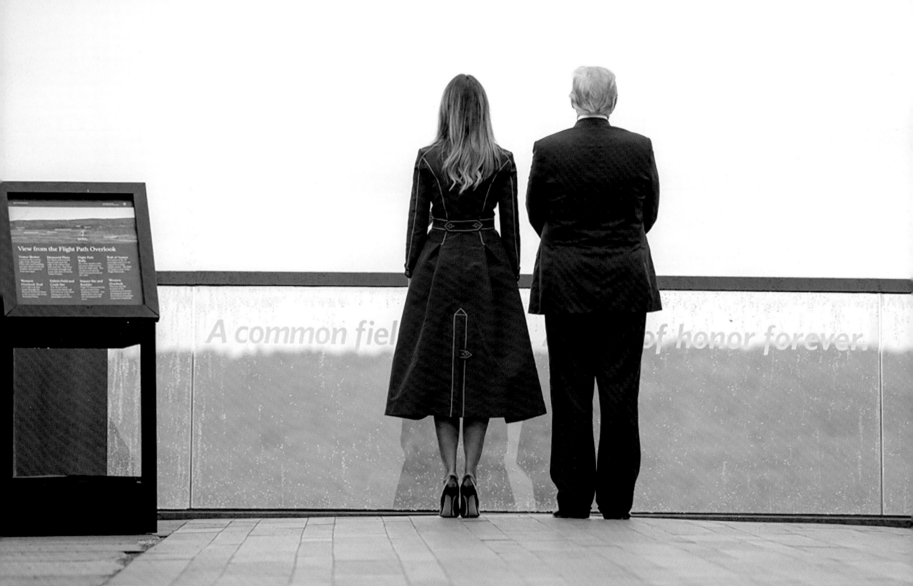

September 11, 2018: The Flight 93 September 11
Memorial Service. (Shealah Craighead)

September 19, 2018: Assessing the damage of
Hurricane Florence to the Carolinas. (Shealah Craighead)

In moments of despair, we witness the true character of the American people. Citizens all across our country rally together to rescue the stranded, to protect the innocent, and to restore hope to families who have experienced tremendous and unbearable loss.

—From the President's remarks on Hurricane Florence recovery efforts in Cherry Point, North Carolina, September 19, 2018

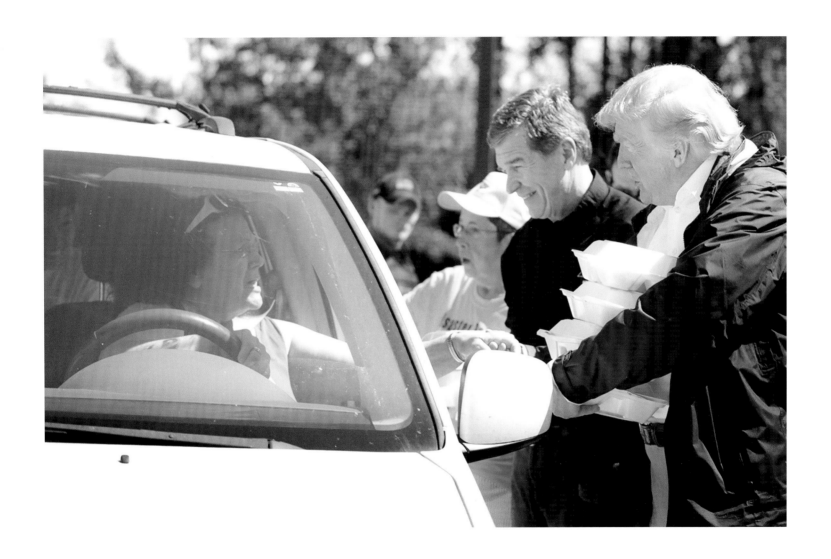

September 19, 2018: Joining the hurricane recovery efforts. (Shealah Craighead)

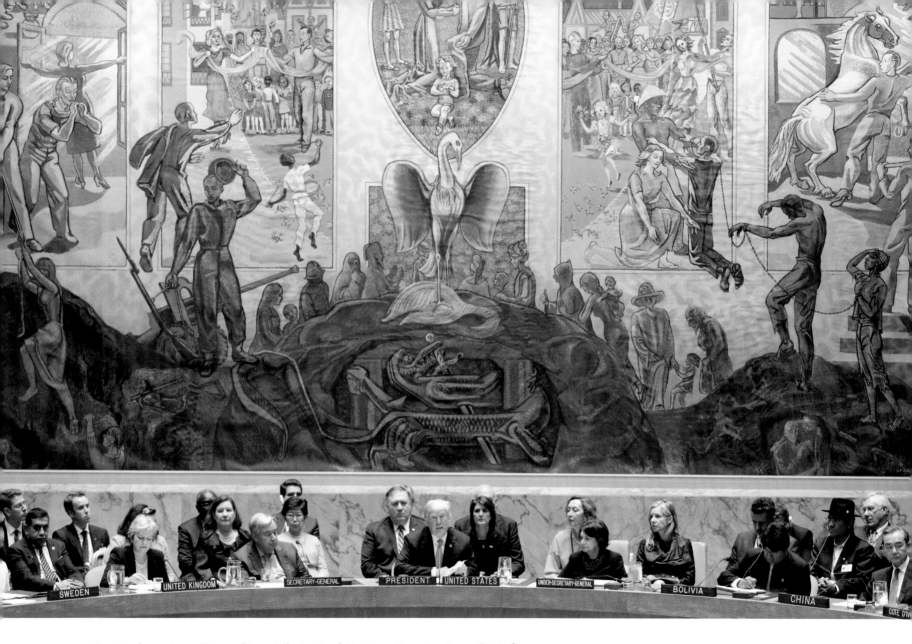

September 26, 2018: Speaking at the United Nations Security Council Briefing on Counterproliferation at U.N. Headquarters in New York City. (Shealah Craighead)

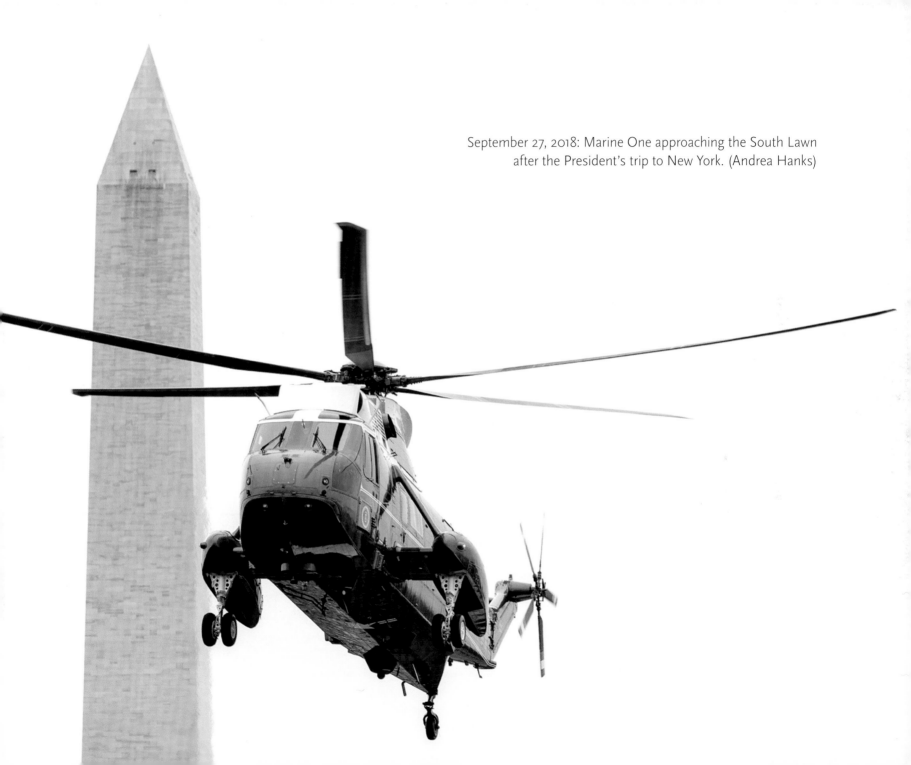

September 27, 2018: Marine One approaching the South Lawn after the President's trip to New York. (Andrea Hanks)

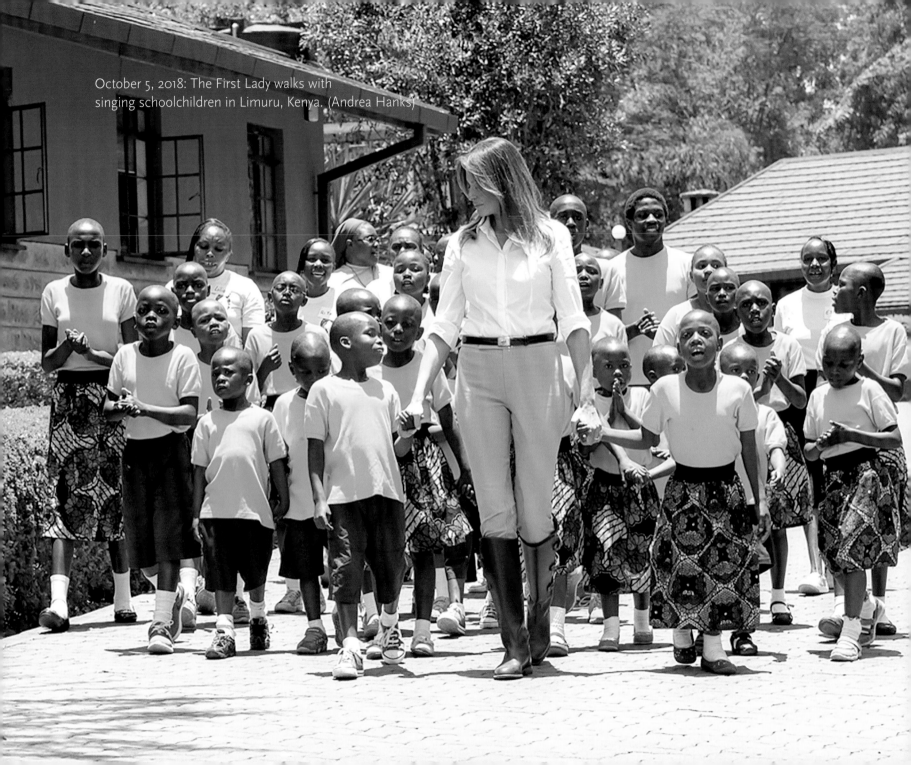

October 5, 2018: The First Lady walks with singing schoolchildren in Limuru, Kenya. (Andrea Hanks)

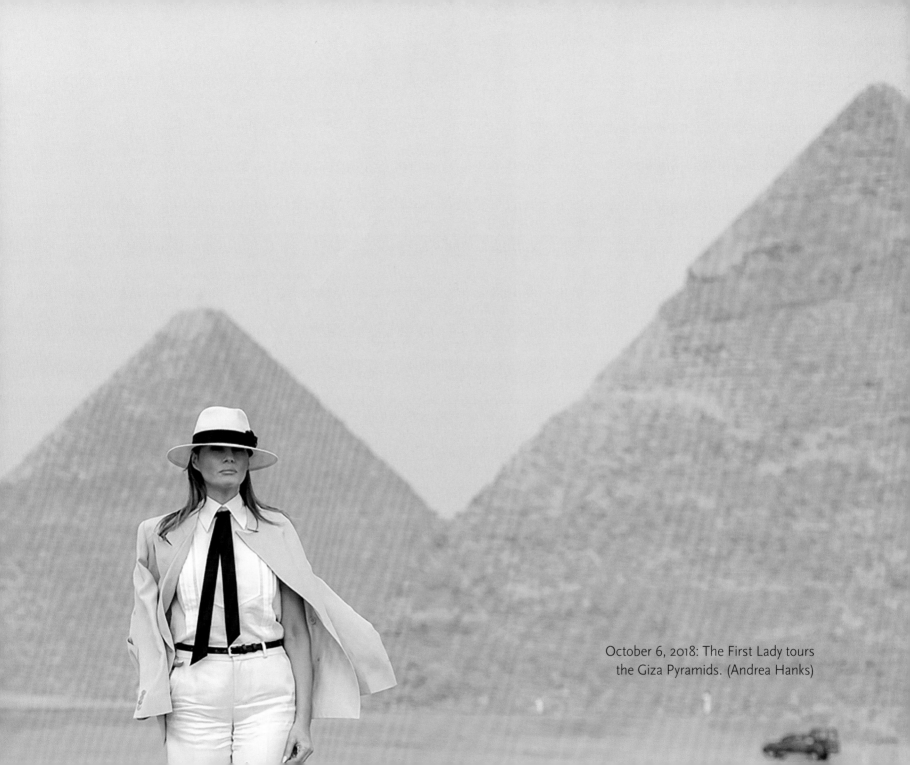

October 6, 2018: The First Lady tours
the Giza Pyramids. (Andrea Hanks)

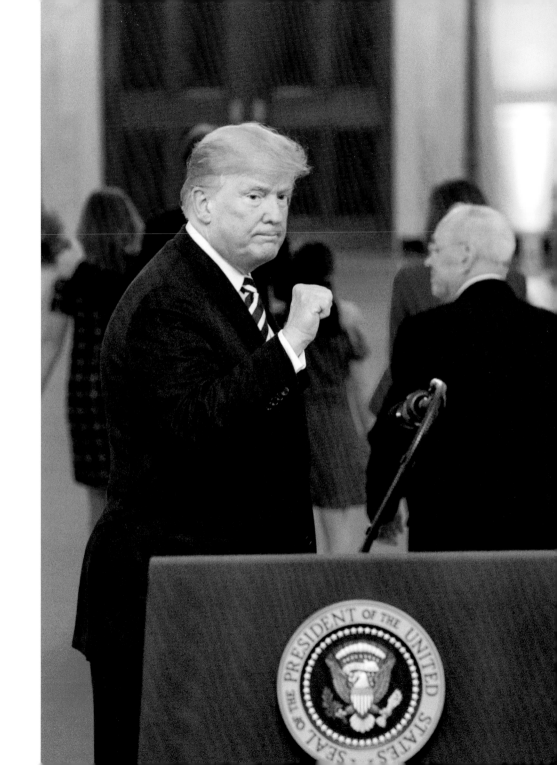

October 8, 2018: The President pumps
his fist after the swearing-in ceremony for
U.S. Supreme Court Associate Justice Brett
M. Kavanaugh. (Joyce N. Boghosian)

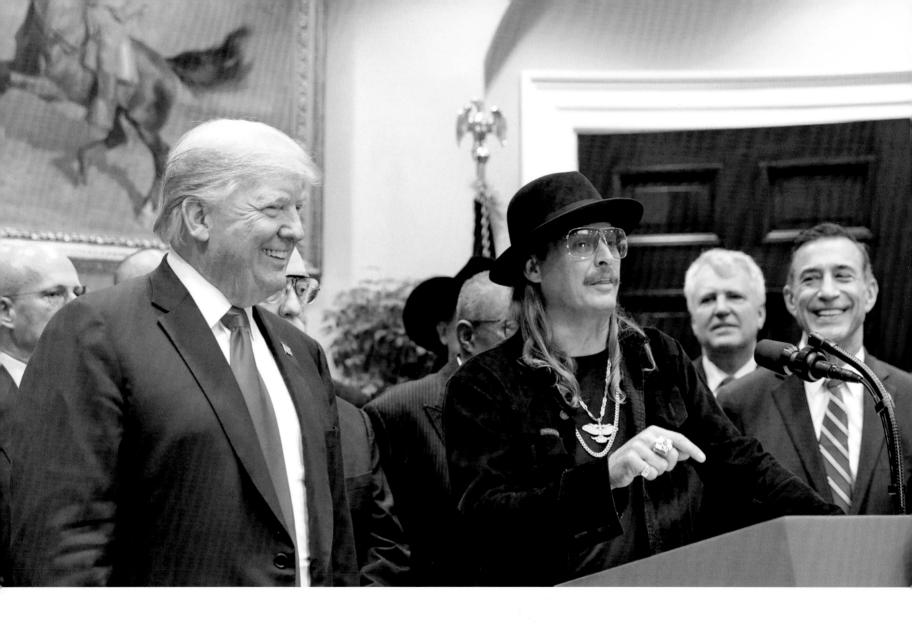

October 11, 2018: President Trump with Kid Rock in the Roosevelt Room of the White House, on the occasion of signing the Music Modernization Act. (Joyce N. Boghosian)

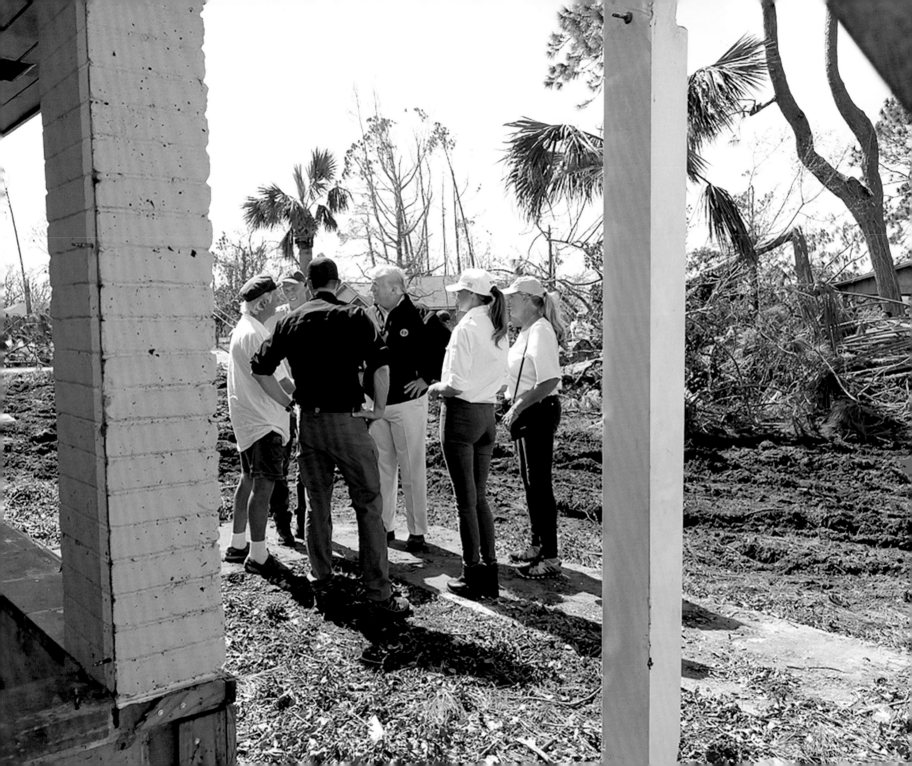

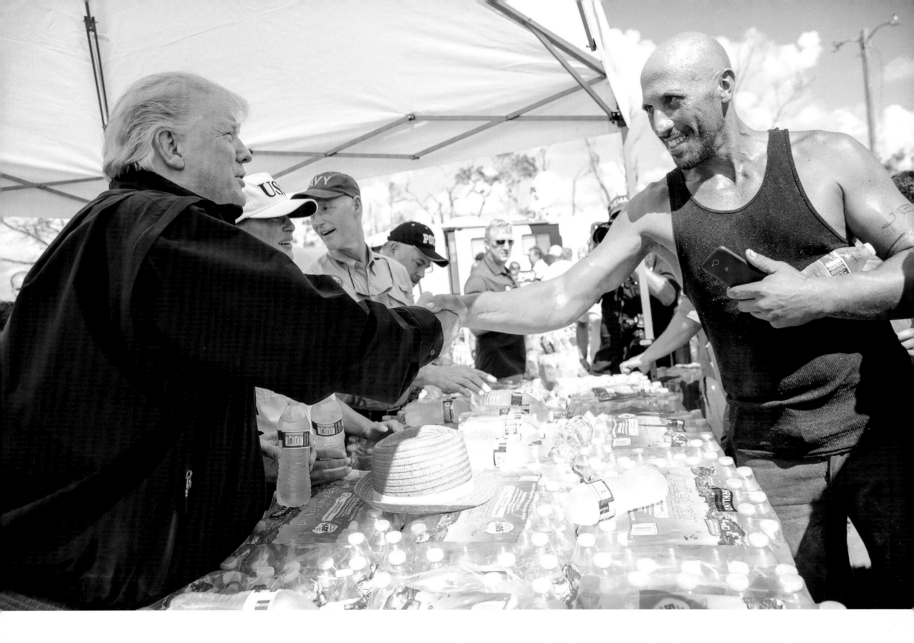

October 15, 2018: In Lynn Haven, Florida, meeting with residents impacted by Hurricane Michael. (Andrea Hanks)

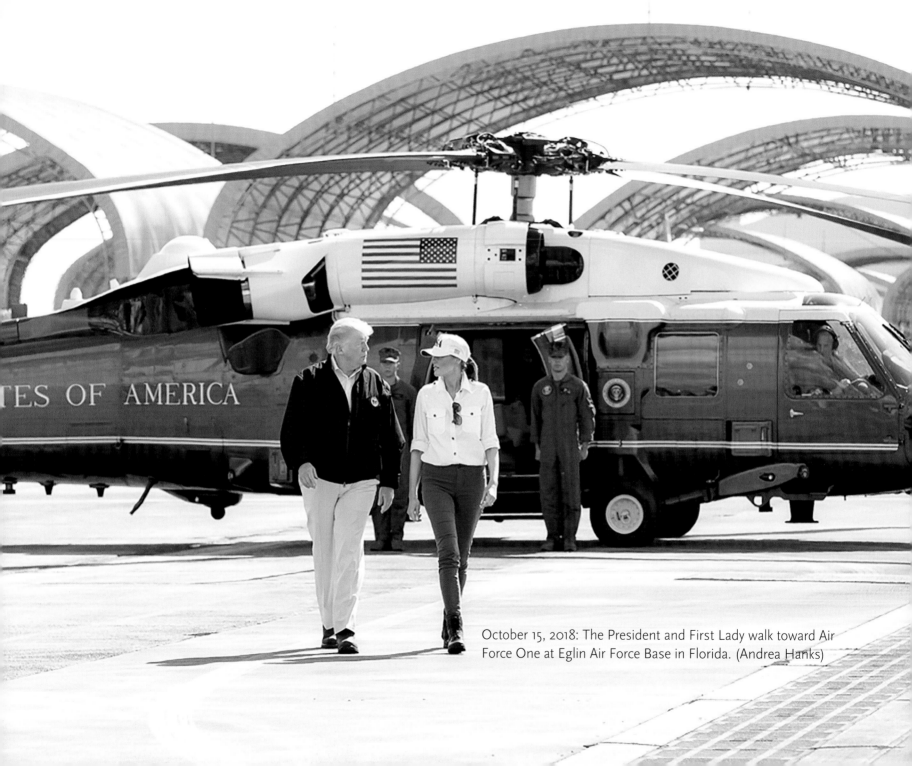

October 15, 2018: The President and First Lady walk toward Air Force One at Eglin Air Force Base in Florida. (Andrea Hanks)

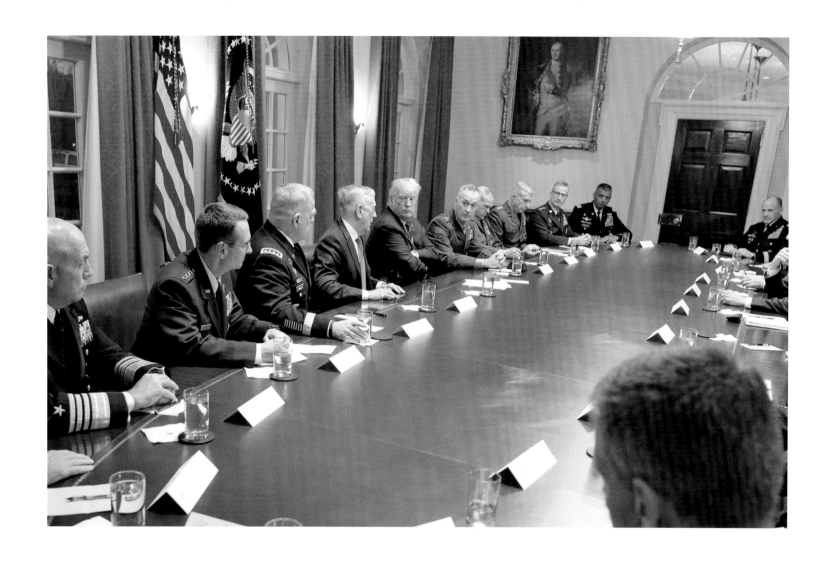

October 23, 2018: Meeting with senior military leaders in the
Cabinet Room of the White House. (Shealah Craighead)

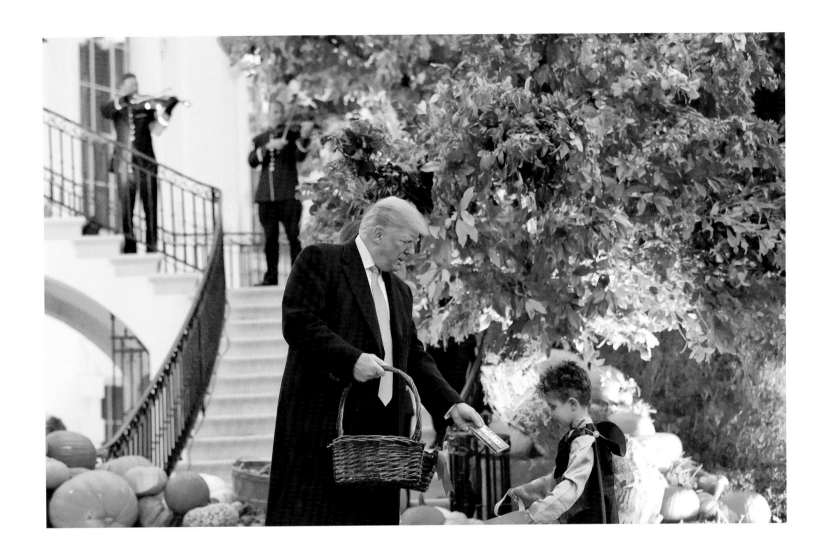

October 28, 2018: The President and First Lady hand out Halloween candy to children outside the South Portico entrance of the White House. (Andrea Hanks)

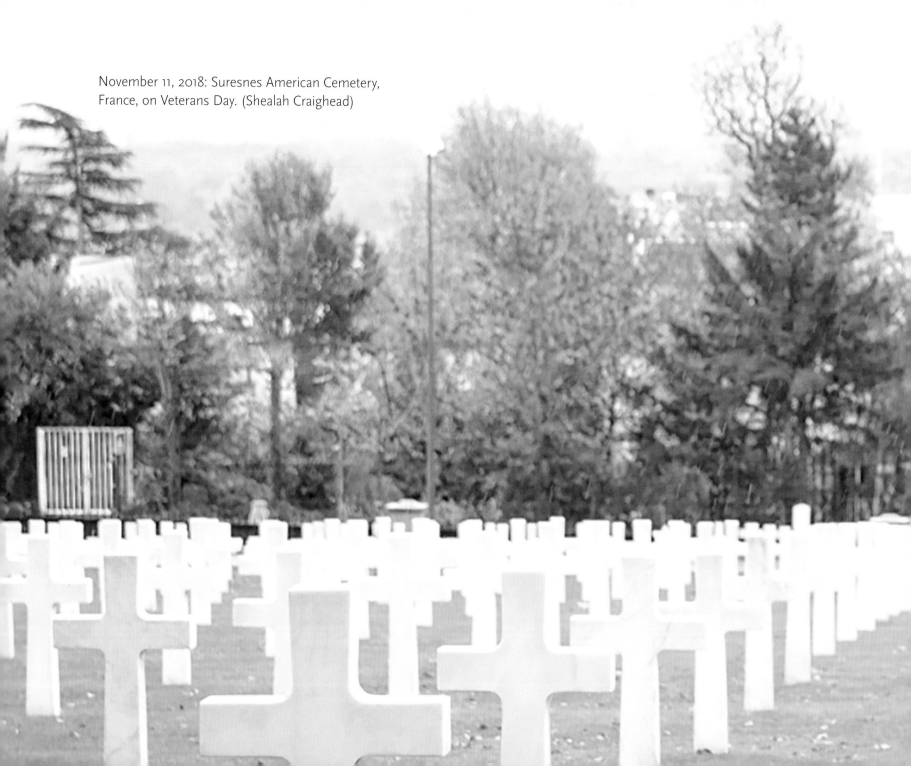

November 11, 2018: Suresnes American Cemetery, France, on Veterans Day. (Shealah Craighead)

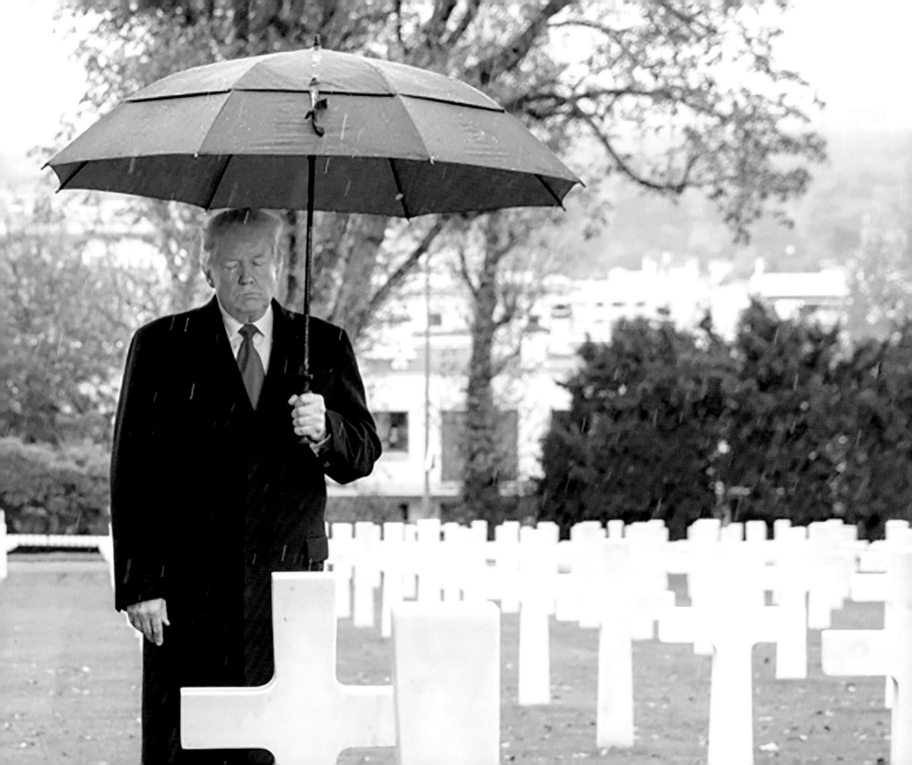

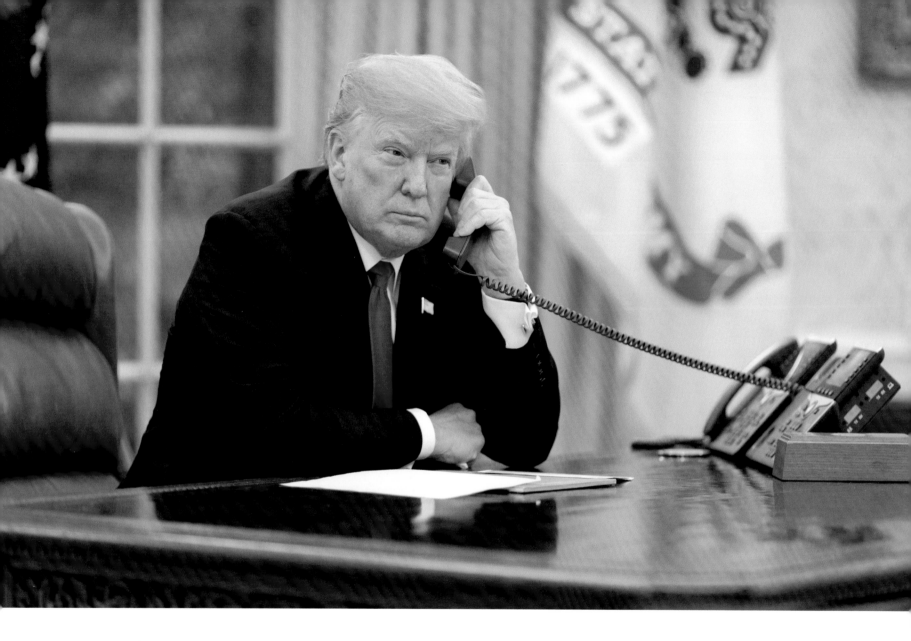

November 14, 2018: In the Oval Office, receiving a briefing
on the wildfires in California. (Joyce N. Boghosian)

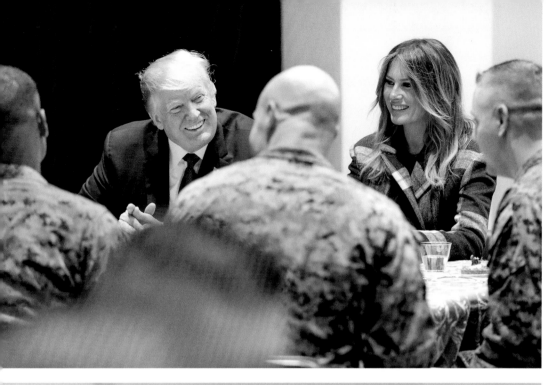

November 15, 2018: The President and First Lady visit the Marine Barracks in Washington D.C. (Andrea Hanks)

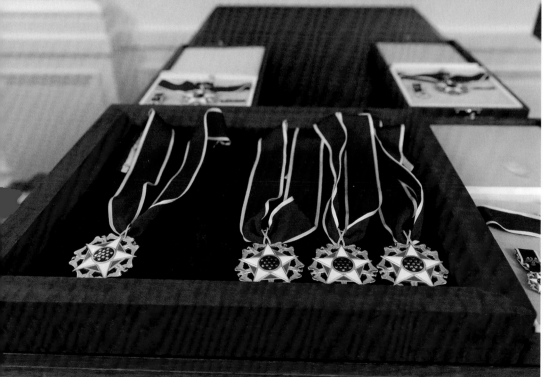

November 16, 2018: The Presidential Medal of Freedom. (Andrea Hanks)

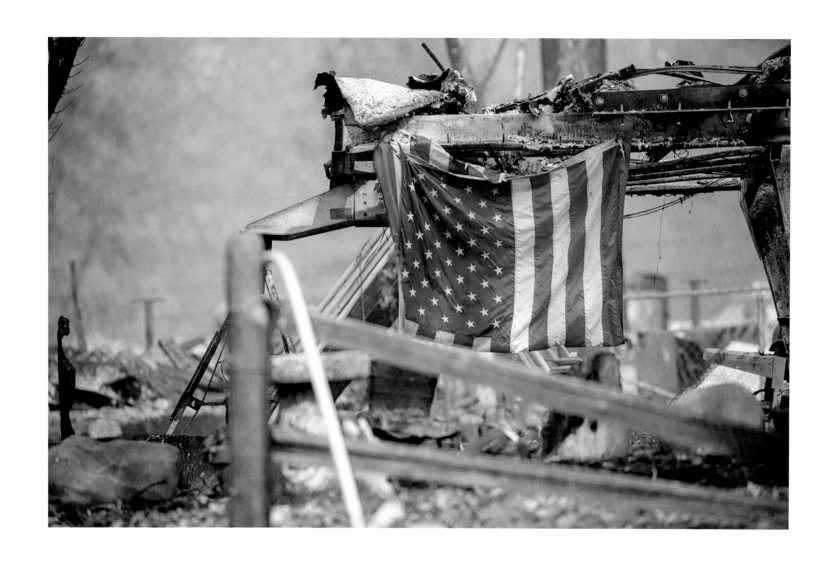

November 17, 2018: Visiting Paradise, California, which
was devastated by the Camp Fire. (Shealah Craighead)

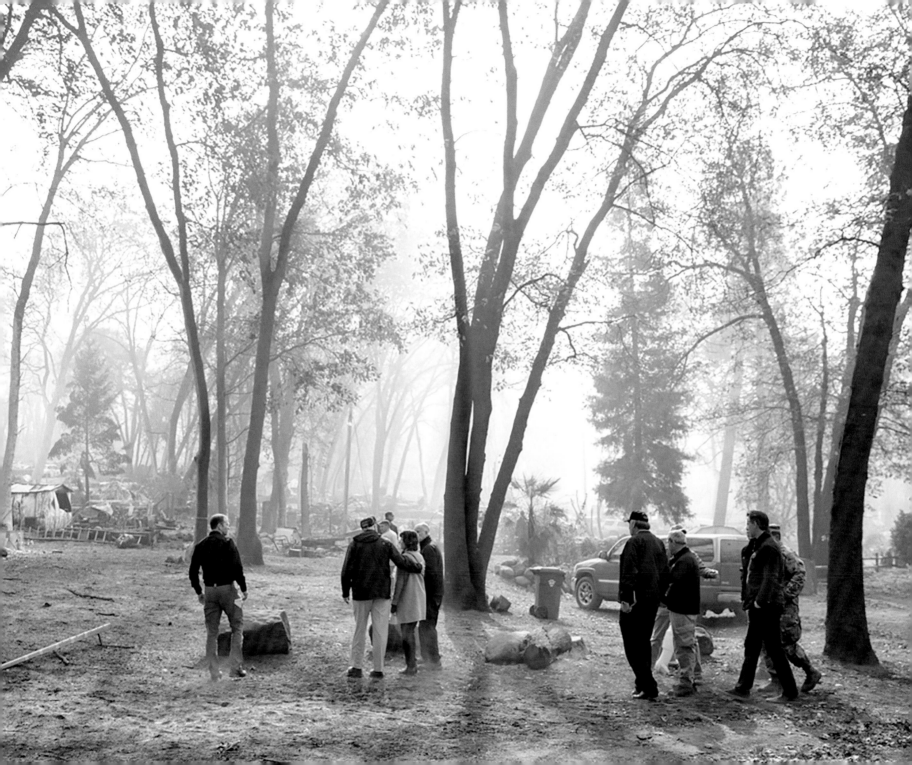

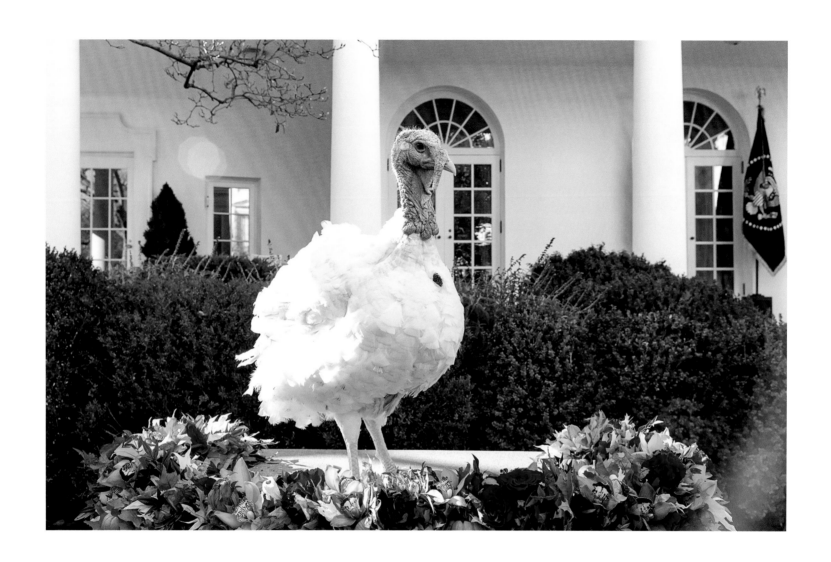

November 20, 2018: The National Thanksgiving
Turkey Pardon. (Andrea Hanks)

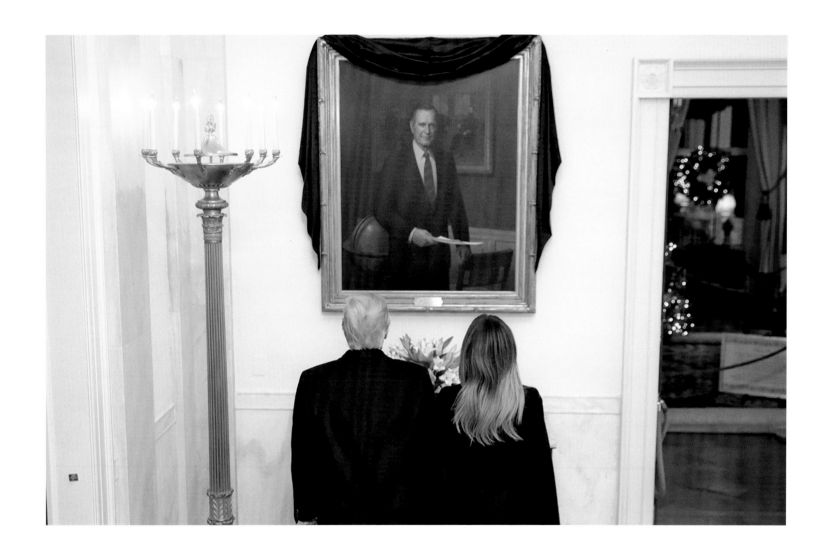

December 3, 2018: The President and First Lady stand before the official White House portrait of former president George H. W. Bush, soon after the former president's passing. (Shealah Craighead)

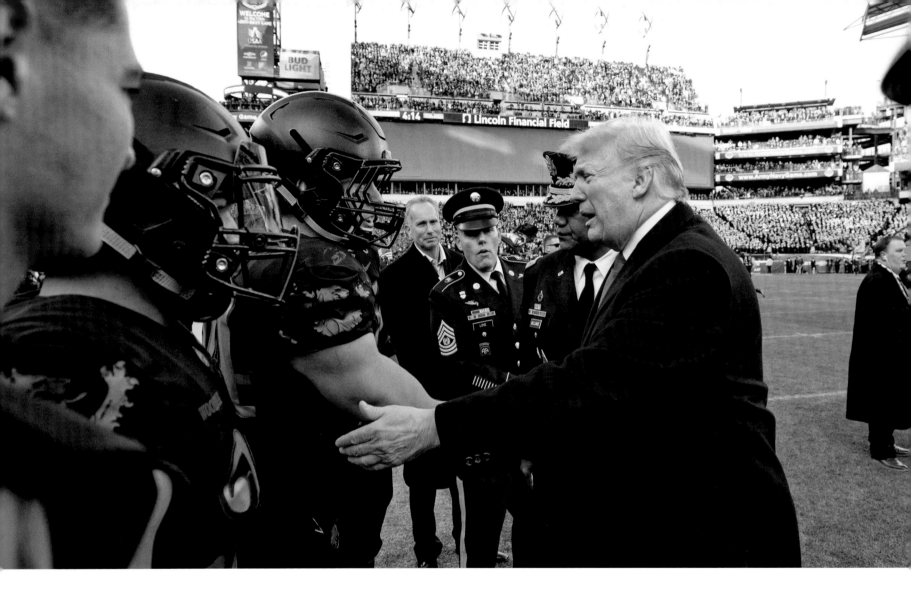

December 8, 2018: The President shakes hands with members of the
U.S. Army football team at the Army-Navy game. (Joyce N. Boghosian)

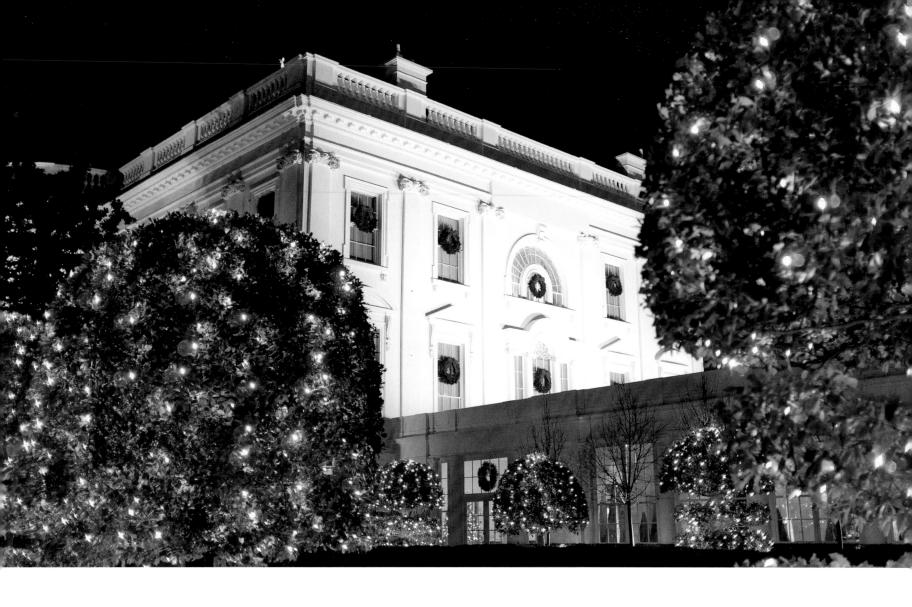

December 12, 2018: Christmas lights at the White House. (Keegan Barber)

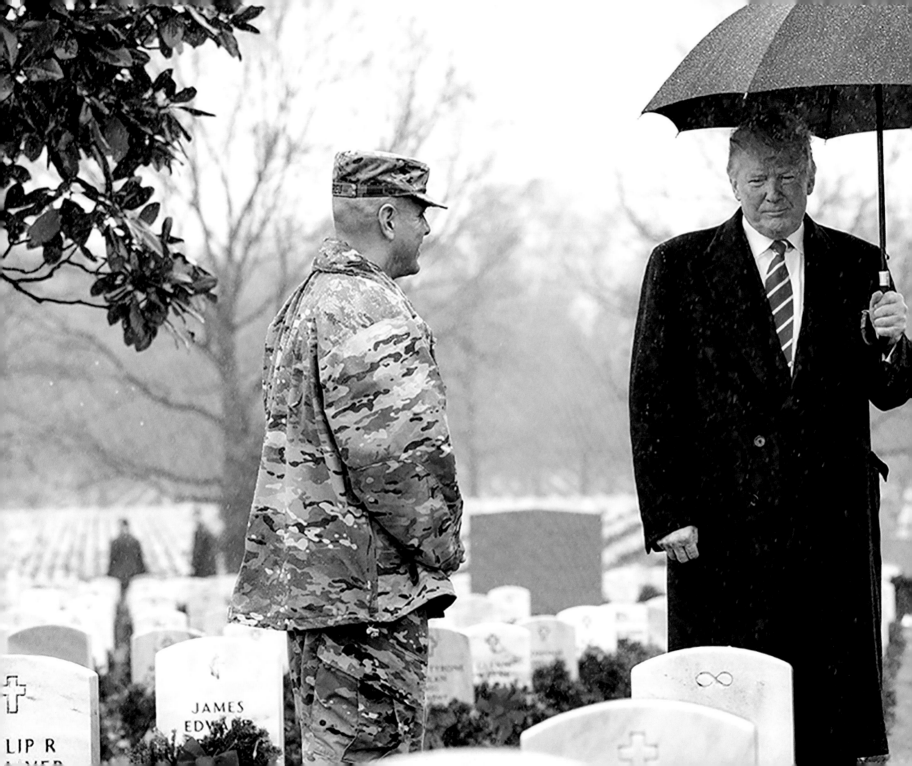

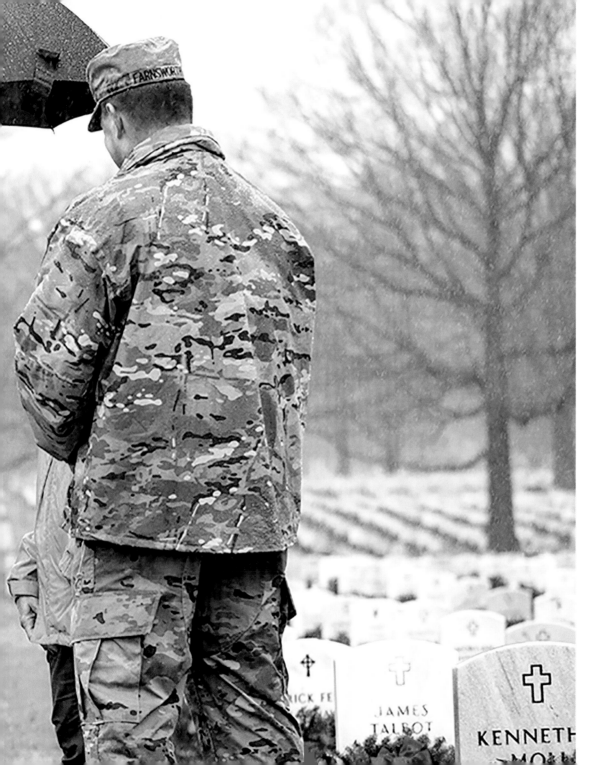

December 15, 2018: Visiting Arlington National Cemetery's Section 60 during the annual Wreaths Across America event. (Joyce N. Boghosian)

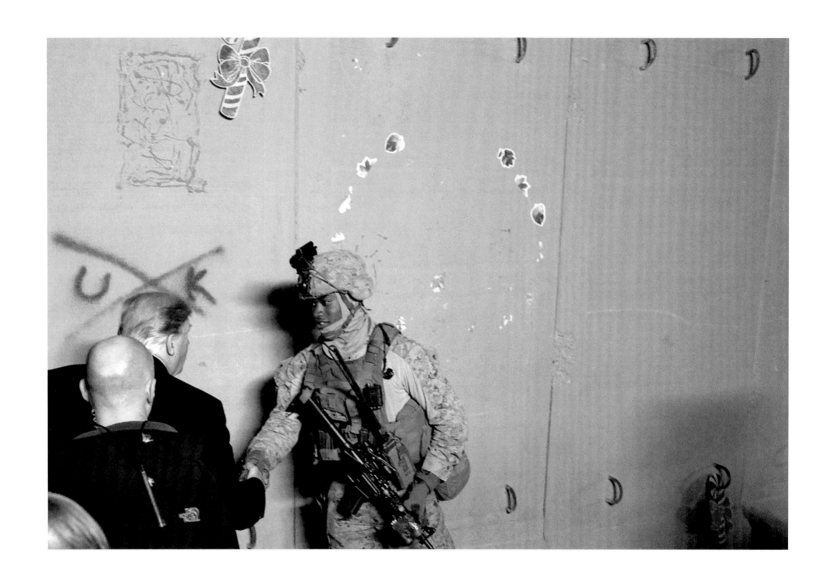

December 26, 2018: Shaking hands with a soldier
at the al-Asad air base in Iraq. (Shealah Craighead)

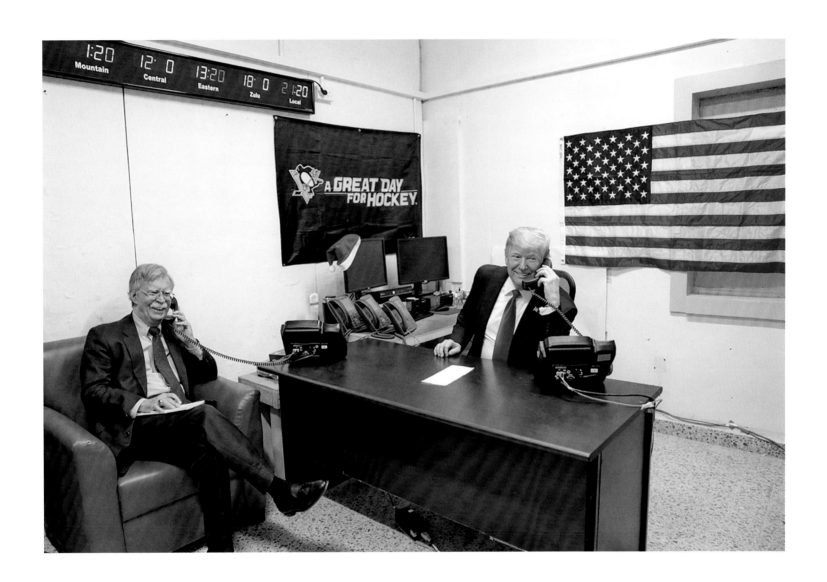

December 26, 2018: With John Bolton at al-Asad air base. (Shealah Craighead)

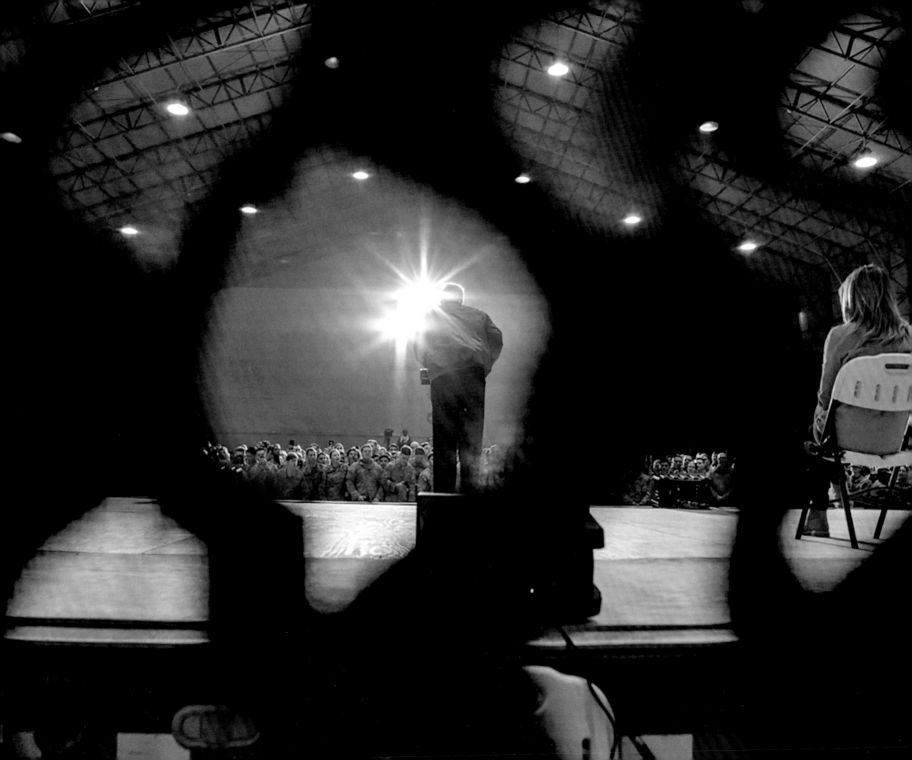

There is no military more capable and, now, more lethal, more fearless, and more skilled than the United States Armed Forces. Our faith and confidence in you is absolute and total. You are the sentinels who watch over our nation. You are the warriors who defend our freedom. You are the patriots who ensure the flame of liberty burns forever bright.

—From the President's remarks at al-Asad air base in Iraq, December 26, 2018

December 26, 2018: Speaking to U.S. troops at al-Asad air base. (Shealah Craighead)

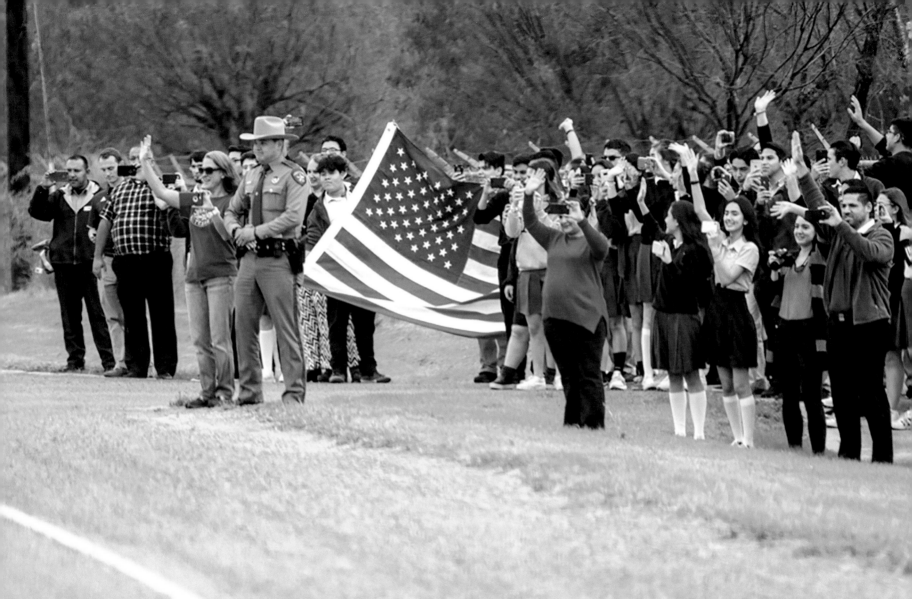

January 10, 2019: Crowds watch the President's motorcade as it drives to the Rio Grande. (Shealah Craighead)

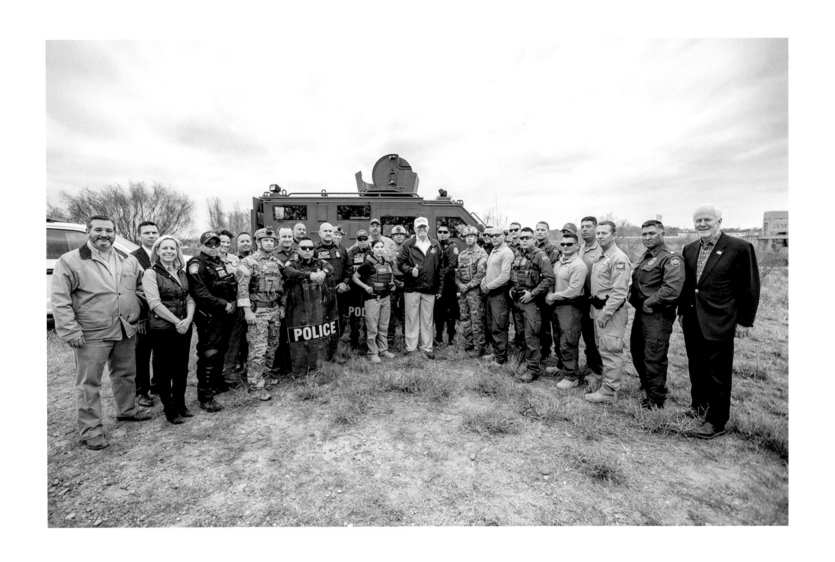

January 10, 2019: With U.S. Customs and Border Protection officers, near the U.S. Border Patrol McAllen Station in Texas. (Shealah Craighead)

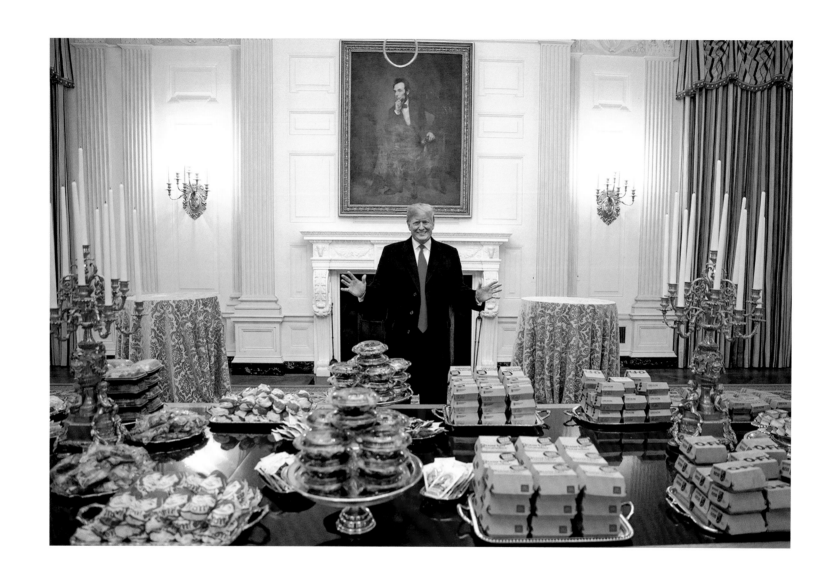

January 14, 2019: A feast for the Clemson Tigers, the 2018
NCAA Football National Champions. (Joyce N. Boghosian)

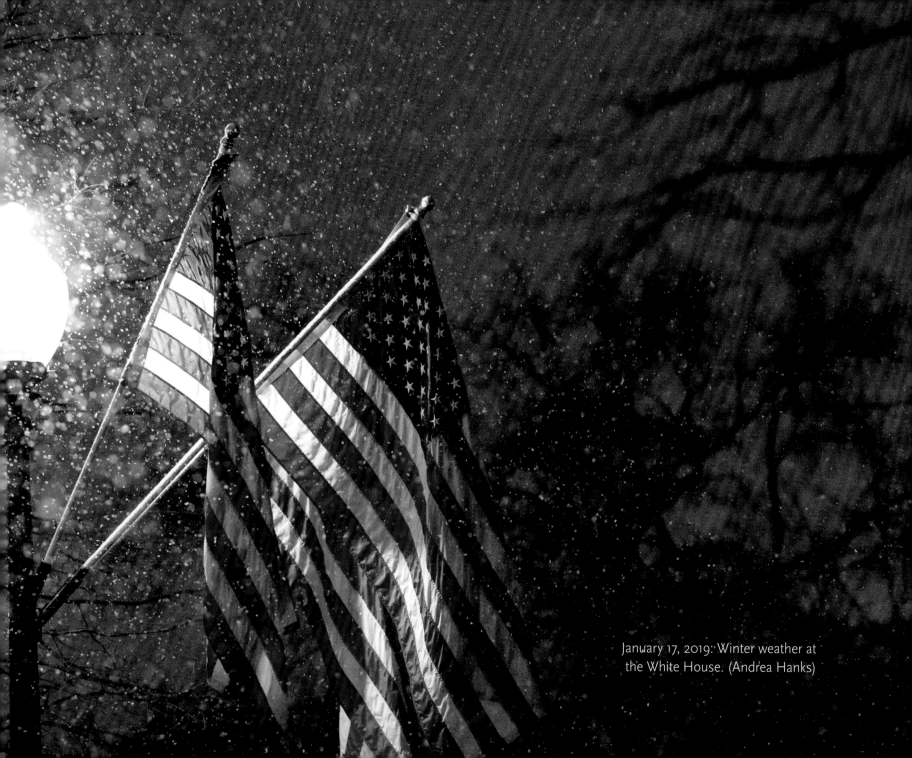

January 17, 2019: Winter weather at the White House. (Andrea Hanks)

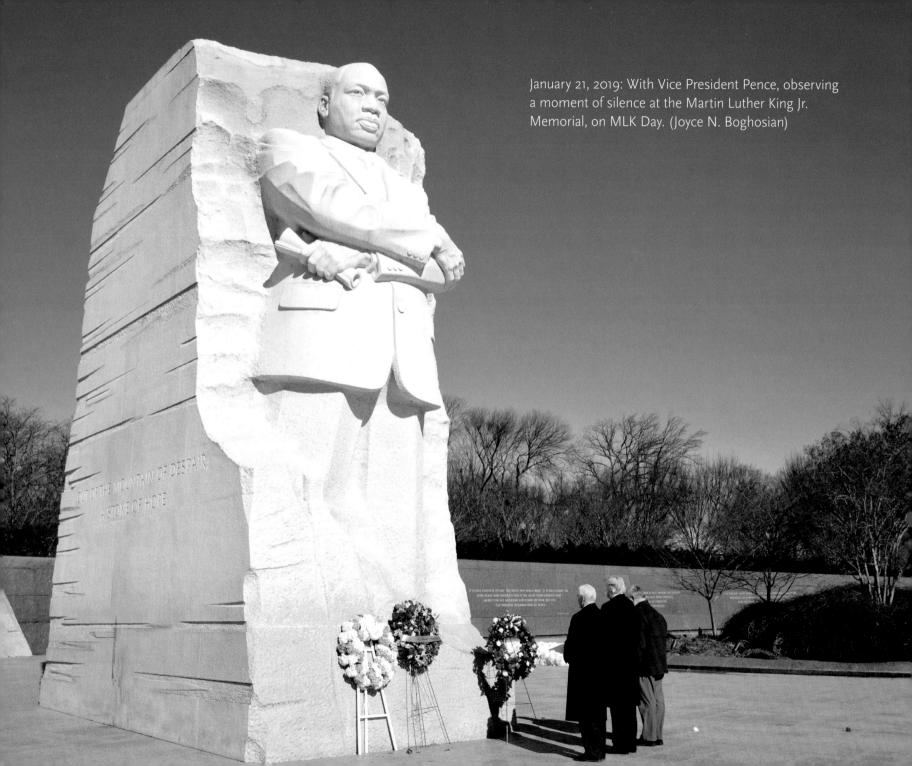

January 21, 2019: With Vice President Pence, observing a moment of silence at the Martin Luther King Jr. Memorial, on MLK Day. (Joyce N. Boghosian)

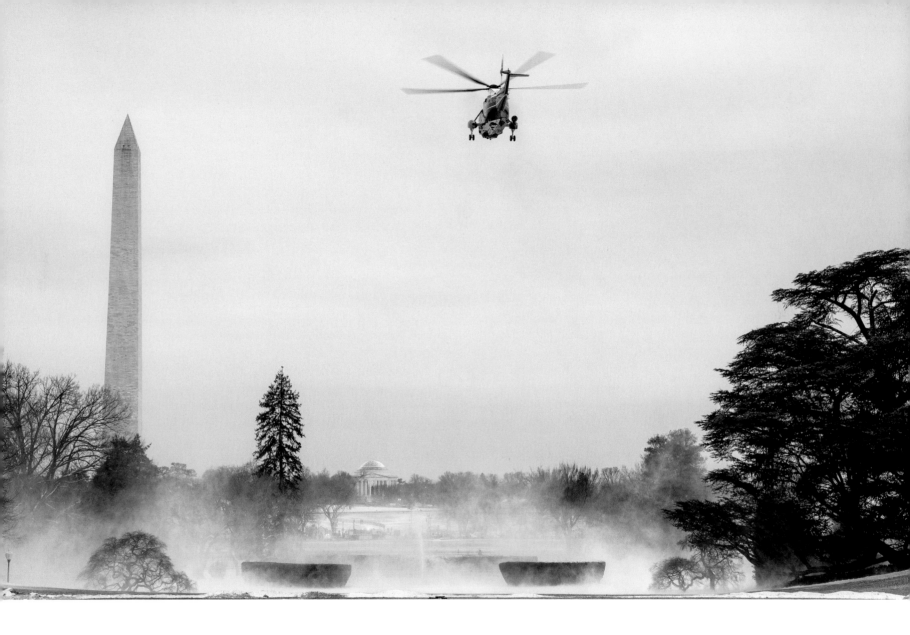

February 1, 2019: Marine One lifts off from the South Lawn of the White House, with the President, the First Lady, and Barron Trump en route to Joint Base Andrews, and then to Palm Beach. (Tia Dufour)

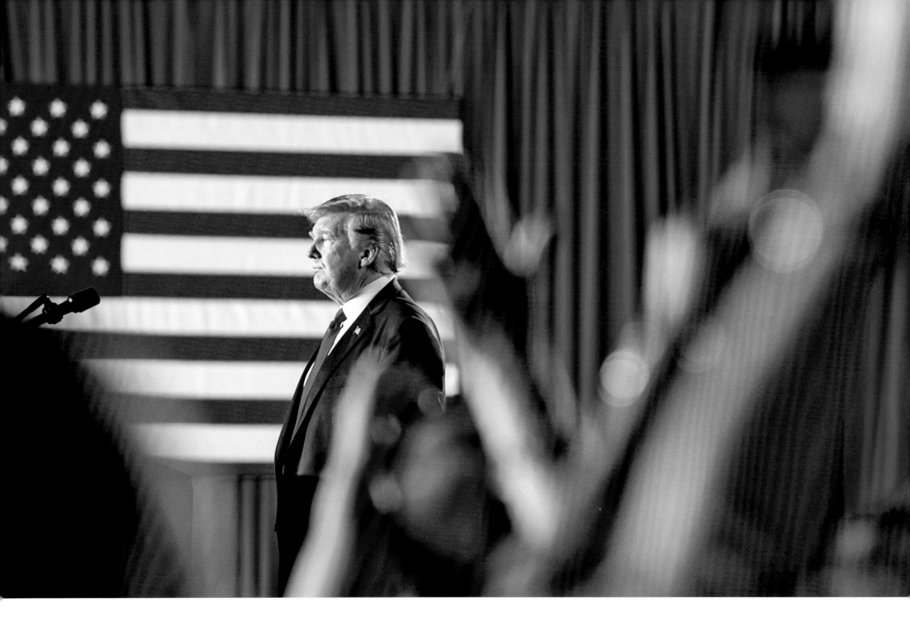

February 18, 2019: Delivering remarks to the Venezuelan
American community in Miami. (Shealah Craighead)

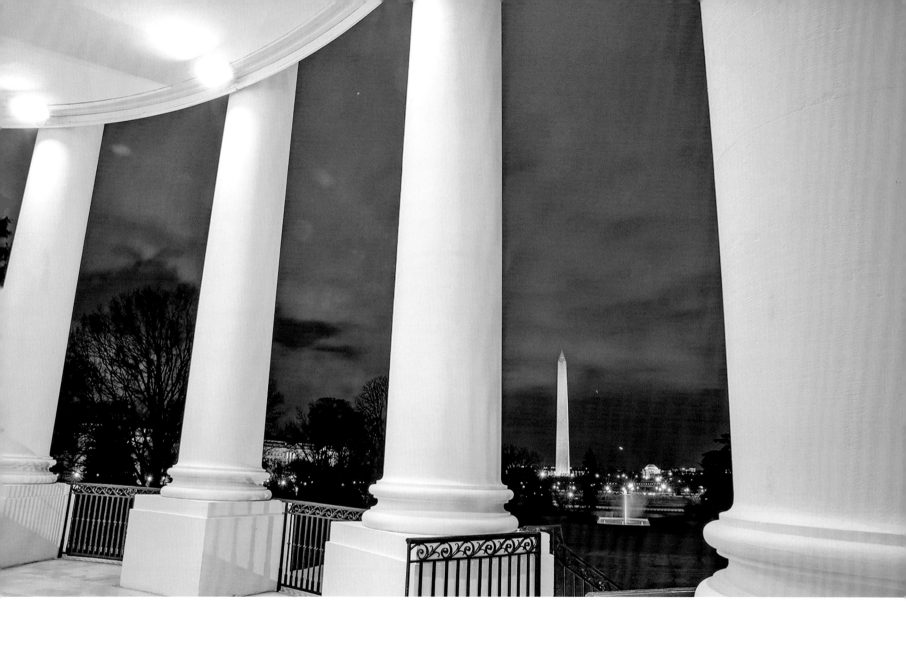

February 18, 2019: Looking out on the South Lawn. (Joyce N. Boghosian)

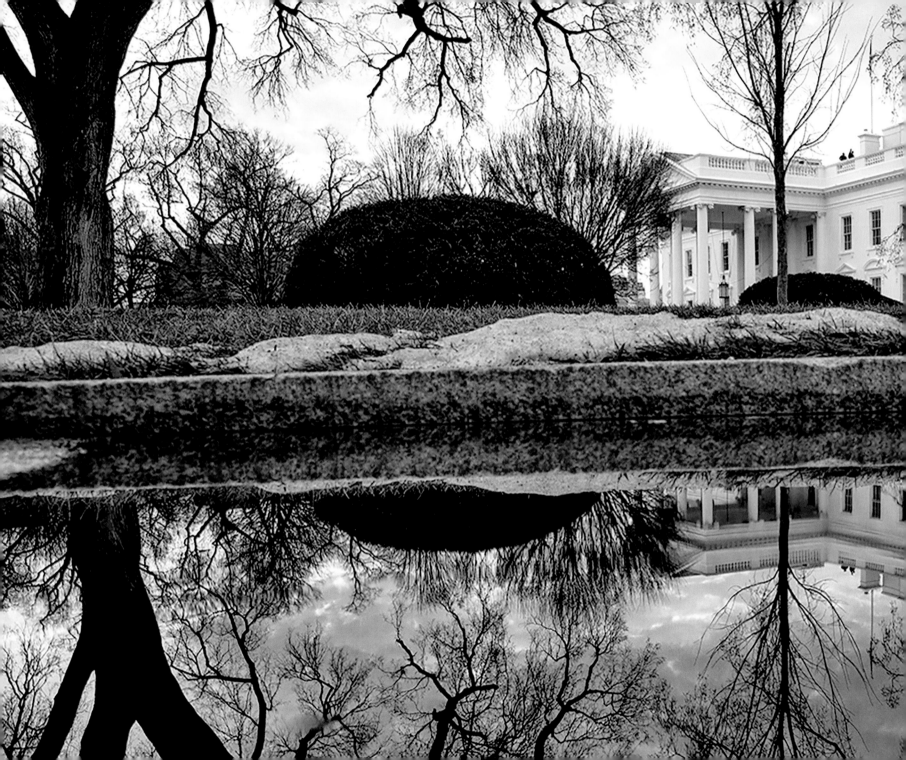

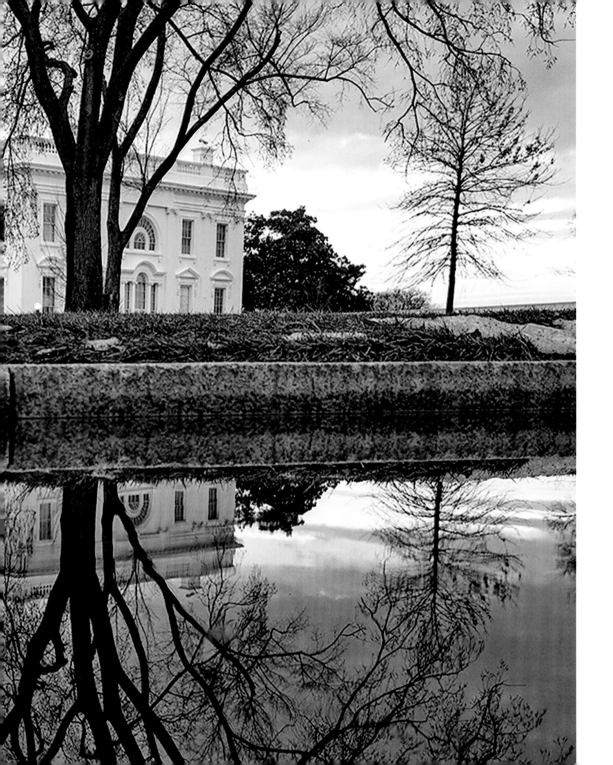

February 21, 2019: A view of the North Portico of the White House, as reflected in melted snow. (Joyce N. Boghosian)

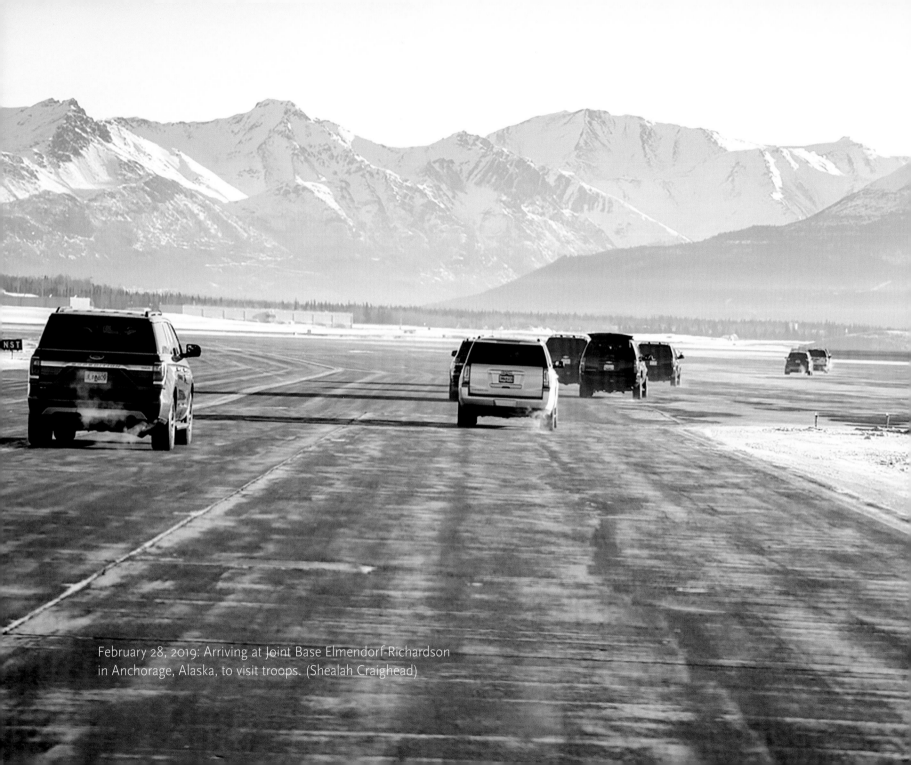

February 28, 2019: Arriving at Joint Base Elmendorf-Richardson in Anchorage, Alaska, to visit troops. (Shealah Craighead)

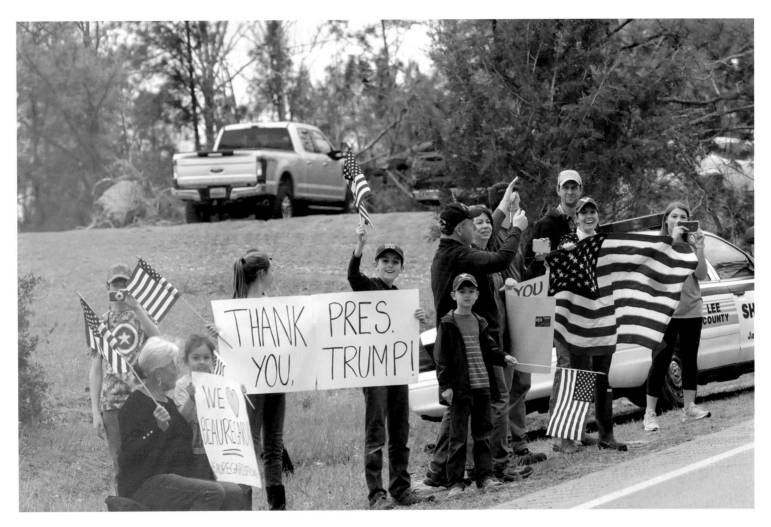

March 8, 2019: Supporters in Lee County, Alabama, welcome
President Trump and the First Lady. (Andrea Hanks)

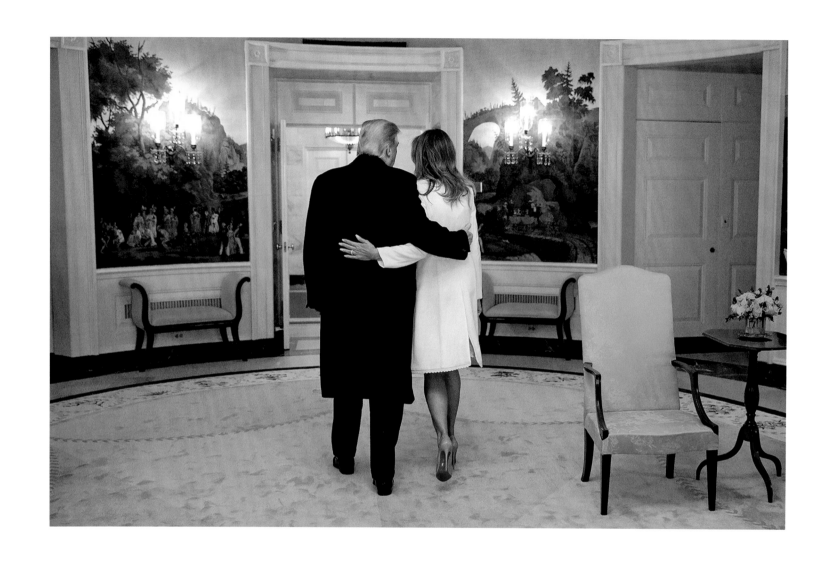

March 17, 2019: Returning to the White House after church
services on St. Patrick's Day. (Joyce N. Boghosian)

March 20, 2019: Employees at the Army Tank
Plant in Lima, Ohio. (Shealah Craighead)

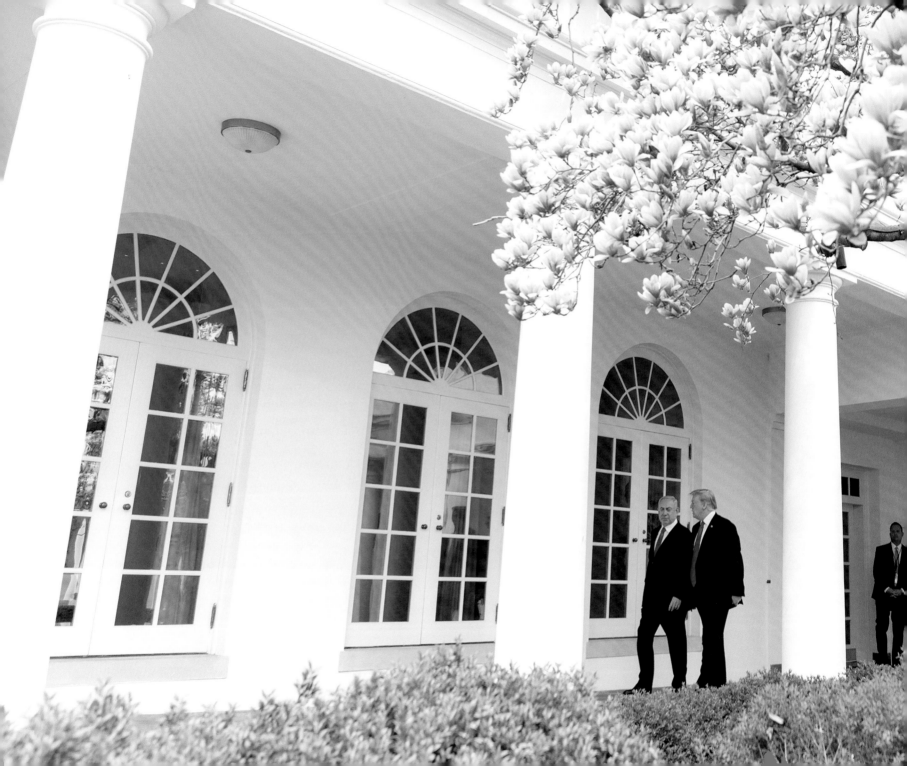

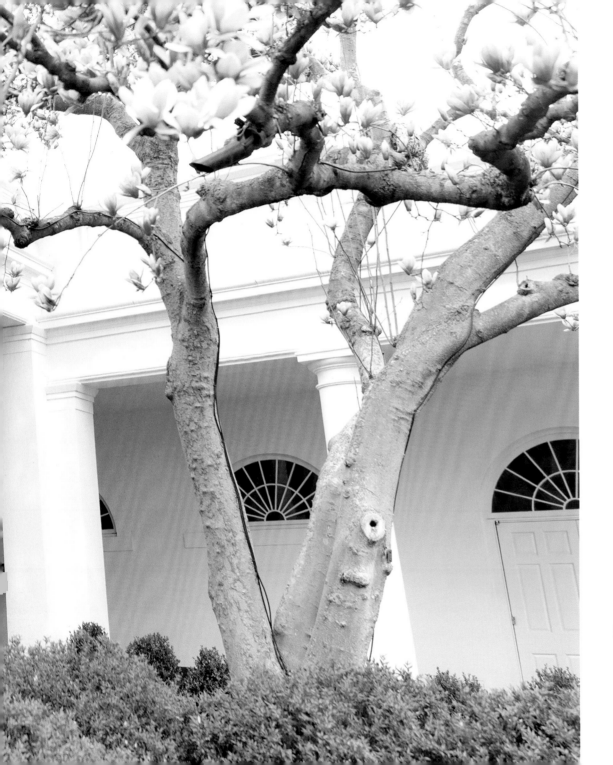

March 25, 2019: With Prime Minister Netanyahu on the West Wing Colonnade. (Shealah Craighead)

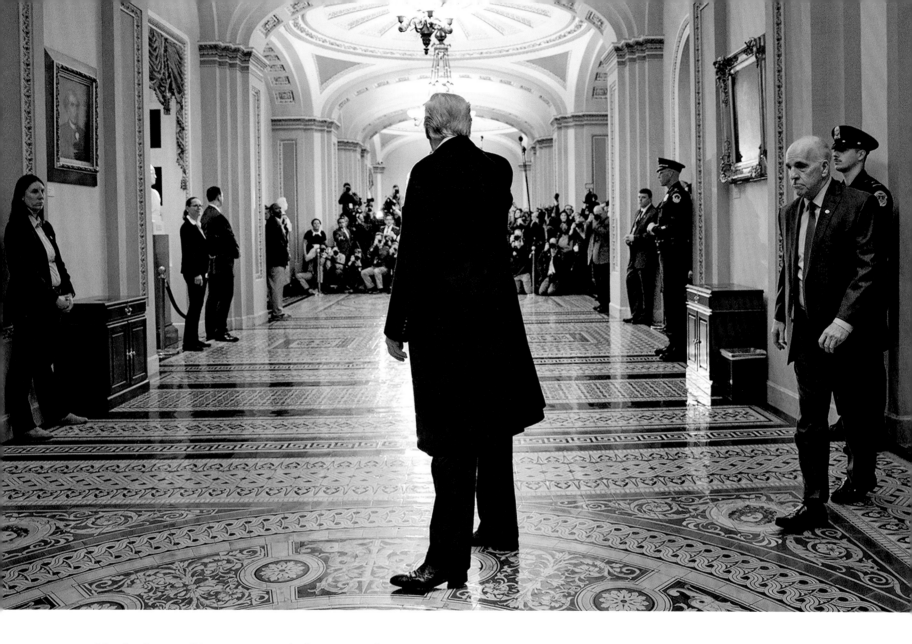

March 26, 2019: Waving to a crowd of reporters after
a Senate Republican luncheon. (Joyce N. Boghosian)

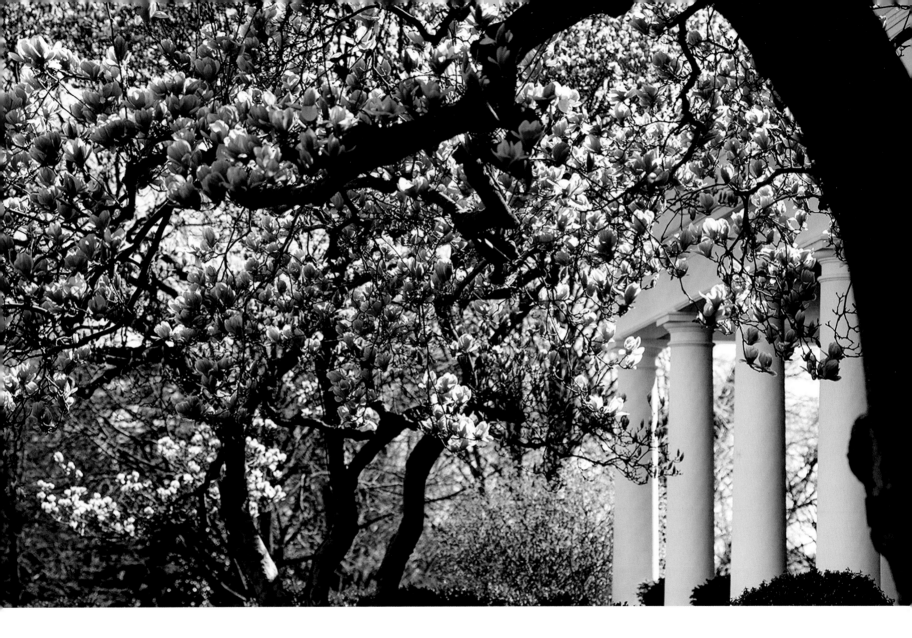

March 26, 2019: Magnolia trees in full bloom
at the White House. (Joyce N. Boghosian)

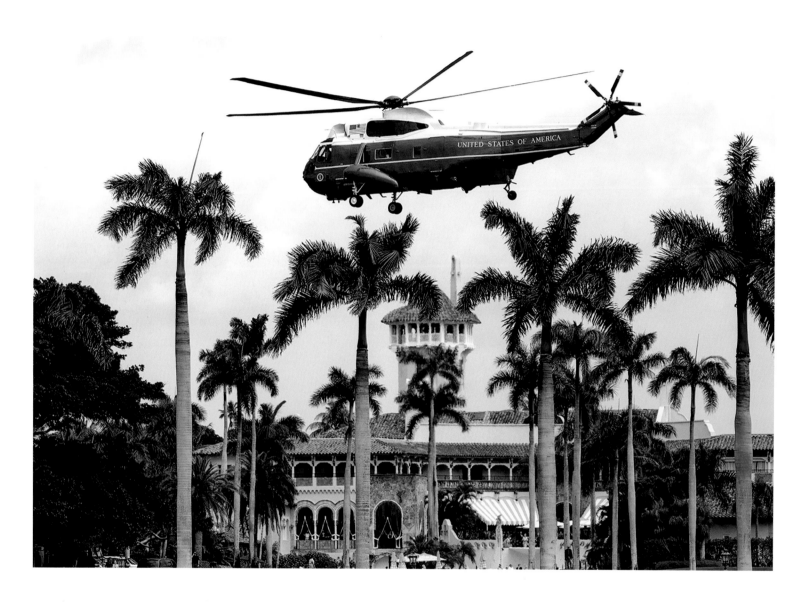

March 29, 2019: Marine One lifts off after returning
the President to Mar-a-Lago. (Joyce N. Boghosian)

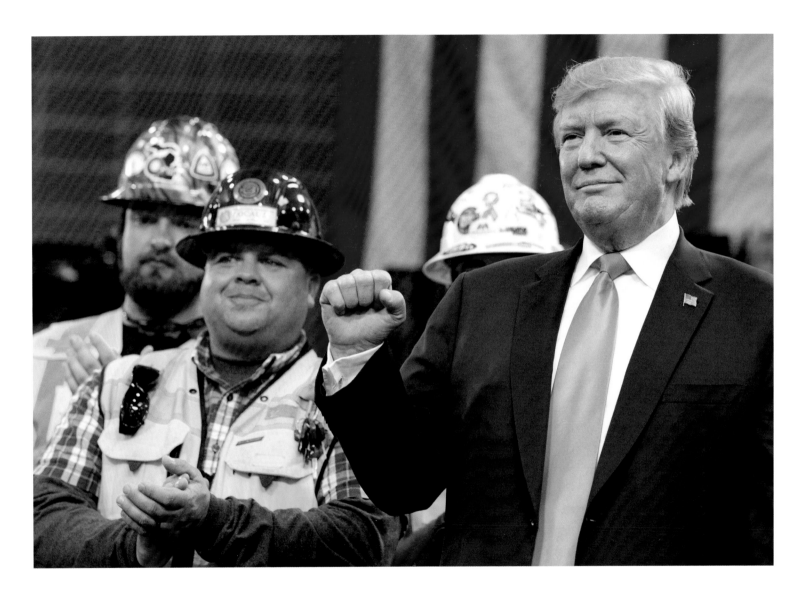

April 10, 2019: Being welcomed by the International Union of Operating Engineers in Crosby, Texas. (Joyce N. Boghosian)

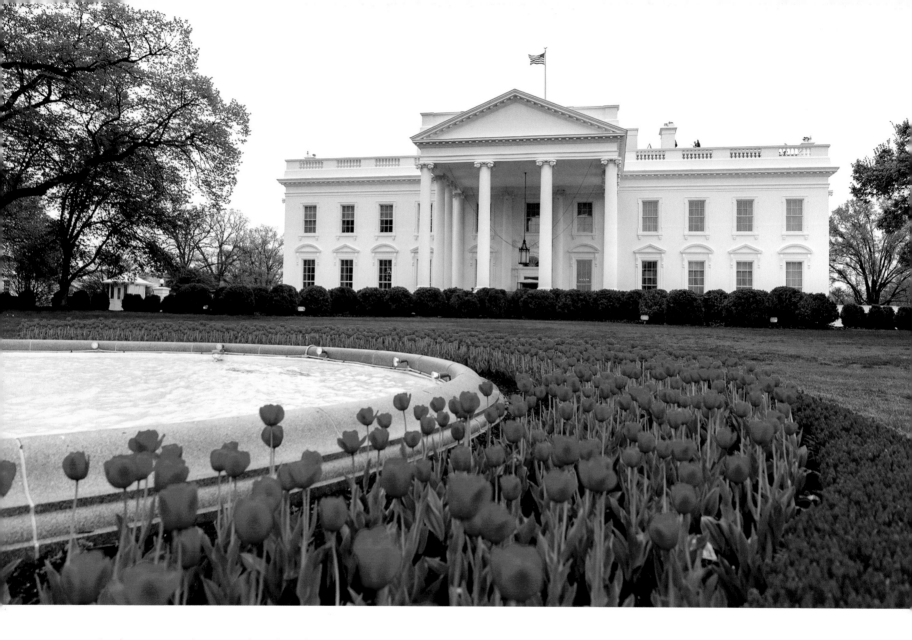

April 12, 2019: Tulips encircling the White House North Portico fountain. (Shealah Craighead)

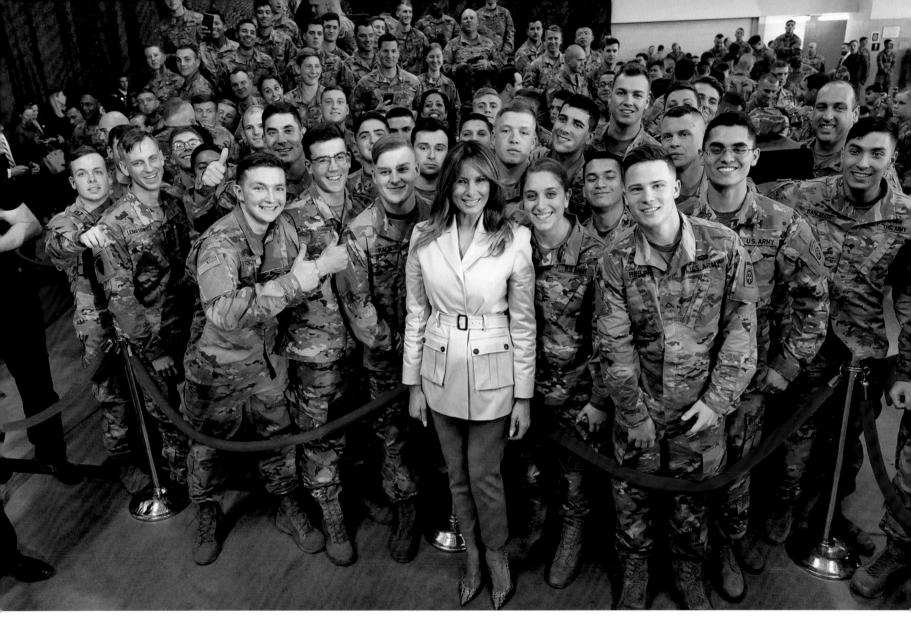

April 15, 2019: First Lady Melania Trump posing with service members during a military appreciation event at Fort Bragg. (Andrea Hanks)

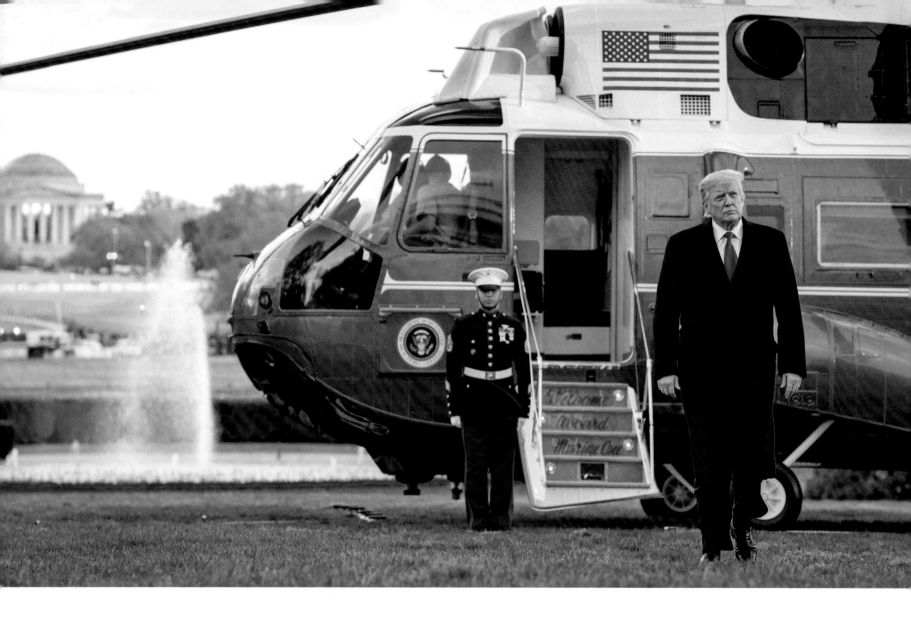

April 15, 2019: Disembarking Marine One on the South Lawn after attending a roundtable discussion on the economy and tax reform at Nuss Truck & Equipment in Burnsville, Minnesota. (Tia Dufour)

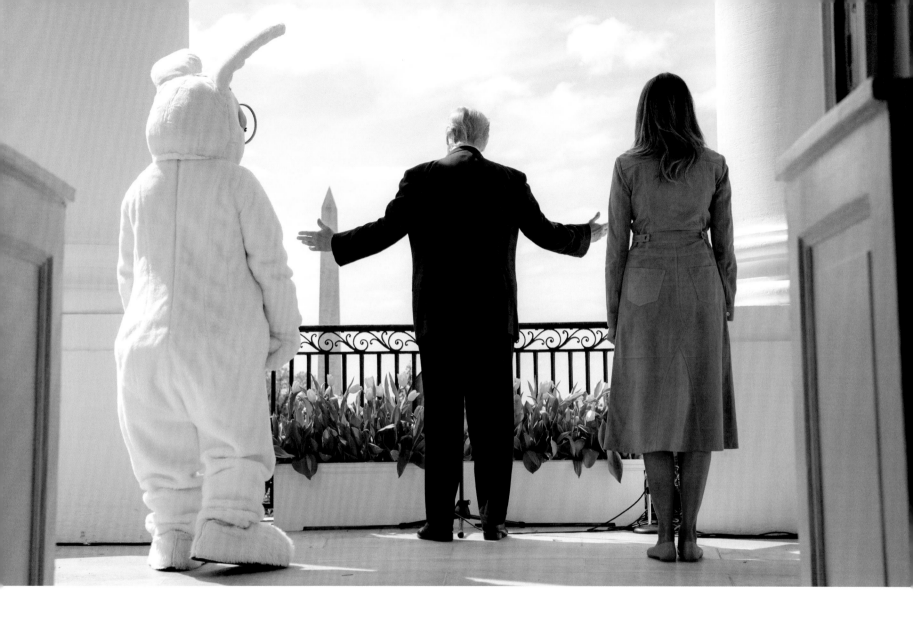

April 22, 2019: Welcoming guests to the 141st
White House Easter Egg Roll. (Shealah Craighead)

April 29, 2019: Bowling balls at the newly renovated
White House bowling alley. (Andrea Hanks)

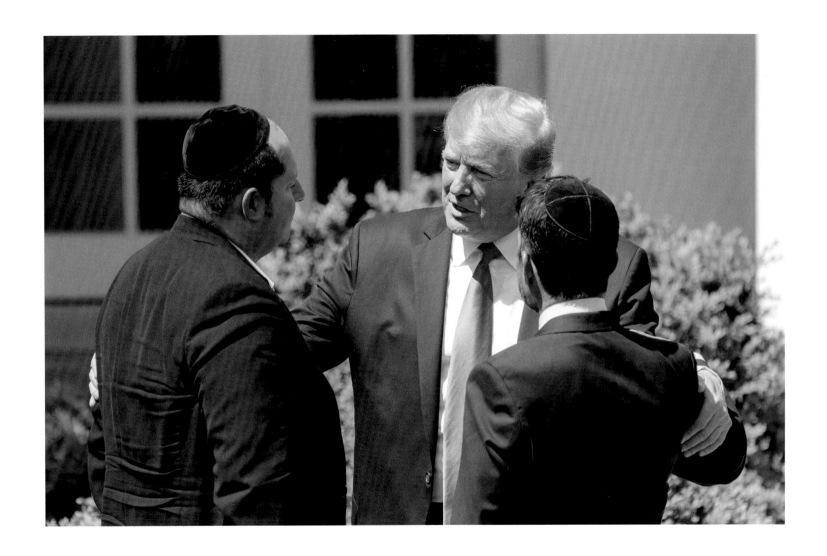

May 2, 2019: In the Rose Garden, during
the National Day of Prayer. (Tia Dufour)

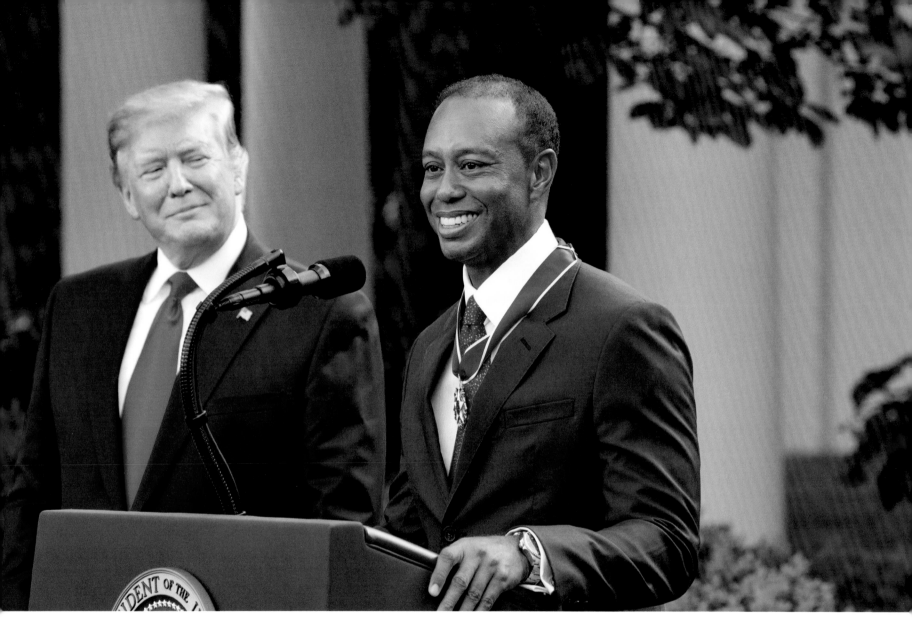

May 6, 2019: Honoring Tiger Woods with the
Presidential Medal of Freedom. (Joyce N. Boghosian)

May 7, 2019: Cookies in support of First Lady
Melania Trump's Be Best initiative. (Andrea Hanks)

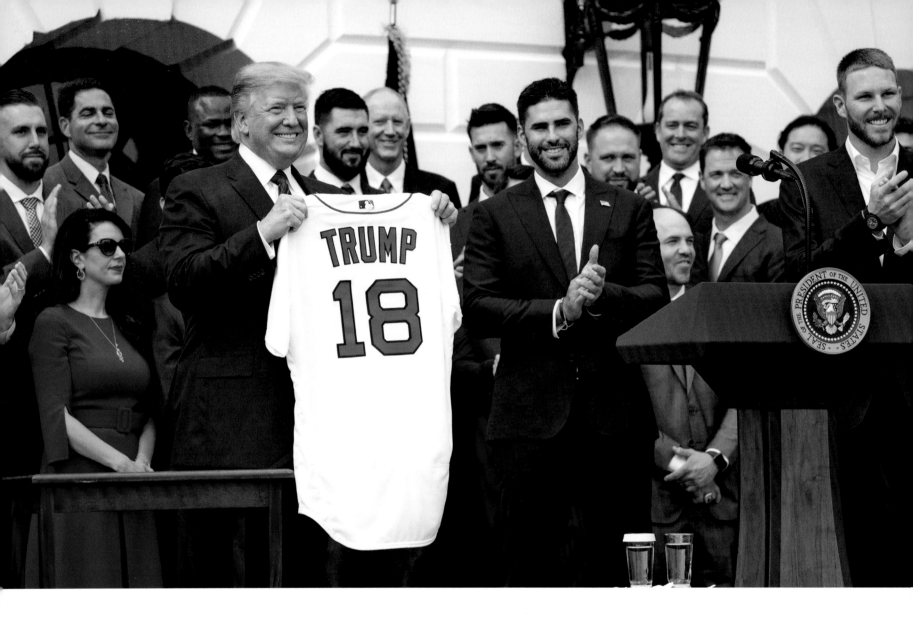

May 9, 2019: Welcoming the 2018 World Series Champion
Boston Red Sox to the White House. (Shealah Craighead)

May 15, 2019: The National Peace Officers'
Memorial Service. (Shealah Craighead)

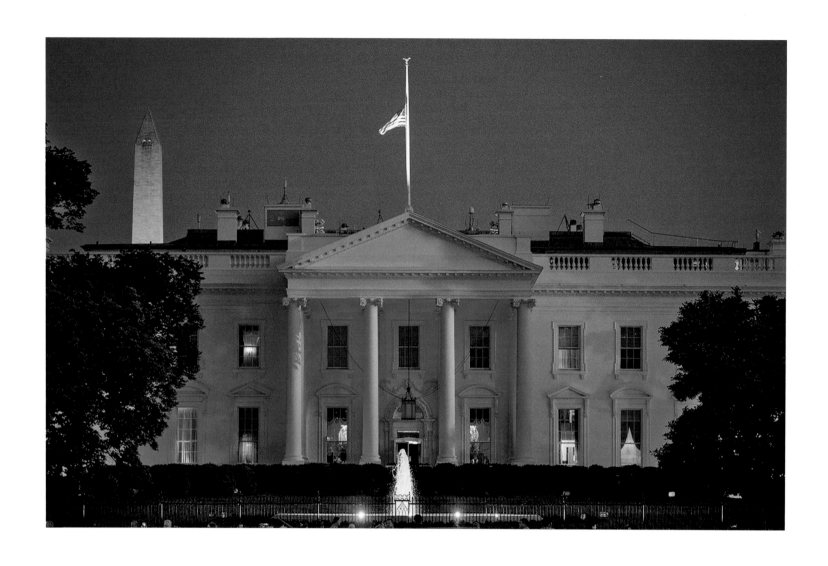

May 15, 2019: The White House lit blue in honor
of Peace Officers Memorial Day. (Joyce N. Boghosian)

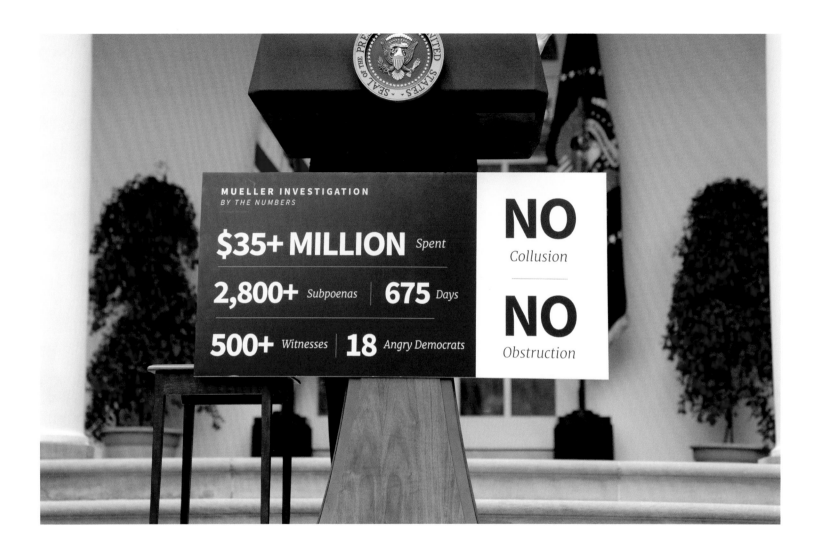

May 22, 2019: Detail of the President's podium as he addresses reporters in the Rose Garden, in the weeks following the release of Special Counsel Robert Mueller's "Report on the Investigation into Russian Interference in the 2016 Presidential Election." (Shealah Craighead)

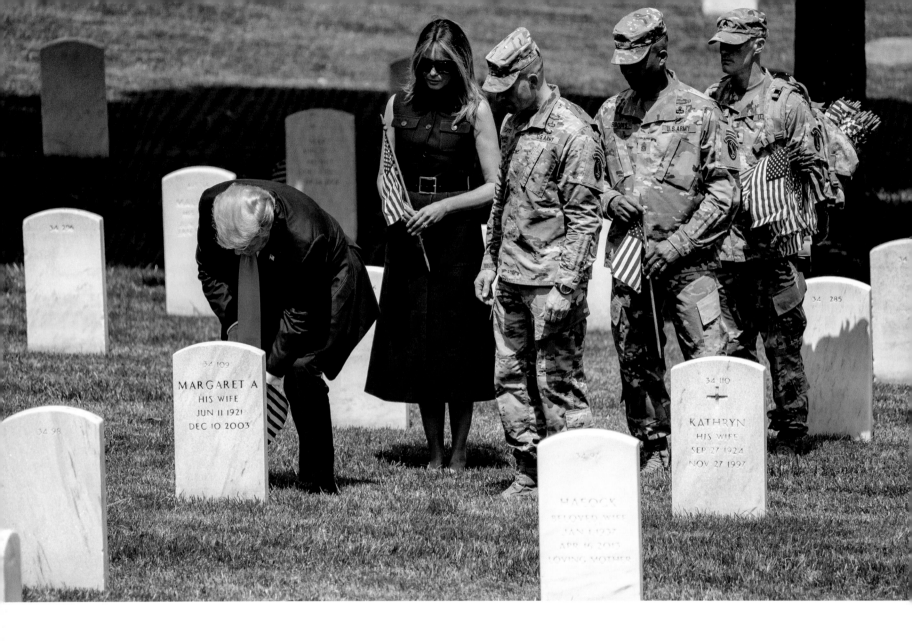

May 23, 2019: Placing flags on gravesites at
Arlington National Cemetery. (Tia Dufour)

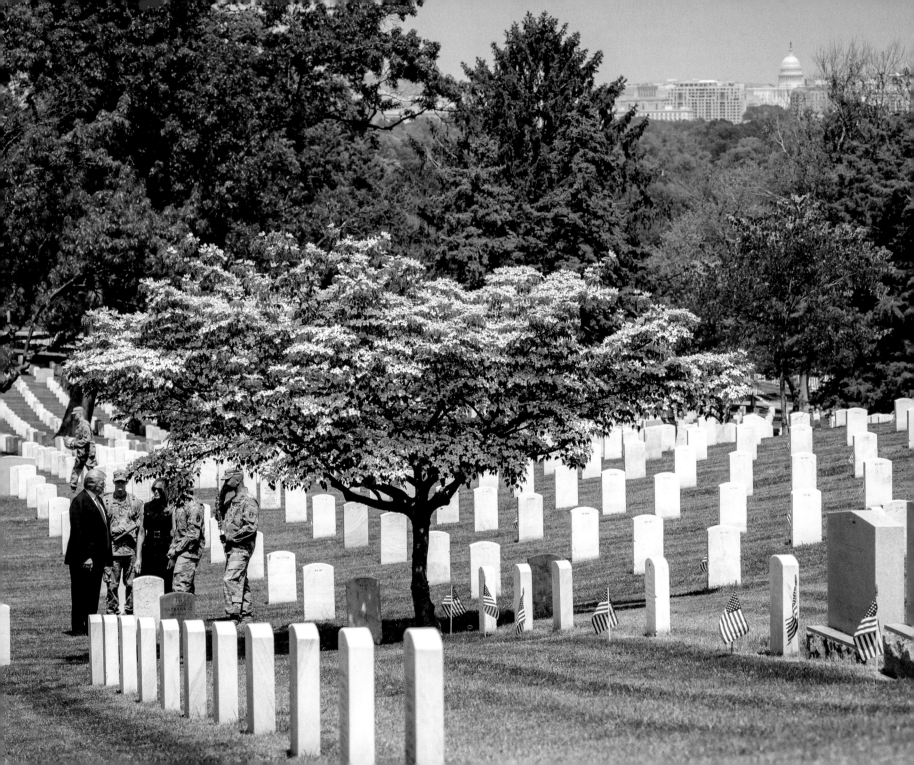

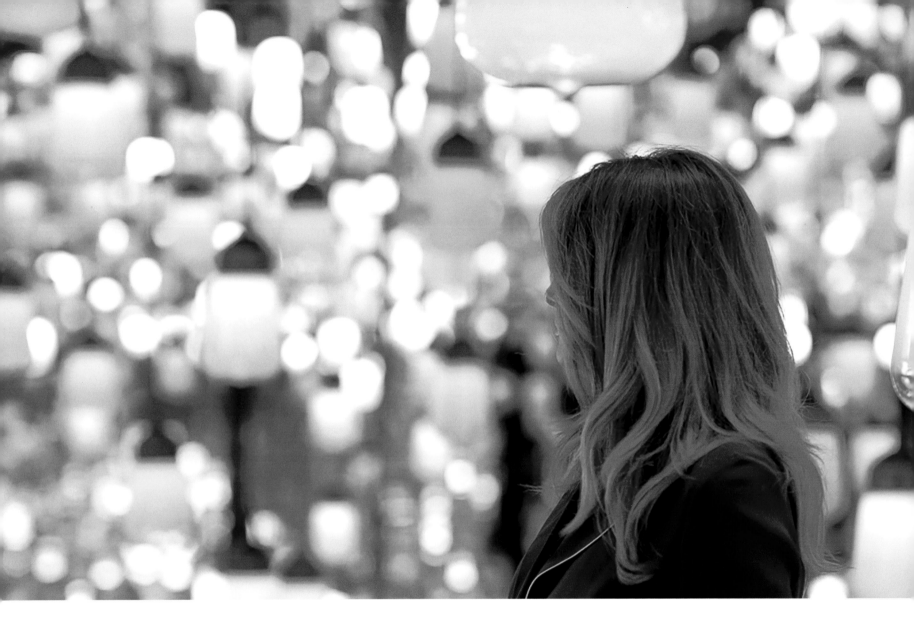

May 25, 2019: First Lady Melania Trump at the Mori
Building Digital Art Museum in Tokyo. (Andrea Hanks)

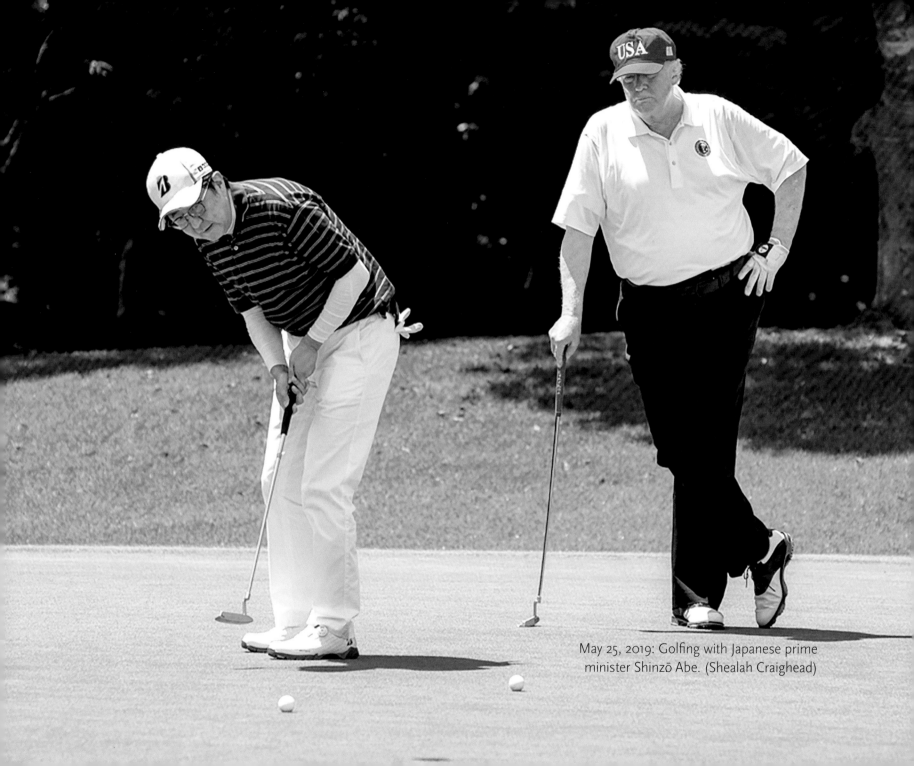

May 25, 2019: Golfing with Japanese prime minister Shinzō Abe. (Shealah Craighead)

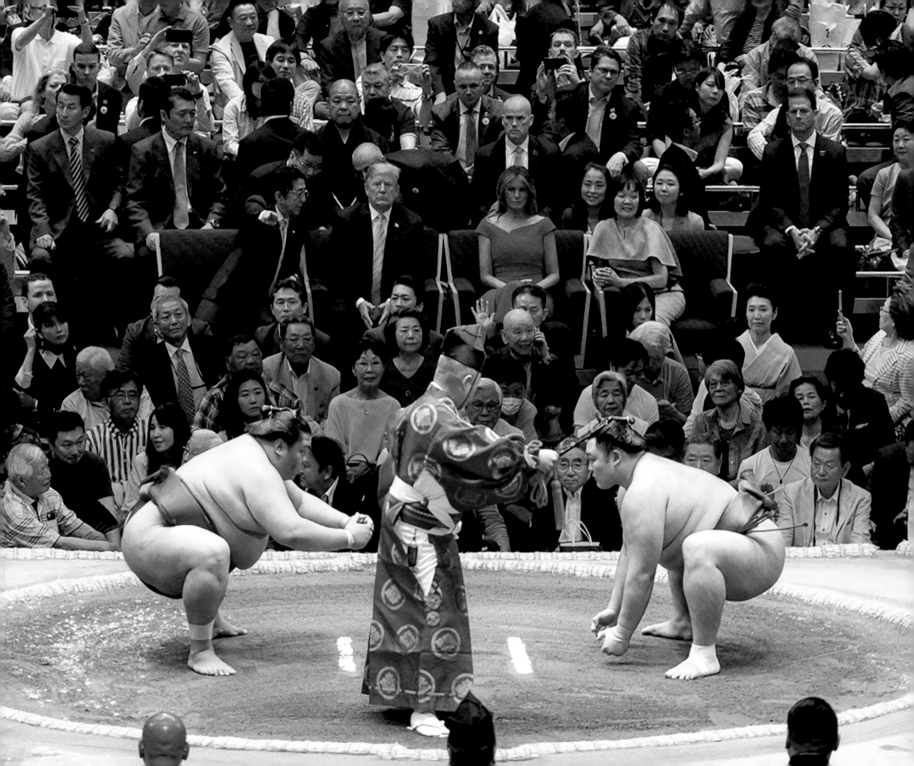

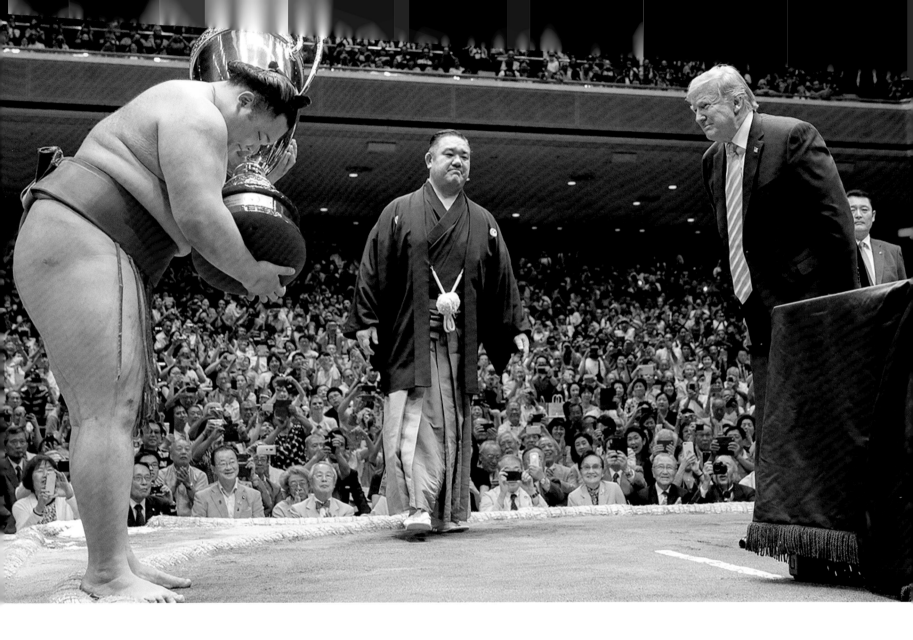

May 26, 2019: Attending a sumo tournament at the
Ryōgoku Kokugikan Stadium in Tokyo. (Andrea Hanks)

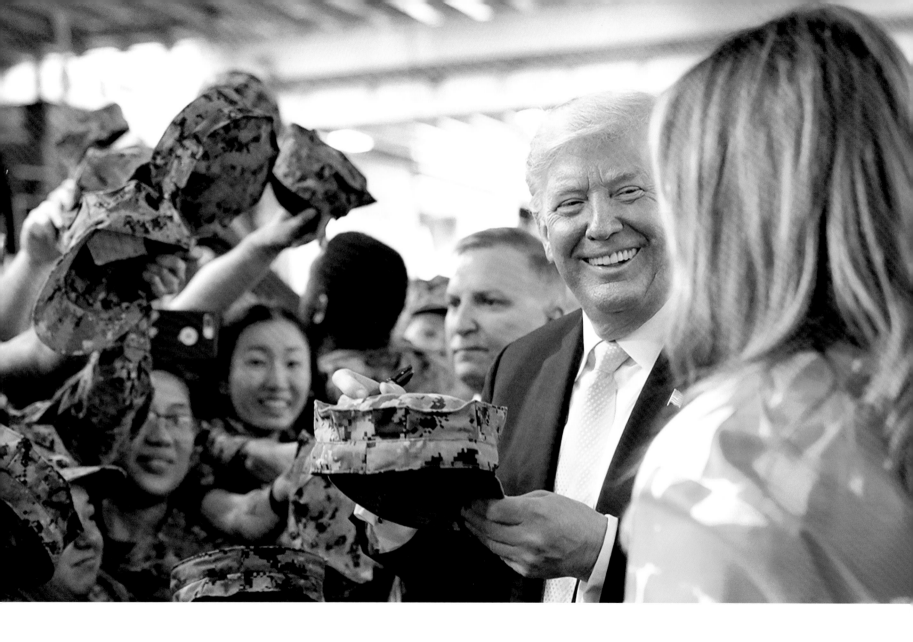

May 27, 2019: With First Lady Melania Trump aboard
the USS *Wasp* in Yokosuka, Japan. (Andrea Hanks)

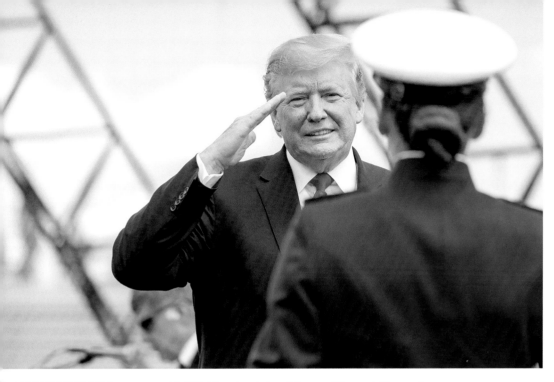

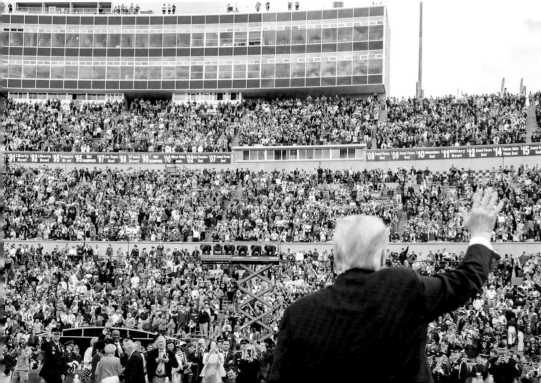

May 30, 2019: At the 2019 U.S. Air Force Graduation Ceremony in Colorado Springs. (Shealah Craighead)

The heroes and legends of every generation have always had to confront new perils and defeat new dangers. No one can foresee all of the challenges this class will face, but we do know that, with absolute certainty, you are going to be ready to serve. You are going to be ready to lead. You are going to be aiming at the absolute highest point. And you are ready to "Fly, Fight, and Win." Always win.

—From the President's remarks at the 2019 United States Air Force Academy Graduation Ceremony in Colorado Springs, Colorado, May 30, 2019

May 30, 2019: The 2019 U.S. Air Force Graduation Ceremony in Colorado Springs. (Shealah Craighead)

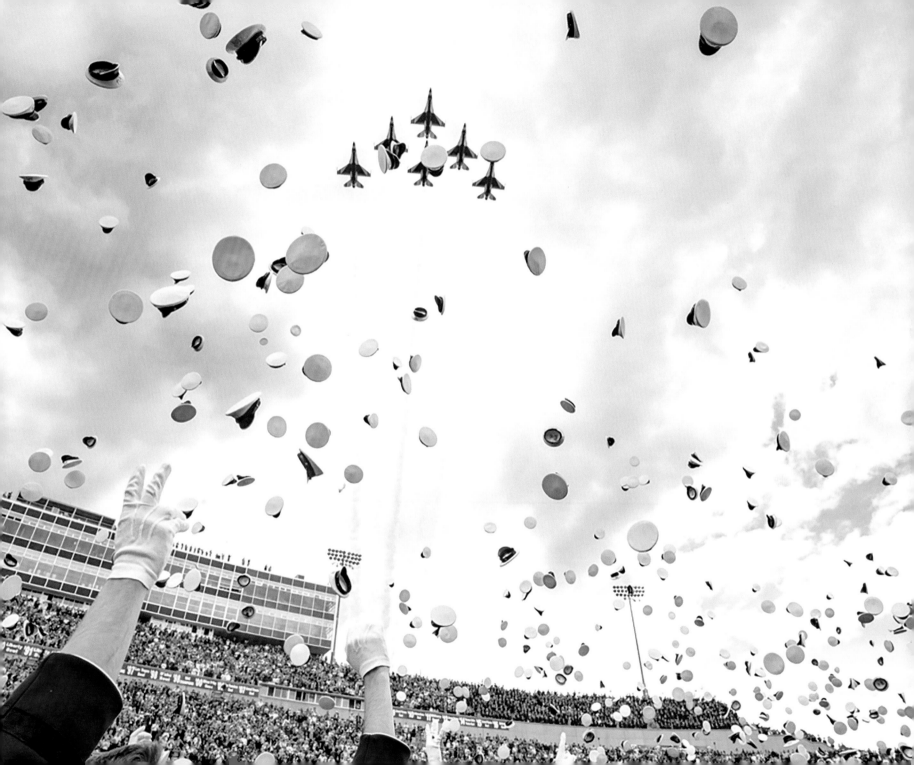

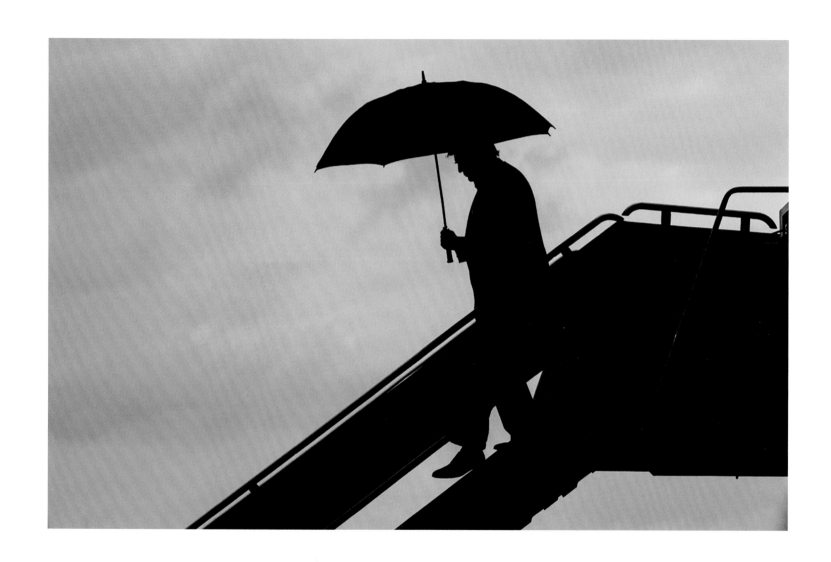

May 30, 2019: Disembarking Air Force One during a rain shower
at Joint Base Andrews, Maryland. (Shealah Craighead)

June 2, 2019: Departing for Europe on Air Force One. (Shealah Craighead)

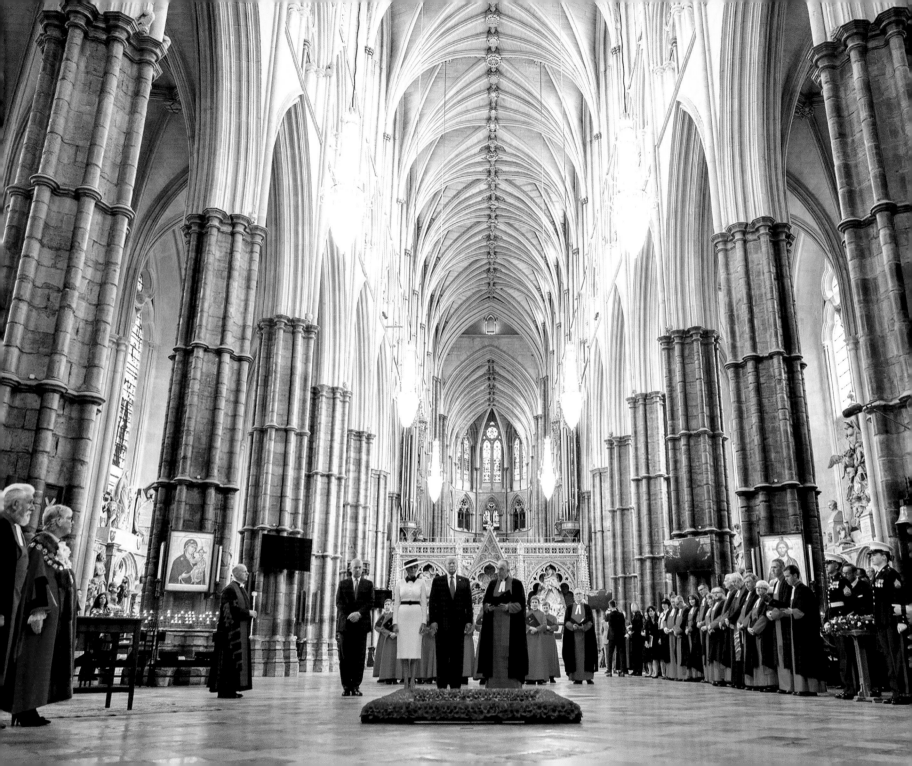

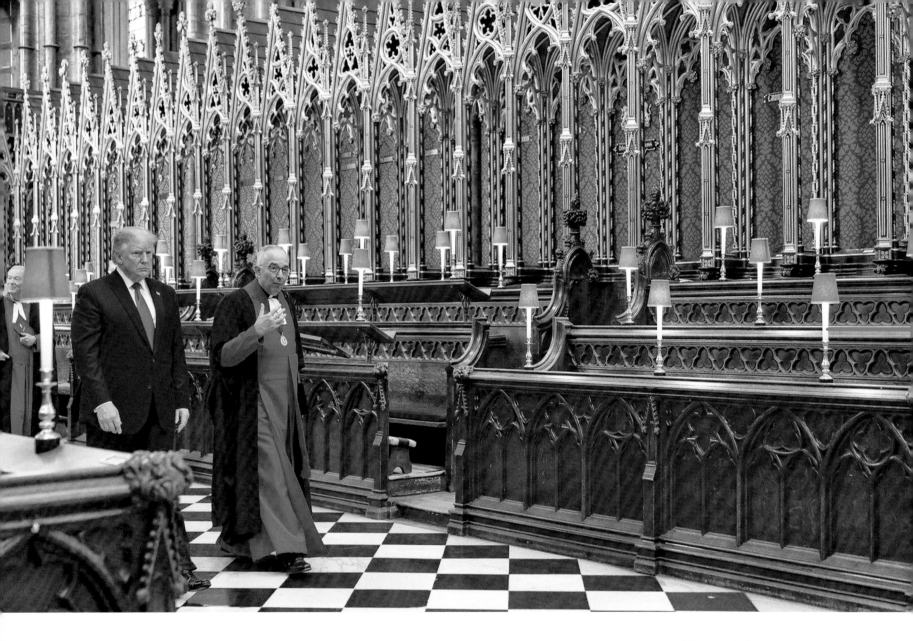

June 3, 2019: Touring Westminster Abbey, including a visit to the Tomb of the Unknown Warrior. (Shealah Craighead)

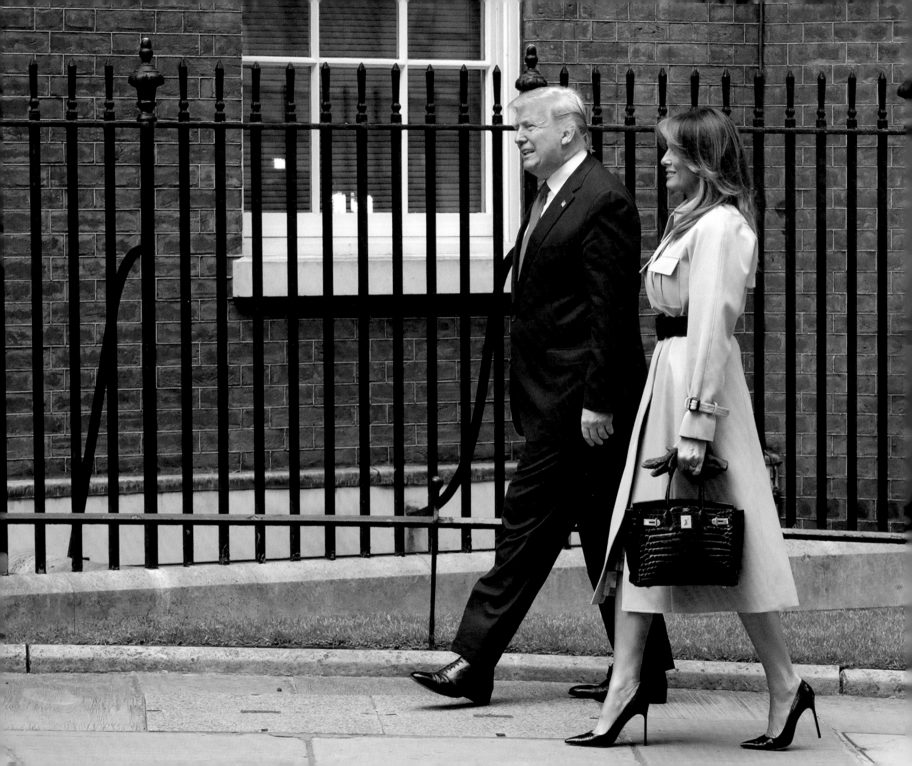

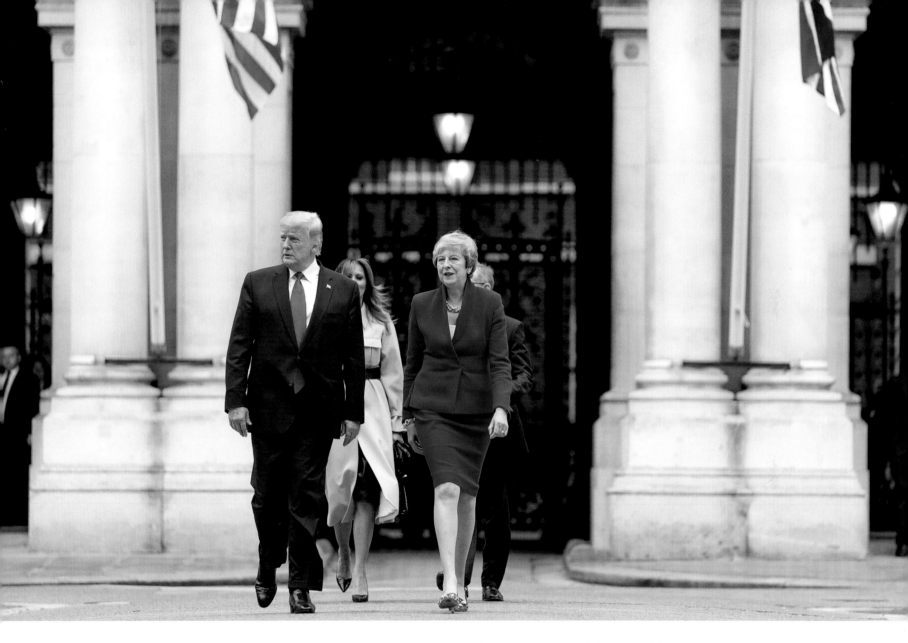

June 4, 2019: Visiting the prime minister's residence at 10 Downing Street.
(Opposite photo by Andrea Hanks, above photo by Shealah Craighead)

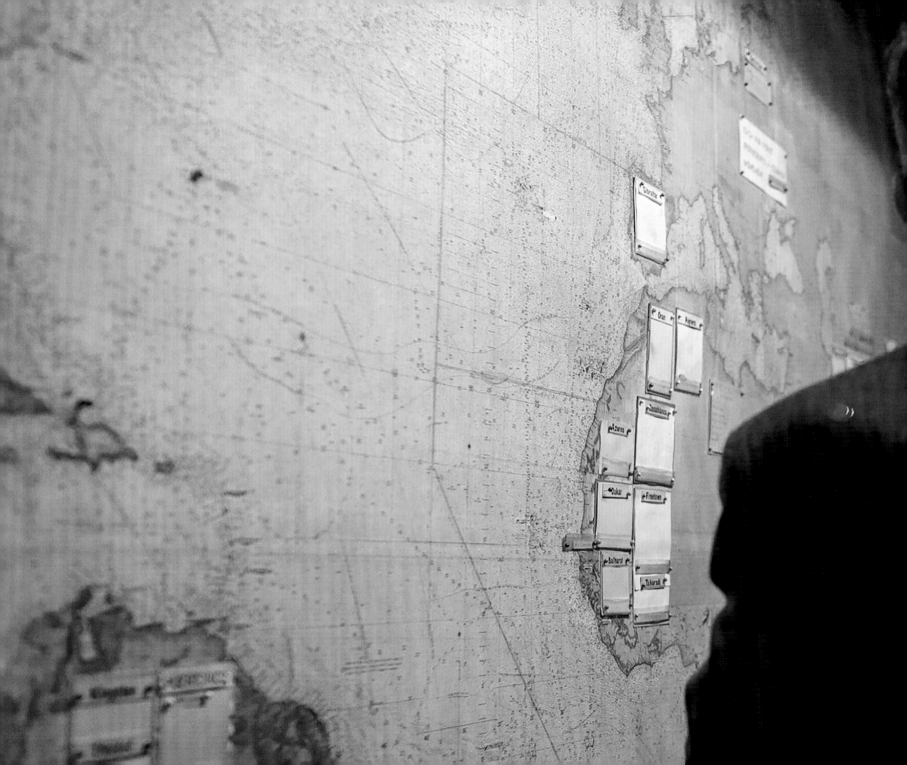

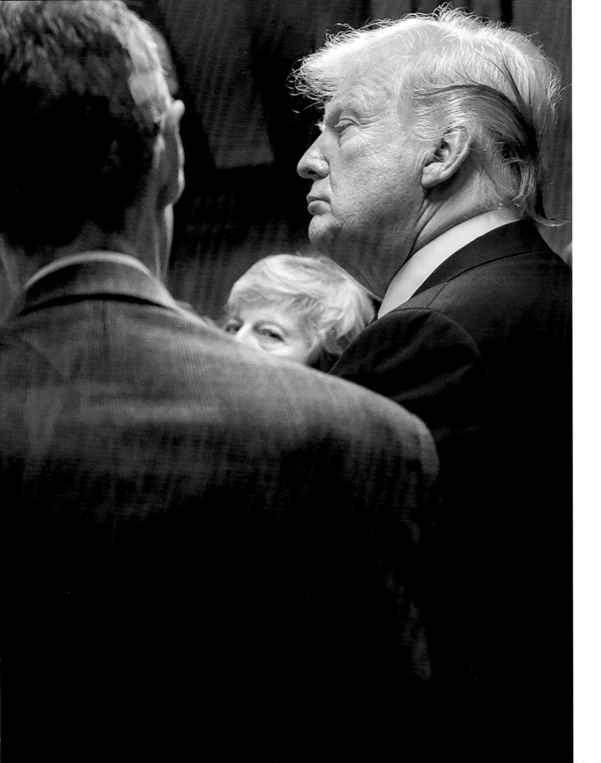

June 4, 2019: Touring the Churchill
War Rooms. (Shealah Craighead)

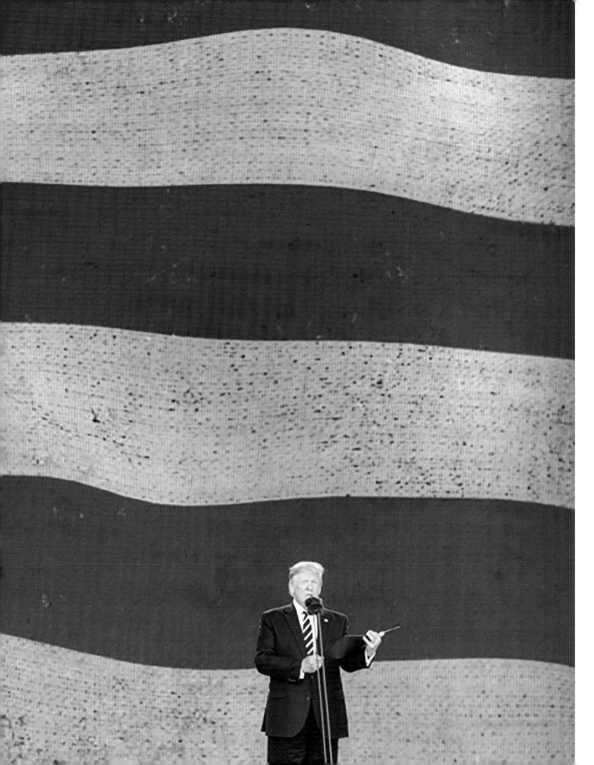

June 5, 2019: Speaking during a D-Day
National Commemorative
Event in Portsmouth, England.
(Shealah Craighead)

Seven decades ago, the warriors of D-Day fought a sinister enemy who spoke of a thousand-year empire. In defeating that evil, they left a legacy that will last not only for a thousand years, but for all time—for as long as the soul knows of duty and honor; for as long as freedom keeps its hold on the human heart.

To the men who sit behind me, and to the boys who rest in the field before me, your example will never, ever grow old. Your legend will never tire. Your spirit—brave, unyielding, and true—will never die.

—From the President's remarks on the 75th Commemoration of D-Day, June 6, 2019

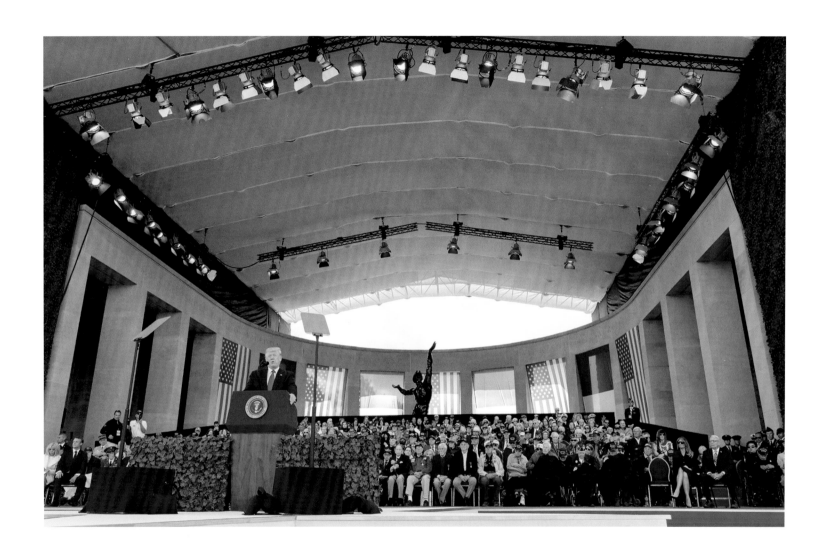

June 6, 2019: At the Normandy American Cemetery to commemorate the 75th anniversary of D-Day. (Andrea Hanks)

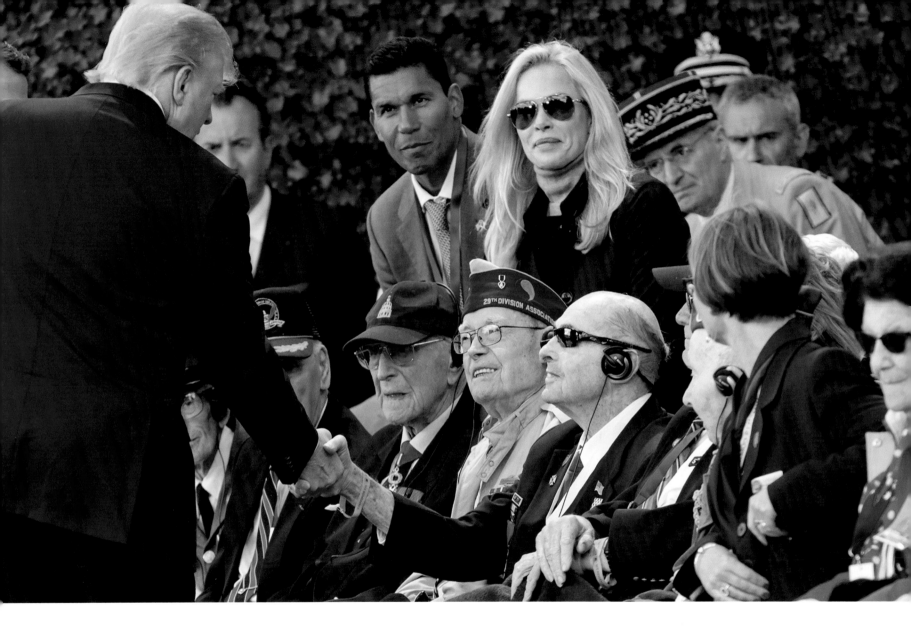

June 6, 2019: Greeting D-Day veteran Ray Lambert at
the Normandy American Cemetery. (Andrea Hanks)

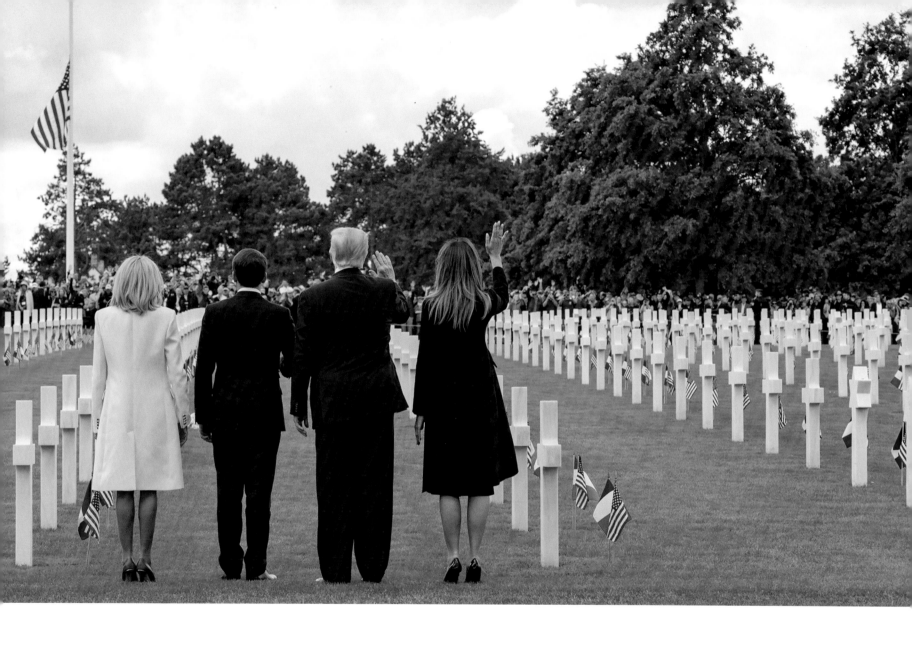

June 6, 2019: At the Normandy American Cemetery. (Andrea Hanks)

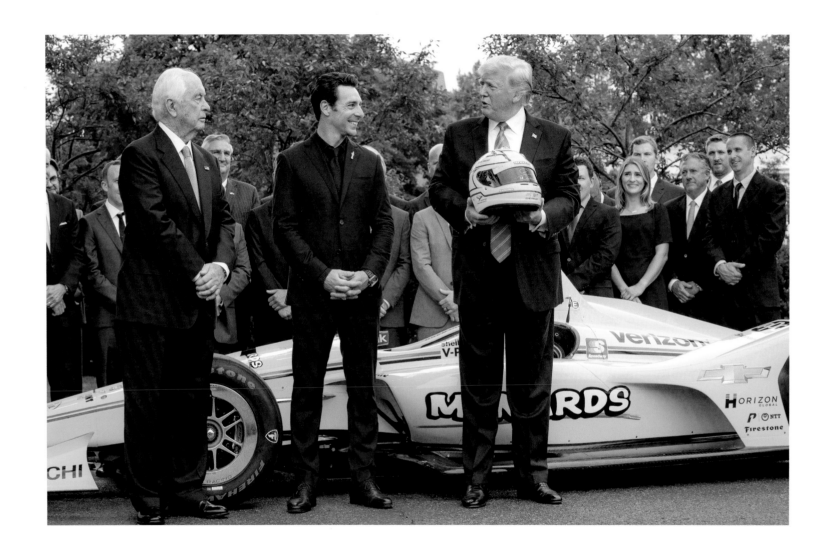

June 10, 2019: Honoring race car driver Simon Pagenaud and Team Penske
owner Roger Penske, winners of the 103rd Indianapolis 500. (Tia Dufour)

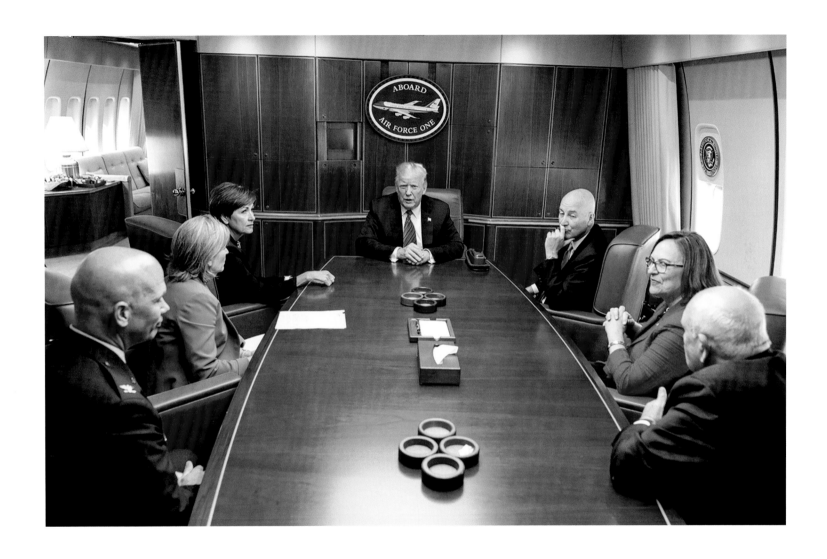

June 11, 2019: A briefing aboard Air Force One on the devastating flooding of communities along the Missouri River. (Shealah Craighead)

June 11, 2019: Military personnel and family members await the President's arrival in Des Moines, Iowa. (Shealah Craighead)

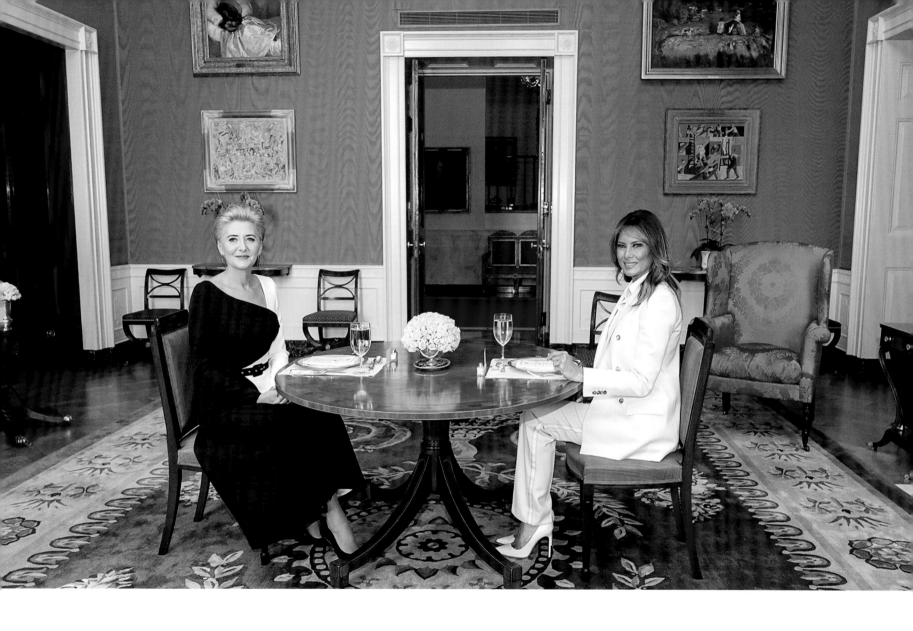

June 12, 2019: The First Lady has lunch with Mrs. Agata Kornhauser-Duda, wife of Polish president Andrzej Duda, in the Green Room of the White House. (Andrea Hanks)

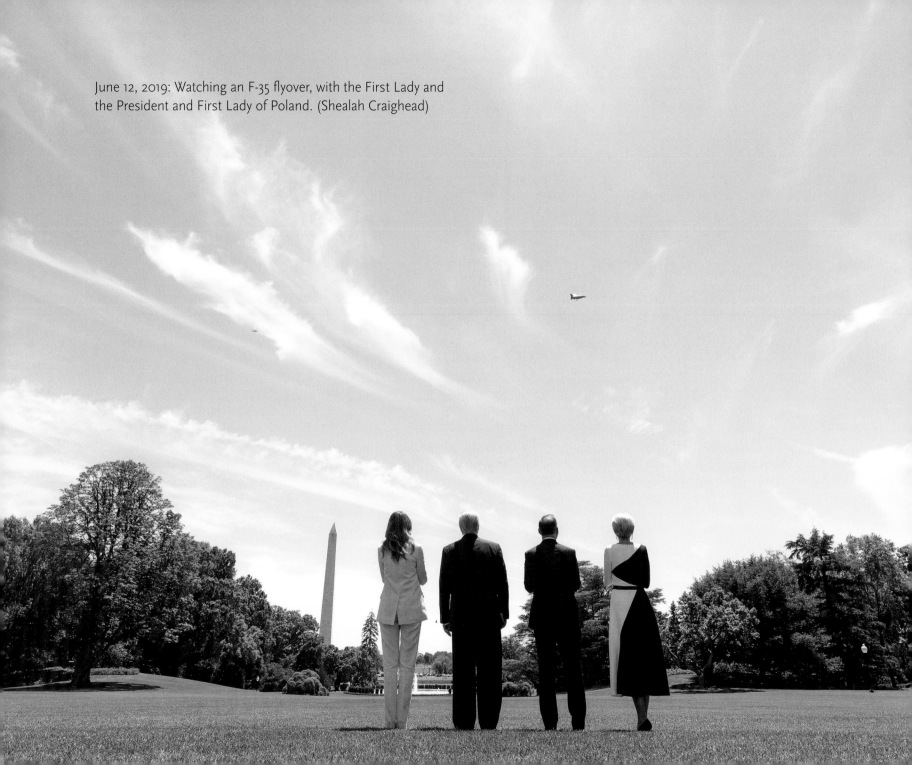

June 12, 2019: Watching an F-35 flyover, with the First Lady and the President and First Lady of Poland. (Shealah Craighead)

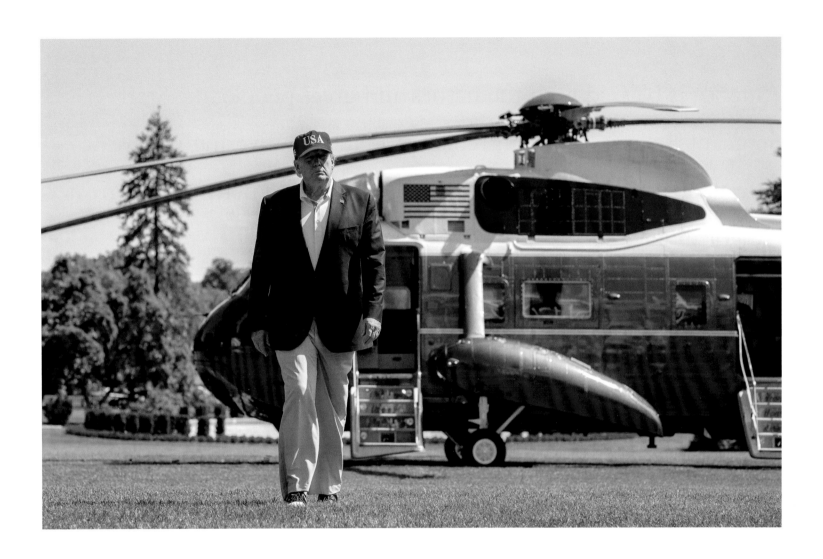

June 23, 2019: Returning to the White House after
a working retreat at Camp David. (Tia Dufour)

America is blessed with the heroes and great people like Staff Sergeant Bellavia whose intrepid spirit and unwavering resolve defeats our enemies, protects our freedoms, and defends our great American flag.

David, today we honor your extraordinary courage, we salute your selfless service, and we thank you for carrying on the legacy of American valor that has always made our blessed nation the strongest and mightiest anywhere in the world.

—From the President's remarks at the presentation of the Congressional Medal of Honor to Staff Sergeant David Bellavia of the U.S. Army, June 25, 2019

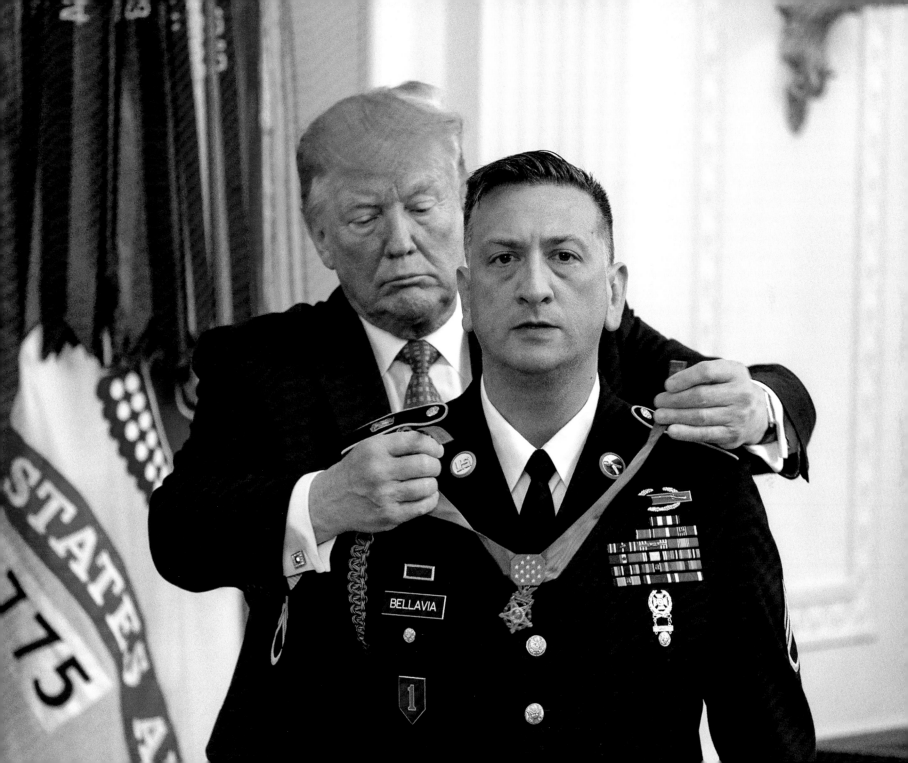

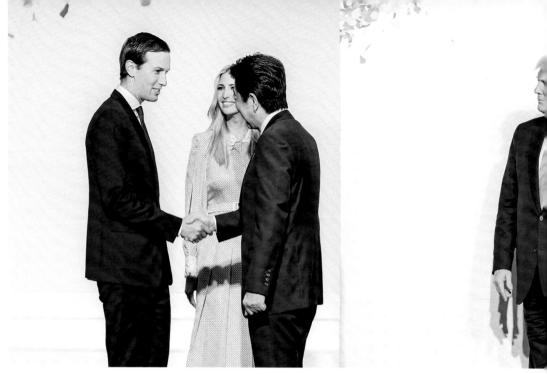

June 27, 2019: With Ivanka Trump and Jared Kushner, being welcomed by Japanese prime minister Shinzō Abe to the G20 Japan Summit. (Shealah Craighead)

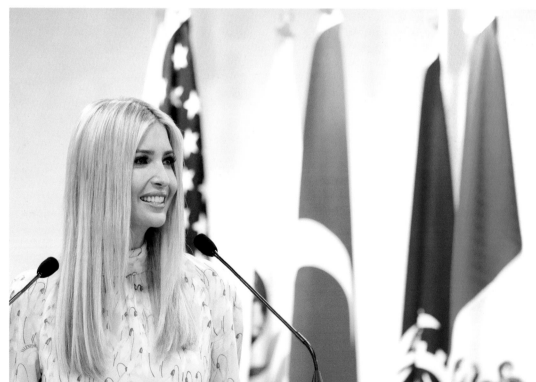

June 29, 2019: Ivanka Trump addresses the G20 Women's Empowerment Event in Osaka, Japan. (Shealah Craighead)

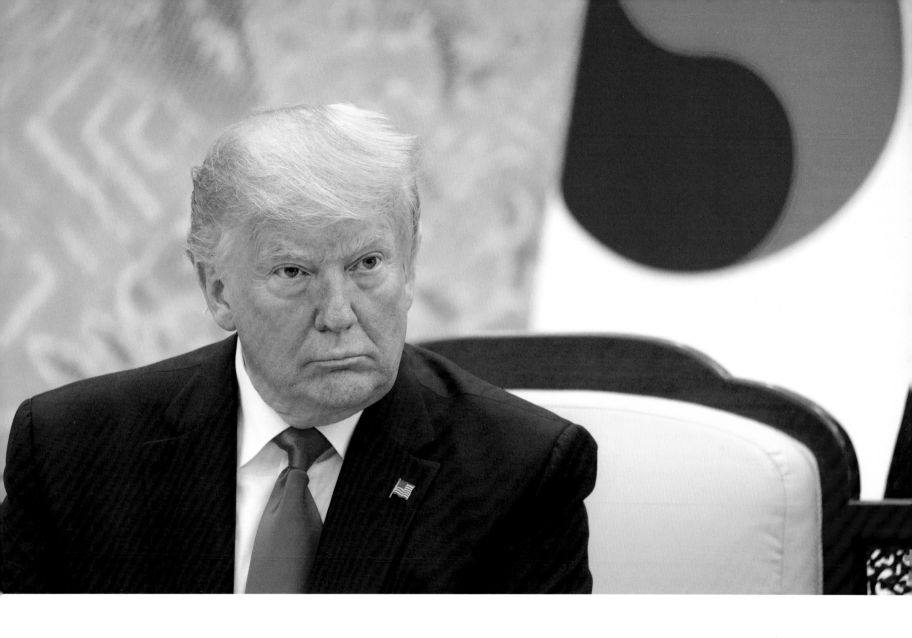

June 29, 2019: Attending a bilateral meeting
in Seoul, South Korea. (Shealah Craighead)

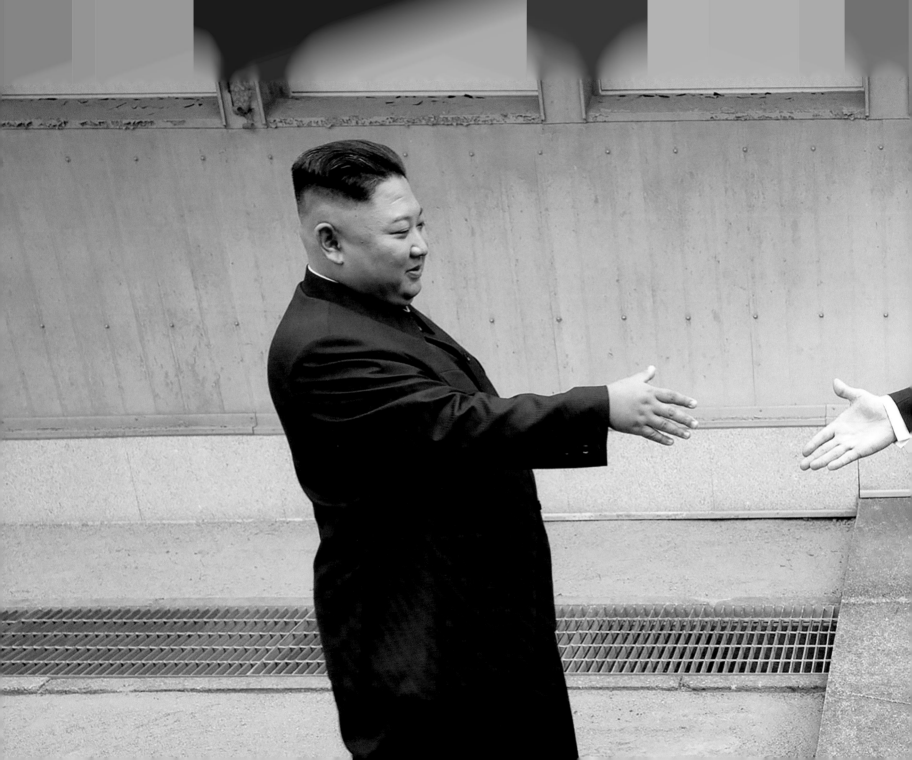

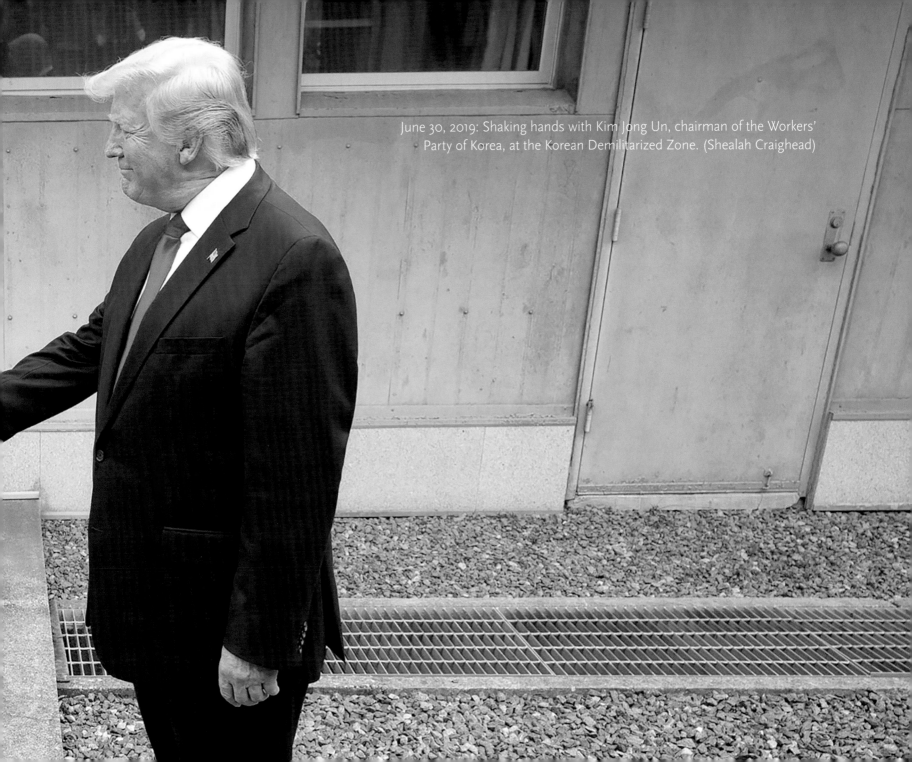

June 30, 2019: Shaking hands with Kim Jong Un, chairman of the Workers' Party of Korea, at the Korean Demilitarized Zone. (Shealah Craighead)

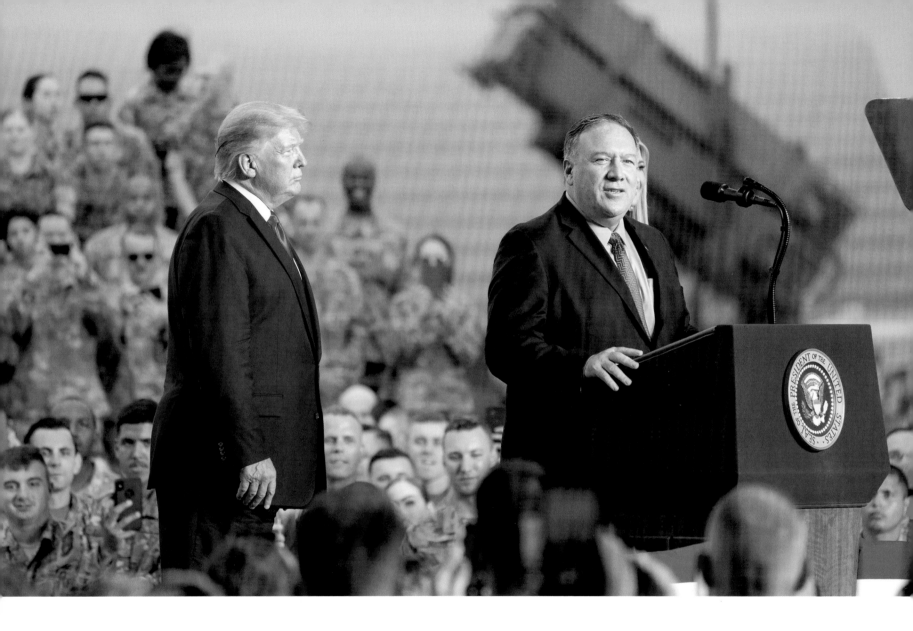

June 30, 2019: Secretary of State Mike Pompeo speaks to military personnel and their families at Osan Air Base in South Korea. (Shealah Craighead)

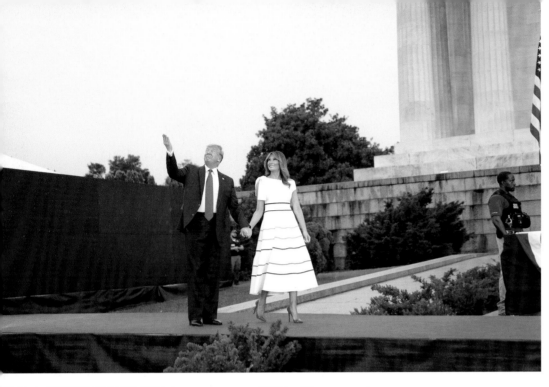

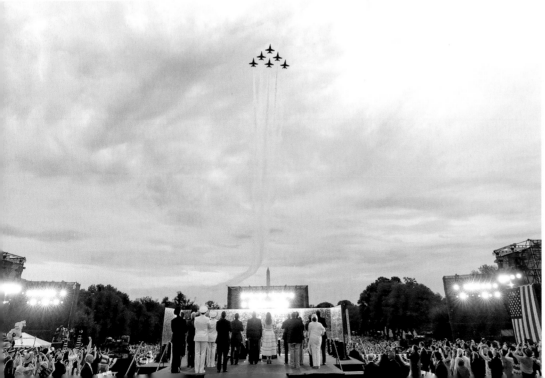

July 4, 2019: The Salute to America event at the Lincoln Memorial in Washington. (Above photo by Shealah Craighead, left photo by Andrea Hanks)

The ideals and values of the American Revolution gave birth to a just and virtuous republic that has both fostered and been sustained by a people animated by courage, faith, and love. Countless contributions from statesmen, businessmen, philanthropists, educators, and other Americans from coast to coast have shaped our communities and inspired generation after generation to preserve and advance liberty, equality, and the American dream.

In 1815, reflecting on the character of America, Thomas Jefferson wrote to his friend—and hero of the Revolutionary War—Major General Marquis de Lafayette: "The cement of this union is in the heart blood of every American." These words are still true today, as the unmatched patriotism of Americans continues to bind us as a Nation.

—*Presidential message on the 243rd anniversary of the adoption of the Declaration of Independence, July 4, 2019*

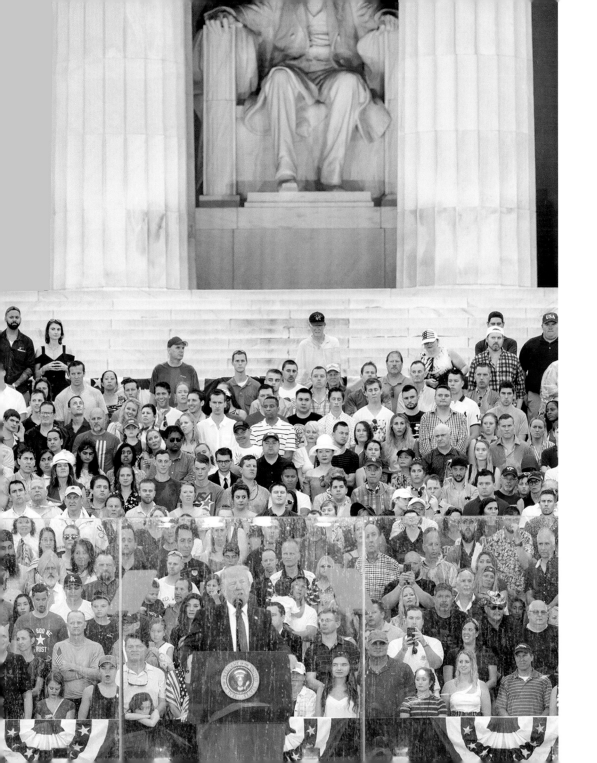

July 4, 2019: The Salute to America event at the Lincoln Memorial in Washington. (Randy Florendo)

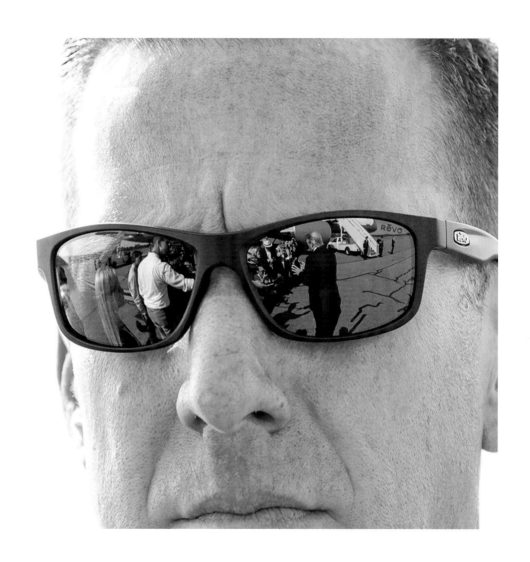

July 7, 2019: The President is seen reflected in the sunglasses of a member of his security detail as he speaks to reporters prior to boarding Air Force One. (Shealah Craighead)

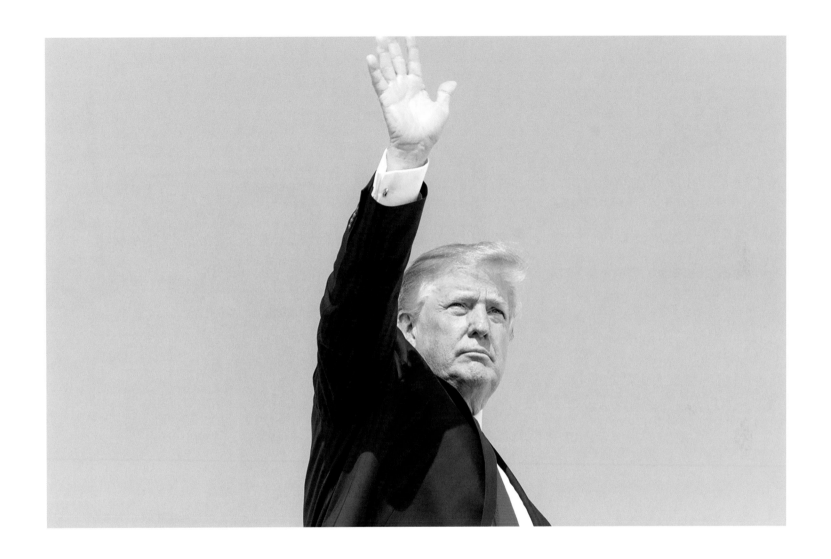

July 7, 2019: Waving at the Morristown Municipal Airport
in Morristown, New Jersey. (Shealah Craighead)

July 15, 2019: The Made in America Product Showcase, on the South Lawn of the White House. (Shealah Craighead)

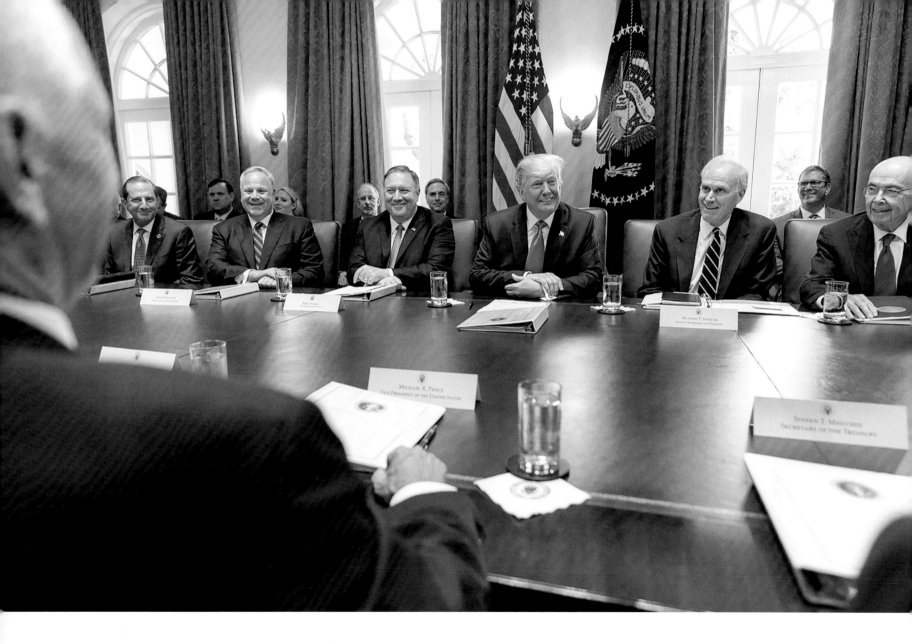

July 16, 2019: A Cabinet meeting at the
White House. (Shealah Craighead)

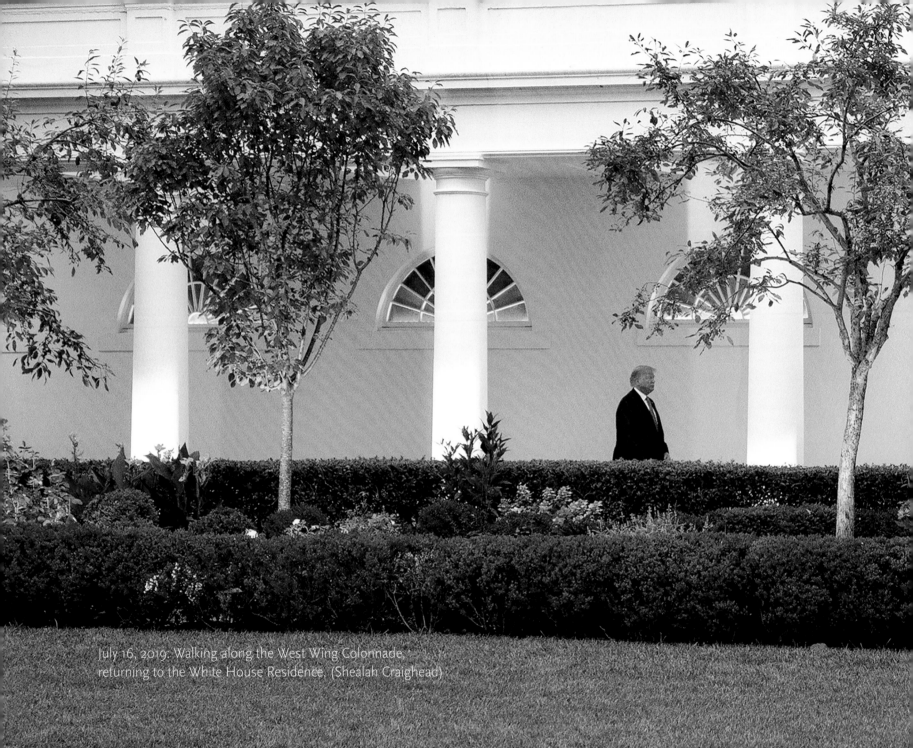

July 16, 2019: Walking along the West Wing Colonnade, returning to the White House Residence. (Shealah Craighead)

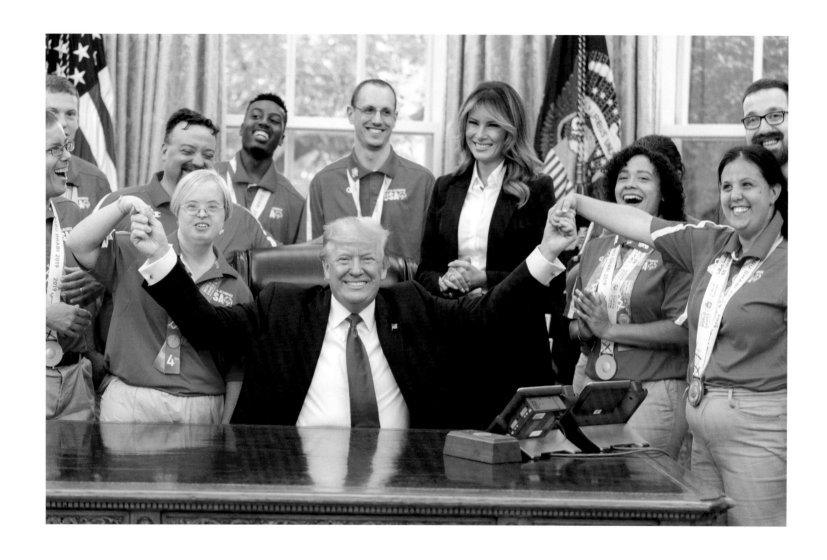

July 18, 2019: The President and First Lady meet with members of Team USA
from the 2019 Special Olympics World Games. (Shealah Craighead)

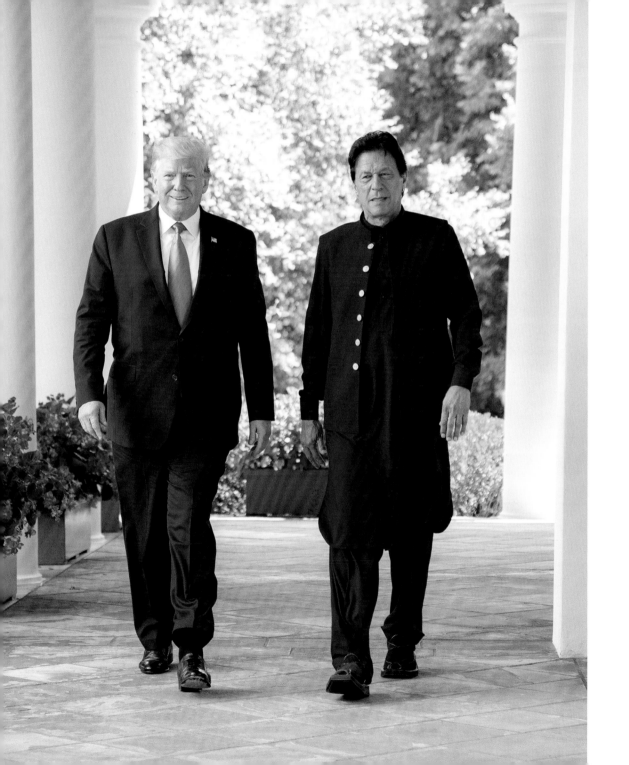

July 22, 2019: Walking with Prime Minister Imran Khan of Pakistan. (Shealah Craighead)

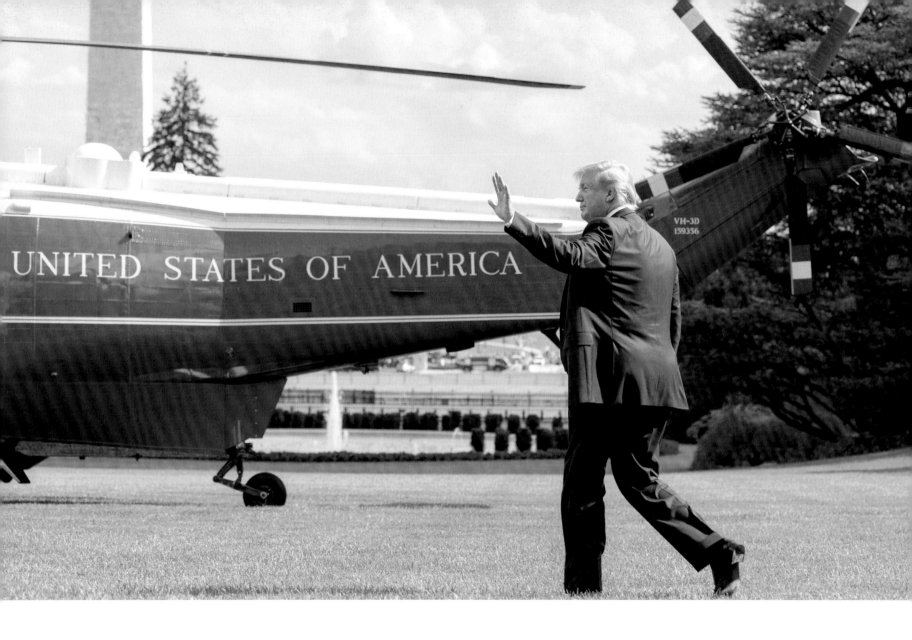

July 24, 2019: Departing from the South Lawn of
the White House for West Virginia. (India Garrish)

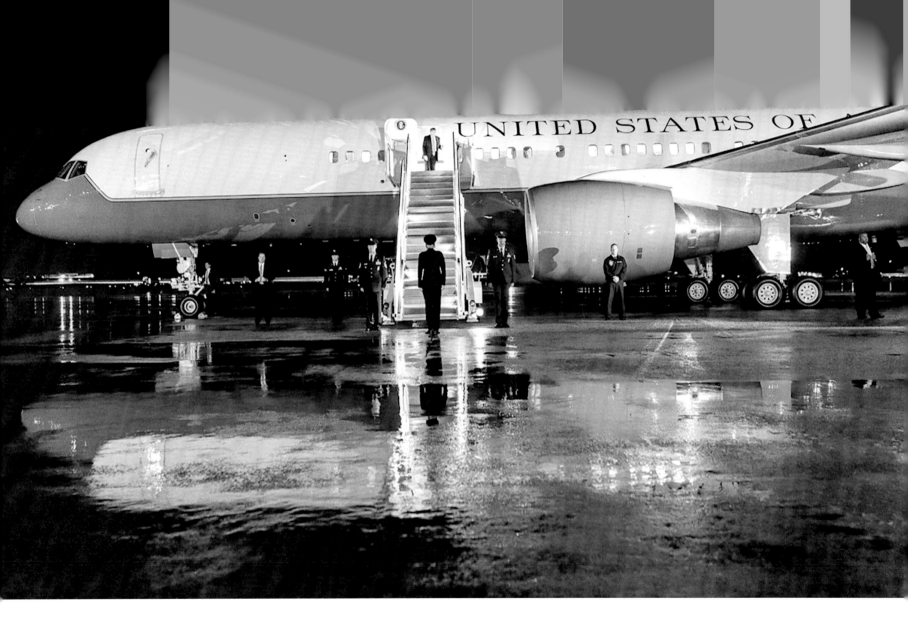

July 24, 2019: Returning from a visit to Wheeling, West Virginia. (Shealah Craighead)

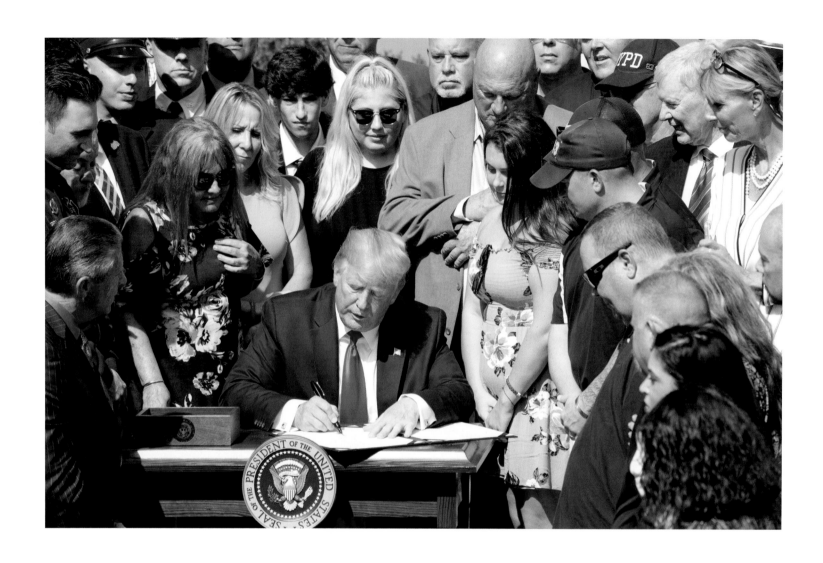

July 29, 2019: In the Rose Garden, signing H.R. 1327, which permanently authorized the September 11th Victim Compensation Fund. (Joyce N. Boghosian)

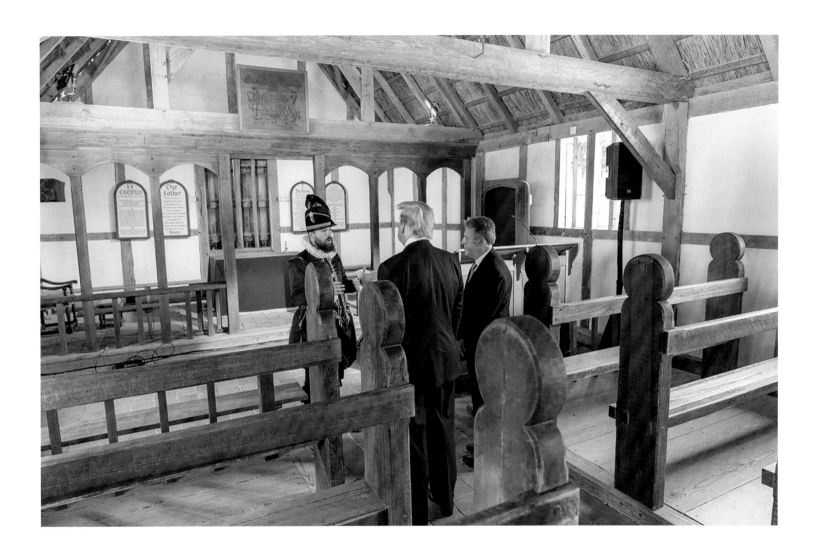

July 30, 2019: Touring the James Fort Replica
at Jamestown. (Shealah Craighead)

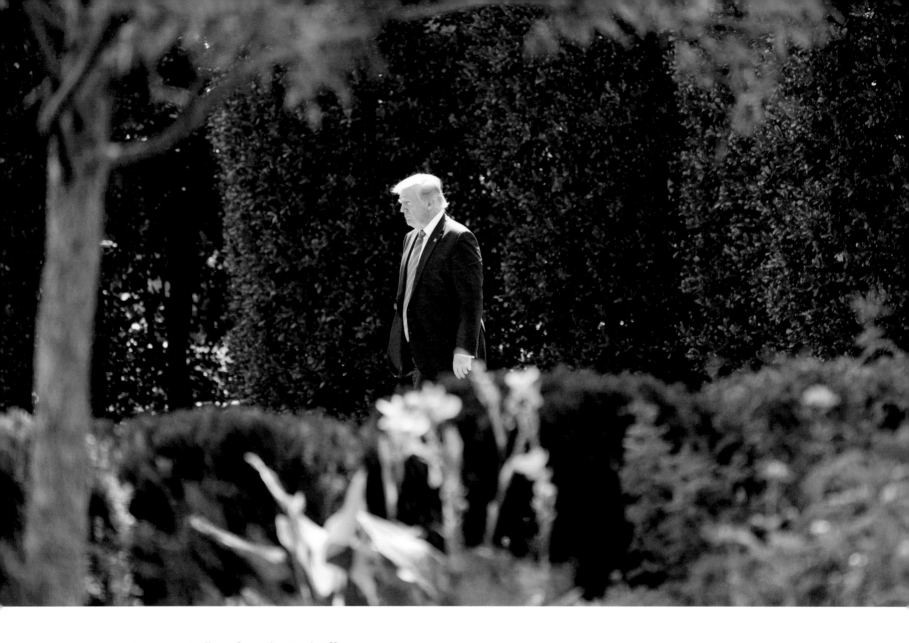

August 2, 2019: Walking from the Oval Office
to the South Lawn. (Joyce N. Boghosian)

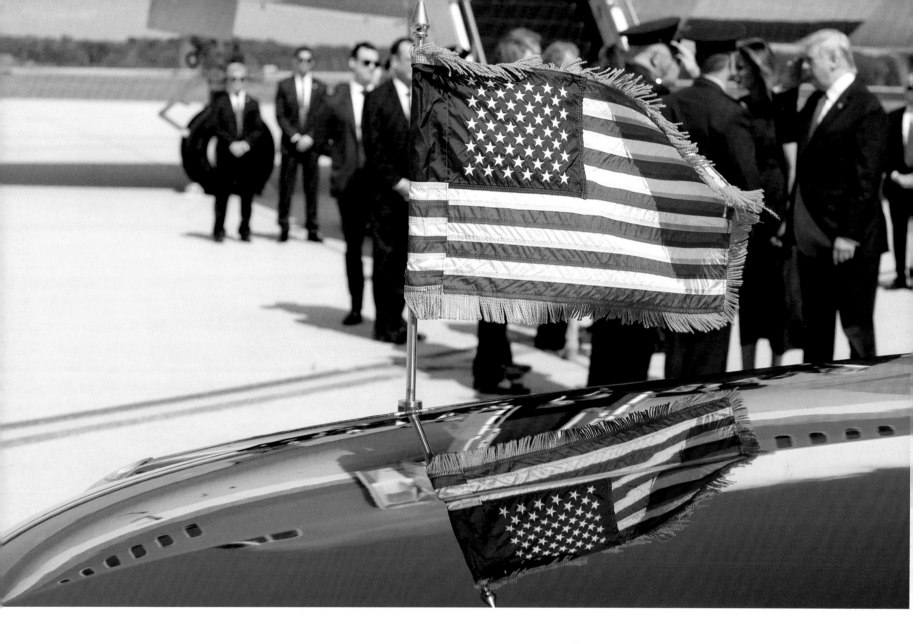

August 7, 2019: Arriving at Wright-Patterson
Air Force Base in Ohio. (Andrea Hanks)

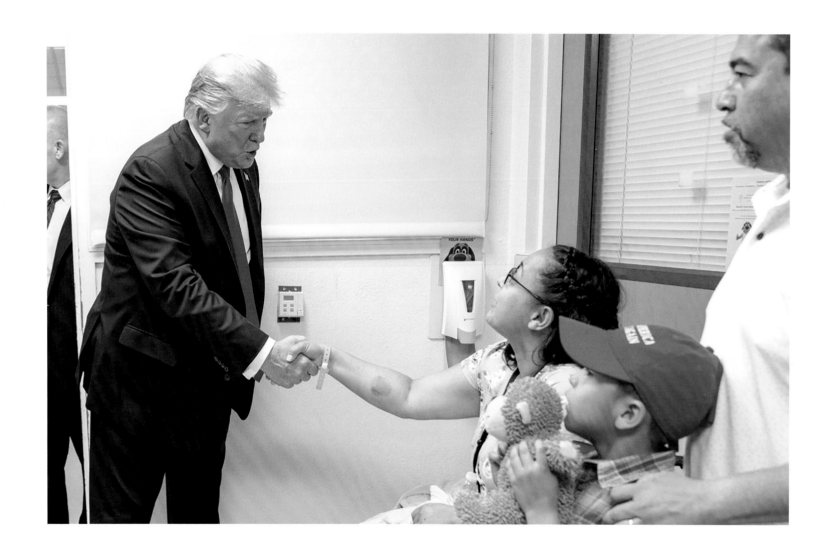

August 7, 2019: Visiting with a shooting victim
in El Paso, Texas. (Shealah Craighead)

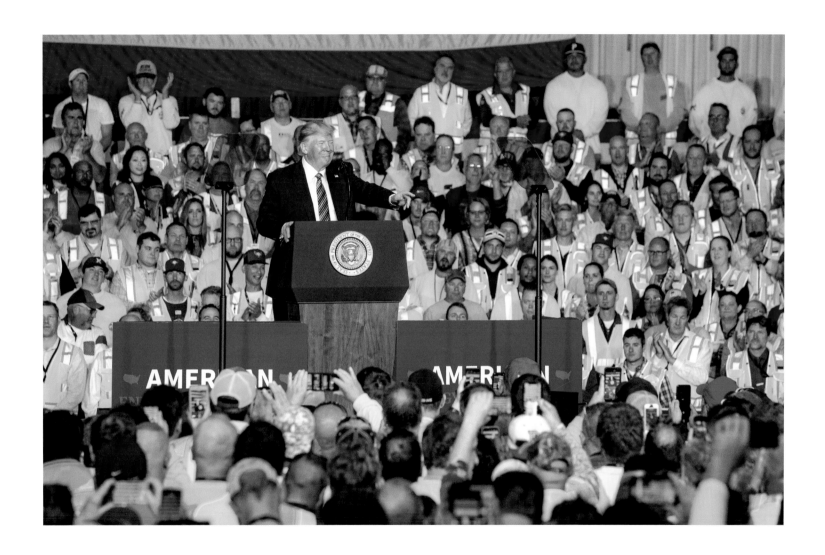

August 13, 2019: Speaking at America's Energy Dominance and
Manufacturing Revival in Monaca, Pennsylvania. (Tia Dufour)

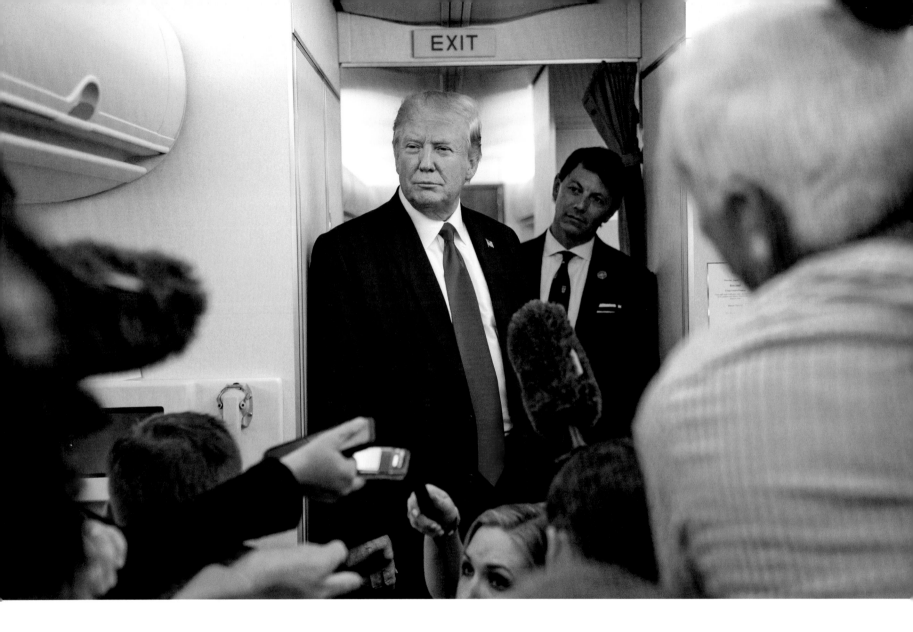

August 15, 2019: Talking to the press aboard
Air Force One. (Joyce N. Boghosian)

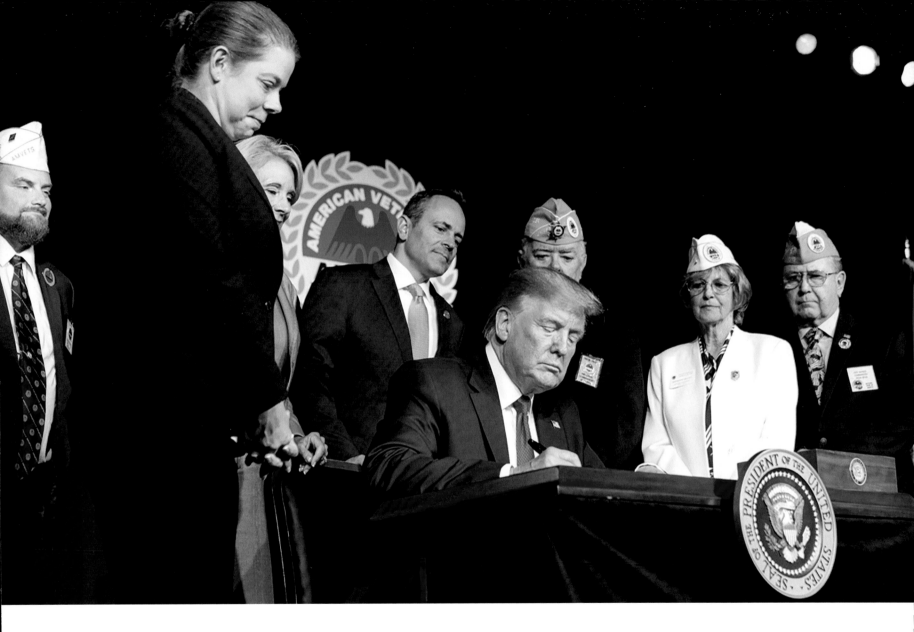

August 21, 2019: At the American Veterans 75th National Convention, signing a Presidential Memorandum on discharging the Federal Student Loan Debt of Totally and Permanently Disabled Veterans. (Shealah Craighead)

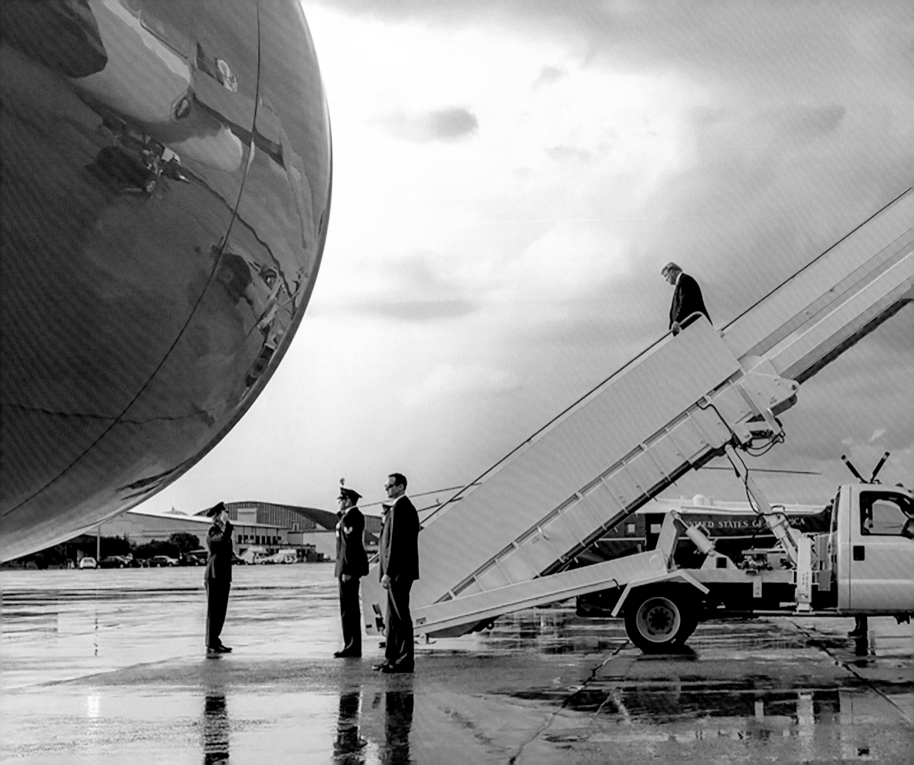

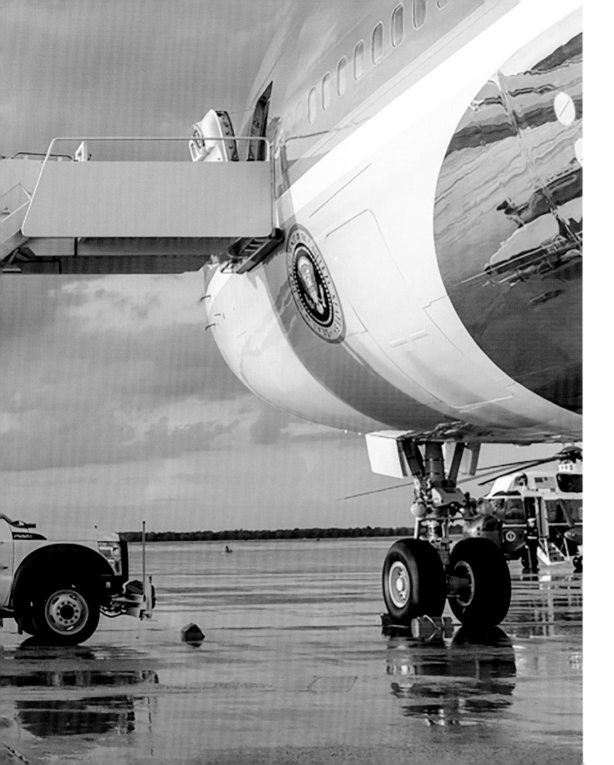

August 21, 2019: Disembarking
Air Force One at Joint Base
Andrews. (Shealah Craighead)

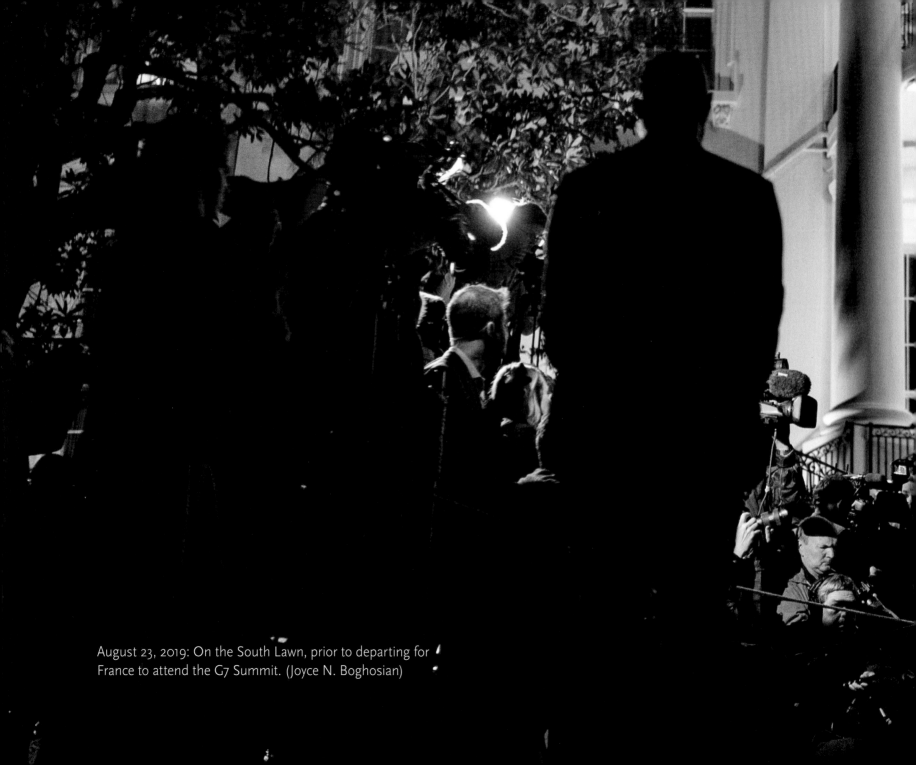

August 23, 2019: On the South Lawn, prior to departing for France to attend the G7 Summit. (Joyce N. Boghosian)

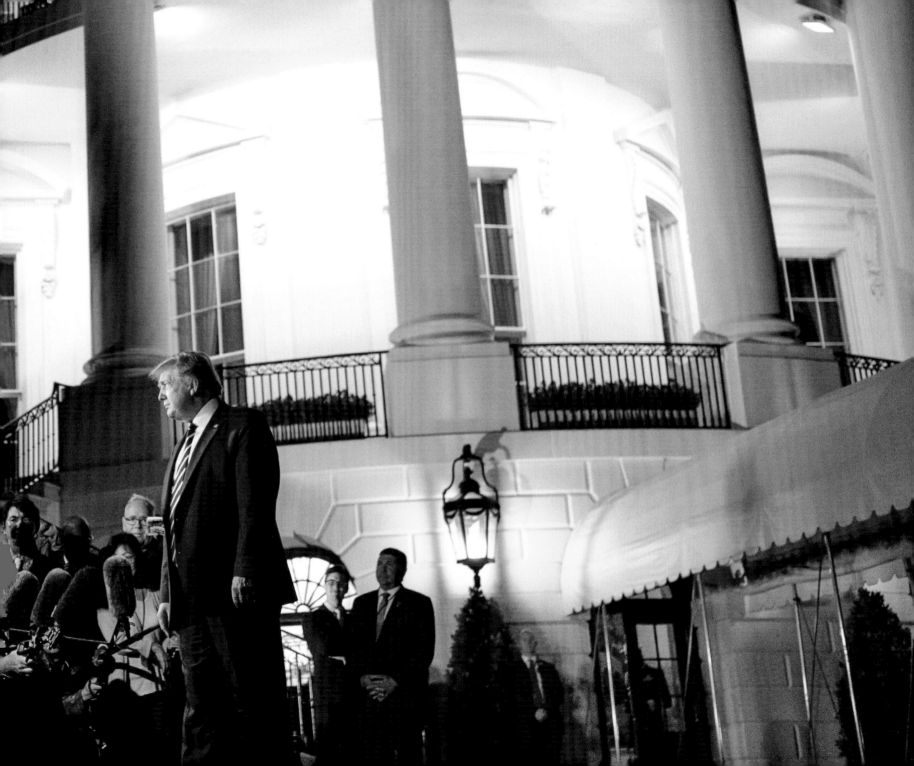

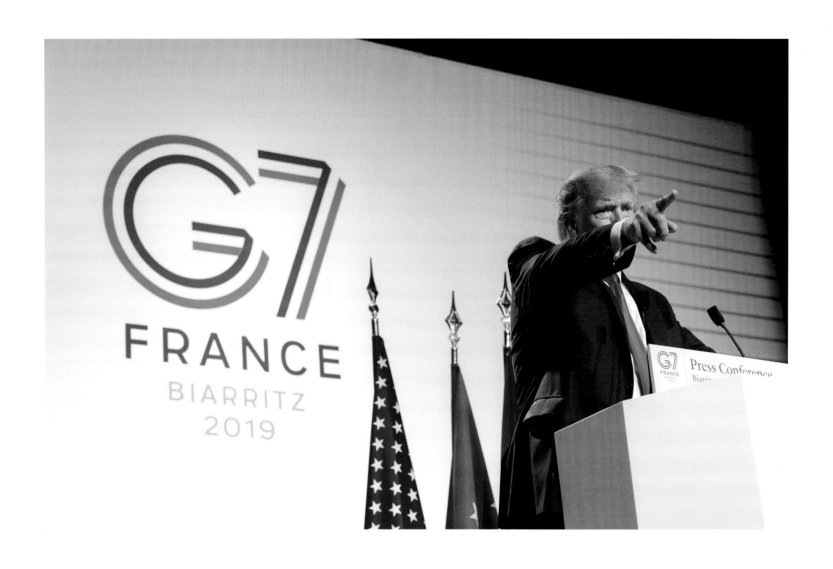

August 26, 2019: In Biarritz, France, at
the G7 Summit. (Andrea Hanks)

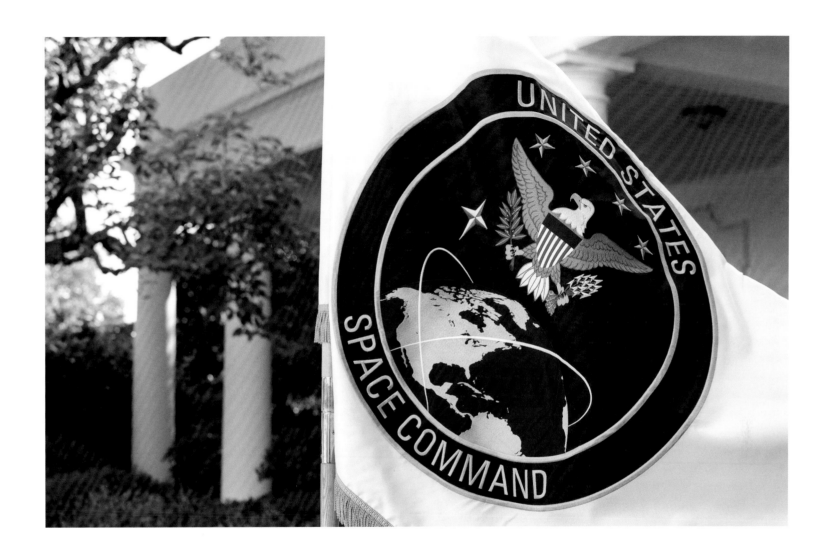

August 29, 2019: The flag of the U.S. Space Command
is unfurled in the Rose Garden. (Tia Dufour)

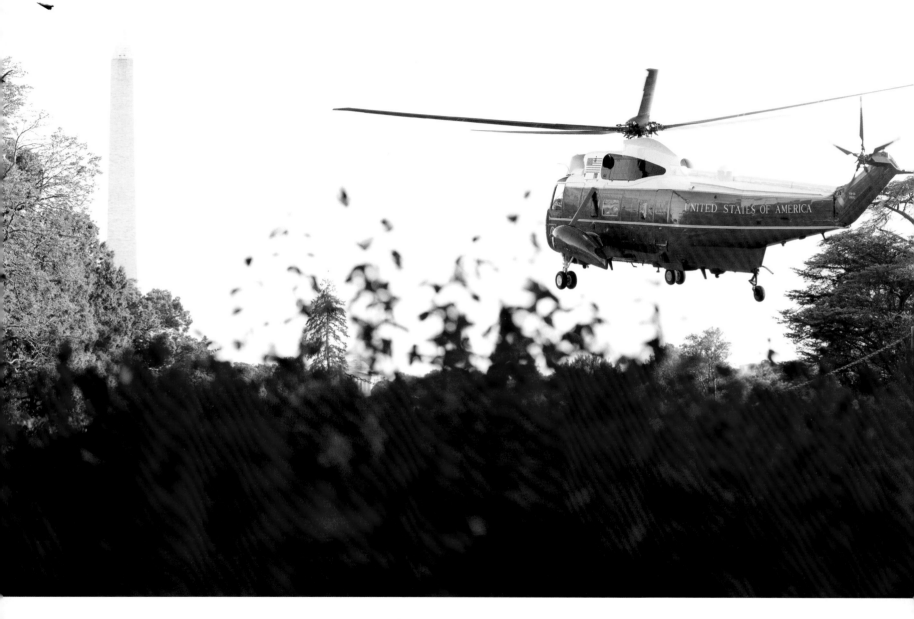

August 30, 2019: Marine One en route to Camp David.
(Above photo by Joyce N. Baghosian, opposite photo by Shealah Craighead)

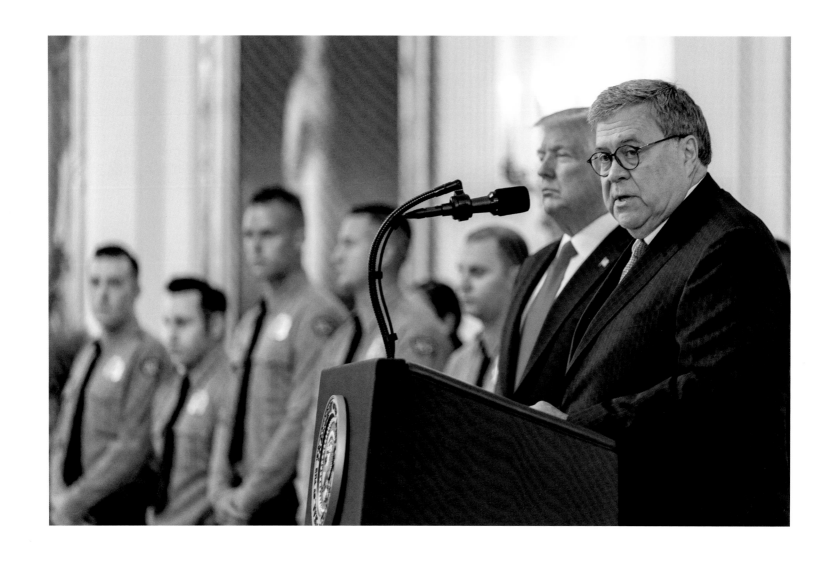

September 9, 2019: Attorney General William Barr delivers remarks at a Medal of Valor and Heroic Commendations Ceremony in the East Room of the White House. (Shealah Craighead)

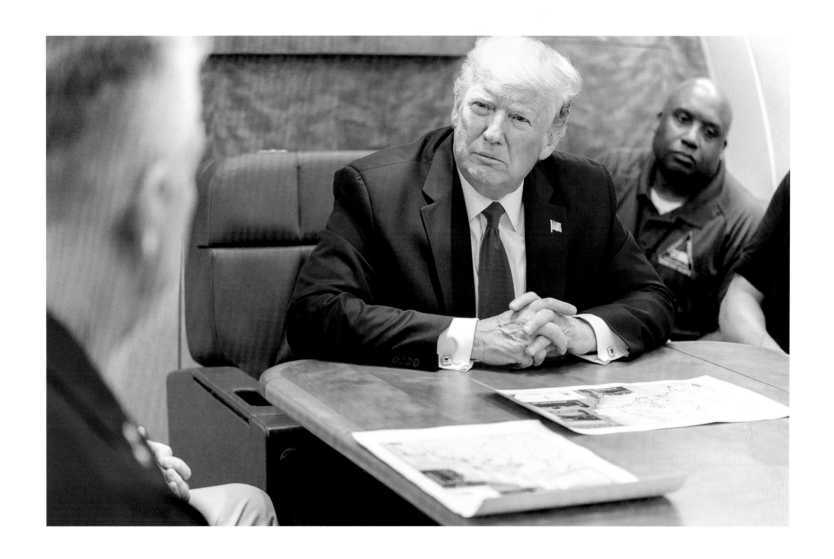

September 9, 2019: Receiving a briefing on Hurricane Dorian from FEMA, the Department of Homeland Security, and other officials. (Shealah Craighead)

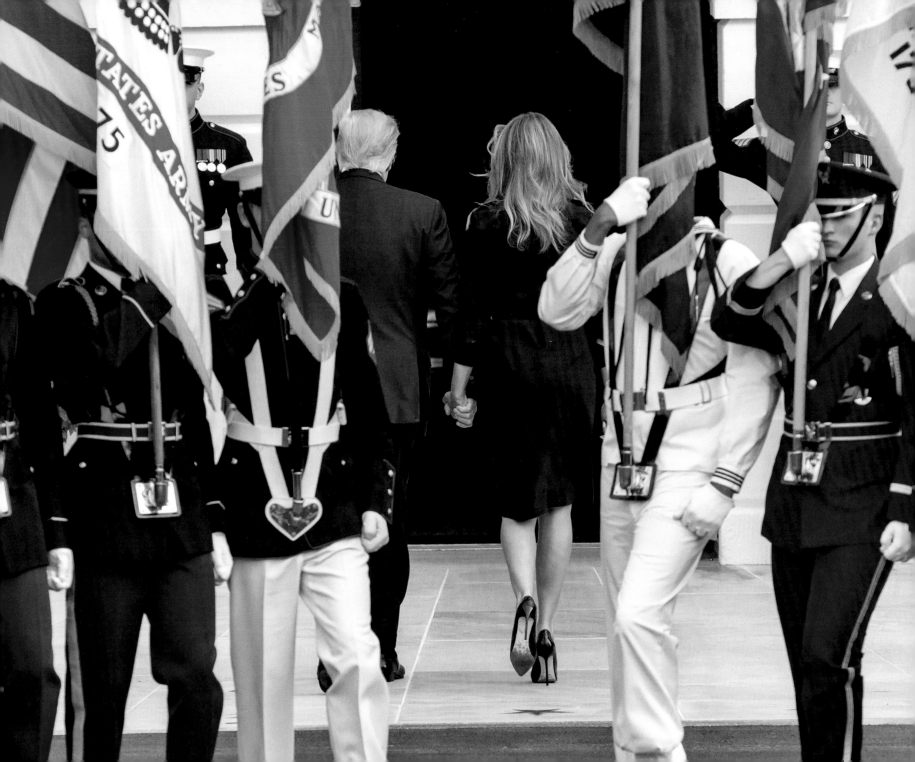

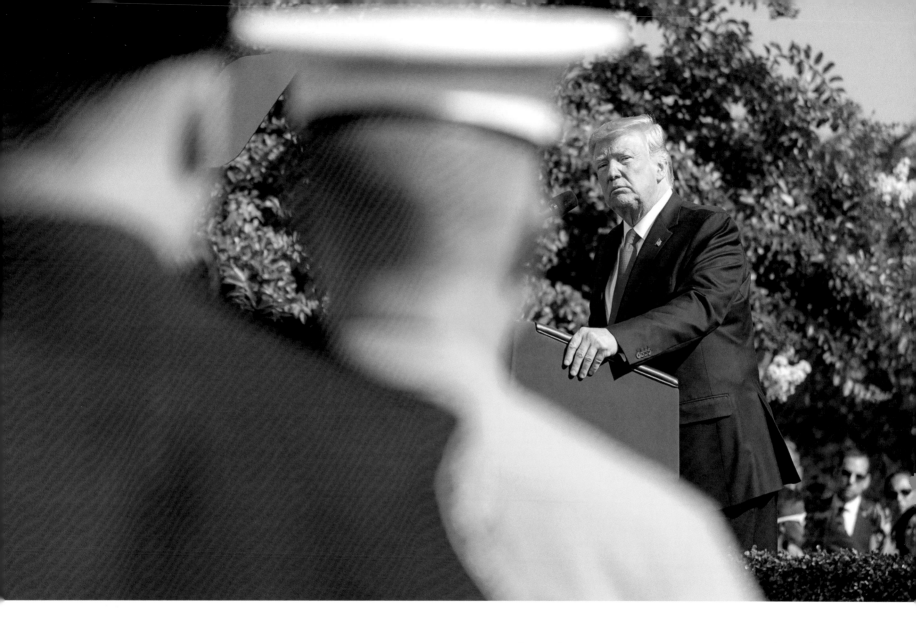

September 11, 2019: Commemorating September 11th.
(Opposite photo by Andrea Hanks, above photo by Shealah Craighead)

The heroes present today remind us of an immortal truth. The future of our nation is secured through the vigilance of our people: The brave men and women who tore through the gates of hell to save the hurt and the wounded. The service members who honor the friends who perished by continuing their exceptional life of service. The moms and dads who endure the loss of their soul mates, and fill their children's lives with all of the adoration in the world. The sons and daughters who suffered grave loss, and yet through it all, persevere to care for our neighbors, defend our homeland, and safeguard our nation. Each of your lives tells the story of courage and character, virtue and valor, resilience and resolve, loyalty and love.

—From the President's remarks at the September 11th Pentagon Observance Ceremony, September 11, 2019

(Shealah Craighead)

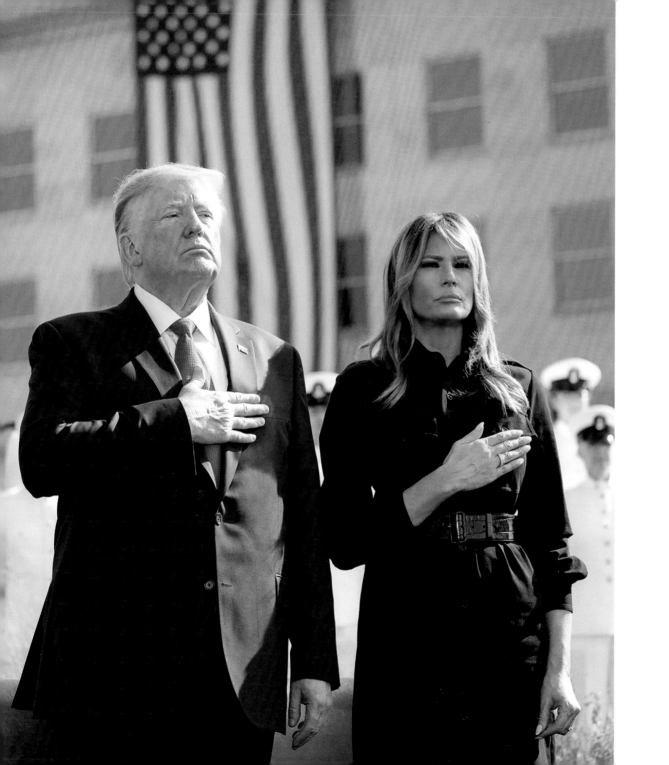

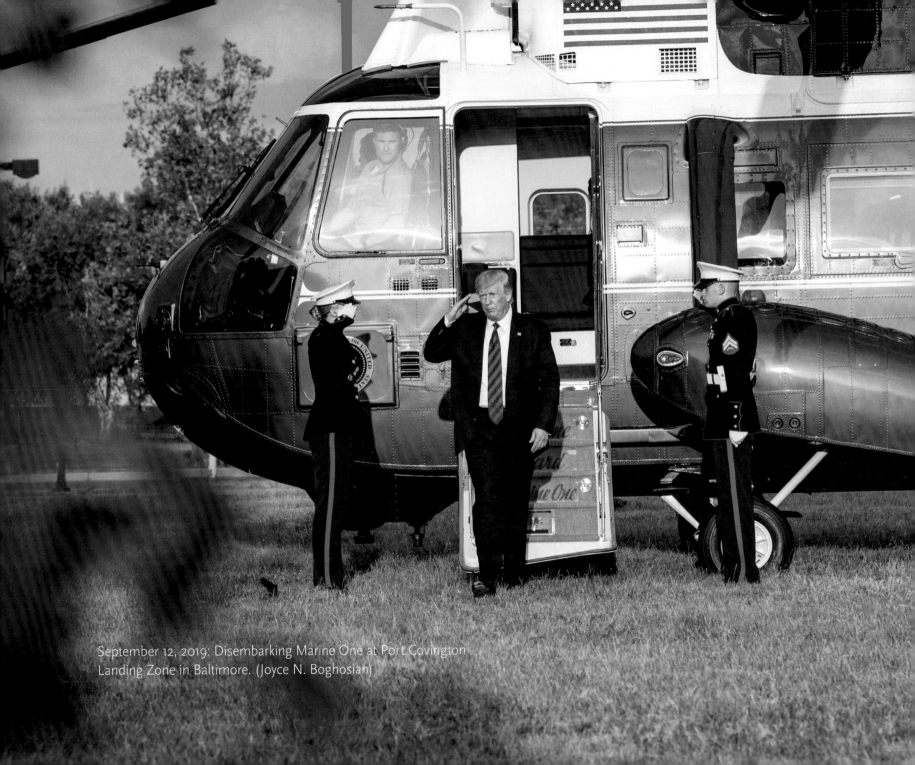

September 12, 2019: Disembarking Marine One at Port Covington Landing Zone in Baltimore. (Joyce N. Boghosian)

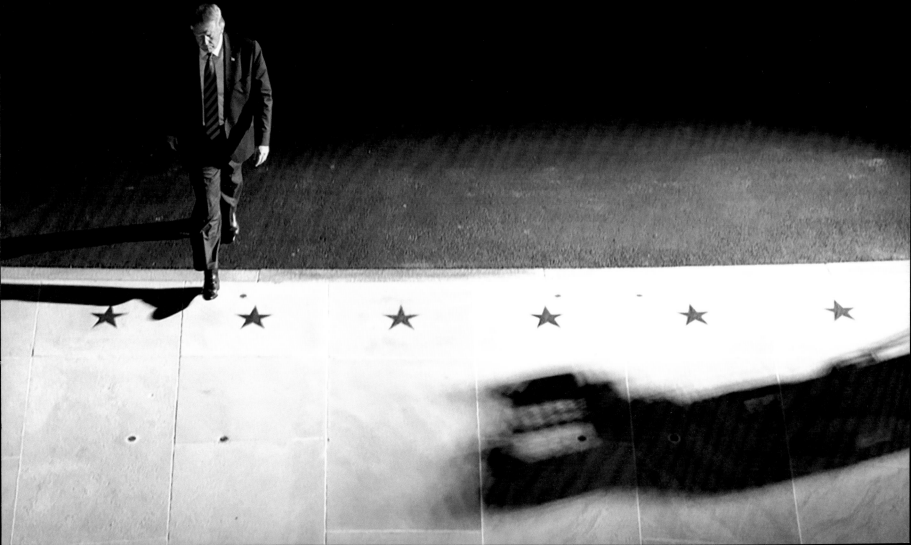

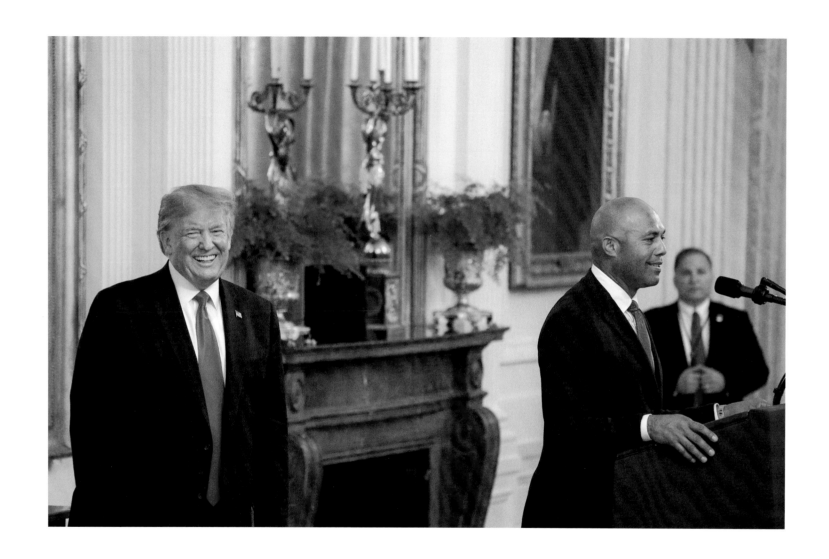

September 16, 2019: Listening to remarks by Presidential Medal of Freedom recipient Mariano Rivera in the East Room of the White House. (Joyce N. Boghosian)

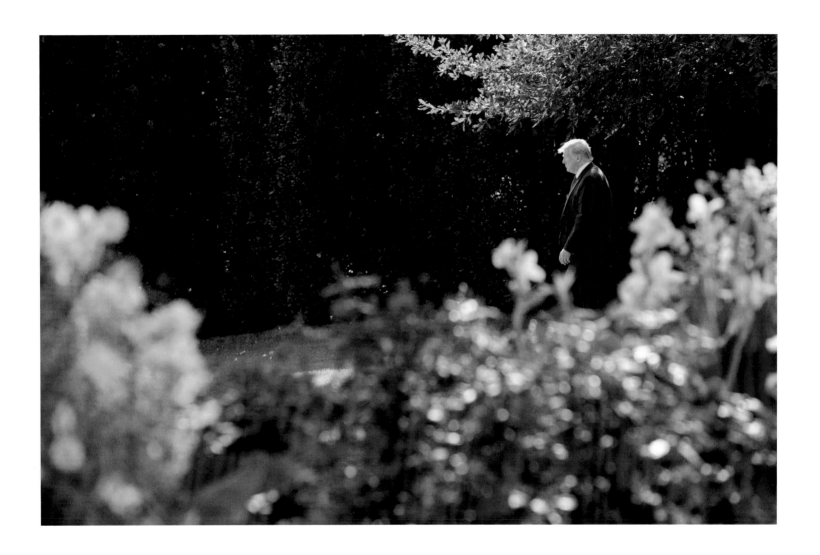

September 16, 2019: Strolling across the South Lawn
of the White House. (Joyce N. Boghosian)

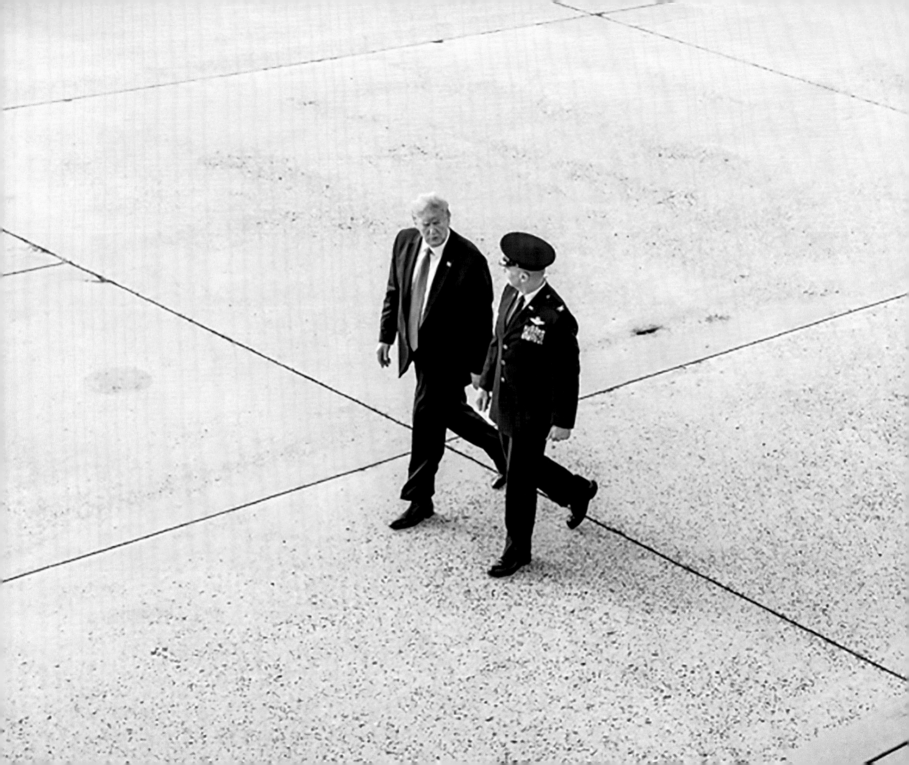

September 16, 2019: Escorted by U.S. Air Force personnel at Joint Base Andrews, Maryland. (Shealah Craighead)

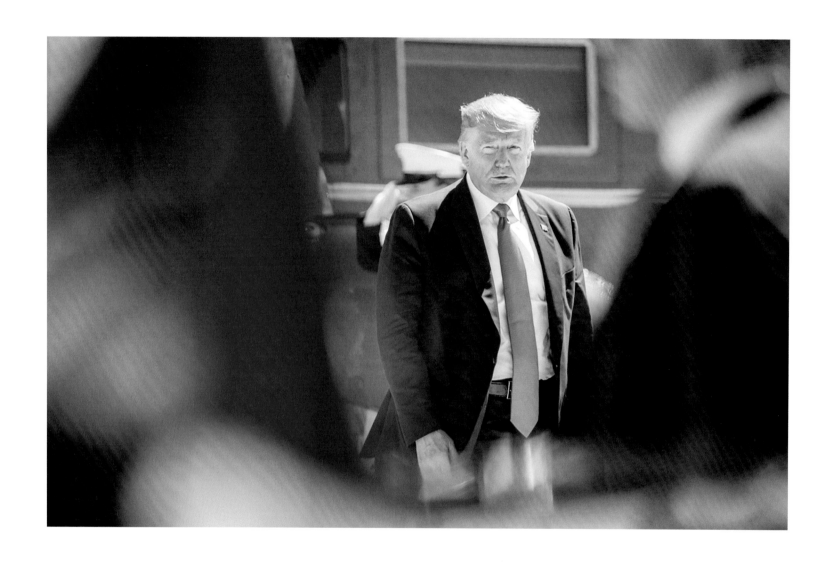

September 18, 2019: Disembarking Marine One
in San Diego. (Shealah Craighead)

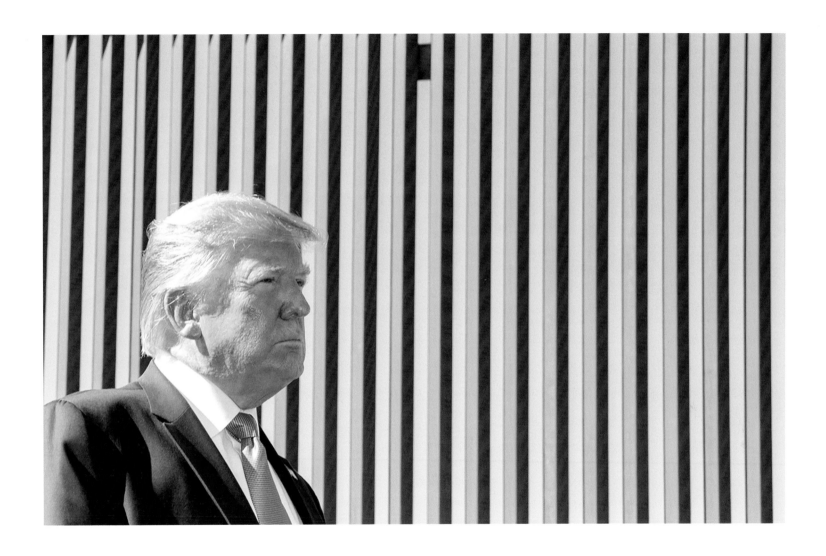

September 18, 2019: Standing before a section of border fencing in San Diego. (Shealah Craighead)

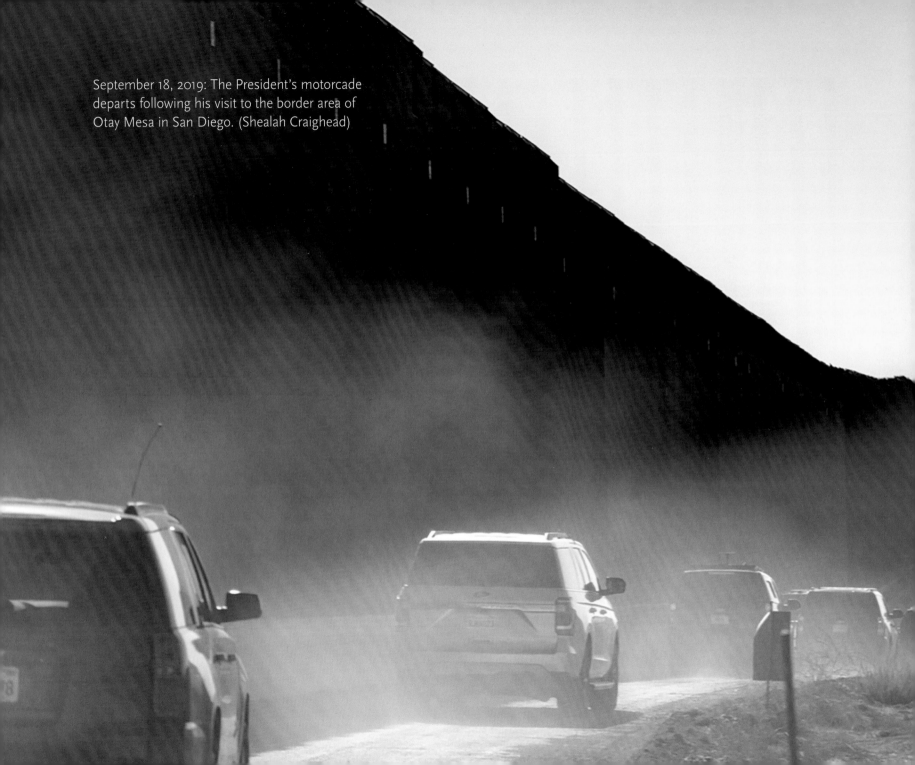

September 18, 2019: The President's motorcade departs following his visit to the border area of Otay Mesa in San Diego. (Shealah Craighead)

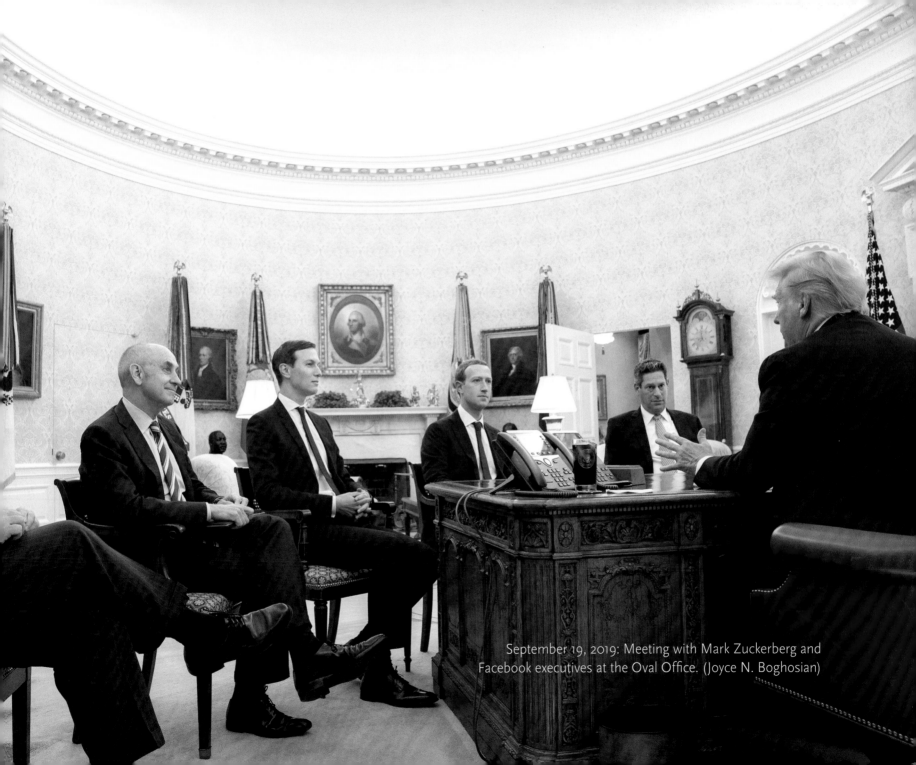

September 19, 2019: Meeting with Mark Zuckerberg and Facebook executives at the Oval Office. (Joyce N. Boghosian)

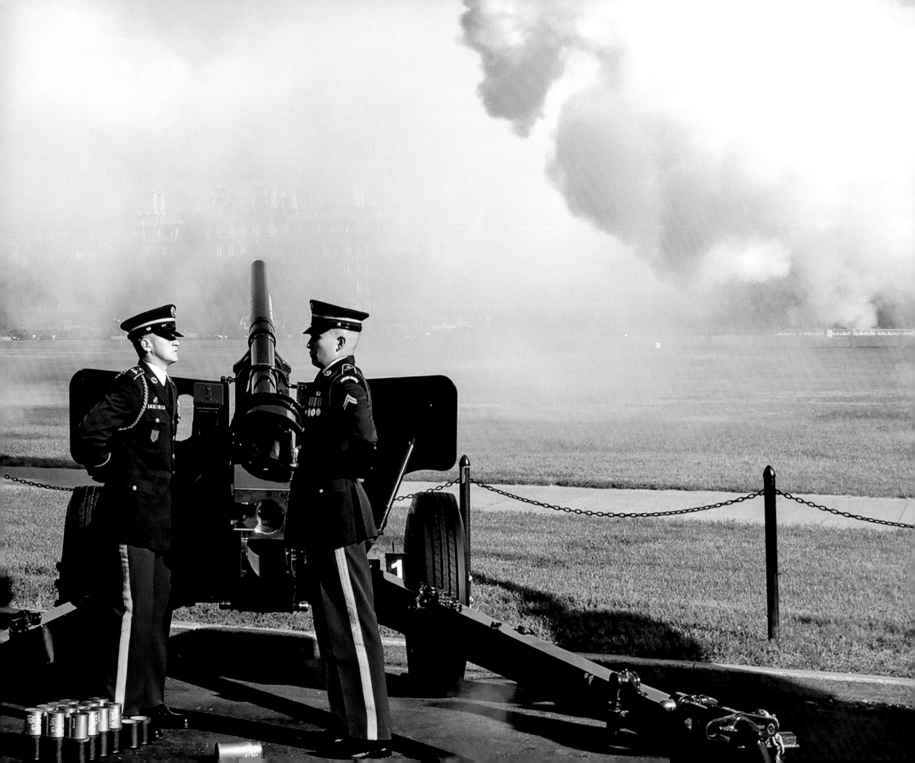

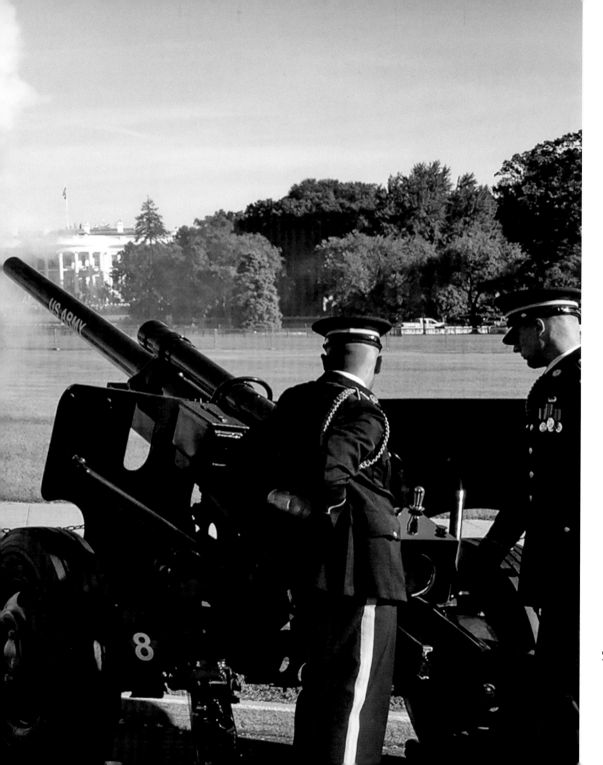

September 20, 2019: Members of the
U.S. Army 3rd Infantry fire a
nineteen-gun salute from the Ellipse
of the White House during the official
State Visit of Australian prime minister
Scott Morrison. (Katie Ricks)

September 20, 2019: The State Dinner in honor of Australian prime minister Scott Morrison and his wife, Mrs. Jenny Morrison, in the Rose Garden of the White House. (right and opposite, bottom by Andrea Hanks; opposite, top by Shealah Craighead)

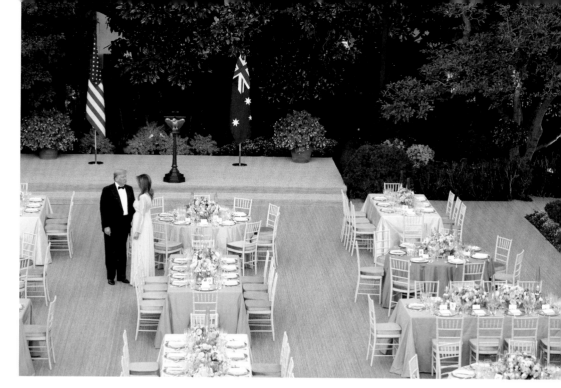

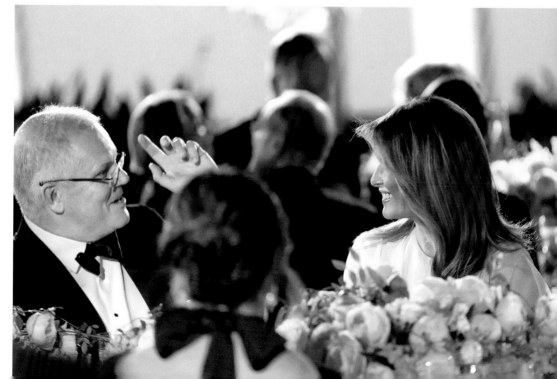

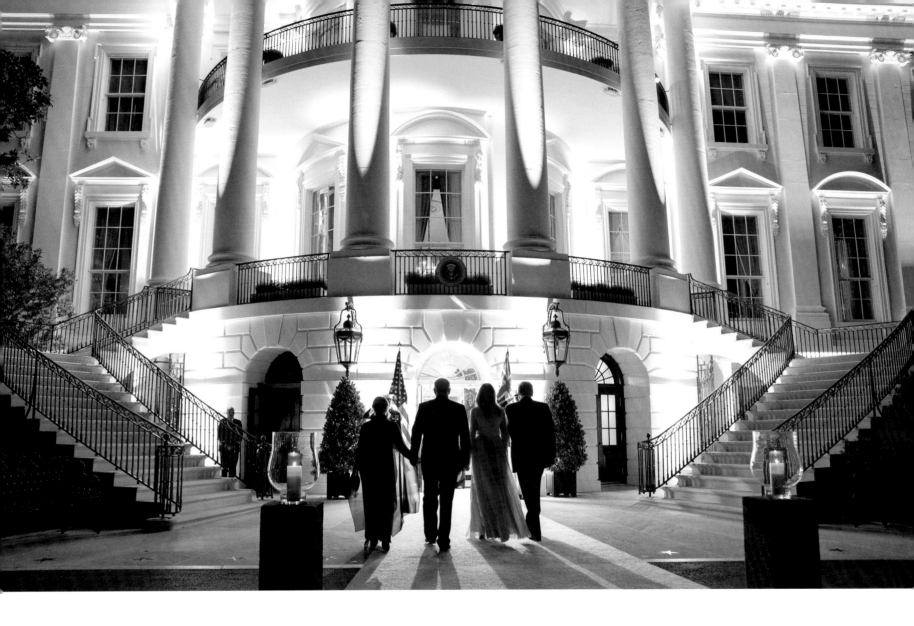

September 20, 2019: President Trump and the First Lady enter the
South Portico of the White House with Australian prime minister
Scott Morrison and his wife, Mrs. Jenny Morrison. (Shealah Craighead)

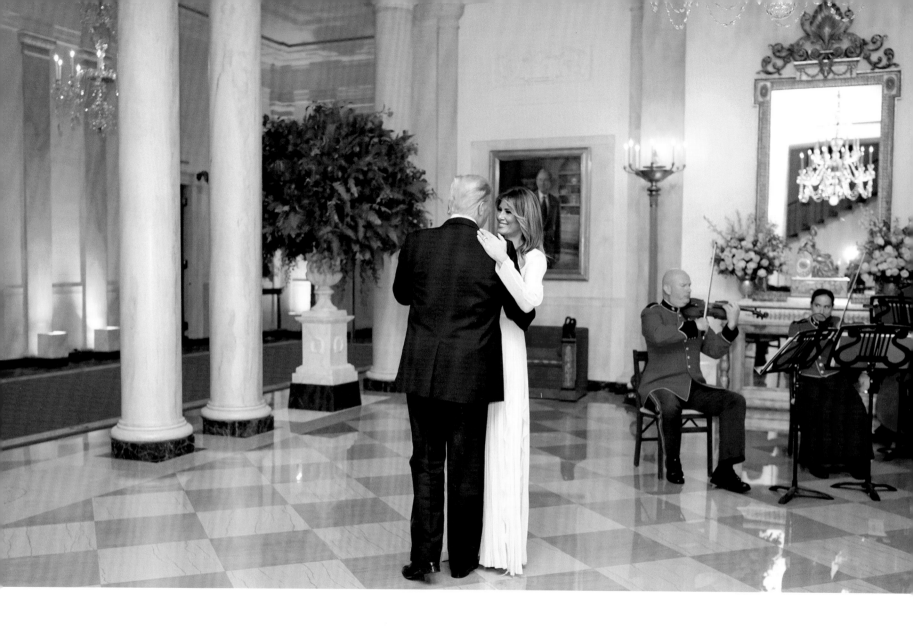

September 20, 2019: Dancing in the Grand
Foyer of the White House. (Andrea Hanks)

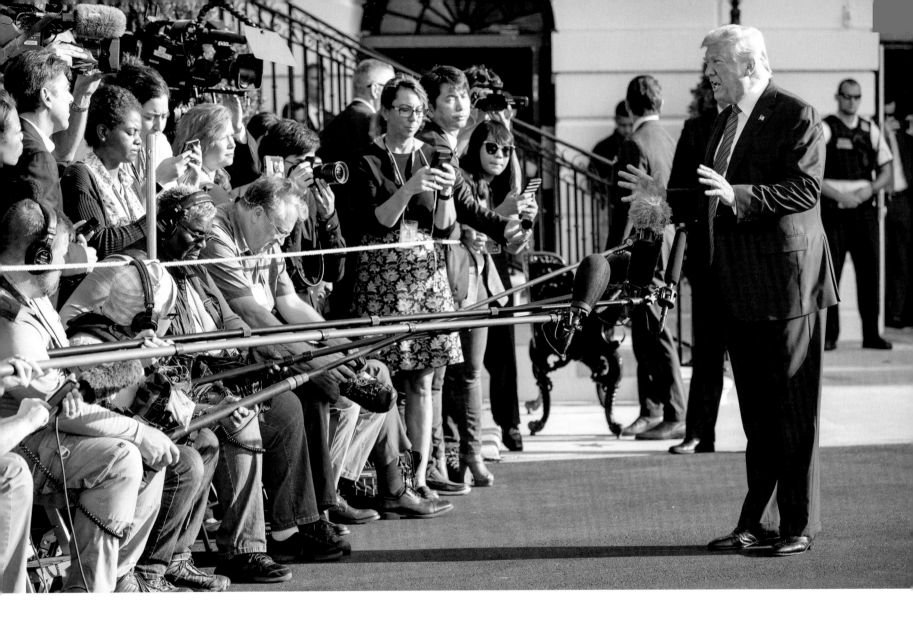

September 22, 2019: Speaking with reporters outside the
South Portico entrance of the White House. (Keegan Barber)

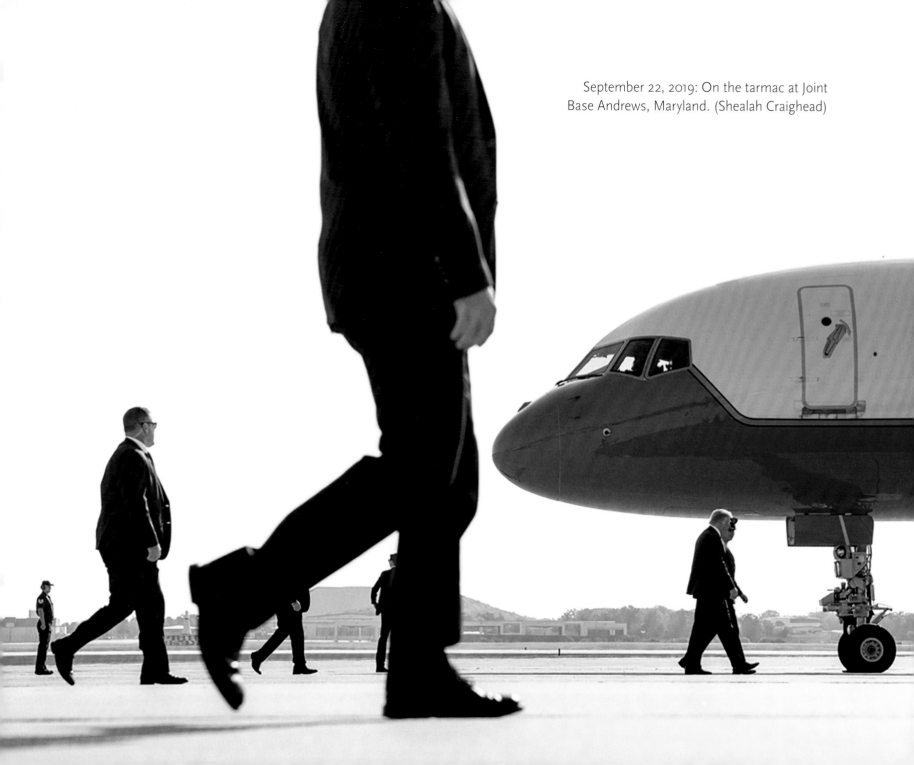

September 22, 2019: On the tarmac at Joint Base Andrews, Maryland. (Shealah Craighead)

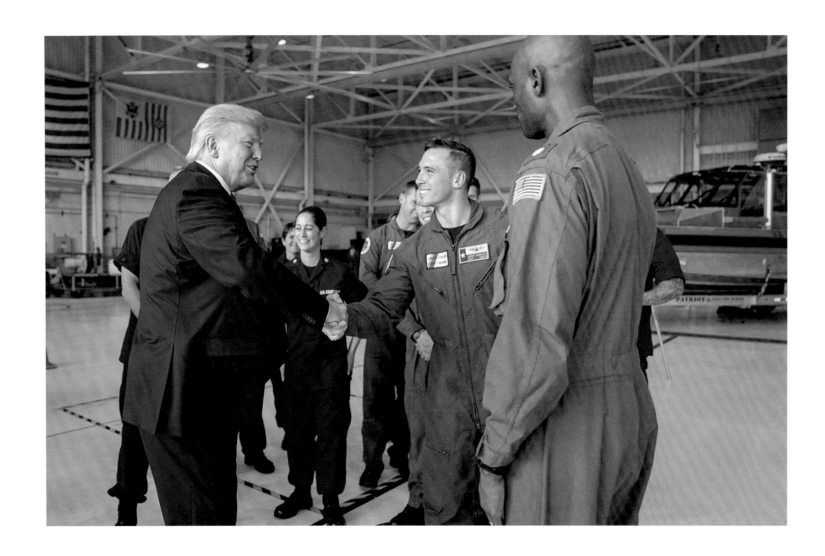

September 22, 2019: Shaking hands with U.S. Coast Guard personnel in Houston after the briefing on Tropical Storm Imelda. (Shealah Craighead)

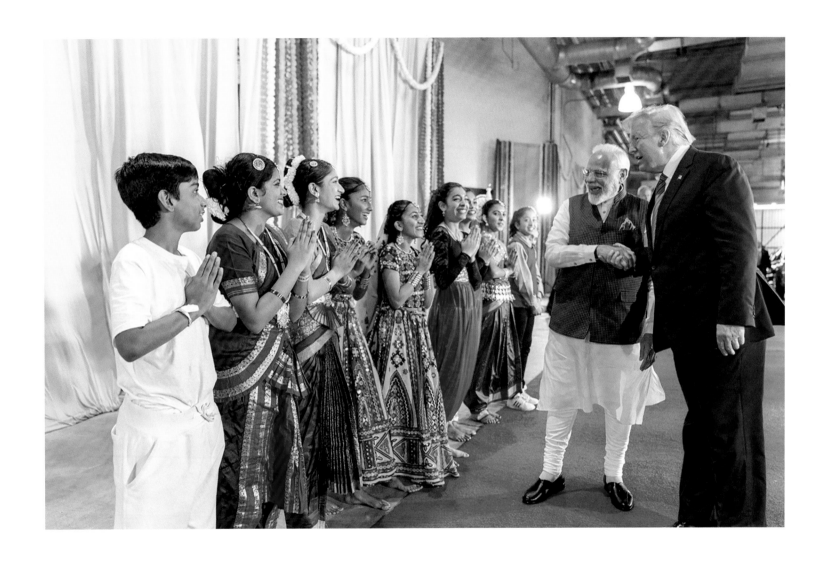

September 22, 2019: With Prime Minister Narendra Modi of India, greeting a group of children at a rally in Houston. (Shealah Craighead)

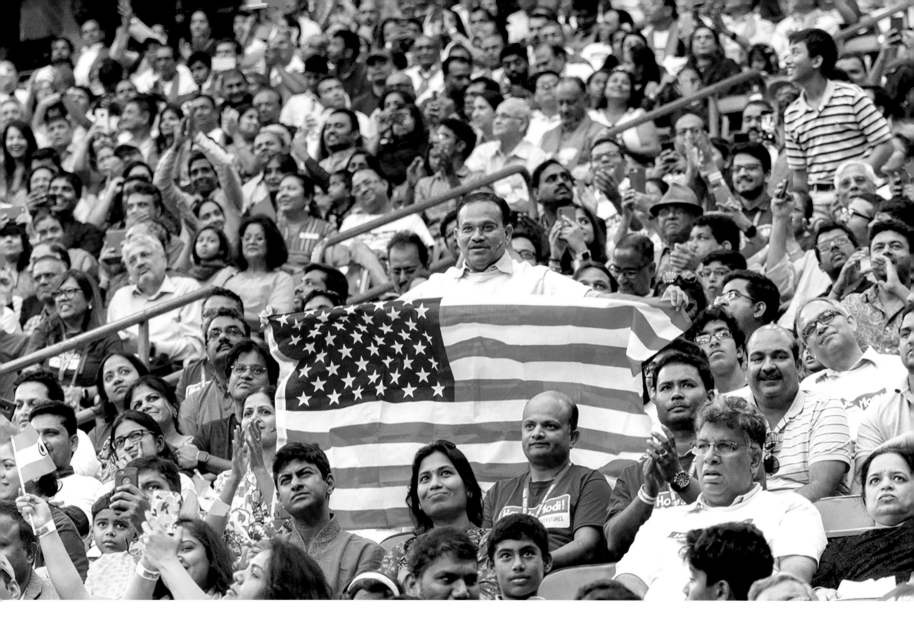

September 22, 2019: Audience members in a crowd of more than 50,000 cheer President Trump and Prime Minister Modi. (Shealah Craighead)

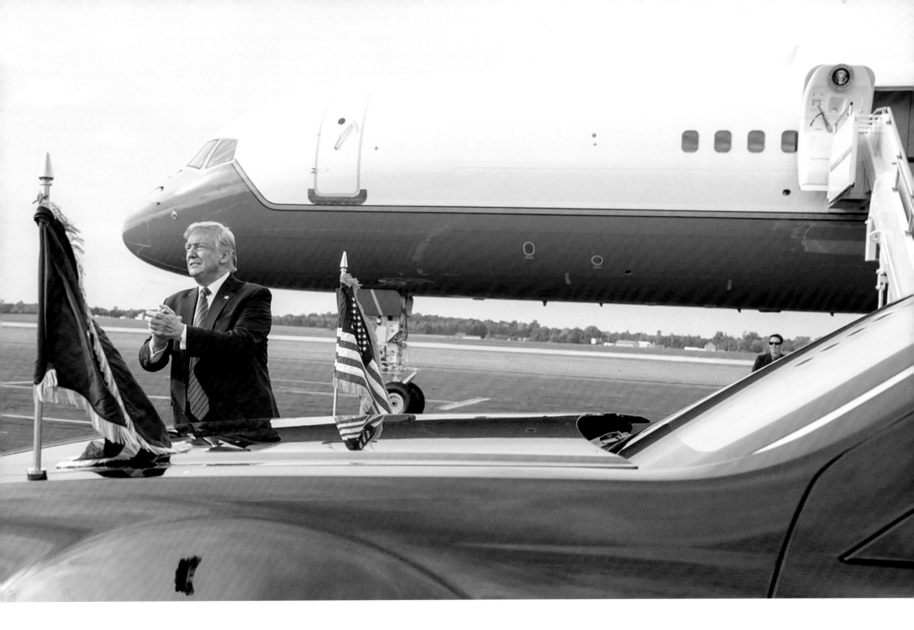

September 22, 2019: Acknowledging supporters
in Lima, Ohio. (Shealah Craighead)

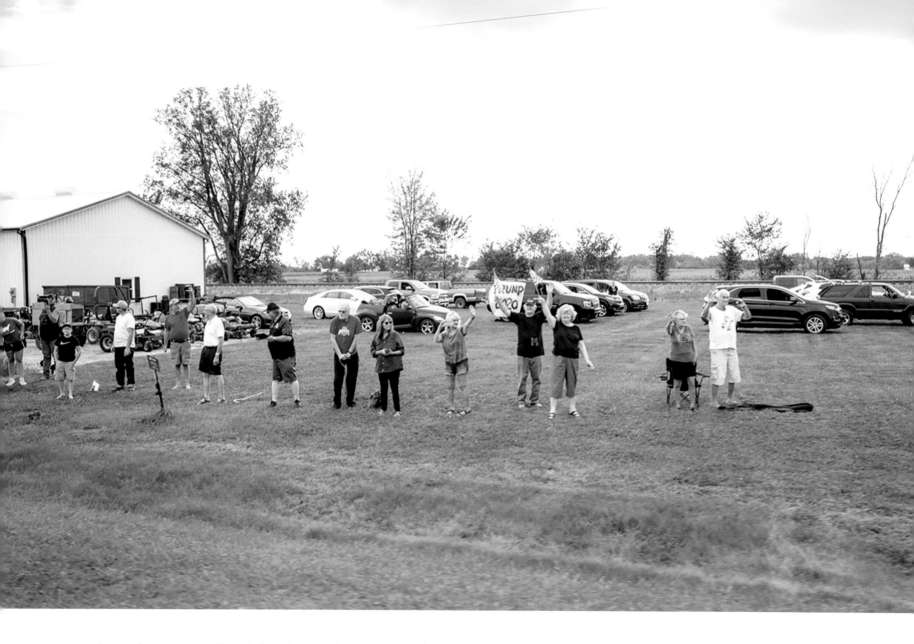

September 22, 2019: Crowds line the President's motorcade route
between Lima and Wapakoneta, Ohio. (Shealah Craighead)

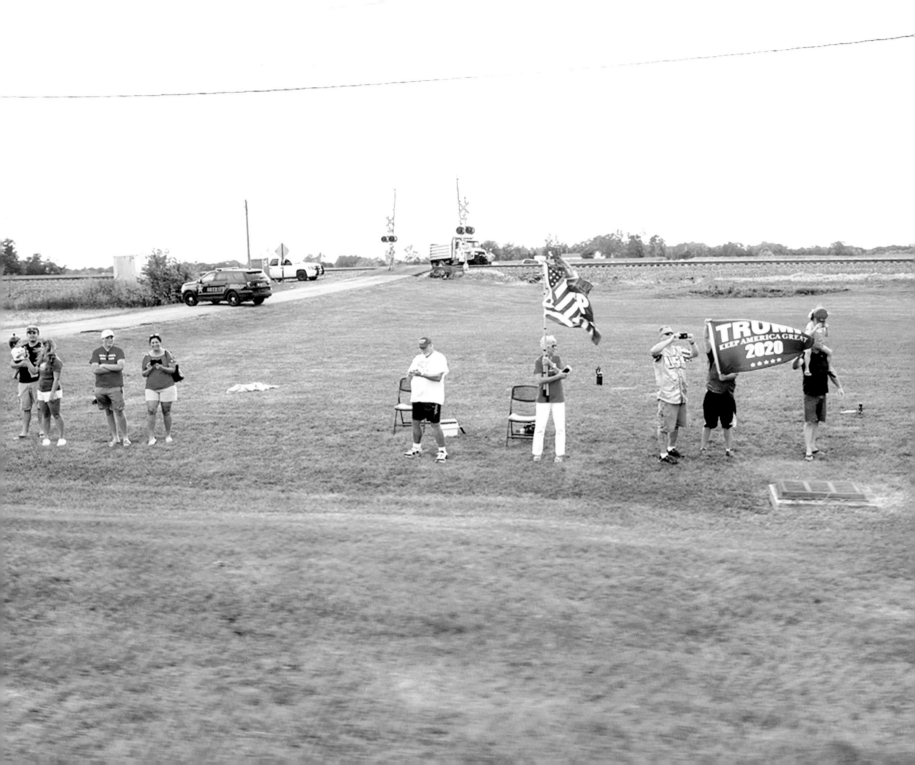

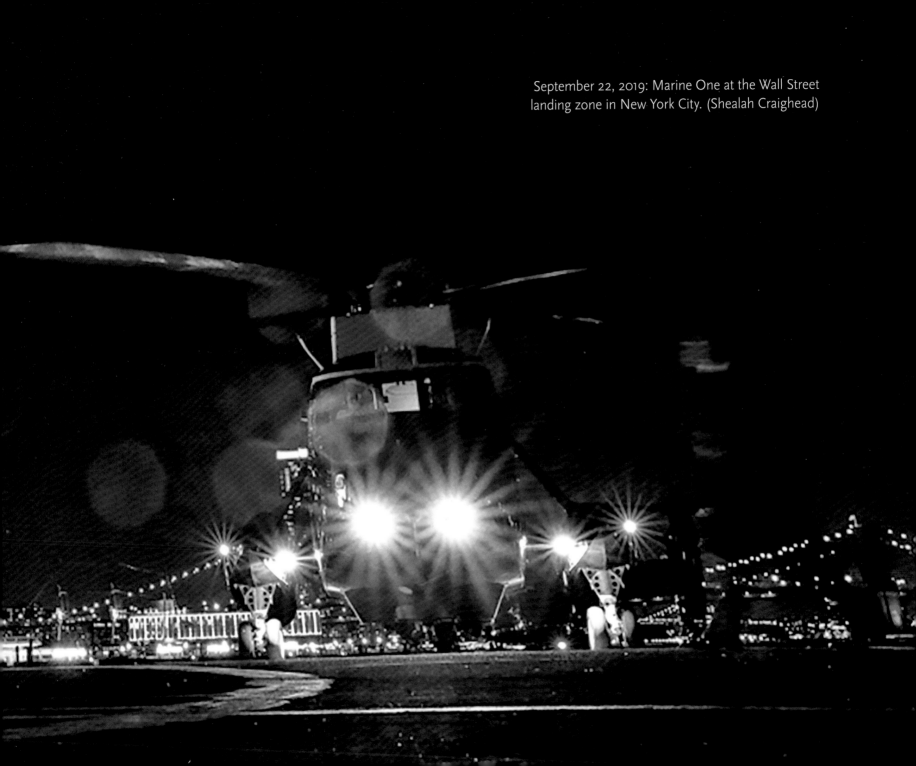

September 22, 2019: Marine One at the Wall Street landing zone in New York City. (Shealah Craighead)

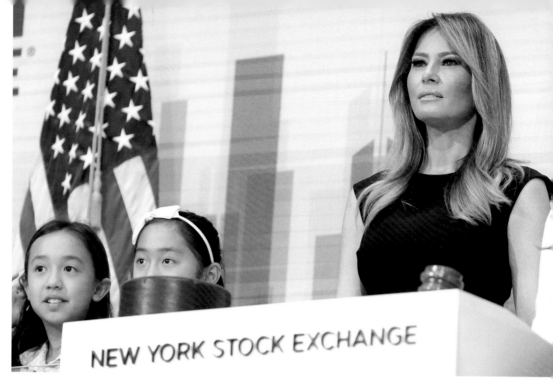

September 23, 2019: First Lady Melania Trump ringing the Opening Bell at the New York Stock Exchange in celebration of the well-being of children, as part of her Be Best campaign. (Andrea Hanks)

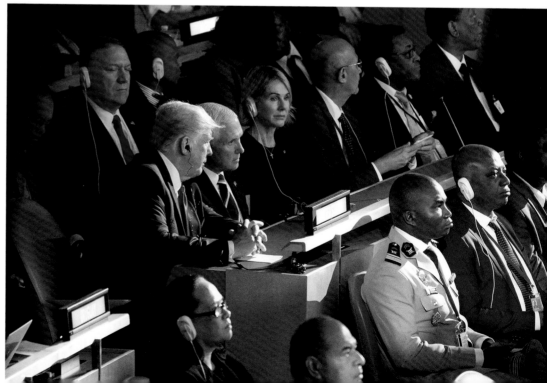

September 23, 2019: Conferring with Vice President Pence at the United Nations Climate Action Summit in New York City. (Joyce N. Boghosian)

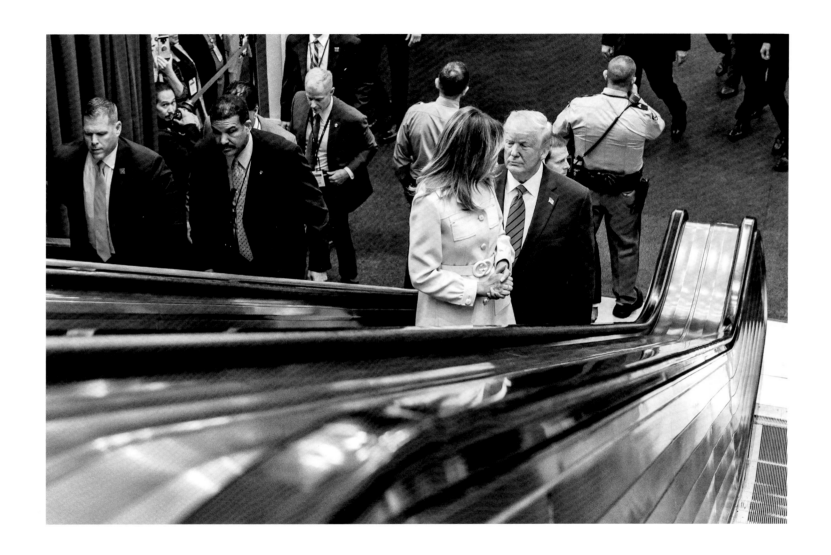

September 24, 2019: The President and First Lady arrive at the
United Nations Headquarters in New York. (Andrea Hanks)

Looking around and all over this large, magnificent planet, the truth is plain to see: If you want freedom, take pride in your country. If you want democracy, hold on to your sovereignty. And if you want peace, love your nation. Wise leaders always put the good of their own people and their own country first.

—From the President's remarks to the 74th Session of the United Nations General Assembly, September 24, 2019

September 24, 2019: Addressing the 74th session of the United Nations General Assembly in New York. (Andrea Hanks)

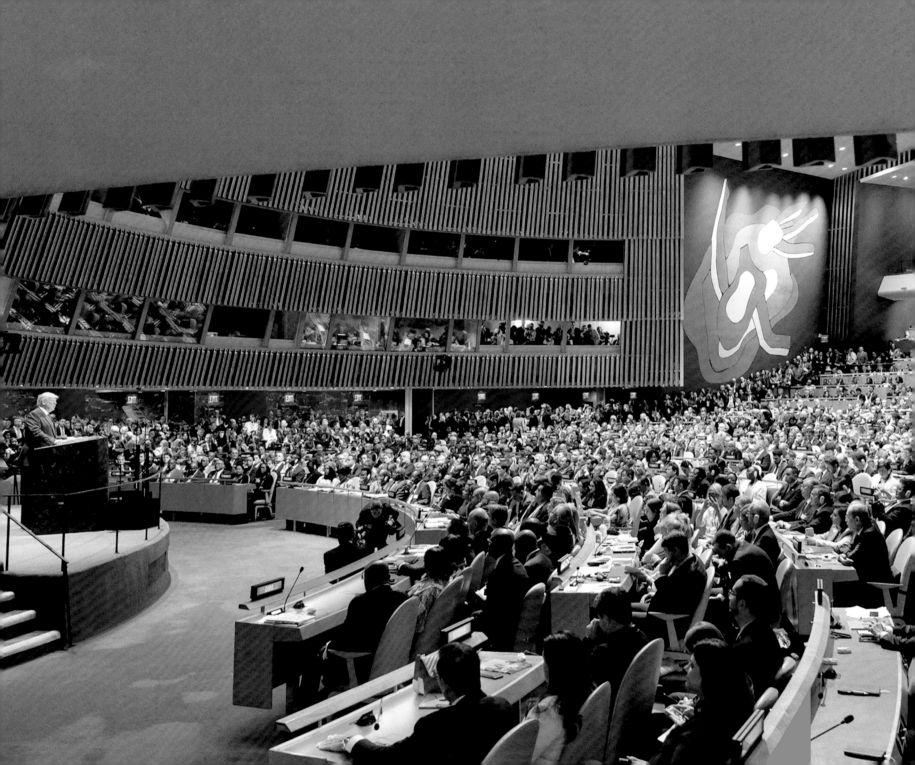

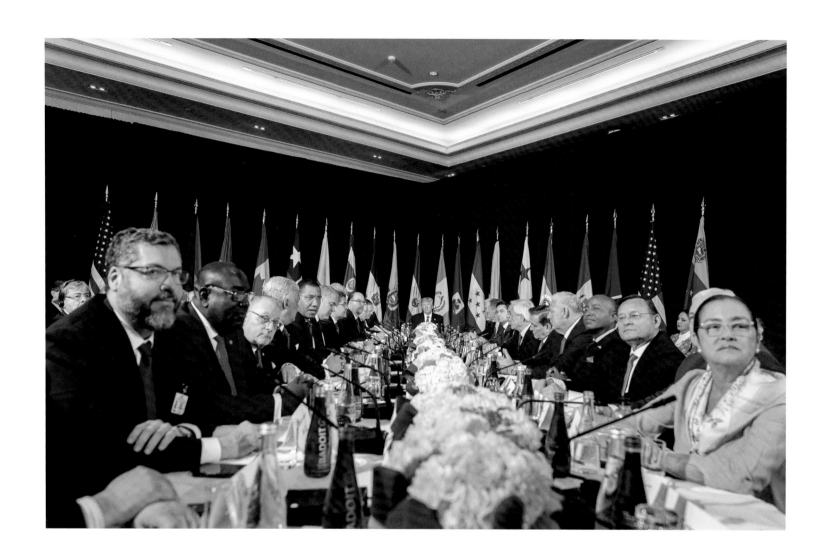

September 25, 2019: A multilateral meeting
on Venezuela. (Shealah Craighead)

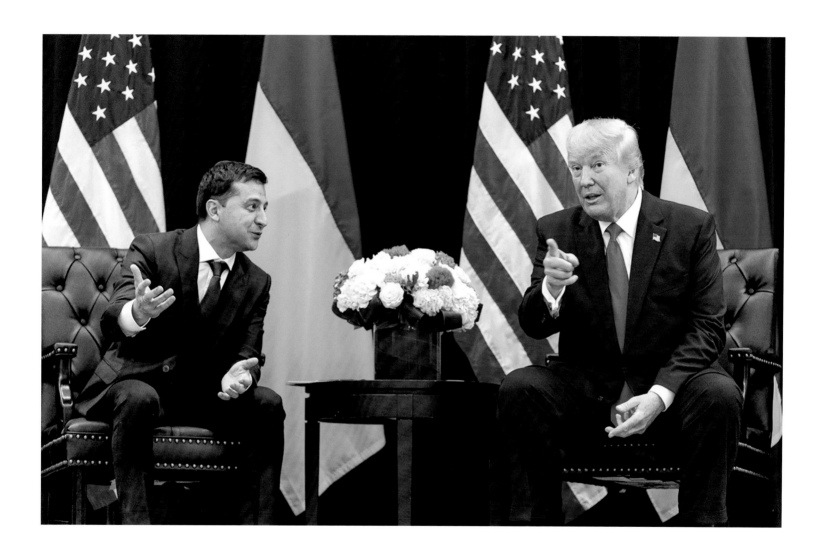

September 25, 2019: With Volodymyr Zalensky,
president of Ukraine. (Shealah Craighead)

September 26, 2019: Departing New York City after the U.N. visit. (Shealah Craighead)

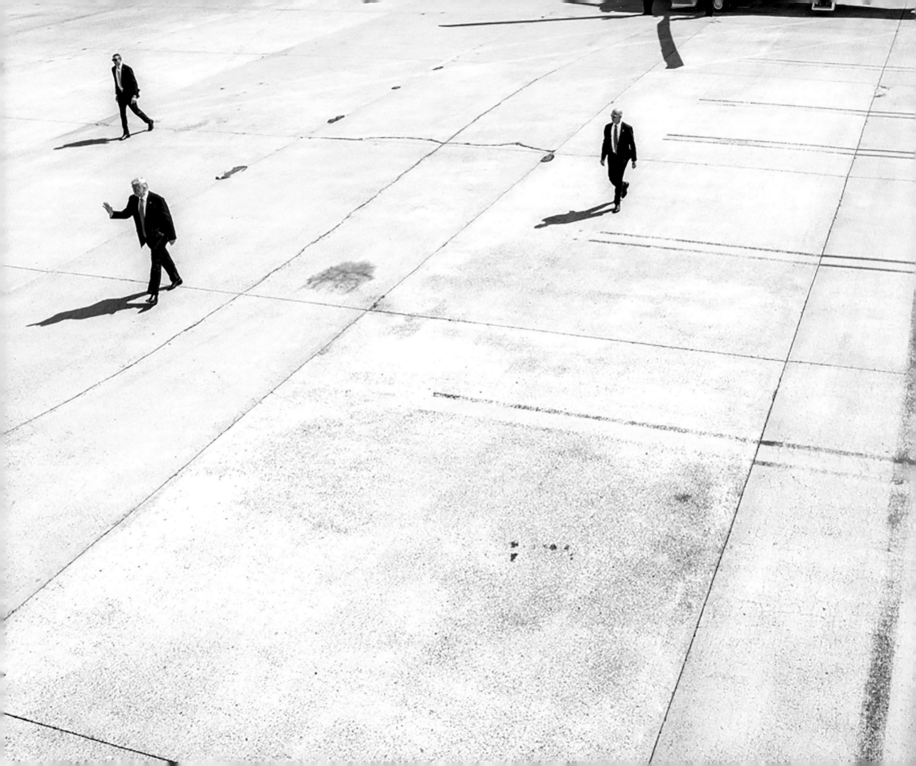

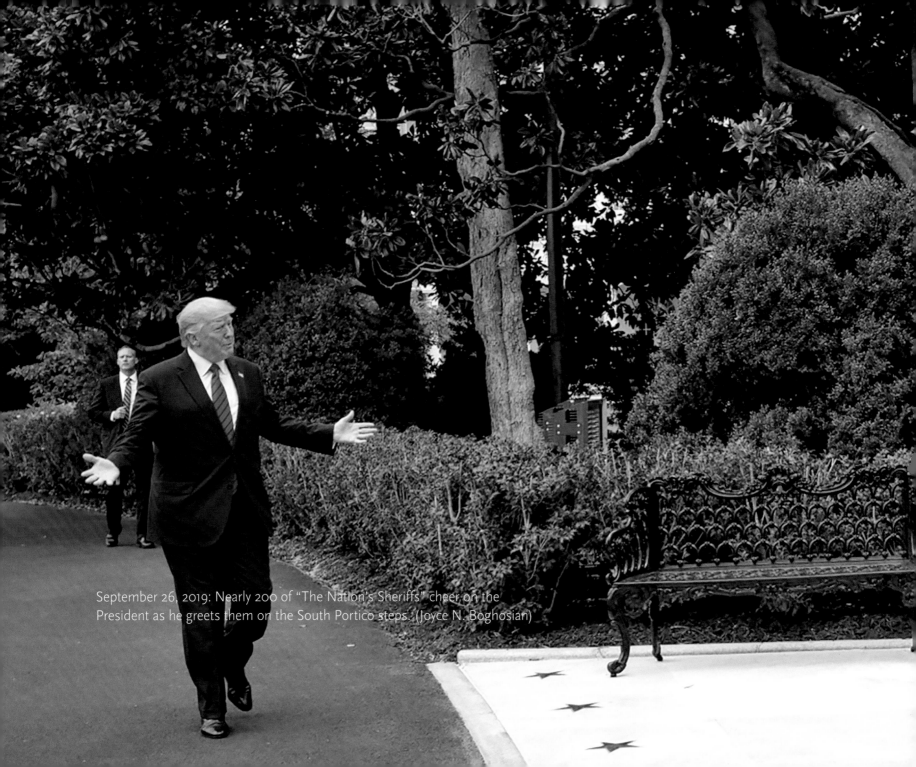

September 26, 2019: Nearly 200 of "The Nation's Sheriffs" cheer on the President as he greets them on the South Portico steps. (Joyce N. Boghosian)

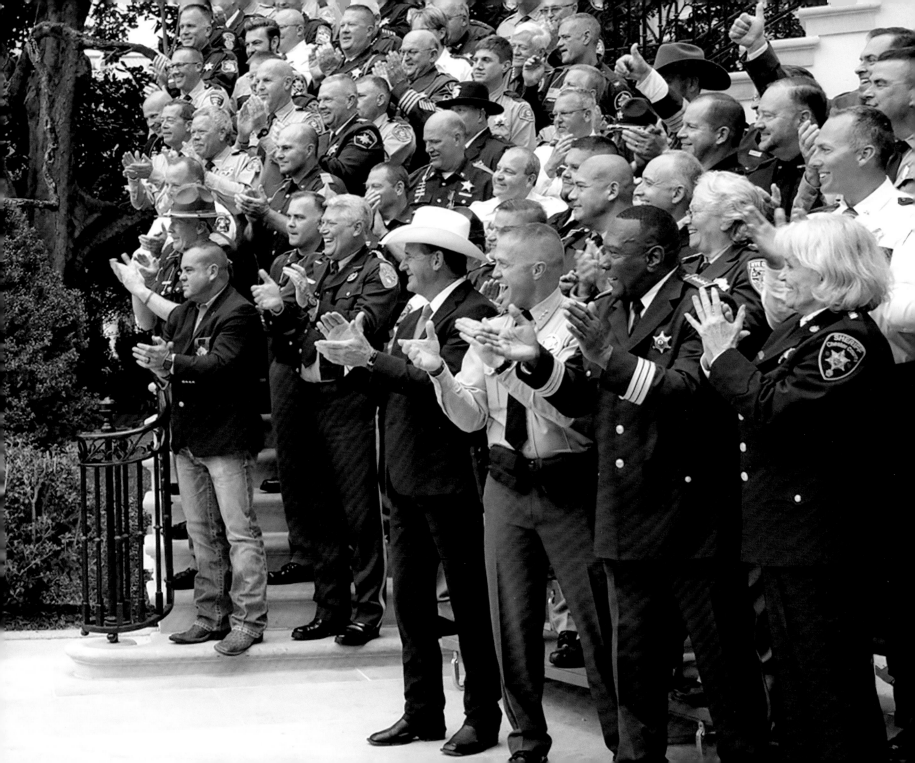

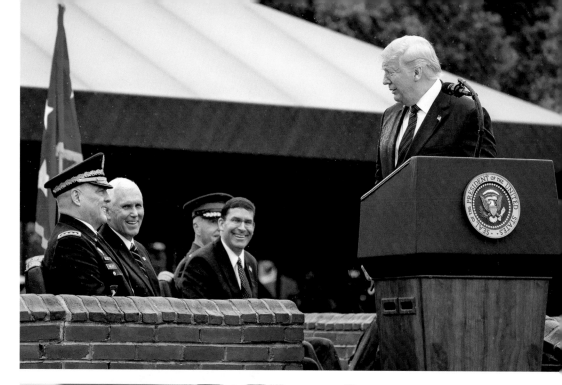

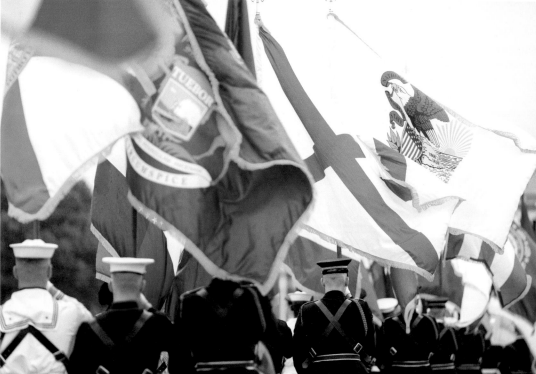

September 30, 2019: At the Armed Forces Welcome Ceremony in honor of the Joint Chiefs of Staff. (Above photo by D. Myles Cullen, right photo by Shealah Craighead)

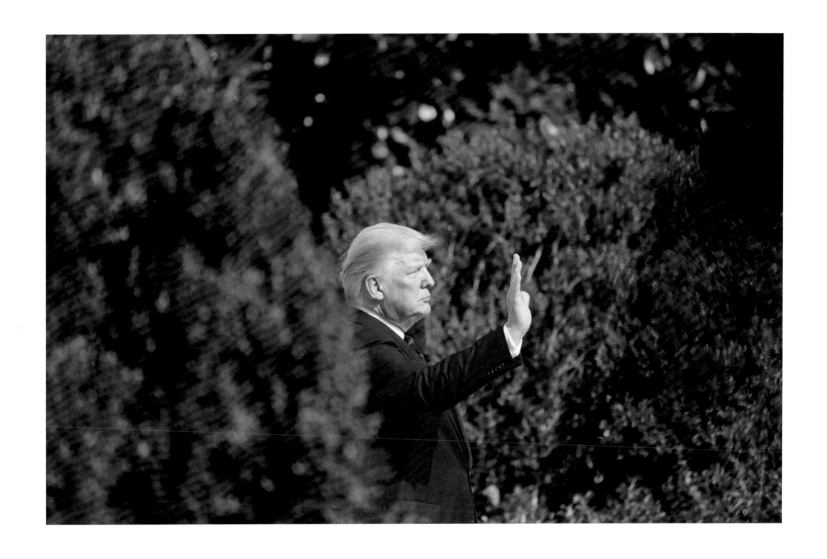

October 2, 2019: President Trump bids farewell to Finnish president Sauli Niinistö. (Joyce N. Boghosian)

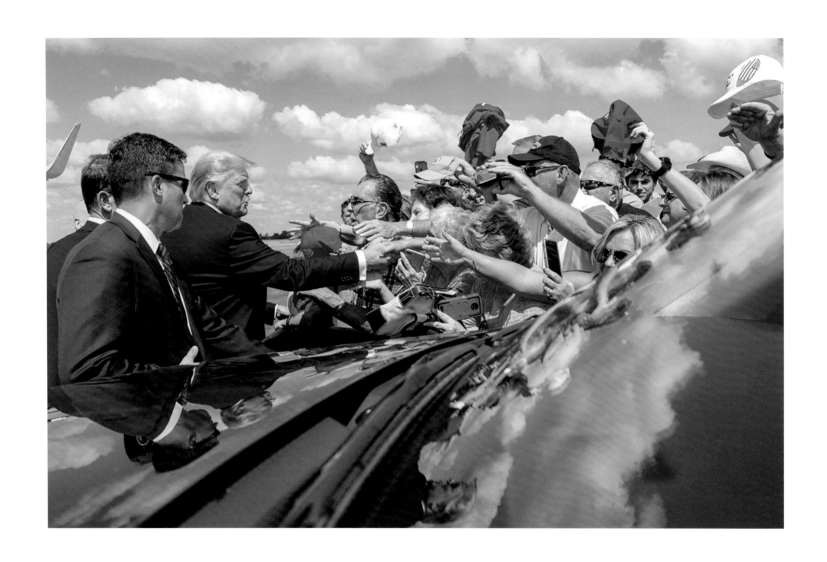

October 3, 2019: Shaking hands with supporters
in Ocala, Florida. (Shealah Craighead)

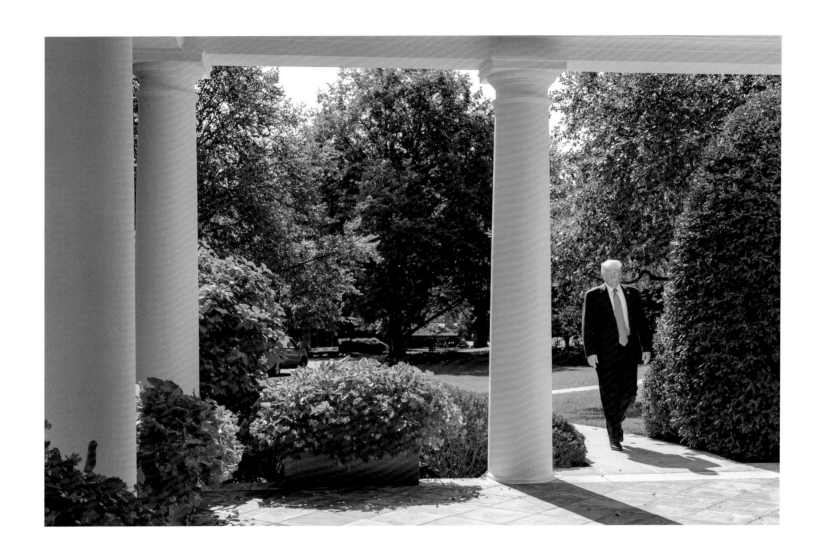

October 4, 2019: Returning to the White House after a visit to Walter Reed
National Military Medical Center in Bethesda. (Joyce N. Boghosian)

October 4, 2019: The First Lady in Moose, Wyoming. (Andrea Hanks)

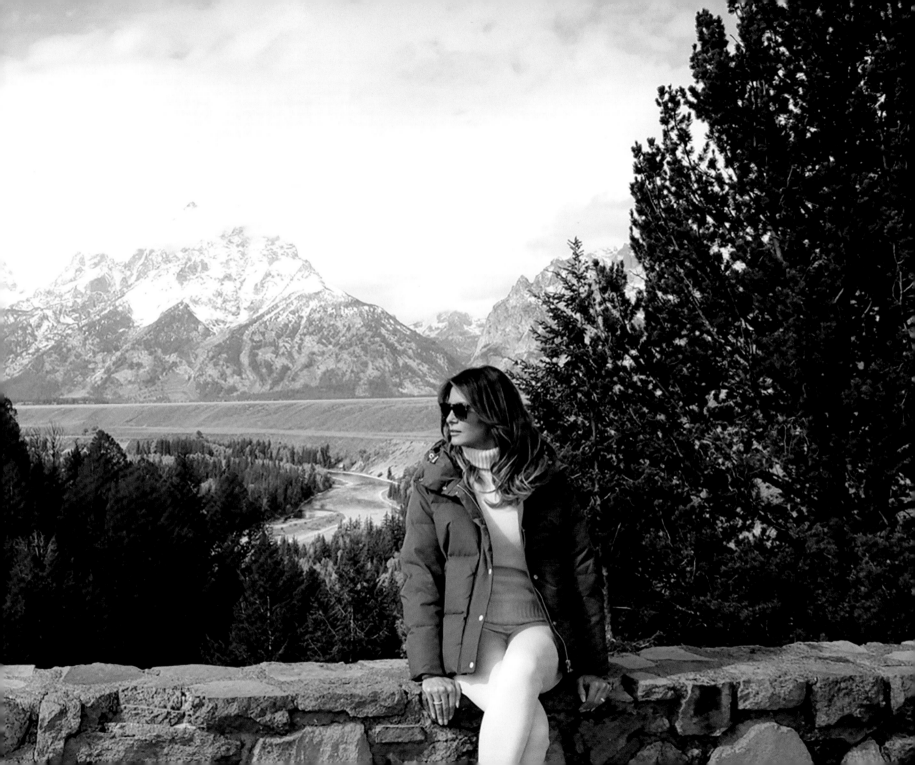

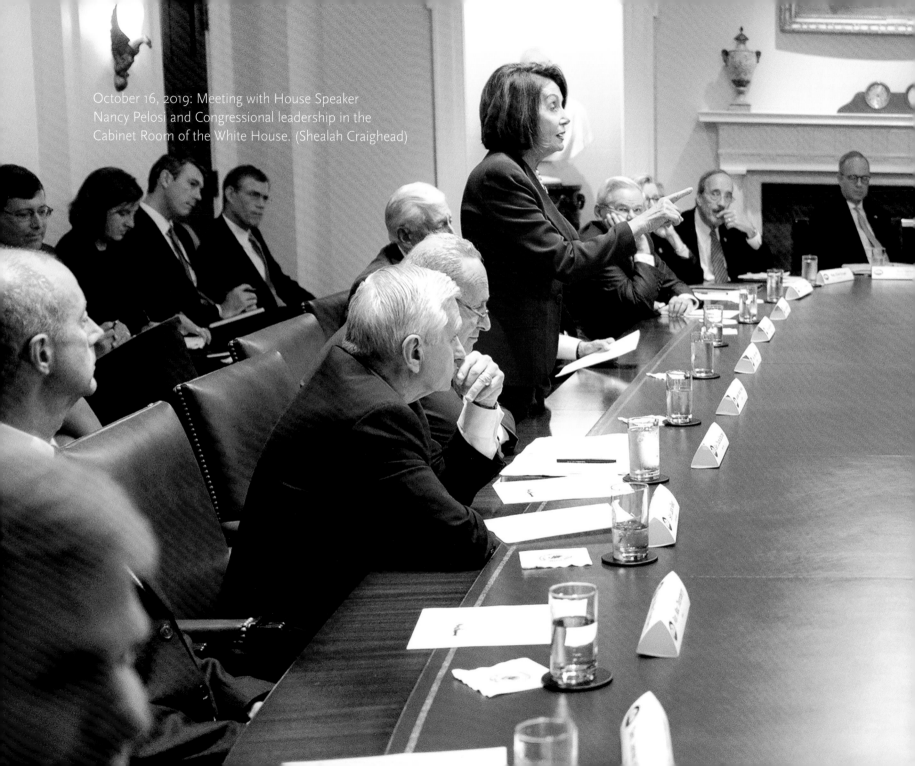

October 16, 2019: Meeting with House Speaker Nancy Pelosi and Congressional leadership in the Cabinet Room of the White House. (Shealah Craighead)

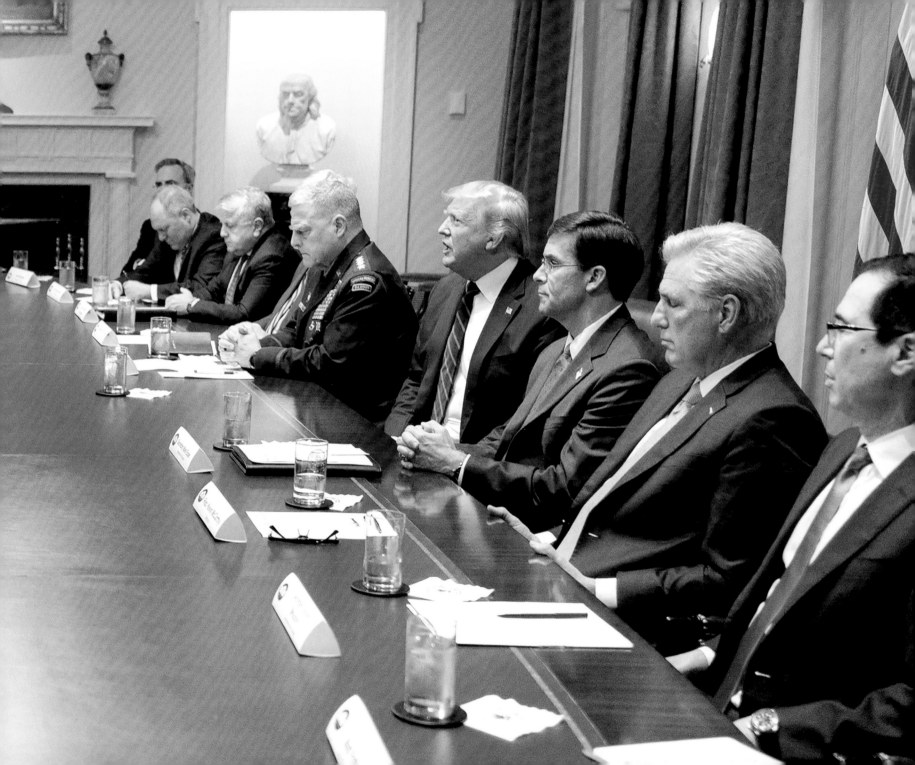

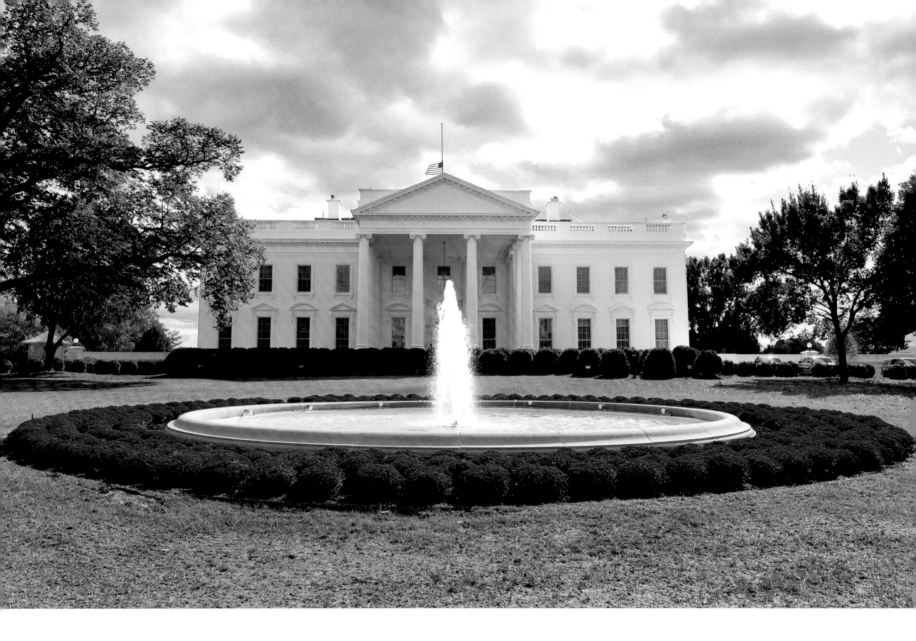

October 17, 2019: The American flag flies at half-staff in honor of the late Rep. Elijah Cummings. (Andrea Hanks)

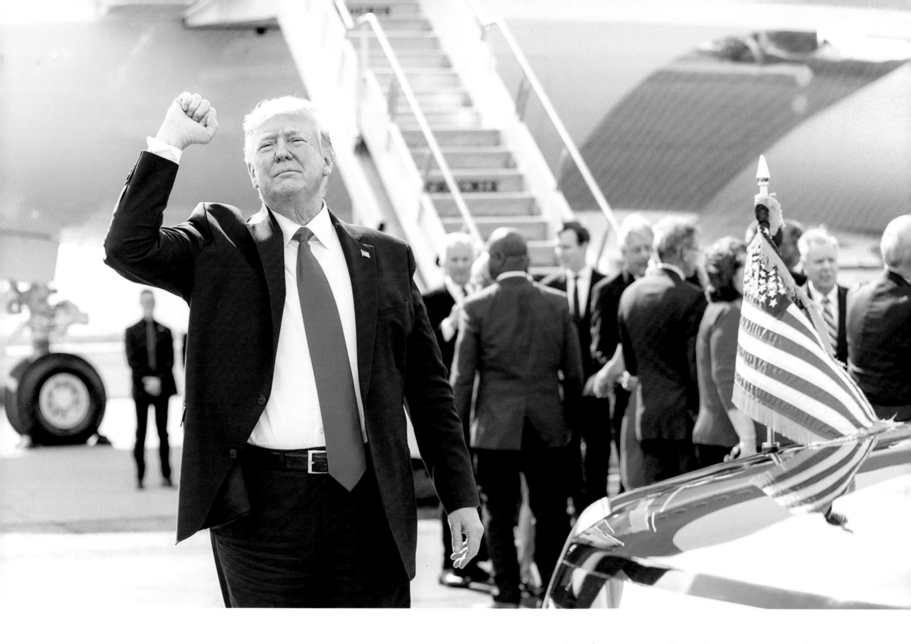

October 25, 2019: Gesturing to supporters in Columbia, South Carolina. (Shealah Craighead)

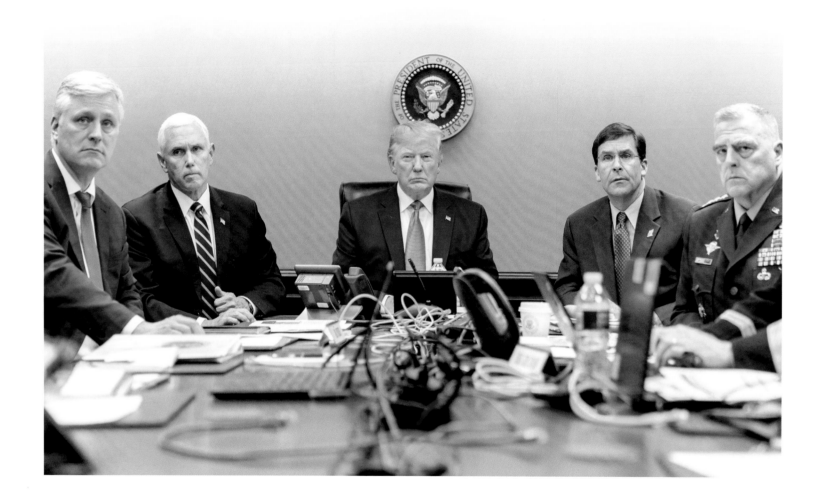

October 26, 2019: In the Situation Room of the White House, monitoring developments as U.S. Special Operations forces close in on ISIS leader Abu Bakr al-Baghdadi's compound in Syria. (Shealah Craighead)

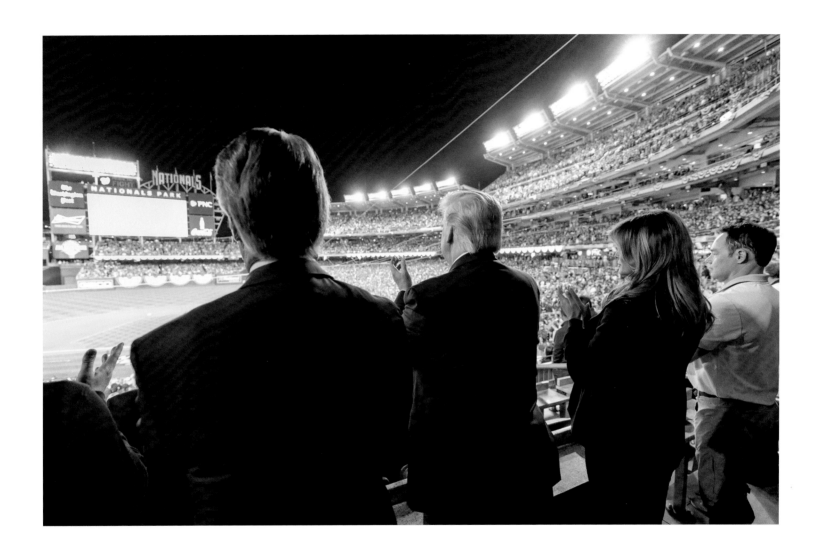

October 27, 2019: Attending Game 5 of the World Series
at Nationals Park in Washington, D.C. (Andrea Hanks)

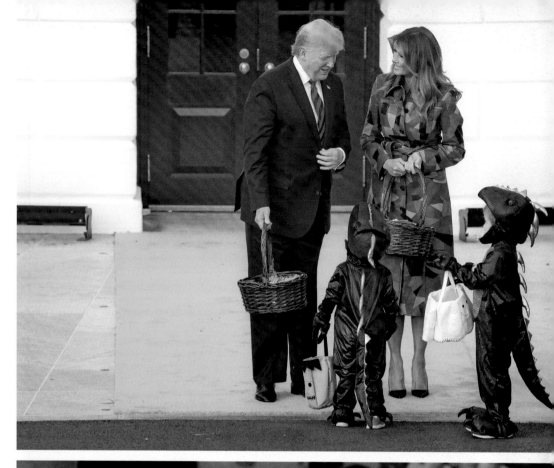

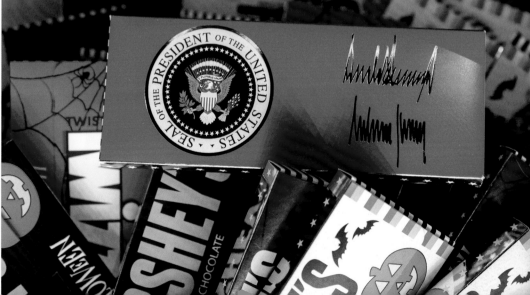

October 28, 2019: Halloween at the White House. (Opposite and top, right by Tia Dufour; bottom, right by Andrea Hanks)

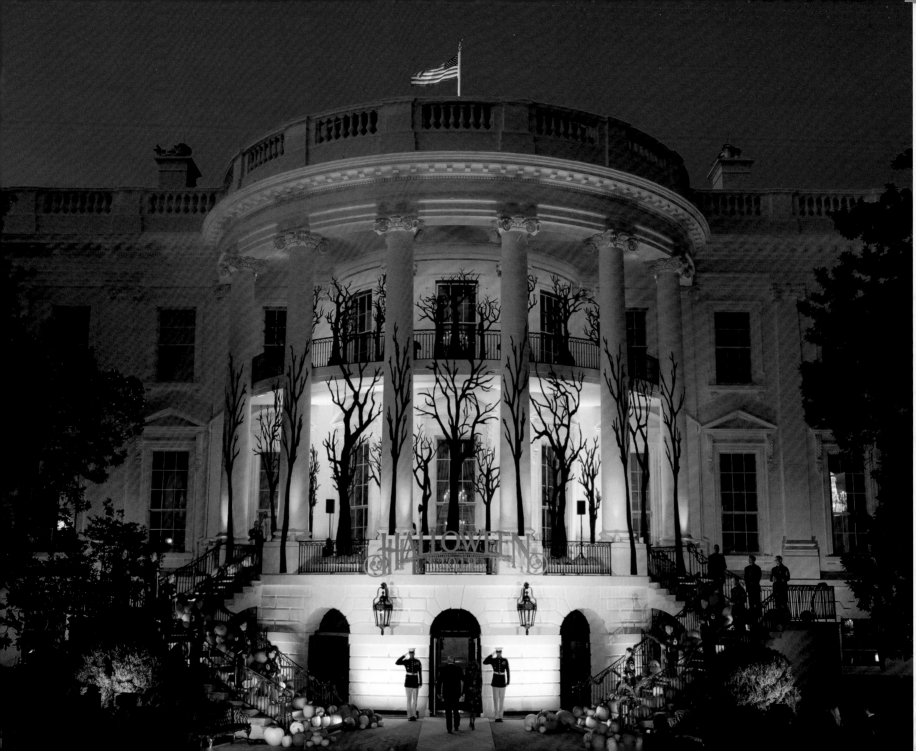

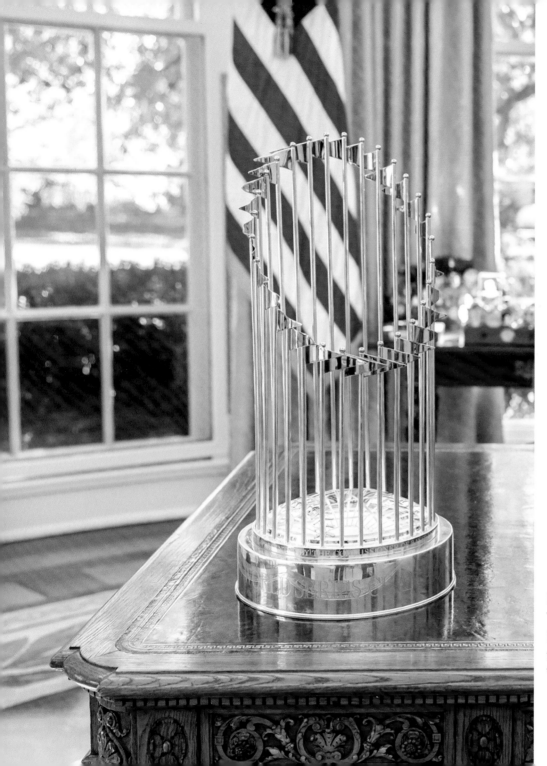

November 4, 2019: The Commissioner's Trophy is displayed on the Resolute Desk in the Oval Office during the visit of the 2019 World Series Champions, the Washington Nationals. (Andrea Hanks)

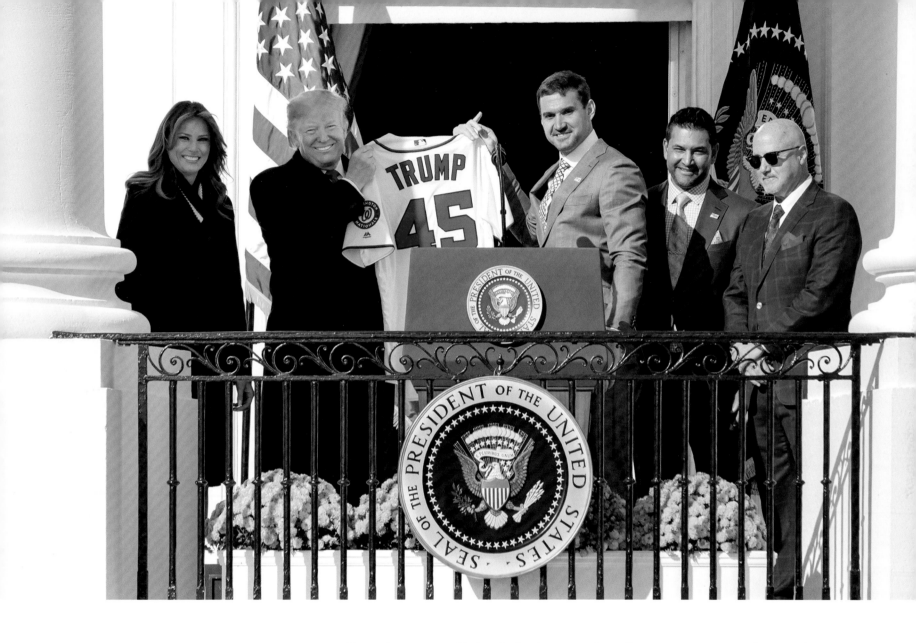

November 4, 2019: Nationals first baseman Ryan Zimmerman presents the President with a Nationals jersey on the Blue Room Balcony of the White House. (Andrea Hanks)

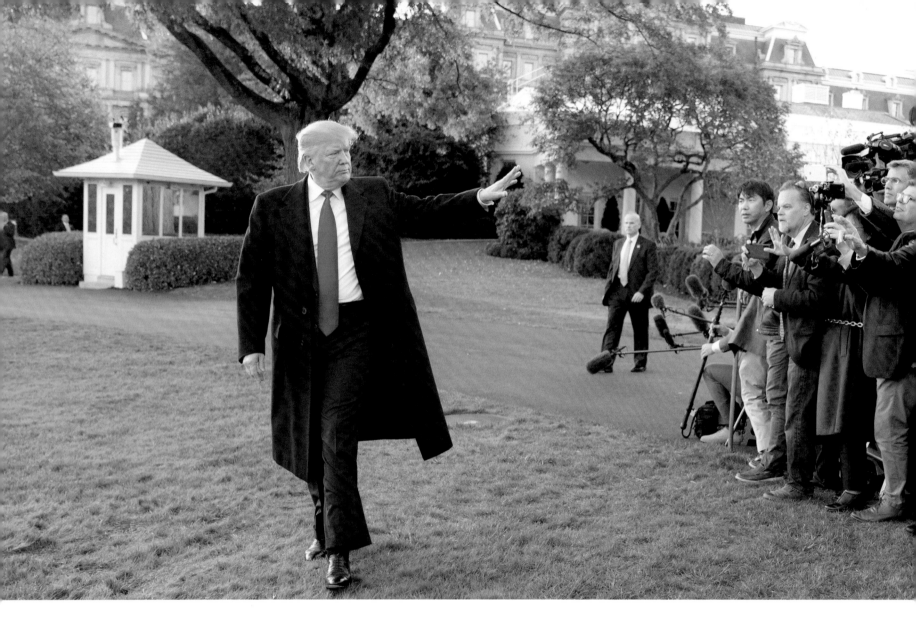

November 4, 2019: Waving to reporters on the South Lawn
before departing for Kentucky. (Joyce N. Boghosian)

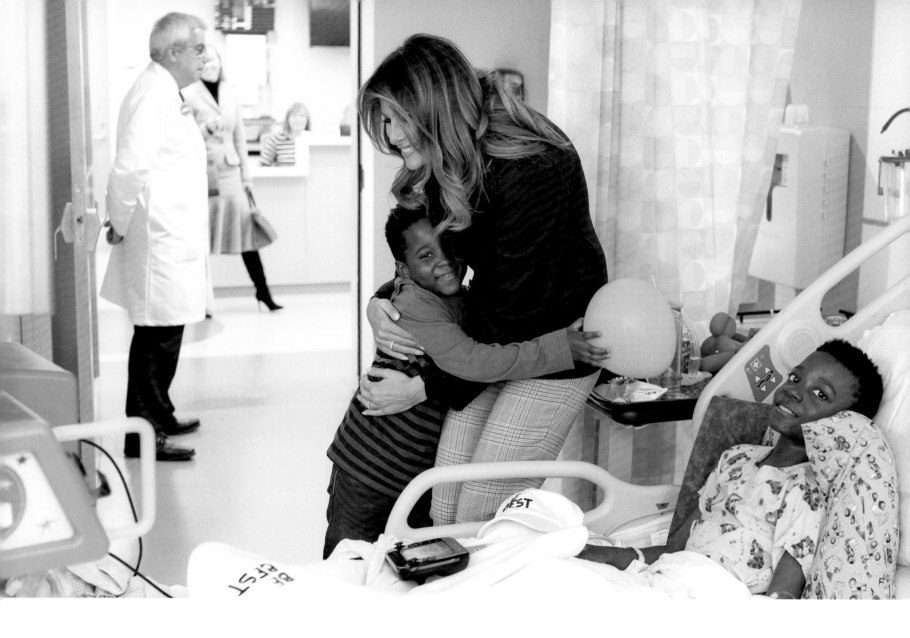

November 6, 2019: The First Lady visiting with patients and family members in the pediatric wing of Boston Medical Center. (Andrea Hanks)

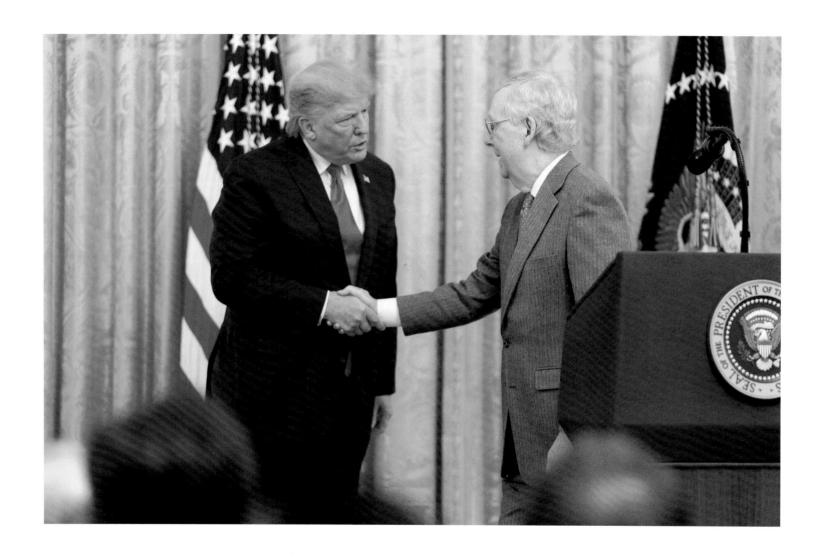

November 6, 2019: Honoring Senate Majority Leader Mitch McConnell during the federal judicial confirmation milestones event in the East Room of the White House. (Shealah Craighead)

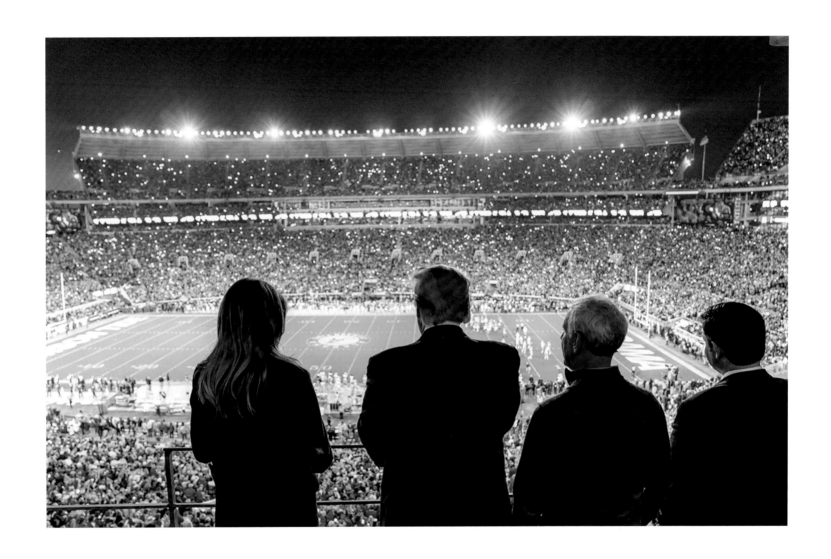

November 9, 2019: At the Alabama-LSU football game in Tuscaloosa. (Shealah Craighead)

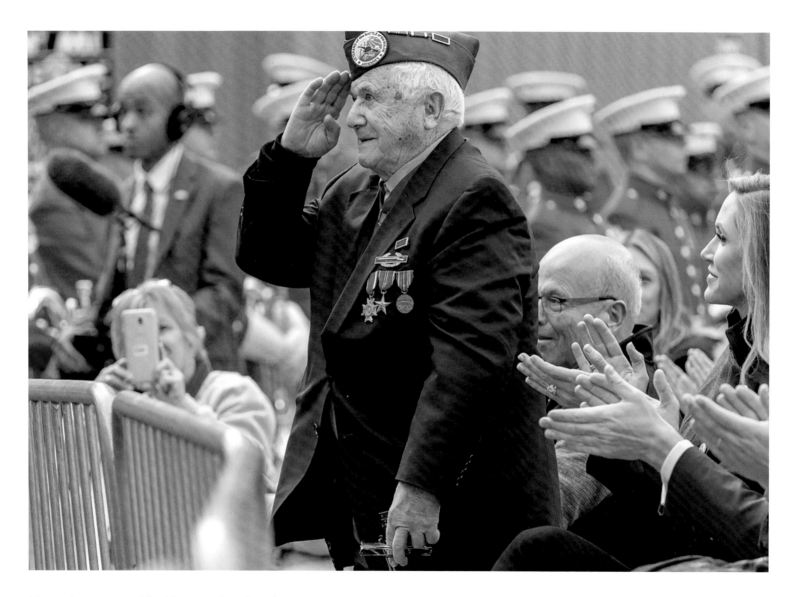

November 11, 2019: The Veterans Day Parade
in New York City. (Shealah Craighead)

With God as our witness, we pledge to always honor our veterans and pay immortal tribute to those who have laid down their lives so that we might be free.

Together, we must safeguard what generations of fearless patriots gave everything to secure. We will protect our liberty, uphold our values, and defend our home. We will ensure that righteous legacy of America's veterans stands as a testament to this nation from now until the end of time.

To every veteran here today and all across our land: You are America's greatest living heroes and we will cherish you now, always, and forever.

—From the President's remarks at the New York City Veterans Day Parade, November 11, 2019

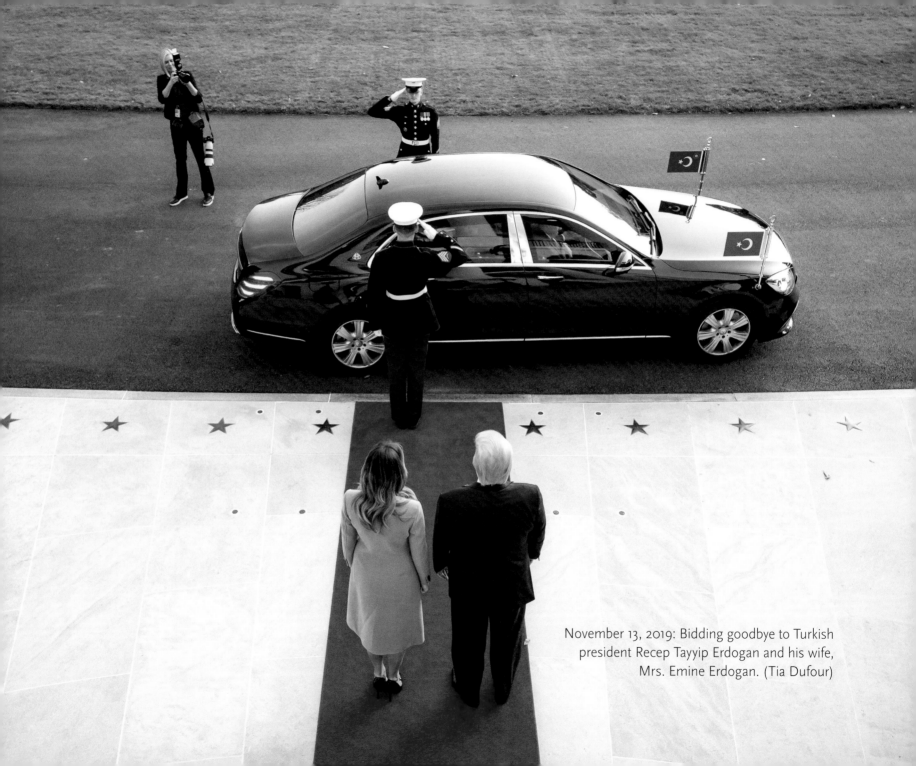

November 13, 2019: Bidding goodbye to Turkish president Recep Tayyip Erdogan and his wife, Mrs. Emine Erdogan. (Tia Dufour)

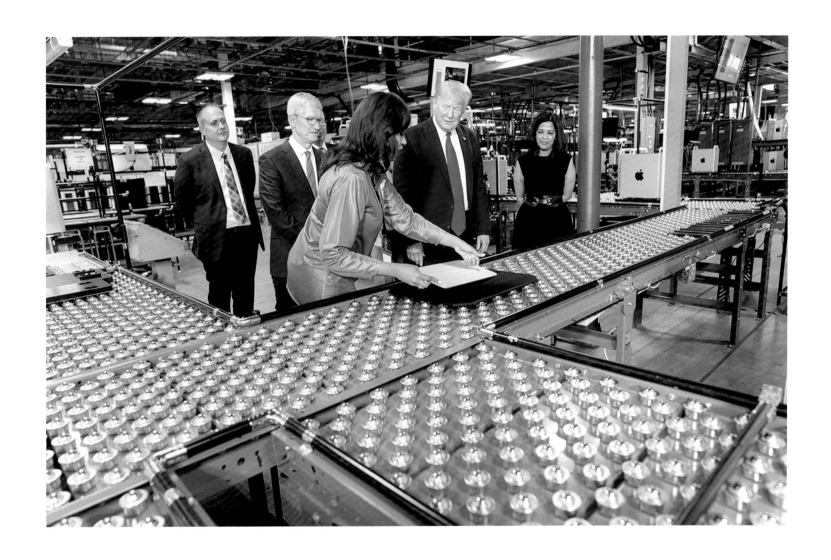

November 20, 2019: The President tours the Apple Manufacturing Plant in Austin, Texas. (Shealah Craighead)

November 21, 2019: The President salutes during the dignified transfer ceremony at Dover Air Force Base for Chief Warrant Officer 2 David C. Knadle and Chief Warrant Officer 2 Kirk T. Fuchigami Jr., who were killed in a helicopter crash in Afghanistan. (Shealah Craighead)

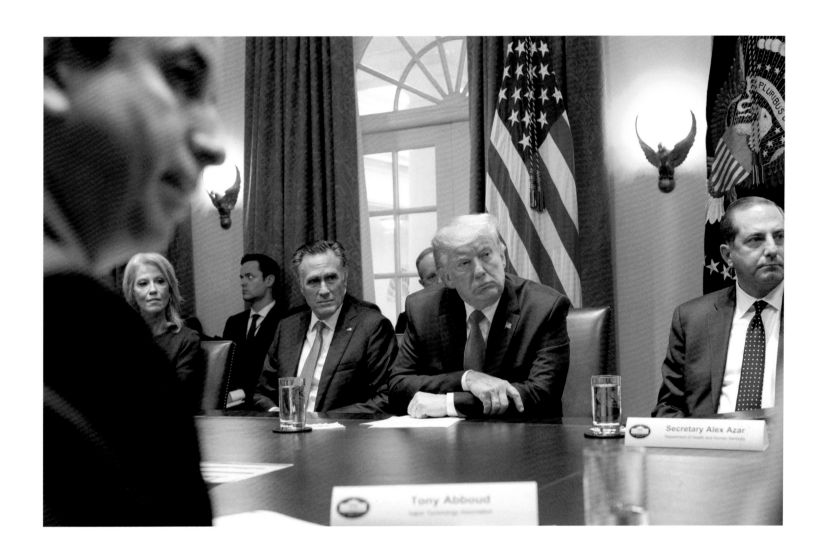

November 22, 2019: Attending a White House Listening Session on Youth Vaping and the Electronic Cigarette Epidemic. (Joyce N. Boghosian)

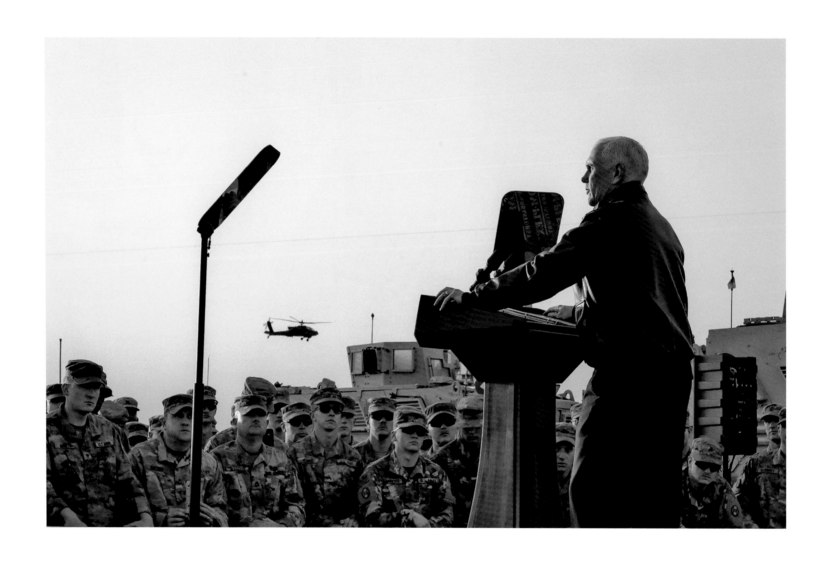

November 23, 2019: Vice President Pence makes a surprise
Thanksgiving visit to troops in Iraq. (D. Myles Cullen)

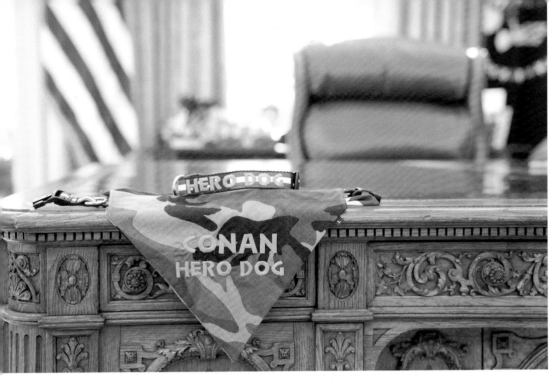

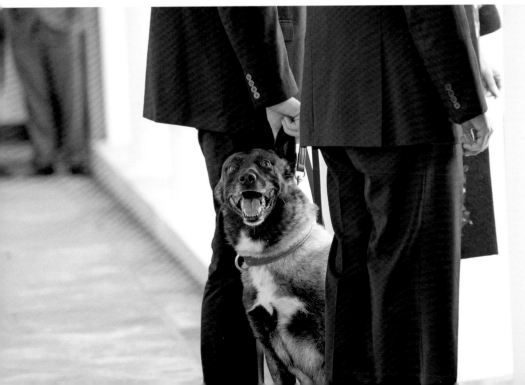

November 25, 2019: Welcoming Conan, the military working dog who participated in the operation against ISIS leader Abu Bakr al-Baghdadi, to the White House. (Shealah Craighead)

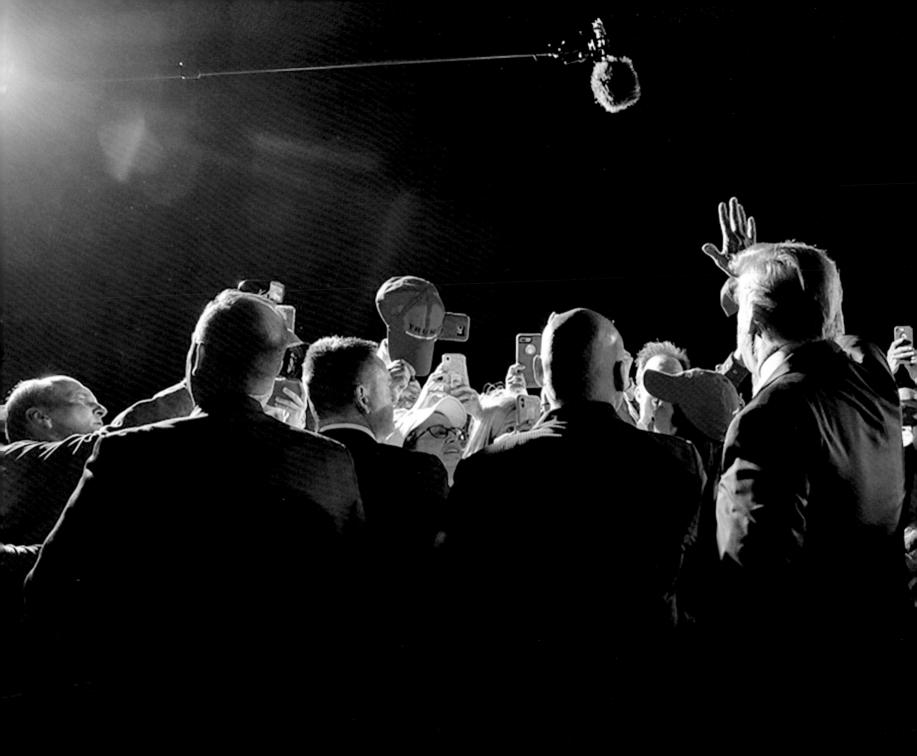

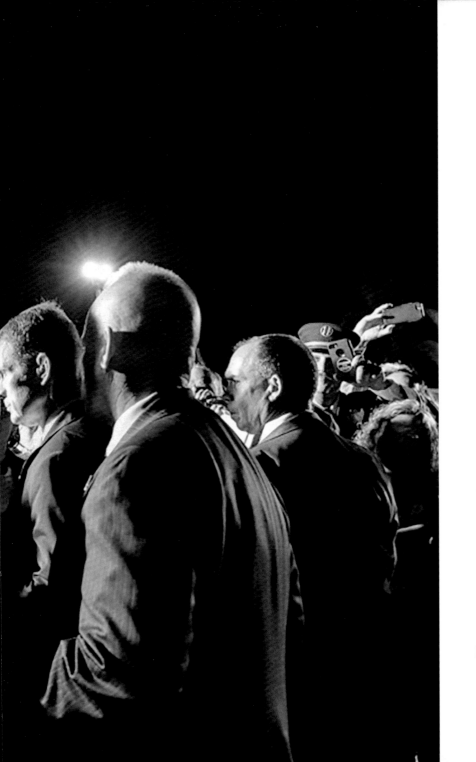

November 26, 2019: The President is welcomed by supporters upon his arrival in Palm Beach, Florida. (Shealah Craighead)

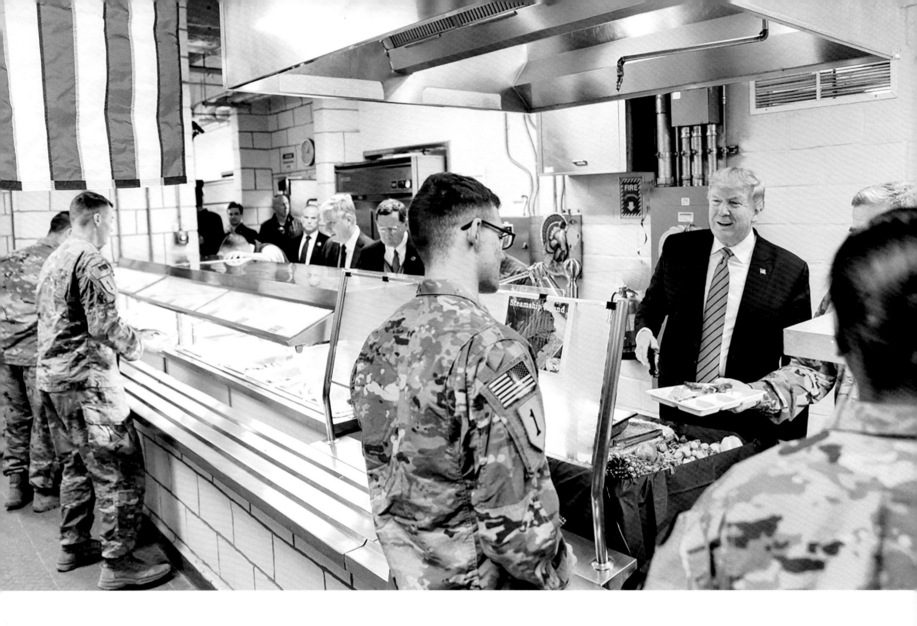

November 28, 2019: Serving Thanksgiving dinner at
Bagram Air Base in Afghanistan. (Shealah Craighead)

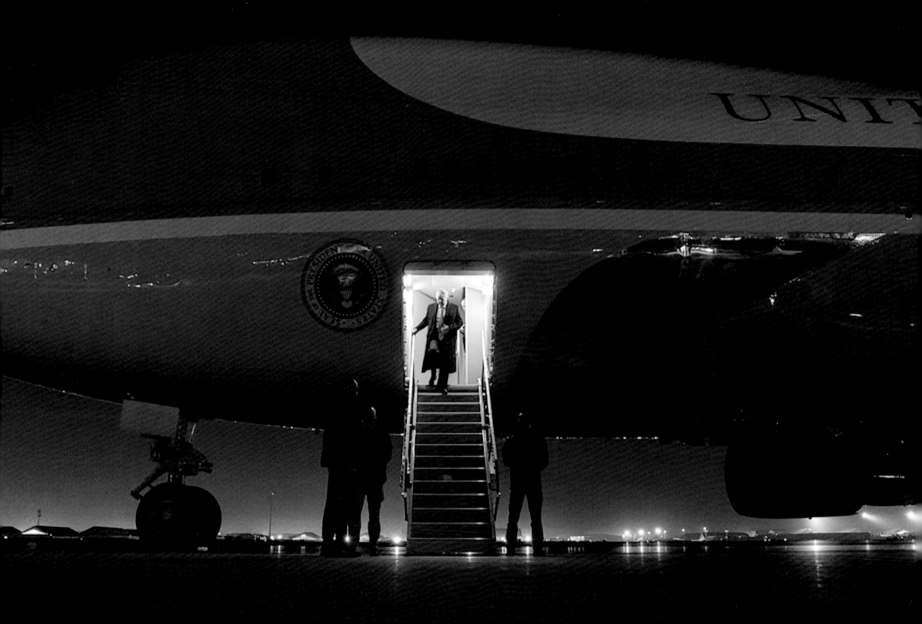

November 28, 2019: Aboard Air Force One
at Bagram Air Base. (Shealah Craighead)

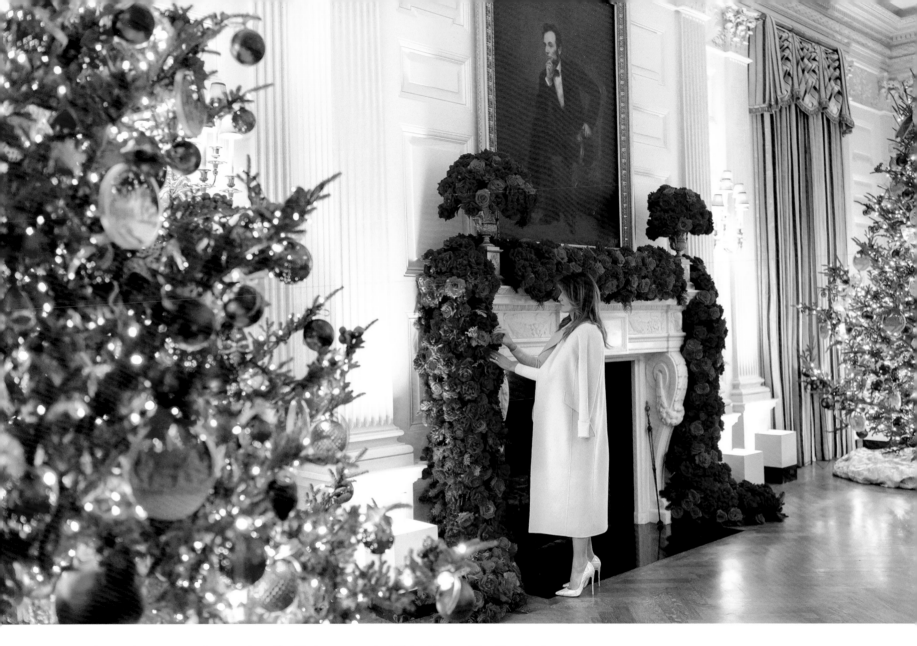

December 1, 2019: Preparations for Christmas at the White House. The First Lady inspects a rose garland in the State Dining Room. (Andrea Hanks)

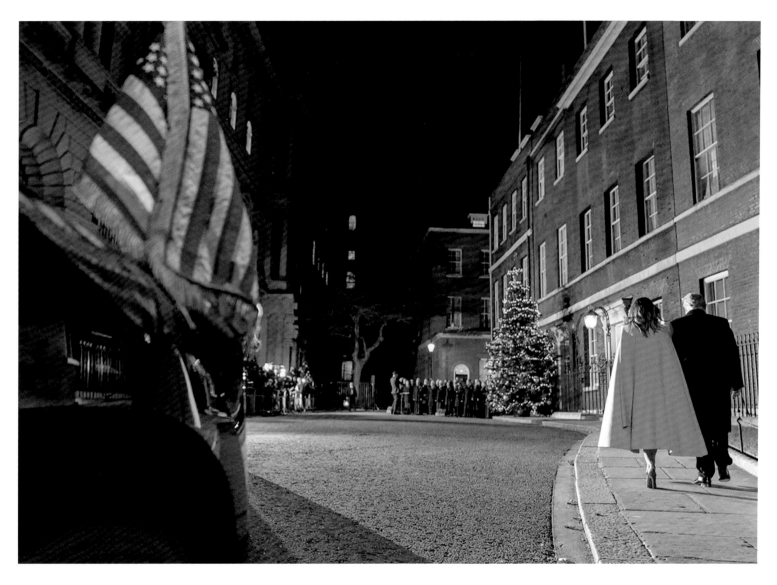

December 3, 2019: With the First Lady, attending a NATO Leaders' Reception at 10 Downing Street. (Shealah Craighead)

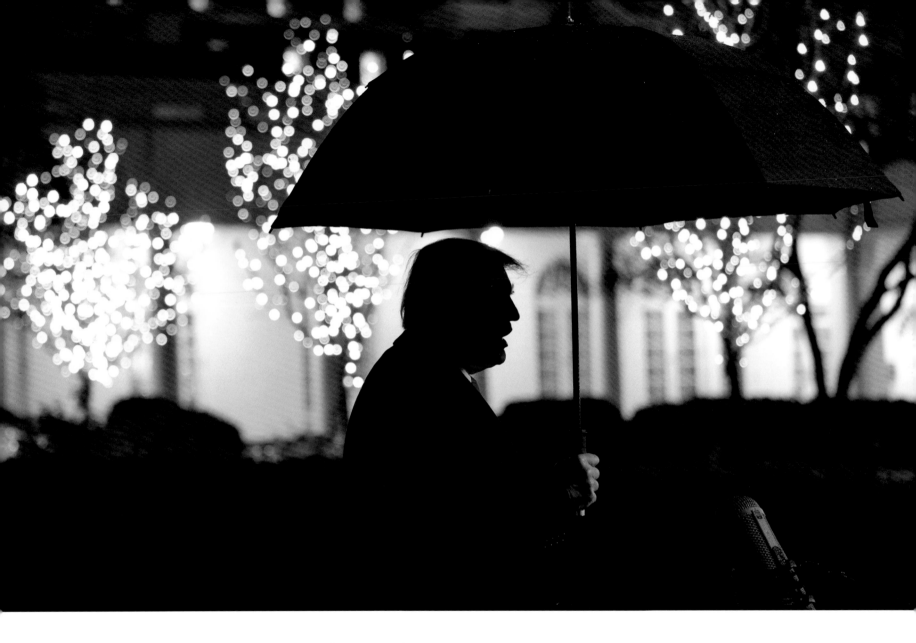

December 10, 2019: President Trump in silhouette on the
South Lawn of the White House. (Joyce N. Boghosian)

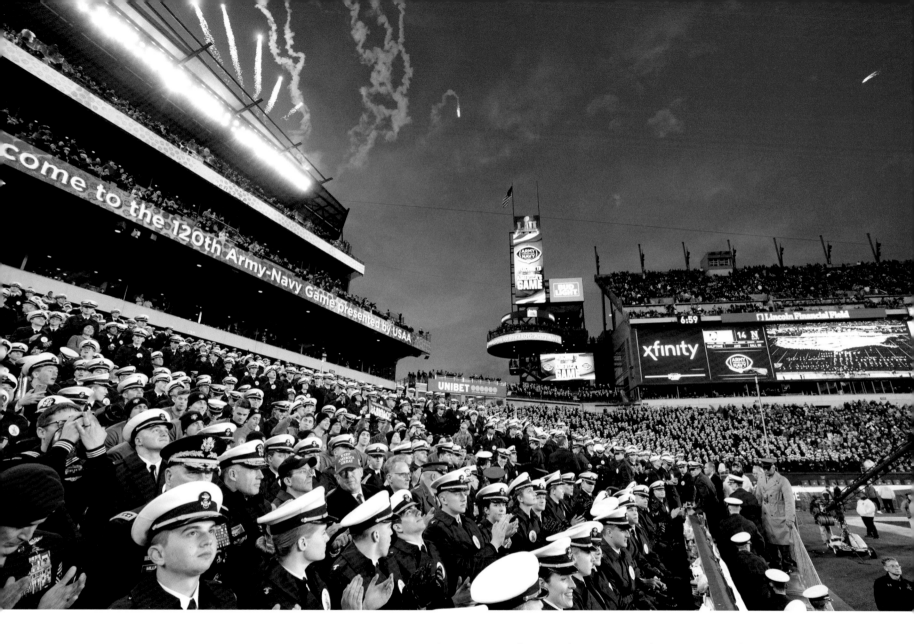

December 14, 2019: The President, sitting with U.S. Navy Cadets, watches a military flyover during the 120th Army-Navy football game. (Joyce N. Boghosian)

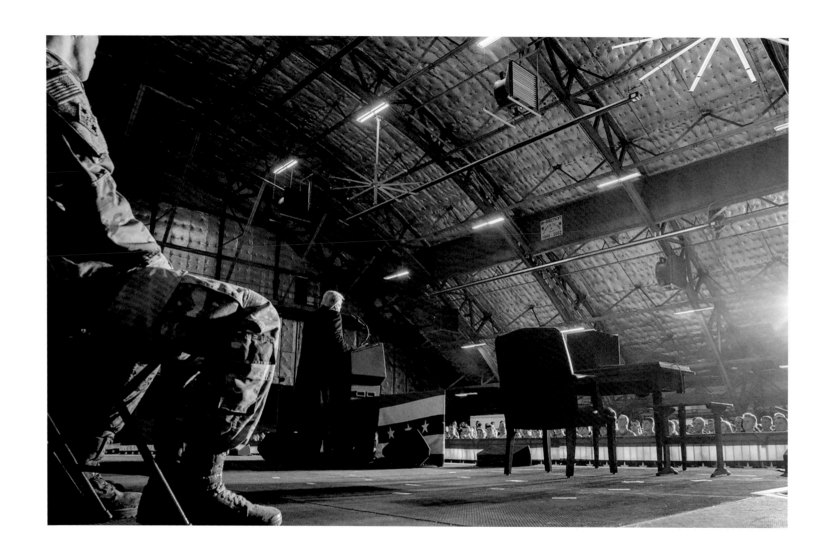

December 20, 2019: Delivering remarks at Joint Base Andrews prior to signing the
National Defense Authorization Act for Fiscal Year 2020. (Shealah Craighead)

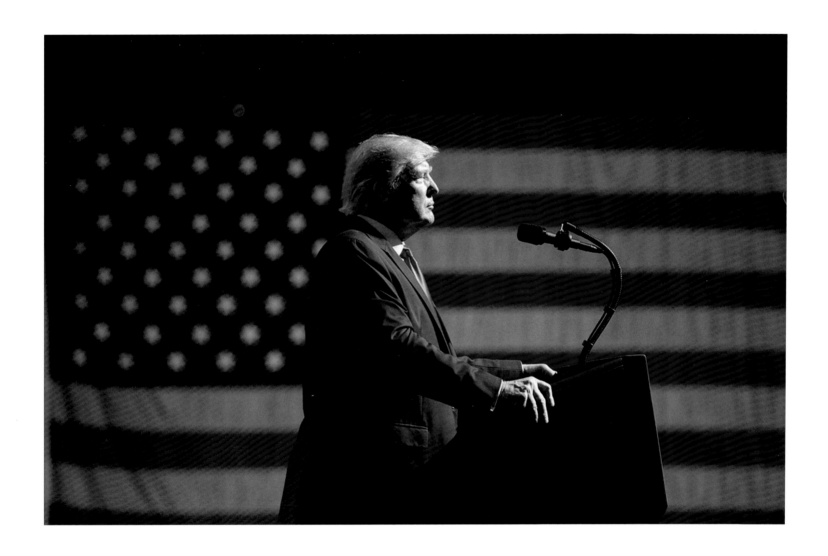

December 21, 2019: At Turning Point USA's 5th annual
Student Action Summit. (Shealah Craighead)

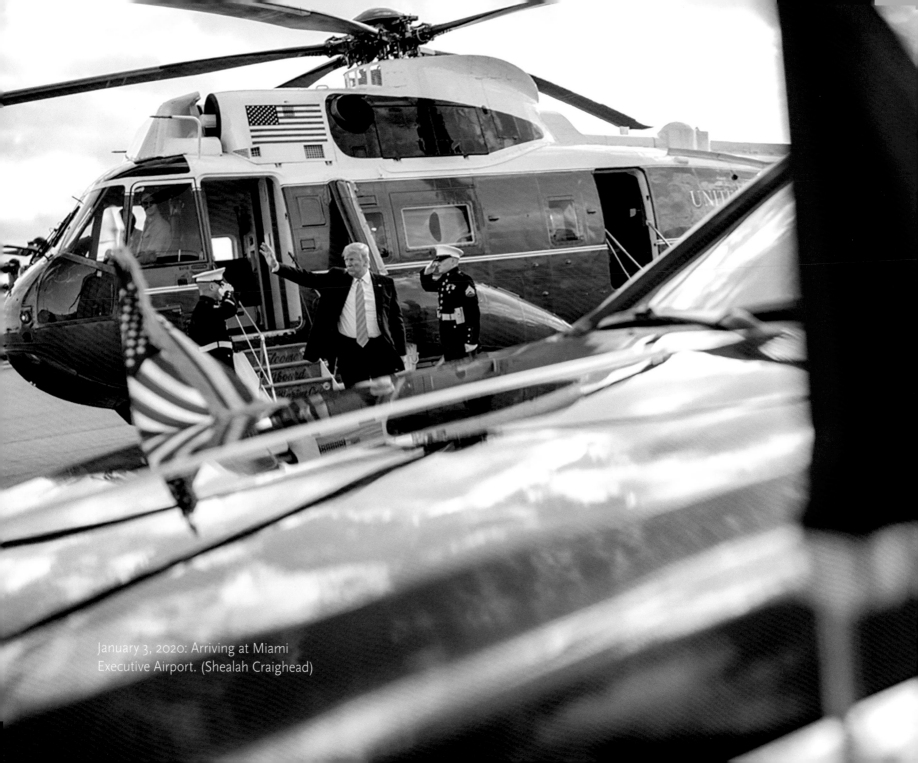

January 3, 2020: Arriving at Miami
Executive Airport. (Shealah Craighead)

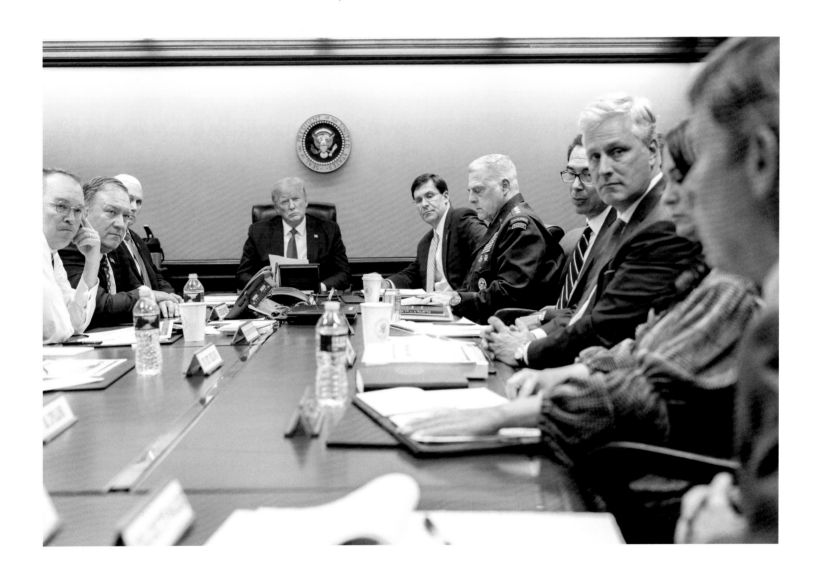

January 7, 2020: Meeting with senior White House advisors in the Situation Room to discuss Iranian missile attacks on U.S. military facilities in Iraq. (Shealah Craighead)

We are Americans. We are pioneers. We are the pathfinders. We settled the New World, we built the modern world, and we changed history forever by embracing the eternal truth that everyone is made equal by the hand of Almighty God.

America is the place where anything can happen. America is the place where anyone can rise. And here, on this land, on this soil, on this continent, the most incredible dreams come true.

This nation is our canvas, and this country is our masterpiece. We look at tomorrow and see unlimited frontiers just waiting to be explored. Our brightest discoveries are not yet known. Our most thrilling stories are not yet told. Our grandest journeys are not yet made. The American Age, the American Epic, the American adventure has only just begun.

Our spirit is still young, the sun is still rising, God's grace is still shining, and, my fellow Americans, the best is yet to come.

—From the State of the Union Address, February 4, 2020

February 4, 2020: Delivering the State of the Union. (Shealah Craighead)

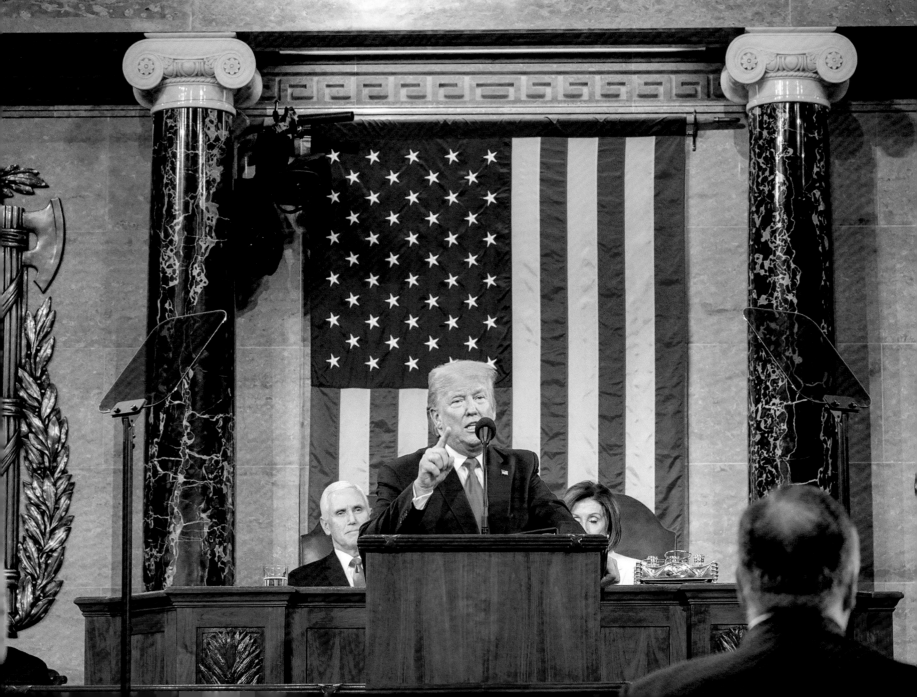

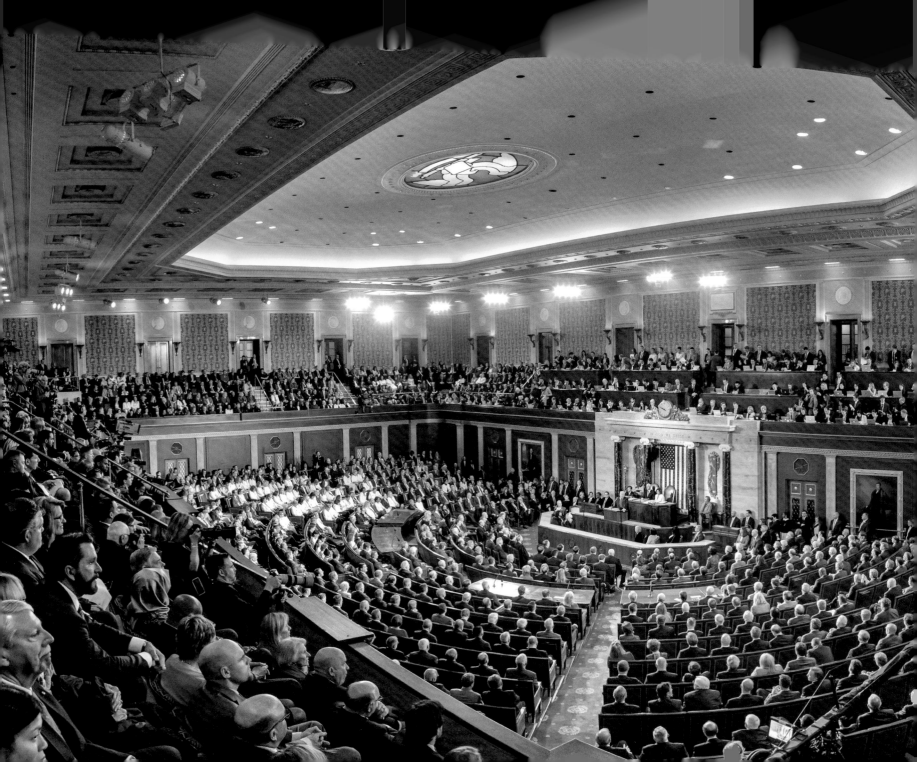

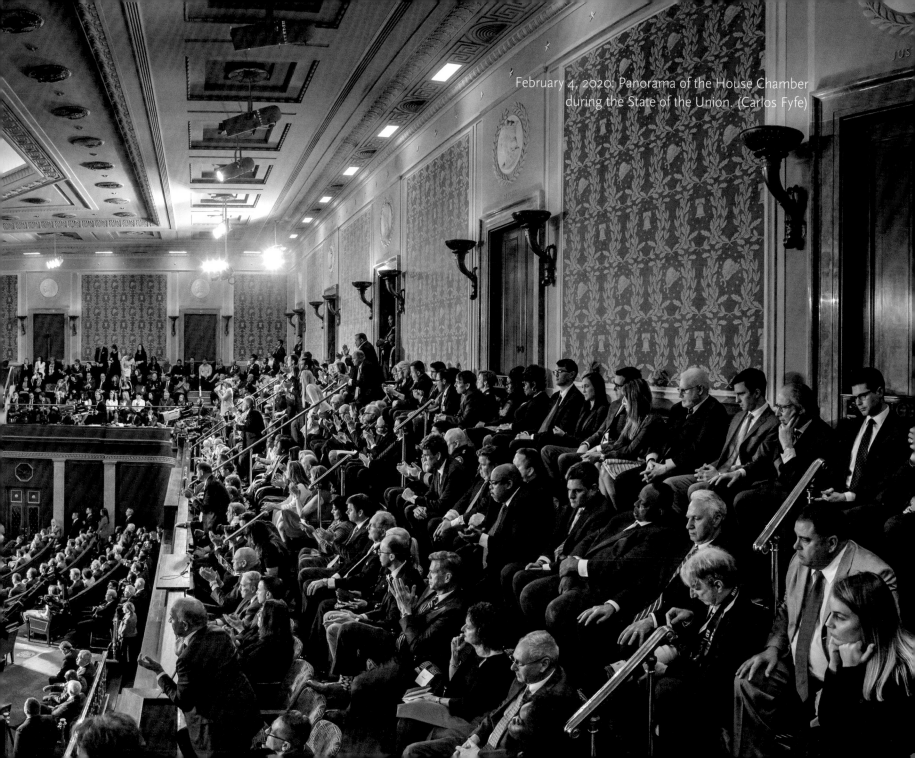

February 4, 2020: Panorama of the House Chamber during the State of the Union. (Carlos Fyfe)

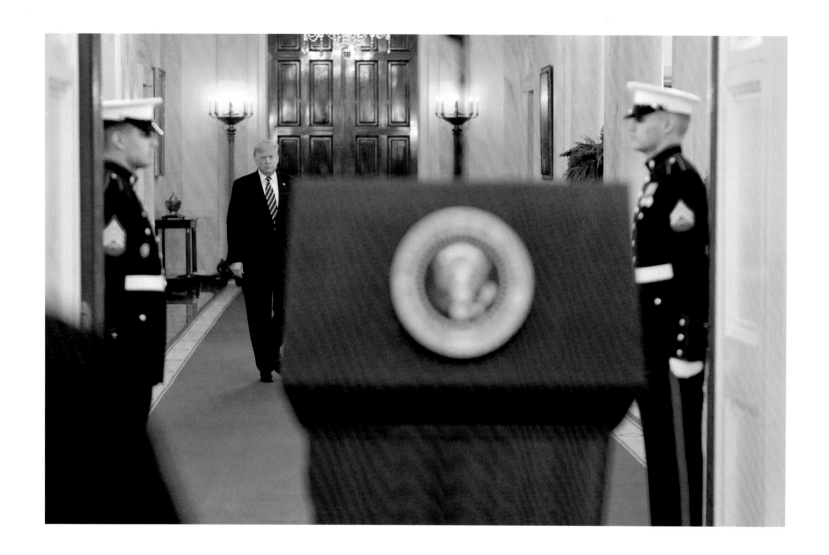

February 6, 2020: Arriving to address his acquittal in
the U.S. Senate Impeachment Trial. (Andrea Hanks)

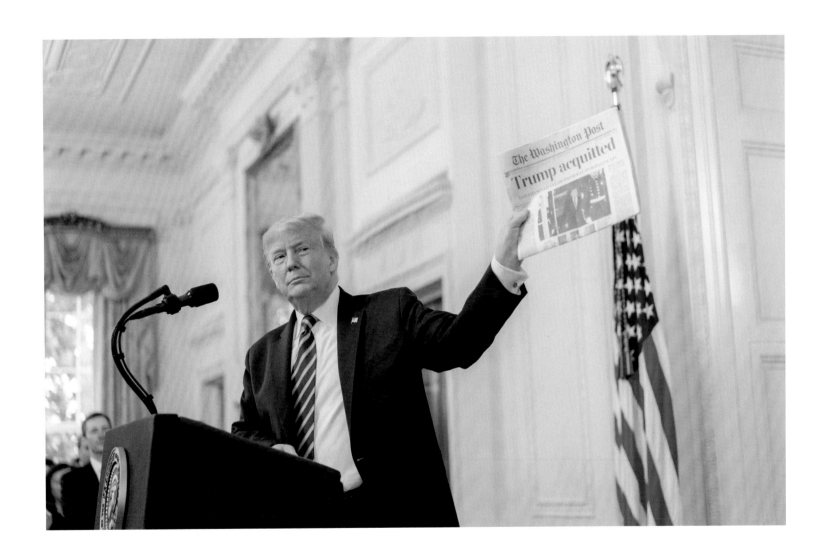

February 6, 2020: In the East Room of the White House, the President displays a copy of that morning's *Washington Post*. (D. Myles Cullen)

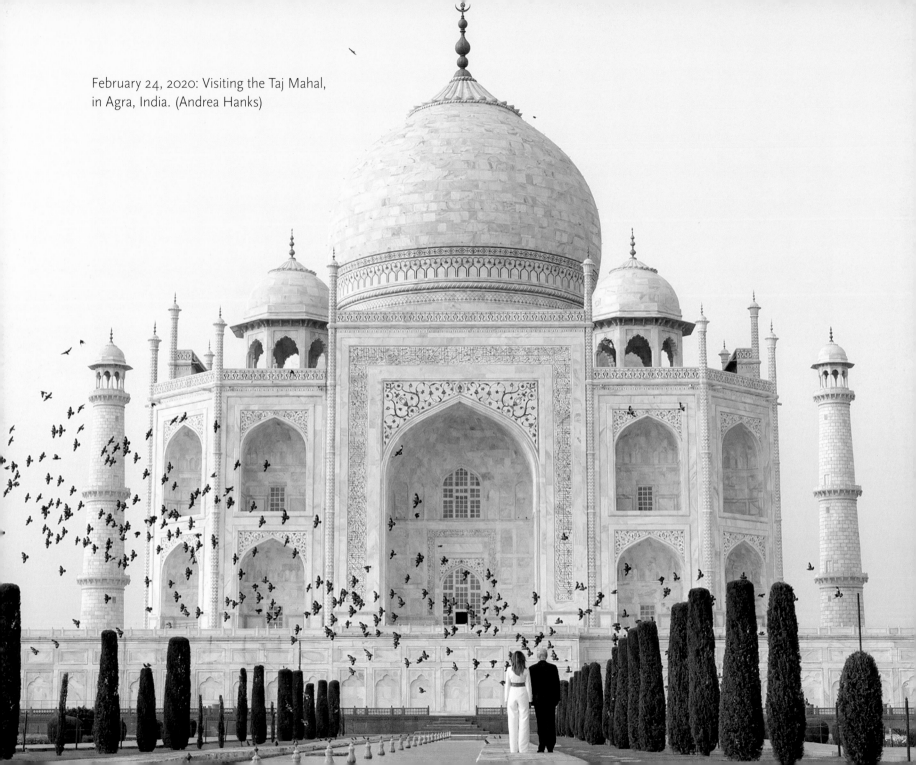

February 24, 2020: Visiting the Taj Mahal, in Agra, India. (Andrea Hanks)

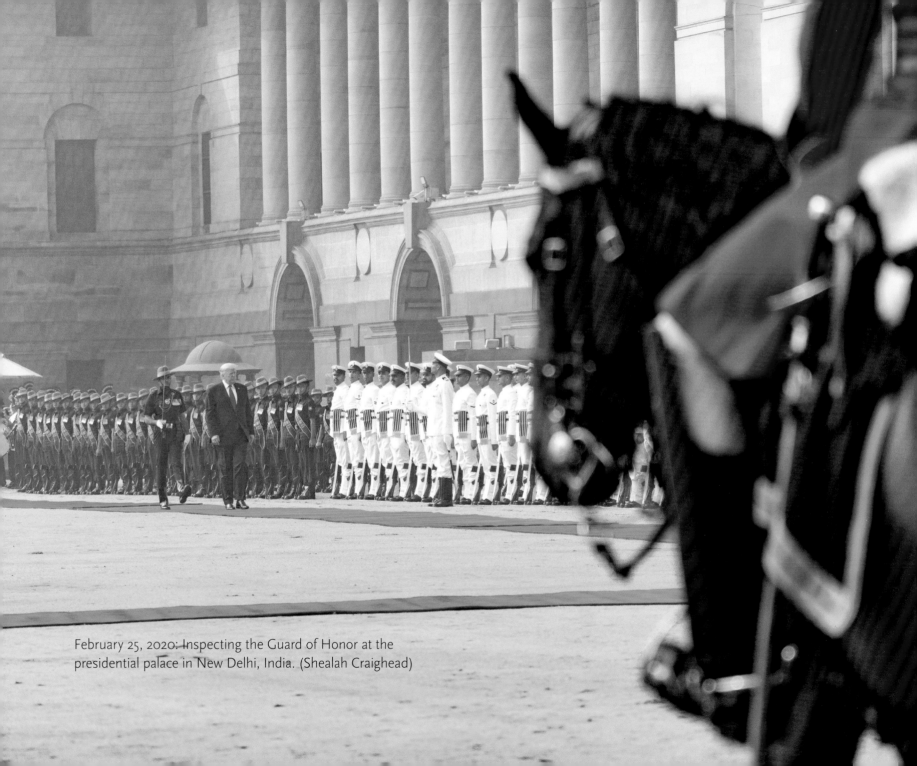

February 25, 2020: Inspecting the Guard of Honor at the presidential palace in New Delhi, India. (Shealah Craighead)

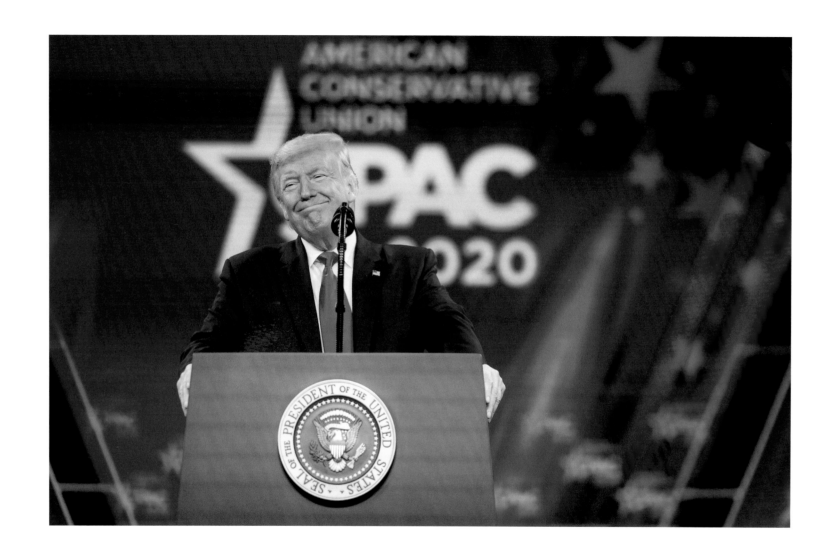

February 29, 2020: Addressing the Conservative Political Action
Conference (CPAC) in Oxon Hill, Maryland. (Tia Dufour)

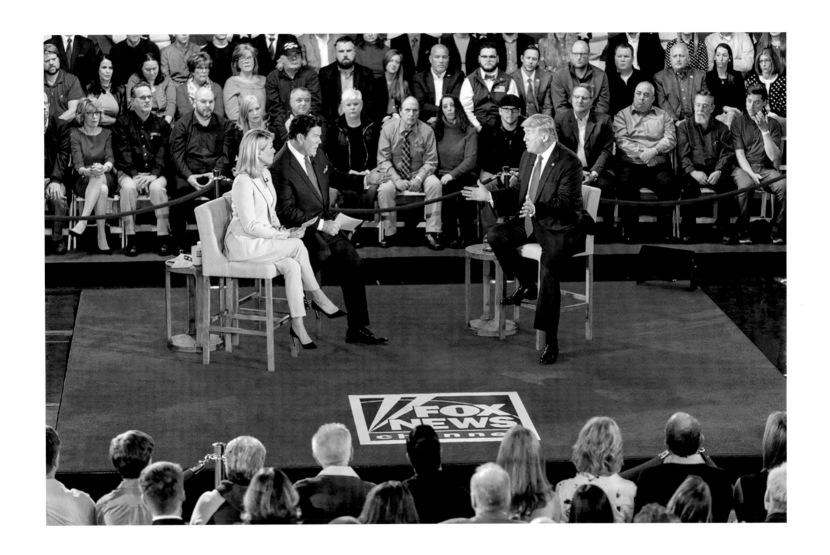

March 5, 2020: With Bret Baier and Martha MacCallum at a Fox News Channel "town hall" in Scranton, Pennsylvania. (Shealah Craighead)

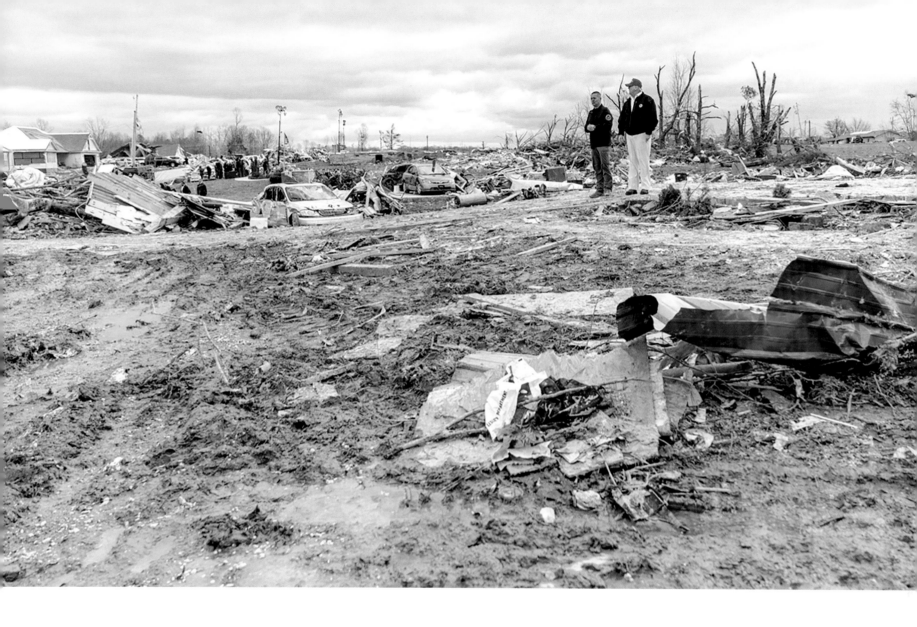

March 6, 2020: Surveying tornado damage
in Cookeville, Tennessee. (Shealah Craighead)

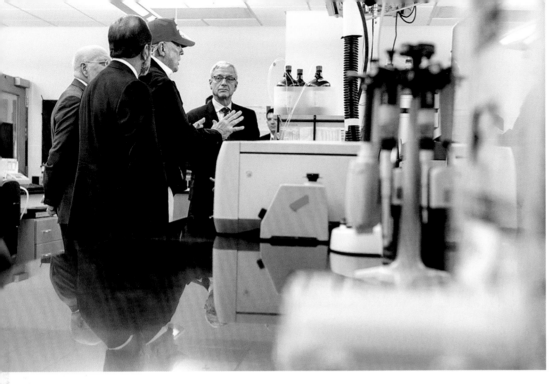

March 6, 2020: Visiting the Centers for Disease Control and Prevention (CDC) in Atlanta, Georgia, with Secretary of Health and Human Services Alex Azar (left) and CDC Director Dr. Robert R. Redfield. (Shealah Craighead)

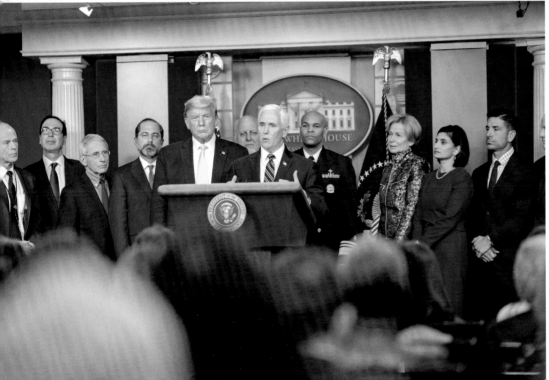

March 9, 2020: A Coronavirus Task Force press briefing in the White House. (D. Myles Cullen)

As history has proven time and time again, Americans always rise to the challenge and overcome adversity.

Our future remains brighter than anyone can imagine. Acting with compassion and love, we will heal the sick, care for those in need, help our fellow citizens, and emerge from this challenge stronger and more unified than ever before.

*—From the President's address to the nation on
the coronavirus outbreak, March 11, 2020*

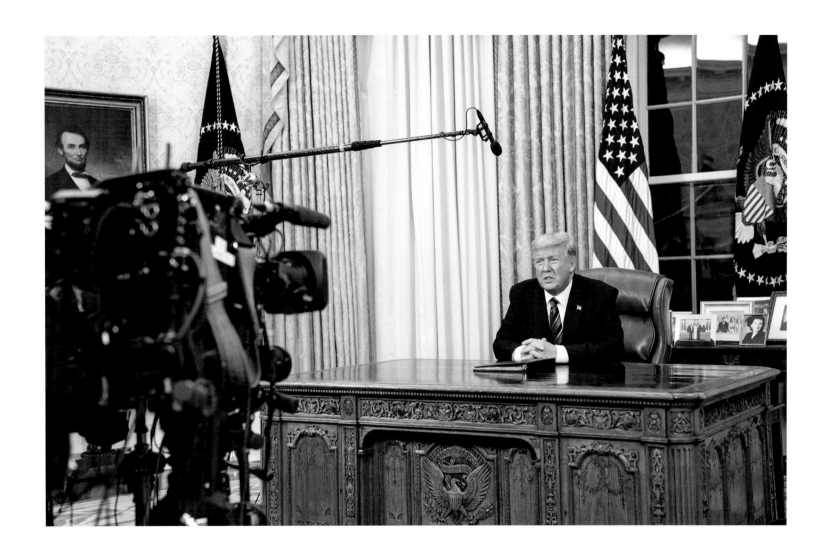

March 11, 2020: Addressing the nation from the Oval Office
on the coronavirus outbreak. (Joyce N. Boghosian)

HarperCollins books may be purchased for educational, business, or sales promotional use. For information, please email the Special Markets Department at SPsales@harpercollins.com.

FIRST EDITION

Photographs © White House Photo Office. Grateful acknowledgment is made to the White House Photo Office as well as the individual photographers credited throughout.

Library of Congress Cataloging-in-Publication Data has been applied for.

ISBN 978-0-06-301124-3

20 21 22 23 24 ITIB 10 9 8 7 6 5 4 3 2 1